The Macclesfield Psalter

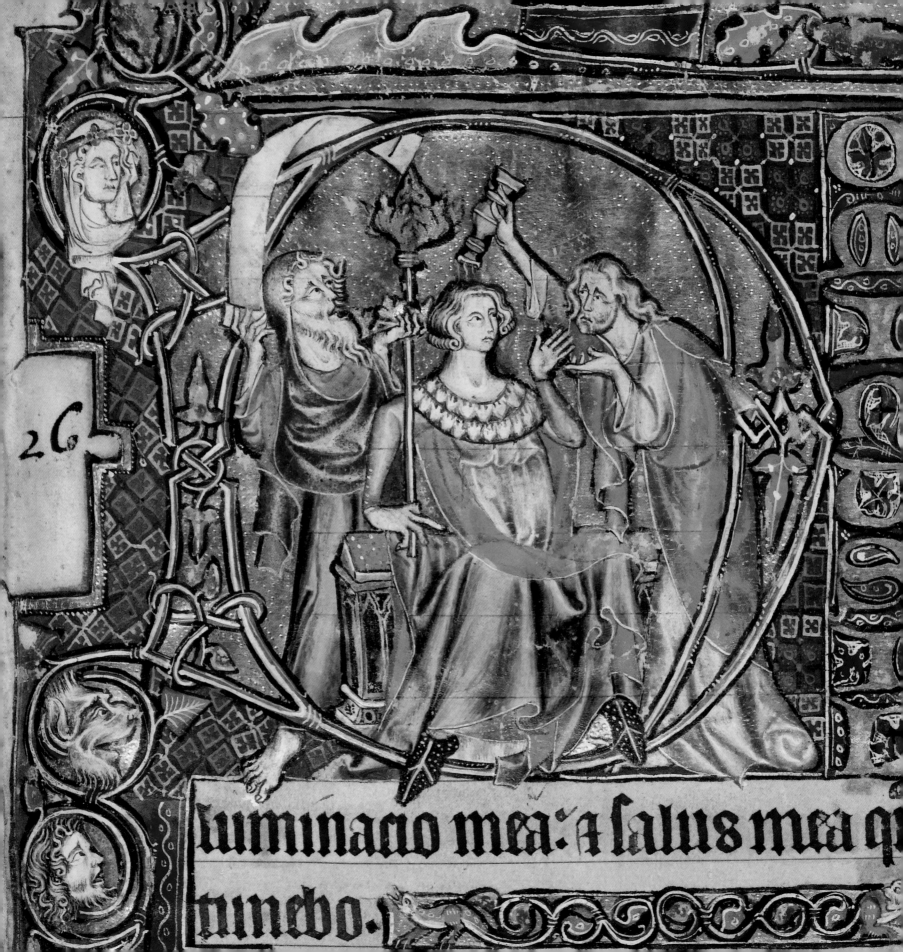

26

luminacio mea: a salus mea q

timebo.

The Macclesfield Psalter

STELLA PANAYOTOVA

*With a Complete Reproduction at the Original Size of this 14th-Century Prayer Book
in the Collections of the Fitzwilliam Museum, Cambridge,
and 95 Color Details*

Thames & Hudson

For John

On the slipcase: Death strikes his victim with a spear: historiated initial, 'Placebo domino', Vespers of the Office of the Dead, Macclesfield Psalter, folio 235v. On the front of the book: A mounted knight, a lady, a wildman and a dog: Macclesfield Psalter, folio 85r. On the preceding pages: (half-title page) Border figure, Macclesfield Psalter, folio 69r; (frontispiece) The Anointing of David: historiated initial, Psalm 26, Macclesfield Psalter, folio 39r. On the following pages: (contents) Border motifs, Macclesfield Psalter, folios 3v and 5r; (pages 8–9) Border figures, Macclesfield Psalter, folio 136v.

First published in 2008 in hardcover in the United States of America by Thames & Hudson Inc., 500 Fifth Avenue, New York, New York 10110

thamesandhudsonusa.com

Library of Congress Catalog Card Number 2008901158

ISBN 978-0-500-23852-3

Printed and bound in China by C&C Offset Printing Co., Ltd.

The Fitzwilliam Museum purchased the Macclesfield Psalter in February 2005 with grants from the National Heritage Memorial Fund, the Art Fund, the Friends of the Fitzwilliam Museum, the Friends of the National Libraries and the Cadbury Trust, and with contributions from a public appeal launched by the Art Fund.

The conservation and rebinding of the manuscript were carried out by the Fitzwilliam Museum's Conservator, Mr Robert Proctor, and sponsored by Judge Colin Colston and Mrs Edith Colston.

The digitization of the manuscript, which provided the images for the reproduction in this edition, was completed by the Fitzwilliam Museum's Chief Photographer, Mr Andrew Morris, and funded by the Seven Pillars of Wisdom Fund.

Throughout the commentary and in captions, references to the Macclesfield Psalter use this title alone. Its full identification is: Macclesfield Psalter, Cambridge, Fitzwilliam Museum, MS 1-2005. References to other manuscripts similarly use familiar titles; locations and full identifications are given in the notes. The author and publisher gratefully acknowledge permission to reproduce details from the manuscripts listed below, the sources of which are abbreviated as shown.

Bede, *Historia ecclesiastica* – Cambridge, Trinity College, MS R.7.3 [TC MS R.7.3]
Douai Psalter – Douai, Bibliothèque Municipale, MS 171 [Bibl. Mun. MS 171]
Ghent Book of Hours – Cambridge, Trinity College, MS B.11.22 [TC MS B.11.22]
Gorleston Psalter – London, British Library, Add. MS 49622 [BL Add. MS 49622]
John of Freiburg, *Summa confessorum* – London, British Library, Royal MS 8.G.XI [BL Royal MS 8.G.XI]
Ormesby Psalter – Oxford, Bodleian Library, MS Douce 366 [BodL MS Douce 366]
Stowe Breviary – London, British Library, Stowe MS 12 [BL Stowe MS 12]

ACKNOWLEDGMENTS

The study of medieval manuscripts, like their original production, is a collaborative venture. The Macclesfield Psalter was made by an accomplished scribe and professional artists to meet the needs of a young man and the expectations of his spiritual tutor. This study has benefited from the generosity of many more experts and advisers. François Avril, Nicholas Baring, Alixe Bovey, Michelle Brown, Joanna Cannon, Mary Carruthers, Lynda Dennison, David King, Frederica Law-Turner, Patricia Lovett, Hector McDonnell, Jeremy Montagu, Lea Olsan, John Pinnegar, Suzanne Reynolds, Nicholas Rogers, Richard and Mary Rouse, Miri Rubin, Michael Siddons, Maureen Street, Teresa Webber and Thomas Woodcock discussed and advised on various aspects of the manuscript. I am particularly indebted to Paul Binski, T. A. Heslop, Michael Michael, Nigel Morgan and Lucy Sandler for their thorough reading of an early draft. Their corrections, insights and provocative questions had a far greater impact on this commentary than the notes and bibliography may suggest. If the commentary does not resolve all of the issues they raised, the failure is entirely mine.

Much of the preliminary research depended on access to the original manuscripts and on the provision of high quality comparative images. I received a warm welcome and wholehearted support from Norma Aubertin-Potter at All Souls College, Oxford, Bruce Barker-Benfield, Martin Kauffmann and Rigmor Båtsvik at the Bodleian Library, Scot McKendrick and Mara Hoffmann at the British Library, Pierre-Jacques Lamblin at the Bibliothèque Municipale in Douai, José Luis del Valle Merino at the Escorial, and David McKitterick at Trinity College, Cambridge.

This book would have been very different without Robert Proctor's astonishing achievement in conserving what was a pile of loose leaves, without Andrew Morris's uncompromisingly high standards in digital photography, and without Spike Bucklow's thorough analysis of the pigments, using the most sensitive, sample-free technologies available to date. Duncan Robinson and David Scrase, who were instrumental in the acquisition of the Macclesfield Psalter, offered generous support during the research stage and kindly read an early draft of my text. Jamie Camplin, Rosemary Roberts, Karin Fremer and Susanna Friedman saw the publication through to completion with admirable attention to detail and gracious flexibility. Finally, I thank John, Julie and Patrick for being as patient and loving as ever.

CONTENTS

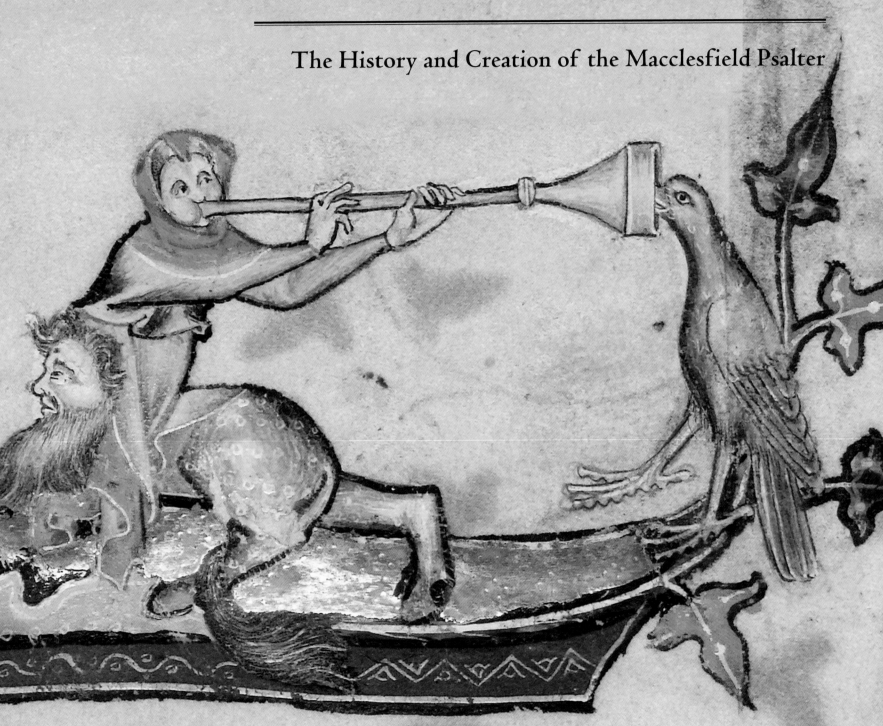

PART I

The History and Creation of the Macclesfield Psalter

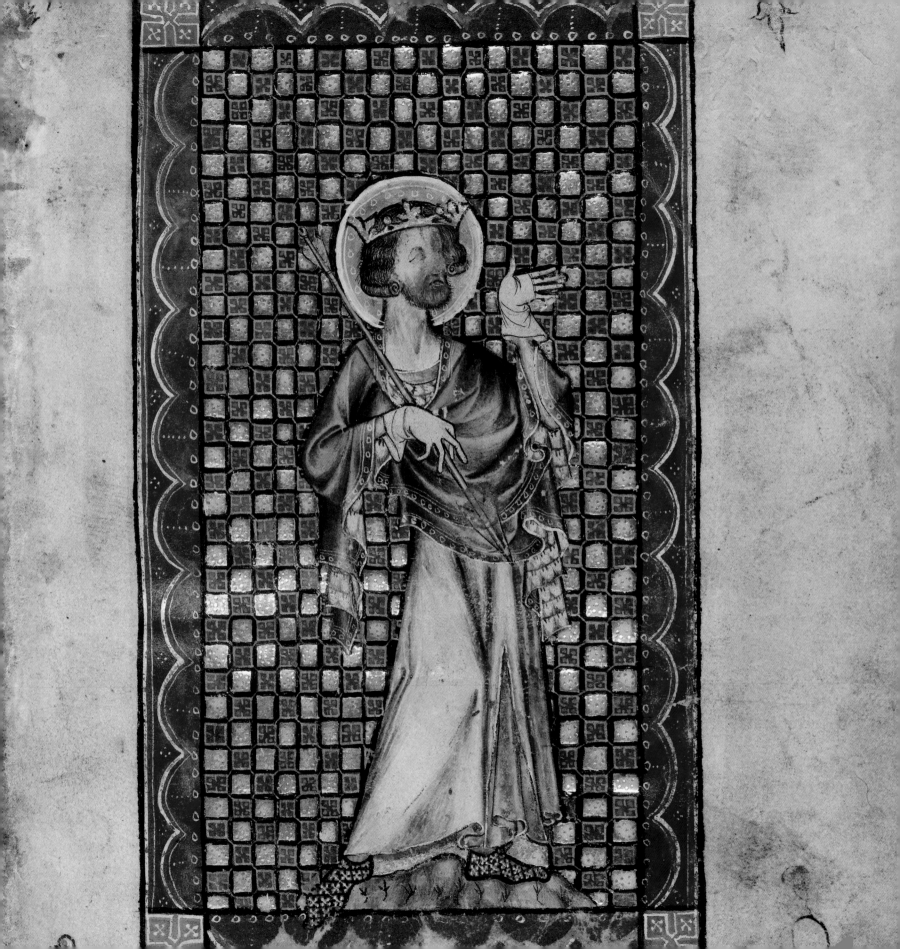

INTRODUCTION

Hidden treasures, quests and miraculous discoveries conjure up a beguiling image of the Middle Ages. Real-life discoveries of treasures are exceptionally unknown in modern times until it resurfaced in the library of the Earl of Macclesfield at Shirburn Castle, Oxfordshire, the Macclesfield Psalter became a celebrity as it went under the hammer at Sotheby's auction rooms in London on 22 June 2004. Following an eventful fundraising campaign, the Fitzwilliam Museum acquired it through the generosity of grant-giving bodies and the wholehearted support of the public. This tiny prayer book was heralded as 'the most important discovery of any English illuminated manuscript in living memory'[1] and 'a window into the world of Medieval England'.[2] Does it live up to such high claims?

Made in East Anglia in the second quarter of the 14th century, the Macclesfield Psalter is the missing link between some of the most celebrated English manuscripts of the time. It demonstrates the intimate connection between manuscript illumination and contemporary monumental painting, and it reveals the vigorous exchange between local traditions, metropolitan fashions and continental trends in 14th-century England.

Through its intricate web of texts and images the Macclesfield Psalter blends contemporary literature, history, everyday experience and humour with painting of the finest quality. We admire the rich, fresh, vibrant pigments, the elegant figures with their unusually expressive faces, the charming naturalism and dynamic interaction of the imagery

in the margins, the irresistible vitality and creative imagination. Through sophisticated pictorial allusions we catch glimpses of major events and figures in English history, and witness contemporary political, social and religious developments. We hear echoes from romances and courtly music, as well as fabliaux and folk festivals. While immersed in the bustle and noise of a medieval town, we are also aware of the psalter's spiritual dimensions. The prayers reflect the penitential humility and hope for salvation of the original owner. They also resonate with the witty tales and pictures his Dominican tutor used for moral instruction, pastoral care and, of course, entertainment. We are reminded of the porous boundaries between the secular and the religious, the private and the public in late medieval art and devotion. But we must be mindful that the window through which we look on medieval England offers the very personal, highly subjective perspective of the manuscript's owner and makers. The psalter opens up to us not so much a panoramic view of the times as a keyhole through which we can spy into individuals' beliefs, attitudes, sentiments, memories and aspirations.

There is no better vehicle for the voyeur than a complete reproduction. It presents us with the entire book, not just a handful of images chosen for display under glass in the museum or selected for a scholarly publication in support of a specific set of arguments. We can examine the whole manuscript at our own pace, developing our own ideas, pursuing specific themes of our choice, or indulging our curiosity in quirky little details. Whether we search for hidden meanings or delight in the richness and beauty of the artwork, the reproduction offers us a unique experience, the privilege of using the manuscript as the original owner would have used it.

(opposite) 1 St Edmund of Bury, holding an arrow, the symbol of his martyrdom: miniature, Macclesfield Psalter, folio 1r.

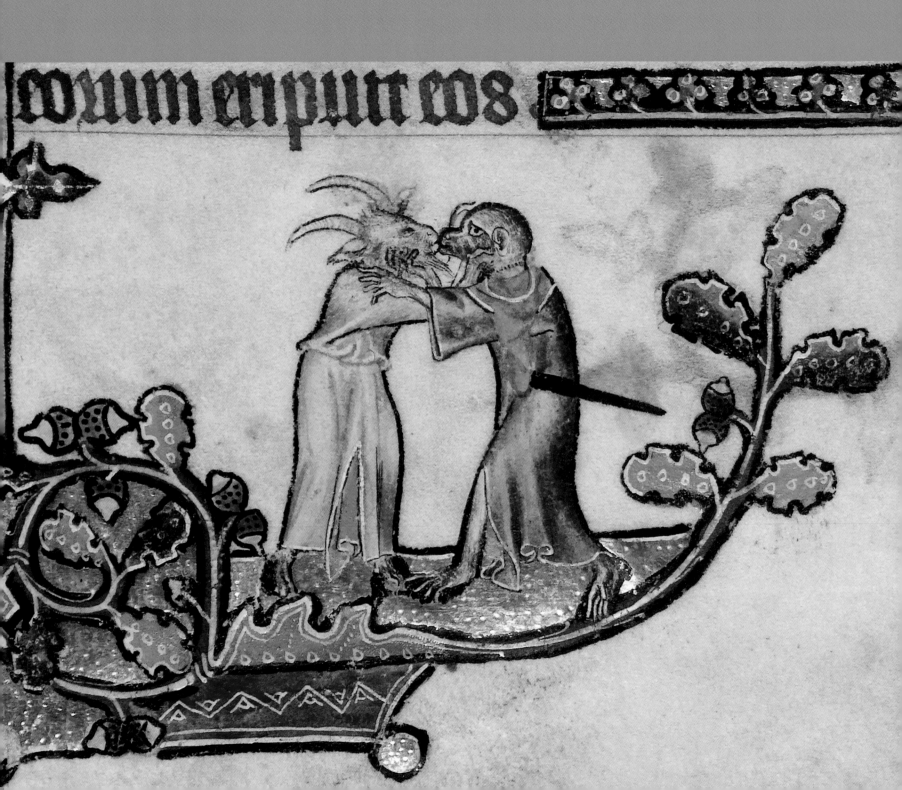

The medieval makers and owners of the Macclesfield Psalter could have perceived its texts and images in a variety of ways, depending on their social background, political allegiances, ideological stance, intellectual capacity, devotional habits, aesthetic tastes and particular circumstances at the time of the manuscript's production. They would have found the pictures helpful as signposts to guide them through the text, useful as mnemonic aids, enjoyable as embellishments of their treasured book, and gratifying as symbols of their piety, status and wealth. Some of the images, instructive in their moral messages and visual interpretations of Scripture, probably functioned as focal points for prayer and as incentives to examine the text closely. Others may have unleashed the imagination, exhilarating in their power to create chains of associations, titillating in their secular, frivolous or obscene connotations, and perhaps disquieting in their ability to implicate the viewer. All these possibilities converge in the Macclesfield Psalter's amalgam of verbal and pictorial meanings. Polyvalent by nature, its images and texts may once have conveyed messages lost on us today, but they also tend to attract modern readings that may yield rare insights as long as one avoids anachronistic views. Bearing in mind that any given interpretation rarely accounts for the intricate web of meanings woven into the manuscript, we may start by picking up the threads exposed on the surface and hope that they will lead us to the centre of the dense fabric.

A Colourful Fabric of Life and Thought

A quick look through the Macclesfield Psalter shows the lofty mingling with the low, the serious with the ludicrous, the sophisticated with the primitive, the official with the subversive, and the refined with the crude. Sacred and solemn images are surrounded by irreverent and obscene marginalia. Standard biblical subject matter rubs shoulders with topical literary and artistic motifs on the one hand and, on the other, with consciously archaizing scenes. Sequential pictorial narratives feature alongside isolated episodes shown out of context, and stories told out of order or even in reverse. Elegantly swaying figures with placid and sweet facial expressions, fashionable coiffure and exquisite drapery, often perceived as representatives of

(opposite) 2 Goat and ape kissing: Macclesfield Psalter, folio 155r.

the 'courtly' art that flourished in aristocratic circles on both sides of the Channel, coexist with ordinary folk engaged in mundane tasks and enjoying a healthy dose of earthy humour. People and activities presumably encountered in everyday life share the page with wondrous hybrids, the creations of a vivid imagination. Highly stylized foliage occurs together with keen observation of nature. Exaggeratedly monumental close-ups are juxtaposed with extreme miniaturization.

Obvious as these contrasts may seem, they probably have less to do with the Macclesfield Psalter, and medieval art in general, than with the way we perceive them or wish to explain them. Although much medieval thinking, writing and representation focused on antithetical pairs of concepts, such as matter and form, body and soul, good and evil, and Heaven and Hell, knowledge was organized in complex systems based on the cosmic and Christian symbolism of three-, four-, five-, seven-, ten- and twelve-fold structures. The three persons of the Trinity and the three continents of the world (before Columbus); the four humours, the four cardinal points and the four Evangelists; the five senses; the seven sacraments and the seven gifts of the Holy Spirit; the Ten Commandments and the ten ages of man (ten periods each lasting seven years); the twelve apostles and the Twelve Articles of Faith were among those most commonly invoked. These categories were often subdivided into smaller units, combined to form larger clusters, opposed or aligned through contrasting or reciprocal meanings. For instance, the three theological and four cardinal virtues joined forces in a holy seven against the seven vices. The Wheel of Sevens comprised seven concentric circles, each including a group of seven interrelated concepts. Apart from organizing human knowledge, these matrices represented an attempt to decipher the numerical and ethical premises of God's creation, the divine rules of harmony that governed society and the individual. The three orders of society – those who prayed, those who fought, and those who laboured – though hierarchically arranged, were also mutually dependent. In fact, these groups hardly reflected the complex structures of medieval society: during the second quarter of the 14th century when the Macclesfield Psalter was produced, even Edward III's court, presumably one of the most exclusive circles, was characterized by a remarkable social fluidity.[1]

This complex system of knowledge was not the sole preserve of an intellectual elite indulging in mental gymnastics. Rather it disseminated the essentials of Christian doctrine, moral theology and natural

philosophy among the faithful at large. If the Fourth Lateran Council of 1215 set the guidelines for an ambitious campaign to raise the educational level of clergy and laity alike, their practical application at the level of the parish and the individual was the work of reformist bishops, schoolmasters and mendicant preachers.[2] By the late 13th century the structures of knowledge outlined above formed the backbone of the vast and diverse literature of pastoral instruction. They informed manuals on theology, preaching, confession and conduct, such as the *De instructione puerorum*, written *c.* 1249–64 by the Dominican William of Tournai; the *Somme le roi*, composed in 1279 by another Dominican, Frère Laurent; the Anglo-Norman verse *Manuel des pechiez* of *c.* 1260, attributed to William of Waddington, together with its English translation, prepared by Robert Mannyng *c.* 1303, *Handlyng Synne*; and the early 14th-century preachers' handbook, the *Fasciculus morum*. More importantly, the clusters of concepts lent themselves to diagrammatic representation, offering the basic catechetical, devotional or curricular material in a visual nutshell, as for instance in the 14th-century encyclopaedia *Omne bonum*.[3] The *Speculum theologiae* of the Franciscan John of Metz, who was active in Paris in the last quarter of the 13th century, is essentially a pictorial treatise, not a verbal one, and the early 14th-century Psalter of Robert de Lisle preserves one of the best-known examples of this graphic form of presentation.[4]

It is this polyvalent and holistic mode of thinking, embracing rather than erasing diversity, that informs the imagery of the Macclesfield Psalter. But here, instead of being presented in a didactic, diagrammatic manner, it is embodied in the voracious appetite for dissonant voices and rainbow colours that manifests itself on every level – stylistic, iconographic and semantic. The fact that such unruly diversity occurs in a prayer book, right beside the biblical text, should not surprise us. The mingling of norm and aberration, of sacred and profane can be observed in medieval literature, music, and social and religious practices, as well as in the visual arts. While the moralists frowned upon it, the pragmatically orientated accommodated and even exploited it.

The liturgy and its celebrants have been compared to a theatrical performance and its actors, not only by modern scholars but also by medieval writers.[5] High-ranking ecclesiastics let their deacons and novices unleash liturgical laughter in the choir during the Feast of Fools, which was celebrated on the feast of the Holy Innocents (28 December) or Christ's Circumcision (1 January), with mask-wearing, cross-dressing, obscene songs and games of dice at the altar.[6] Civic communities delighted in the sensual cacophony of the charivari, known in England as 'rough music', which lampooned adulterers, cohabiting couples and second marriages with lewd music and scatological verses.[7] Such topsy-turvy performances have been celebrated as triumphs of the ludic elements in human nature and as a powerful vehicle of social liberation through the carnivalesque.[8] Conversely, they have been interpreted as much needed – and carefully controlled – valves for letting off the steam of social tension.[9] However, generalizing individual occurrences of parody, the obscene or the scatological as invariable components of sociological constructs is, at best, misleading.[10]

High and low, central and marginal, secular and religious co-existed with ease. Poets borrowed the elevated vocabulary and traditional meter of romances for their bawdy fabliaux, and suffused troubadour lyrics with innuendos for the benefit of those who could detect them.[11] It was the prohibition of explicit obscenity in the 'high' genres of courtly literature that inspired imaginative writing and reading shot through with skilfully crafted metaphors. In line with the daring experimentation of *ars nova*, which allowed religious lyrics to be sung to secular tunes and the other way round, 14th-century English religious motets combined Latin top parts with a vernacular tenor line.[12] Theologians, rhetoricians and preachers relaxed their harsh opposition to monstrosities, spicy stories, scandalous images, secular musicians and actors as they saw the educational value of entertainment and its potential for the cure of souls.[13] Roger Bacon (d. 1292?) compared the art of preaching to music, while the early 14th-century rhetorician Robert of Basevorn advised preachers to use 'subtle', 'interesting' or 'terrifying' stories to grab the attention of their audiences.[14] In his treatise on memory, the contemporary theologian Thomas Bradwardine recommended the use of wondrous, extreme, even shocking mental images for the effective memorizing and recalling of ideas.[15]

Religious processions and special masses were an integral part of tournaments during Edward III's reign, and the king's games drew on a wide range of diverse sources for their props and costumes, from romances to the seven deadly sins, from travel accounts to topical stories.[16] In 1335 Edward III purchased a romance from a nun at Amesbury, Isabella of Lancaster.[17] Edward II's sister Mary (1279–

1332) was also a nun at Amesbury, but enjoyed gambling (as the payment of her debts by her father, brother and nephew, Edward III, reveals).[18] The late 12th-century scatological French poem *Audigier* enjoyed enormous success in the courts of Europe and was even quoted in a letter by Edward III.[19] Slapstick humour was an integral part of culture on all levels – at court and in the marketplace, in public and in private; the 'Montypythonesque' is probably the aspect of the Macclesfield Psalter that we relate to most easily.

One instance of this intermingling of apparent opposites is particularly relevant to the Macclesfield Psalter, in view of the Dominican friar depicted on folio 158r [3]. By the time the manuscript was painted, the mendicant orders had stood for a century at the meeting point of pastoral concerns, changing attitudes to the performance arts, and helping to shape the educational agenda of the reformist papacy.[20] At the forefront of developments in theology, canon law and the natural sciences in Europe's leading universities, the friars were nevertheless fully immersed in the down-to-earth needs of their urban environment and in the worldly tastes of the royal and aristocratic households where they functioned as confessors. Vying for the attention of expanding and increasingly literate audiences in the face of strong competition from minstrels and jongleurs, the mendicants adopted the tactics of their adversaries.[21] They borrowed exempla from romances, popular tales, current politics and everyday life. They performed like actors. St Francis called the friars 'Christ's jesters' (*joculatores Christi*). The Dominicans compiled handbooks not only for preaching and confession but also for polite conduct and for light conversation at table. Even Thomas Aquinas composed a princely manual, *De regno* (1267), for the king of Cyprus. They also designed pictorial bibles, such as the mid-14th-century Holkham Bible Picture Book, in the fashion of secular chronicles and romances, in order to appeal to the tastes and sentiments of their wealthy lay patrons.[22]

Emotion

Two saints stand at the very beginning of the Macclesfield Psalter, focal points of devotion inviting us to enter the manuscript physically and spiritually. On folio 1r St Edmund of Bury (841–869) [1], the king and patron saint of East Anglia, martyred by the Vikings in Suffolk, holds an arrow, anchoring the onlooker's eye, memory and prayer in the instrument of his suffering. His elegantly restrained

3 *Dominican friar at prayer: Macclesfield Psalter, folio 158r.*

pose, solemn gestures, and grave but calm expression preserve the dignity and self-control of a king who is also God's man and is thus immune from excessive passions. He epitomizes the ancient ideal of the measured gesture and movement, the equilibrium between body and soul, between reason and emotion – an ideal that dominated medieval dialectic, ethics and art well into the 13th century. In the case of St Edmund, this ideal was reinforced by the monastic and aristocratic concepts of temperance, patience, gentle character and mellow urbanity that informed hagiography and the cults of the major new saints from the 12th century onwards.[23] It must be stressed that what we see in St Edmund is not lack of affect, but rather lack of excess. Having set certain parameters for looking, remembering and praying, St Edmund points and prompts us to turn the page.

What we encounter overleaf [37] is the complete antithesis: unbridled emotion, deep sorrow, powerful anguish, pathos, drama. St Andrew's expression has more in common with contemporary psychosomatic forms of religiosity in the Rhineland, with the mystic's rapture, than with affective piety in early 14th-century England. It is particularly foreign to the measured, sweet and gentle sentiments of the previous century. St Andrew (d. *c.* 60), who was widely venerated in the Latin West and the Byzantine East as the first apostle to follow Christ, was the saint whose feast opened medieval liturgical manuscripts, as it fell at the beginning of Advent (30 November); he was also the patron saint of Scotland. Andrew is shown holding the saltire cross of his martyrdom and a small book – perhaps this very book. Like St Edmund, he too invites us to enter the manuscript,

but in a different state of mind and with a different approach to prayer. The very similarity of St Edmund's and St Andrew's poses emphasizes the contrast between their facial expressions. It seems as if two distinct attitudes towards devotional affect manifest themselves back to back on the same leaf.

Our study of emotions and their representation in the Middle Ages is fraught with uncertainties.[24] While the universalist, essentially Darwinist standpoint of evolutionary psychology maintains that basic emotions, genetically transmitted and cross-cultural, are common to all of us, the componential theories of the social constructionists argue for three combinatorial and highly variable components of emotion, namely the physiological, the cognitive and the behavioural.[25] Both views can be qualified in a number of ways. First, while basic emotions, such as anger, fear, sorrow or happiness, are shared across cultures, more complex, cognitively tinged emotions, like shame or guilt, tend to be culture-specific. Second, the cognitive element in emotions often makes them work in tandem with, rather than against, reason. Third, both basic and cognitive emotions are informed by ethics — conditioned by moral values, expectations and judgments. This leads to two further points particularly relevant to our study. In the Middle Ages emotion was considered not so much a natural, spontaneous reaction, as an expression of the moral, intellectual and social stance of an individual, the result of discipline and education or the lack of them.[26] It was a socially determined, premeditated projection of the self onto the screen of normative behaviour, an artifice, a self-conscious image of the inner soul. Finally, this codified expression should not make us question the authenticity of emotion.[27] Stereotypical behaviour aimed at — and relied on — the wide recognition and correct interpretation of emotions. A clichéd expression guaranteed maximum communicative impact and minimal ambiguity. Bearing all this in mind, we are perhaps entitled to think that in the 14th century the artist painted, and the onlooker saw, sorrow and anguish in St Andrew's face just as we do.

The gradual change in Western concepts of gesture and emotion from the mid-12th century onwards has been associated with the new socio-economic climate of the city and the growth of urban professionalization, on the one hand, and, on the other, with the rediscovery of Aristotle, the renewed study of physiognomy and the growing interest in human physiology and psychology.[28] While the classical theory of measure remained the norm, 13th-century canonists and theologians rehabilitated gesticulation when required for professional reasons — whether by an actor or a preacher — and allowed the expression of a wider range of emotions.

However, our perception of this change may be somewhat exaggerated. Ancient and medieval rhetoric and philosophy recognized a strong emotional component in reading, looking and remembering, while at the same time acknowledging a cognitive element in emotion.[29] The visualization of powerful affects was one of the main strategies of creative mnemonics. The rational construction and careful storage of striking, extreme images ensured the swift and orderly retrieval of concepts. This synthesis of reason and emotion was crucial for the repeated and imaginative reliving of a past experience, which in turn was central to monastic meditation, lay devotion, mendicant preaching and scholastic discourse. In his *Summa theologiae* (II–I Q. 22 A. 48) Thomas Aquinas held that passions belonged to the soul–body composite and could arise not only from external causes but also from internal movement — namely, the intellectual consideration of universals that conjure up appearances of the specific in our imagination. He recognized that God and the angels experience intellectual affect more perfect than, but analogous with, human emotion. Affect was admitted even in the divine realm.

Transferring such abstract concepts from university textbooks into the concrete images of a layman's prayer book would have been problematic had Aquinas's fellow friar been more self-effacing. The depiction of the Dominican in the Macclesfield Psalter makes speculations on that dangerously nebulous figure of the theological adviser unnecessary. His presence does not simply reveal, rather it emphasizes the involvement of a learned mind in the planning of the manuscript.

We no longer credit the *Zeitgeist* with artists' growing interest in human affect and expression. It is considered naïve — and justly so — to posit a direct connection between the increasingly realistic portrayal of emotion in 14th-century art and contemporary responses to economic, social or political events, such as the great famine, the Black Death or the Hundred Years' War. Such connections are indeed best avoided as generic explanations of the tendency for grave, sour, even grotesque expressions in much 14th-century painting. An artist's training, models, aspirations, ingenuity, freedom of expression and creative experimentation should be the first point of reference. But by the same token we should perhaps allow an artist to press into service

pictorial conventions, imagination and the ethos of his time in order to stir up emotions and elicit a response in line with, or beyond, the commissioner's requirements and the recipient's expectations. In such cases – the most obvious ones in the Macclesfield Psalter, as we shall see, are the opening pages of Psalm 52 and the Office of the Dead (fols. 77r, 235v) – the portrayal of affect is not a random echo of what was 'in the air', but a skilfully crafted device of involvement and participation. The thick knot of sensory, emotional and cognitive experiences, namely observation, recollection, reflection, compassion and self-expression, pulls together the artist and the viewer into a vivid exchange with the image and the adjacent text.

ITALIANISM AND CLASSICISM

The virtuoso portrayal of emotion reveals a strong preoccupation with the inner and outer conduct of the individual, and is inextricably linked with the growing interest in the realistic depiction of the human body. Emotional expression and anatomical precision are two sides of the same coin in art, and their faithful representation is often taken as a benchmark of revolutionary moments in its history. Back in 1943 Otto Pächt detected their presence in 14th-century English painting, mainly in East Anglian manuscripts of *c.* 1320–40, and explained them through successive waves of Italian influence.[30] He saw Tuscan panel painting, the works of Giotto, Duccio, Simone Martini and their disciples, as the direct source of this influence, although he found an echo of the Pisano brothers in what he termed 'sculptural, rather than painterly' modelling in some of the East Anglian manuscripts. Pächt

4, 5 Nude and trumpeter ('tubicinarius'): Macclesfield Psalter, folios 110v and 223r.

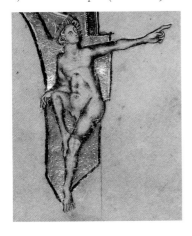
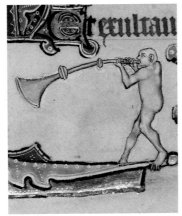

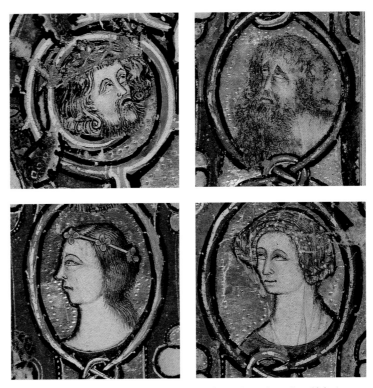

6–9 Border faces: Macclesfield Psalter, folio 161v (top left) and 77r (top right and below); see also the faces of St Andrew [37] and of the figures in the Anointing of David [frontispiece].

also admitted that certain 'pagan elements' might have been transmitted via Italian manuscripts, mainly Bolognese law books, which were spreading fast through the universities and religious institutions of medieval Europe in the late 13th and early 14th centuries. For instance, he traced the musicians blowing long trumpets back to the *tubicinarii*, trumpeters who accompanied ceremonies in antiquity, who were depicted on Greek vases and Roman sarcophagi, and featured in Bolognese manuscripts. The makers of the Macclesfield Psalter would have been familiar with the marginalia in such books, in which hunched hybrids arched their long necks (fols. 16v, 59r, 119r, 39r, 176r) and classicizing *tubicinarii* blew their trumpets (fols. 17v, 22v, 38r, 95v, 223r) in every centre of learning across Europe.

What 'Italianisms' can be found in the Macclesfield Psalter and how Italian are they? The figures and their drapery are often built up with delicate shading and modelling of the inner surfaces, which simulate tangible volume and texture (fols. 31r, 52r, 109v). However, black outlines emphasizing the silhouette are also employed, sometimes together with sophisticated modelling on the same figure (fol. 1v).

10, 11 Hybrid border figures, Macclesfield Psalter, folios 15v and 181v.

The human body is rendered with admirable accuracy. The flesh is shaded now in grey, now in green overtones, showing a general familiarity with Tuscan painting of the early 14th century rather than specific knowledge of individual panels or frescoes (fols. 110v, 223r [4, 5]). The same is true of the modelling of faces and hair. The faces combine the treatments seen in the works of the leading 14th-century Tuscan artists: the grave expressions, hollow cheeks, narrow, squinting eyes and open mouths with visible teeth (fols. 1v, 77r, 161v [6–9]) of the figures painted by Giotto in the lower church at Assisi during the first decade of the century;[31] the soft, ovoid, thoughtful, mildly sorrowful faces, with wrinkled foreheads, doubled upper eyelids, small chins and strong white highlights on the nose and upper lip (fols. 20v, 39r) of Duccio's *Maestà* made for the high altar of Siena Cathedral between 1308 and 1311;[32] and the pronounced eyelids strongly edged in black, as well as the dense, meticulously articulated hair and beards (fols. 1v, 15v, 181v [10, 11]) of Simone Martini's *Maestà* in the Palazzo Pubblico in Siena, completed in 1315, and in his contemporary work in the Cappella di San Martino at Assisi.[33] Closer parallels are found in the altarpiece painted *c.* 1325 for Santa Croce in Florence by Ugolino da Siena (d. 1339 or 1349).[34] The heightened affect of his expressive faces, with mouths pugnaciously thrust forward, long, straight noses, and prominent ears, the thin, elegant fingers, the persistent use of purple and violet in combination with green, and the preference for azurite over ultramarine, which gives a greenish tinge to his blues, are all present in the Macclesfield Psalter (fols. 1r, 8v, 18v, 20v, 39r, 92v, 114v).

Although the gold or diapered backgrounds of the Macclesfield miniatures and large initials are devoid of spatial depth, the borders and small initials abound in three-dimensional conceits, with humans and hybrids, sometimes entangled in, or cutting through, the foliage (fols. 10v, 121v, 124v), supporting the initials in caryatid fashion (fols. 42r, 209v), or peeking through them into the text (fols. 92v, 210v). Also typical of Trecento pictorial mannerisms are the foreshortening of figures (fol. 13v) and the depiction of protagonists from behind, who by turning their backs on the viewer seem to draw us into the pictorial reality of the image (fol. 190r). Such playful virtuosity and delight in experimentation are characteristic of Sienese polyptychs from the first quarter of the 14th century, the innovative design and content of which were often conditioned by Dominican patronage.[35]

However, while some of the essential Trecento techniques have been mastered in the Macclesfield Psalter, intimate familiarity with individual Italian painters or specific works of art cannot be readily observed. Moreover, the characteristics discussed above are not exclusive to the Macclesfield Psalter. They are prominent in manuscripts of the 1320s and 1330s associated with Norwich, notably the Ormesby, Douai and St Omer psalters, of which more shortly. Italianate features have been detected in other contemporary media, including stained glass in the nave of the church at Stanford-upon-Avon, Northamptonshire, from the second quarter of the 14th century[36] and in the west window of *c.* 1340 at York Minster,[37] the wall paintings in the chapel built in the 1320s at Ely Cathedral by Prior John Crauden,[38] the mid-14th-century murals from St Stephen's Chapel in Westminster Palace, and the Last Judgment in the Chapter House of Westminster Abbey.[39]

The main question that exercised Otto Pächt – and everyone who has discussed the matter since – concerns the channels and means by which Italian influence reached England. The documentary evidence, slender as it is, offers important insights into the ways in which Italian works of art were acquired.[40] The key instigators of the transmission seem to have been royal and high ecclesiastic patrons, including Queen Isabella, Edward III's master painter Hugh of St Albans, John Grandison, Bishop of Exeter, and Abbot Thomas de la Mare of St Albans. The main channels were the routes of commercial, political and intellectual exchange that led from Italy via Avignon to England. Among the agents were the ecclesiastics constantly travelling between England and the papal court at Avignon, which by the second quarter of the century was attracting leading Italian artists; the Italian merchants and bankers in London, such as

the Bardi, Peruzzi and Frescobaldi, financiers of the royal family and art patrons in their home country; and last, but not least, the Italian artists working in London by *c.* 1300 and the English artists active abroad, who perhaps included the mason responsible for Pope John XXII's English-style tomb in Avignon.

This list of possibilities can be supplemented with two contemporary examples. Although not indicative of art patronage *per se*, they are pertinent to three interconnected aspects of the Macclesfield Psalter: the classicizing motifs, the distinct intellectual undercurrent in the imaging strategy, and the involvement of a Dominican friar in the production of the manuscript.

The distinguished Oxford friar, Thomas Waleys (d. in or after 1349), was lector at the Dominican *studium* in Bologna in the 1320s and chaplain to Cardinal Matteo Orsini in Avignon in the 1330s.[41] His commentary on the psalms, probably written in Bologna, is replete with quotations and vivid stories from ancient history, literature and mythology. His promising career ended in 1333 when he preached a sermon against John XXII in Avignon, under the pope's window, as it were. John XXII, whose views on the beatific vision were under scrutiny, was particularly anxious about opposition from leading theologians. Thomas Waleys was duly imprisoned and released only in 1342 by Pope Clement VI.

In 1333, the year of Thomas Waleys's arrest, Richard Bury (d. 1345), tutor and personal secretary of Edward III, met Petrarch in Avignon.[42] The next year he became Bishop of Durham, Lord Treasurer and Keeper of the Privy Seal. A passionate collector of books and erudite friends, Richard Bury kept scribes, illuminators and binders on his manors, as well as a team of Dominicans and Franciscans compiling, correcting, expounding and indexing manuscripts. The wisdom in his books was enhanced by the discussions of scholars in his household. Among them was the Dominican Robert Holcot (d. 1349), who may have compiled the famous *Philobiblon* published under Richard's name.[43]

Thomas Waleys and Robert Holcot were the most eminent of the seven members of the classicizing group that flourished between about 1320 and 1350.[44] They transformed the standard output of university masters – lectures on the Bible, exegesis, sermons and aids to preaching – into a celebration of ancient history, literature and wisdom. All were friars and all were based in Oxford or Cambridge. Five of the seven were Dominicans and all but one of them were in Cambridge at some point in their careers. Robert Holcot, the most

gifted of all seven, held his regency at the Cambridge Blackfriars, most probably between 1334 and 1336.[45] It was during this period that he wrote his commentary on the Book of Wisdom, which made him famous overnight. A scholar turned romancer, Holcot drew on preachers' jingles and local legend as well as on Boethius, Virgil and Ovid. He was particularly keen on topical commentary, alluding to current or recent events and controversies. Moreover, he blended poetic emotion with artistic flair. His works are rich in examples from the visual arts: panel paintings, stone carvings, frescoes and manuscripts. The illuminator's technique of mixing his colours suggested moral lessons to him. The devil was an artist who painted vices in the shape of animals in the sinner's soul. Holcot painted unforgettable pictures in the minds of his listeners and readers. His creative use of mental imagery and passion for the stories of antiquity, his emotional commitment, gentle humour and down-to-earth, forgiving patience resurfaced in his affectionate approach to the education of the young.

It is perhaps more than a coincidence that the classicizing friars and the Italianate features in English art flourished in the second quarter of the 14th century. It may also be significant that both Italianisms and the classicizing movement seem to have reached a peak in the 1330s in East Anglia.

By 1300 the English Province of the Dominican order was divided into four visitations. The East Anglian visitation, including the Dominican houses in the dioceses of Norwich, Ely and parts of Lincoln, was headed by the Cambridge priory. Its importance in contemporary politics, regional and national, ecclesiastic and royal, can hardly be overstated.[46] Six provincial chapters were held there in the 14th century. The English provincial between 1328 and 1336 was a Cambridge Dominican, Simon Boraston, who was arrested in 1330 for supporting the alleged plot of the Earl of Kent against the regime of Queen Isabella and Roger Mortimer. The Cambridge Blackfriars produced two prominent members of the English episcopate during Edward III's reign, Thomas Lisle, Bishop of Ely (1345–55), and Thomas Ringstead, who was one of Holcot's followers among the classicizing friars before becoming Bishop of Bangor (1357–66).

The Cambridge Blackfriars were fully integrated into local life, too. Their priory was within the parish of St Andrew, they trained priests for local parishes, confraternities met in their church, and official documents of land ownership were deposited with them for

12, 13 David and Goliath: Macclesfield Psalter, folio 174r, and Gorleston Psalter, BL Add. MS 49622, folio 204v.

safe keeping. Gifts and bequests flowed in from all stations of society, from near and far. Shortly after 1296 the generosity of Alice (d. 1317), widow of Robert de Vere, fifth Earl of Oxford, funded developments that almost amounted to a new foundation. An impressive bequest came in 1356 from Elizabeth de Bohun (1313–1356), wife of William de Bohun, Earl of Northampton, and commissioner of the Dominican Astor Psalter.[47]

Last, but not least, the Dominican priory was at the heart of a growing university. Each province of the Dominican order had one *studium generale*, except England, which had two – Oxford and Cambridge. The Cambridge priory was a vibrant international community. As part of their lifelong commitment to study, the Dominicans travelled extensively to learn and teach. The list of friars in the 14th century includes Germans, Poles, and Italians from Naples, Perugia and Siena. English friars travelled frequently to the continent, too. This fits in with the overall picture of academic life in 14th-century England.[48] During the 1330s, one of the most fruitful periods in the development of English scholastic thought, academic

contacts with Paris were diminishing and English students preferred Oxford or Cambridge instead, while the number of foreign students in England, especially Italians, was on the rise.

The Cambridge Blackfriars were truly exceptional in one respect – their classical learning and passion for antiquity. Some of the other characteristics discussed above would have been present in Dominican houses elsewhere in East Anglia, though to a lesser extent. Norwich had a strong academic reputation during the first half of the 14th century, but it rested mainly on the Franciscans, who enjoyed a dynamic exchange of minds with Cambridge, Oxford, London and the continent.[49] The Norwich Dominicans do not seem to have produced or attracted major scholars. Their main exchange was with the Cambridge Blackfriars, whose graduates they welcomed to academic or administrative positions. The close contact with the head of the order's East Anglian visitation would have ensured the swift dissemination of texts and ideas from Cambridge to Norwich.

This prompts us to ask not simply what Italian models reached East Anglia, where they came from, when and how, but also why their impact, at least in the medium of manuscript illumination, was greater there than in other regions during the first half of the 14th century. Before artistic ideas are 'copied', they have to become desirable. Not only their aesthetics but also their ethos need to be in line with the values of those 'influenced' by them. This is not to imply that the classicizing friars brought about the Italianate phase in 14th-century English art. Rather it suggests that intellectual and artistic endeavours should be seen as parallel and mutually related developments at the two focal points of international exchange in East Anglia – Norwich and Cambridge.

The East Anglian School of Illumination

The Macclesfield Psalter embodies the essence of the East Anglian school of illumination. Coined in the early 1900s, this umbrella term grouped together stylistically diverse manuscripts, which displayed a veritable explosion of bold marginalia and sometimes contained liturgical features pointing to East Anglia.[50] Since then the relationship between manuscripts both within and outside the East Anglian group has been redefined, resulting in clearer divisions of sub-groups and a sound appreciation of their complex interaction.[51]

Among the Macclesfield Psalter's immediate ancestors are three celebrated East Anglian manuscripts associated with Norwich: the

Gorleston Psalter of *c.* 1310–20, with an added Crucifixion miniature of the 1330s,[52] the Stowe Breviary made between 1322 and 1325,[53] and the second and third campaigns of illumination in the Ormesby Psalter dating from the 1320s and 1330s respectively.[54]

The Gorleston Psalter, commonly assigned to Norwich on the basis of stylistic comparisons and liturgical evidence (including a Norwich Cathedral litany added later), is one of the richest resources of marginalia in early 14th-century English illumination. Margot McIlwain Nishimura has argued convincingly that it was commissioned in the mid-1310s by John de Warenne, seventh Earl of Surrey and Sussex (1286–1347), for the church of St Andrew in Gorleston on the Suffolk–Norfolk border, near Great Yarmouth. The dedication of this church and the feast of St Andrew are written in gold in the calendar. The Warenne arms feature prominently at major text divisions and the ubiquitous rabbits pun on the earl's family name, his seal and his profitable warrens.

Except for the Crucifixion miniature (fol. 7r), probably added in the 1330s, the scale, style and painting technique of the Gorleston Psalter, monumental and profoundly linear, are the very antithesis of what we see in the Macclesfield Psalter. However, numerous compositions, iconographic motifs and marginalia reappear in the Macclesfield Psalter with the accuracy of verbatim quotations (compare Macclesfield Psalter, fols. 22r, 77r, 122r, 134r, 151v, 152r, 174r, 193v, and Gorleston Psalter, fols. 178r, 153v, 202v, 156v, 164r, 133r, 204v, 158r [12–15]). A curious feature preserved in the Gorleston Psalter has all but disappeared from the Macclesfield. The gold ground between the limbs of free-standing marginal figures, which makes them look like cut-out puppets (Gorleston Psalter, fols. 158r, 204v), suggests that they were copied from exemplars where they were integral to the border. The Gorleston initials for the main division psalms (1, 26, 38, 51, 52, 68, 80, 97, and 109) show a preference for an iconographic scheme going back to the early 13th century, which displays a characteristically English, eclectic approach to psalm illustration. We find the same approach and iconographic programme, with minor alterations, in the Macclesfield Psalter. The lack of narrative continuity or discernible patterns in the arrangement of the marginalia, the tendency of the images to establish direct contact with the viewer, and their careful response to the adjacent text, whether in a literal, moralizing or humorous fashion, are all present in the Macclesfield Psalter as well. This suggests intimate familiarity not only with the pictorial vocabulary but also with the imaging strategy of the Gorleston Psalter.

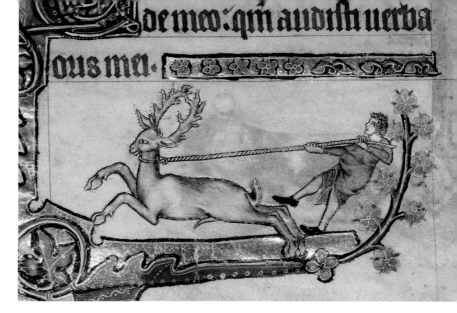

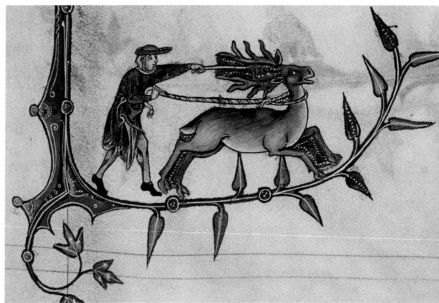

14, 15 Stag hunt: *Macclesfield Psalter, folio 193v, and Gorleston Psalter, BL Add. MS 49622, folio 158r.*

The Gorleston Psalter was produced in a single campaign and copied by one scribe. The calendar, the major initial opening the Office of the Dead (fol. 215r) and the figure of St Peter on folio 16r were painted by one artist, while the rest was the work of the second, main designer. They were assisted by two or three decorators, one of whom seems to reappear in the Stowe Breviary [24, 25].[55]

The Stowe Breviary survives in a fragmentary state, having lost numerous leaves and some entire quires, and many images with them. What does survive presents an artistically complex volume, although it was completed in a single campaign and remains one of the most

firmly localized and datable East Anglian manuscripts. In addition to the feasts in its Sarum calendar that are specific to the Norwich diocese, it contains two sets of notes on political and ecclesiastical history, which were penned by the original scribe and refer in part to events in the diocese. The mention of Thomas of Lancaster's execution in 1322 is accepted as the *terminus post quem*, while the omission of the death in 1325 of John Salmon, Bishop of Norwich, is considered a less reliable *terminus ante quem*. These remarks are valid for the first 354 leaves; the Ordinal, added in the second half of the 14th century (fols. 358–95), will not concern us.

The uniform script and text layout, as well as the catchwords, all written in a distinct cursive hand known as *anglicana*, suggest that the Stowe Breviary was the work of a single scribe. It was illuminated by two major artists and a number of less competent hands. One of the main illuminators was responsible, in part, for the decoration of the Escorial Psalter, probably commissioned by Cecily Bardolf for the Austin friar depicted with her, who was perhaps her confessor and has been identified with Robert of Morley of the Norwich Austin house.[56] Particularly revealing for this artist's style is the only marginal drawing in the manuscript that was left uncoloured (fol. 68r). The other major Stowe artist painted the Herdringen Psalter, of undetermined provenance,[57] and contributed to the All Souls Psalter, whose calendar and litany combine Norwich and Ely features,[58] to the *Secretum secretorum* presented to Edward III by his clerk Walter of Milemete in 1326,[59] to the Tiptoft Missal, a massive collaborative project of the mid-1320s variously assigned to Ely, London and Cambridge,[60] and to the dispersed Hungerford Hours of the early 1330s.[61]

Rather than collaborating in a hierarchical, production-line fashion, with the masters executing the major illumination and leaving the decoration to their less competent colleagues, each artist of the Stowe Breviary seems to have painted the borders and the marginal grotesques on pages where he supplied the main initial. Although this is not the division of labour we are accustomed to in deluxe Gothic manuscripts, it seems a practical approach to the only painted sections in a volume whose text decoration is executed entirely in penwork. It was an expedient measure that ensured its completion. The artistic personalities stand out most clearly in their individual interpretation of stock motifs. They relish the opportunity to introduce variations into shared patterns and respond playfully to each other's pictorial decisions. It is this dialogue between highly trained professionals,

16–23 Border motifs (left to right from the top): 16, 17 Stowe Breviary, BL Stowe MS 12, folios 264v and 327r; 18, 19 Stowe Breviary, folio 116v, and Macclesfield Psalter, folio 20v; 20, 21 Stowe Breviary, folio 273r, and Macclesfield Psalter, folio 101r; 22, 23 Stowe Breviary, folio 150v, and Macclesfield Psalter, folio 162v.

bringing their expertise and personal tastes into a prestigious collaborative project, that transforms the Stowe Breviary from a mere workshop product into a storehouse of texts and images that would nourish East Anglian manuscript production well into the 1330s.

The Macclesfield Psalter is greatly indebted to the Stowe Breviary in a number of respects, ranging from key codicological, palaeographical and liturgical features to iconographic motifs, specific elements of the ornamental vocabulary, and unusual pigments, such as the combination of vibrant greens and purples or of murky green and mosaic gold. The anxious faces in many of Stowe's initials (fols. 264v, 327r [16, 17]) culminate in the Macclesfield's anguished expressions. The strongest connections resurface in the large arsenal of figural marginalia shared by the two manuscripts [18, 23]. It seems obvious that the pictorial vocabulary of the Macclesfield Psalter developed from the rich repertoire of the Stowe Breviary as much as from that of the Gorleston Psalter [24, 26].

The Macclesfield Psalter also owes much to the Ormesby Psalter, named after Robert of Ormesby who presented the manuscript to Norwich Cathedral. He is documented in 1336–37 at the cathedral, where he was probably the sub-prior.[62] The manuscript underwent several distinct campaigns of illumination between the 1280s and the 1360s. Begun for an unknown patron, it was adapted in the 1320s for the couple depicted within the full-page Tree of Jesse in the *Beatus* initial on folio 9v [27], a Bardolf woman and a Foliot man. This leaf (fol. 9) was intended to replace the following one (fol. 10), which contains the beginning of Psalm 1, written by the original scribe, and a blank space left for a half-page initial. In the 1320s, instead of filling in the blank space, the full-page initial with the Tree of Jesse was painted on the new leaf. Every effort was made to finish the text on its reverse exactly as it ended on folio 10v, which was to be discarded. For some reason both leaves were retained and folio 9 was bound in reverse, providing a frontispiece for Psalm 1. The Tree of Jesse was painted by one of the two main artists of the second campaign. Named the Jesse Master by Frederica Law-Turner, he was also responsible for the large initial to Psalm 26. The other artist of this campaign, the celebrated Ormesby Master, whose work is commonly assigned to Norwich in the 1320s, painted the exquisite classicizing trumpeters and wrestling nudes that made the Ormesby Psalter the main representative of Otto Pächt's early phase of Italian influence.

24–26 Hybrid border figures, Gorleston Psalter, BL Add. MS 49622, folio 214r; Stowe Breviary, BL Stowe MS 12, folio 305r; and Macclesfield Psalter, folio 32r.

The work of the Ormesby and Jesse Masters bears a close relationship to the Macclesfield Psalter, both in style and iconography. Marginal compositions of the Ormesby Psalter, such as the 'bawdy betrothal' (fol. 131r [66]) or the trumpeter (fol. 147v), are playfully reinterpreted in the Macclesfield Psalter (fols. 39r, 139v). The proportions, grey flesh tones, subtle modelling, developed muscle structure and youthful plumpness of some Macclesfield nudes (fols. 28v, 240v) echo the carefully sculpted bodies by the Ormesby Master. The facial types in the Macclesfield Psalter, with their elongated, grim, surly expressions, are strongly reminiscent of the characters painted by the Jesse Master in the full-page *Beatus* initial (fol. 9v).

The third campaign, probably coinciding with Robert of Ormesby's ownership in the 1330s, was executed by one of the most innovative and experimental Italianate artists. He painted David within the *Beatus* initial in the space at the beginning of Psalm 1 on folio 10r which had been left blank by the first and second campaigns. He also added the figures of two donors, probably Robert of Ormesby and Bishop William Ayermin, on folio 9v, over the first lines of Psalm 1 originally penned beneath the *Beatus* initial. It was probably at this stage that the decision was made to reverse the leaf and use it as an additional frontispiece, rather than as a replacement for folio 10.

The Italianate artist of the Ormesby Psalter's third campaign is named the St Omer Master after another deluxe psalter associated

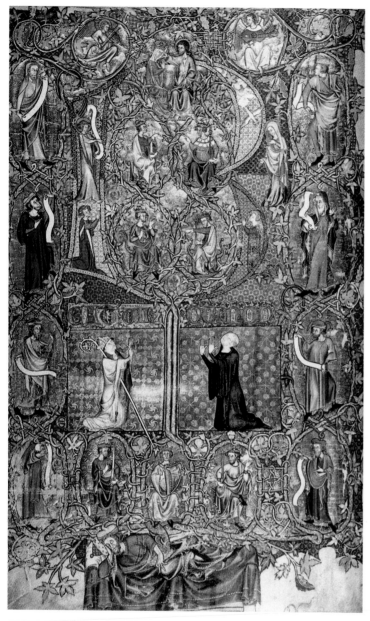

27 *Tree of Jesse: historiated initial and border, Psalm 1, Ormesby Psalter, BodL MS Douce 366, folio 9v.*

with Norwich.[63] It was begun for the St Omer family of Mulbarton in Norfolk in the 1330s, but the illumination campaign was interrupted after the second quire and is represented thereafter only by sporadic painting or underdrawings at some of the major text divisions. The illumination was completed in the early 15th century, probably for Humphrey, Duke of Gloucester (1390–1447).

The work of the St Omer Master in the original campaign represents the culmination of the Italianate trend in English 14th-century illumination. In terms of style and painting technique, his work is characterized by precious minuteness, mannered poses and movements, dynamic angularity and abundant use of thick white pigment for flesh and draperies. All of these traits are discernible in the Macclesfield Psalter, though at an earlier stage of their development.

The painting technique – though not the hand – of the St Omer Master is found in yet another majestic work of the 1330s, once the finest complete example of the mature Italianate style in English illumination, the Douai Psalter.[64] With a consideration of this manuscript we turn from the Macclesfield's predecessors to its siblings.

The Douai Psalter is related to both the Gorleston Psalter and the Stowe Breviary in textual content. The calendars of the three manuscripts are particularly close (Appendix 2). The dedication of the church at Gorleston features prominently in the Douai calendar. The notes on historic events in the Douai Psalter were copied from the Stowe Breviary or from a shared model. The Douai Psalter once contained a 14th-century inscription recording the donation of the manuscript in the 1370s by Thomas of Popely, vicar of St Andrew's Church in Gorleston (1371–93), to John of Brinkley, Abbot of Bury St Edmunds (1361–79), or to his successor, John of Timworth (1379–89).[65]

The large psalm initials in the Douai Psalter, like those in the Macclesfield Psalter, are indebted to the iconography of the Gorleston initials. But the Douai style has very little in common with the Stowe and Gorleston manuscripts. It shows the minute and delicate preciousness and the exquisite modelling of fabrics and flesh that mark the summit of the Italianate phase in English illumination. It was painted by two main artists, the Douai Master and the so-called Douai Assistant, collaborating very closely, often on the same page. The term 'assistant', normally used to imply subordination at best and a level of aesthetic judgment at worst, is particularly misleading in the case of the Douai Psalter. It was the Douai Assistant who produced the overall design and illuminated the small initials and borders throughout; the Douai Master made guest appearances in the major historiated initials and in the two prefatory miniatures, the Crucifixion and the Virgin with Child, which are no longer extant. A close parallel for the former survives in the Crucifixion miniature by the Douai Master added to the Gorleston Psalter, probably in the 1330s.

With that exception, students of the Douai Psalter have relied for an appreciation of the manuscript on a handful of black and white photographs taken before the First World War.[66] As the German armies approached Douai in 1914, the librarian of the Bibliothèque Municipale buried the manuscript underground in a zinc chest. When it was brought to the surface four years later it was full of acidic water. We can only try to imagine the original splendour of the Douai Psalter from the pile of fragments that remain, individual leaves sadly crumbling away as one turns the pages of the hefty album into which they were pasted after they were conserved in the 1970s (fols. 30r, 124v [28, 29]). Caroline Hull's reconstruction of the manuscript is an impressive piece of detective work.[67]

Fortunately, the same team, the Douai Master and Assistant, worked on another manuscript, a copy of Bede's *Historia ecclesiastica*, now in Trinity College, Cambridge.[68] It has only six illuminated leaves, marking the Prologue (fol. 1r) and the beginnings of Bede's five books (fols. 2v, 34r, 61v, 95v, 133v [30, 31]). Though far more modest than the Douai Psalter, the Trinity Bede shows the same division of labour: the Douai Assistant designed and painted the opening pages of the Prologue and each book, while the Douai Master graced a few of them, notably that of Book II (fol. 34r), with spectacular busts. The parchment is of mediocre quality, full of holes, and the sheets are of irregular size. The text was copied by at least four hands of varying competence. The penwork decoration was executed as part of the writing campaign, probably by the scribes themselves. All these aspects suggest that the Trinity Bede was an in-house product, though its place of origin and intended destination are unknown. The arms painted on the foredge, the only piece of internal evidence that might suggest early provenance, remain unidentified.

Michael Michael discovered a third manuscript that preserves the hand of the Douai Assistant, this time working alone. It is a copy of the principal work, the *Summa confessorum*, of the Dominican John of Freiburg (d. 1314).[69] Although the volume belonged to St Albans Abbey by the late 14th century,[70] the illumination points to East Anglia of *c.* 1330 (fol. 1r [32]). The other manuscripts known to have been at St Albans *c.* 1330–50 were either acquired from elsewhere or copied in the abbey; those in the latter group were decorated in a style very different from that of the *Summa confessorum*. If the *Summa* was copied at St Albans, therefore, the illuminator must have travelled some distance from East Anglia to work on what is otherwise a fairly modest book. It seems more likely that the manuscript was produced in East Anglia *c.* 1330 and acquired by St Albans slightly later.

When the Macclesfield Psalter left Shirburn Castle for Sotheby's, Christopher de Hamel identified its artist as the Douai Assistant.[71] Although he is not the only artist in the Macclesfield Psalter, as we shall see, he designed and painted most of it. He deserves to be renamed the Macclesfield Master. Indeed, the affinity between the Douai and Macclesfield Psalters in content, iconography and style can hardly be

28, 29 The Anointing of David, Psalm 26, and the Annunciation to the Shepherds, Psalm 97: historiated initials, Douai Psalter, Bibl. Mun. MS 171, folios 30r and 124v.

30 Illuminated leaf: Bede, 'Historia ecclesiastica', Prologue, TC MS R.7.3, folio 1r.
31 Illuminated initial: Bede, 'Historia ecclesiastica', Book II, TC MS R.7.3, folio 34r.

on our appreciation of the Douai Psalter has been compared to the replacement of a black-and-white with a colour screen.[73]

The four manuscripts illustrated by the Macclesfield Master differ in content, form, themes and prospective use, ranging from a monumental psalter to a small private prayer book and from ecclesiastical history to a scholastic *Summa* on the confessional. They suggest that the artist was working in a centre that catered for the devotional, scholarly and pastoral needs of a diverse clientele. The association of East Anglian illumination with specific centres on the basis of stylistic comparisons, provenance, or liturgical features pointing to the dioceses of Norwich, Ely and Lincoln (the Holland Part) is a vexed issue. Individual manuscripts have been assigned to Bury St Edmunds, Croyland, Ely, Peterborough and Ramsey, but the majority tend to be allocated to Norwich. The seat of an important diocese, with some sixty parish churches within its walls by *c.* 1300, and the economic centre of East Anglia's prosperous cloth industry and herring trade, Norwich was one of the largest cities in 14th-century England, with a population that had reached 25,000 by 1333.[74] A significant number of artists and craftsmen are documented in Norwich in the late 13th and early 14th centuries.[75]

overstated. Even a cursory glance at only two of the major illuminated pages of the Douai Psalter, those for Psalms 38 and 68 (fols. 48v and 83v)[72] reveals as many as five motifs found throughout the Macclesfield Psalter. The two figures conversing outside the Douai initial for Psalm 38, the beast's profile in the medallion beneath them and the owl perched on the gloved hand of the hybrid in the upper margin reappear in the Macclesfield Psalter (fols. 235v, 39r, 91r). The hobby-horse-turned-hobby-duck to the left of the Douai initial for Psalm 68 and the cat and mouse in the lower right border feature on folios 55r and 106r of the Macclesfield Psalter. The impact of the Macclesfield Psalter's discovery

Similar evidence for Cambridge is slim, under-researched and largely circumstantial.[76] The volumes known to have been in Cambridge, in the houses of the Austin, Dominican, Franciscan and Carmelite friars, in the late 13th and early 14th centuries are scholars' books that bear little resemblance to the contemporary deluxe East Anglian manuscripts.[77] And yet, a number of illuminated manuscripts from the 1310s and 1320s have been tentatively associated with Cambridge.[78] It has also been suggested that by *c.* 1340 artists from London, Oxford and Norwich were gravitating towards Cambridge.[79]

Although the manuscripts to which the Macclesfield Psalter is most directly related are assigned to Norwich, as we saw, certain features point to both earlier and later volumes associated with Cambridge. They include specific plant forms, the combination of a dull green pigment with mosaic gold, and the integration of delicate hues of green, violet, rose and slate grey into the otherwise conventional palette dominated by blue, orange and pink. These elements are absent from the Macclesfield Psalter's earliest Norwich predecessor, the Gorleston Psalter of the 1310s, but are prominent in contemporary manuscripts whose liturgical texts point to the diocese of Ely and may suggest a Cambridge origin. Foremost among them is the Howard Psalter of *c.* 1310–20, made in all likelihood for John Fitton of Norfolk (d. 1326), who was probably married to a lady of the Freville family of Cambridgeshire.[80] Not unlike the Macclesfield Master, the

32 Dominican preacher: historiated initial in John of Freiburg, 'Summa confessorum', BL Royal MS 8.G.XI, folio 1r.

artist of the Howard Psalter illuminated a wide range of texts, devotional, liturgical and legal, for lay, religious and academic patrons, and was probably working in a scholarly environment. Michael Michael has drawn attention to further manuscripts related in style and in their border motifs to the Howard Psalter.[81]

Curiously, the Howard artist collaborated with an illuminator who had worked with the Master of the Queen Mary Psalter,[82] the main exponent of the 'court' style, in the 1310s. Named the Subsidiary Queen Mary Artist, this illuminator was active in East Anglia *c.* 1315–20.[83] Another contemporary artist and collaborator of the Queen Mary Master, the Ancient 6 Master, may have begun his career in East Anglia in the 1310s and returned there in the 1330s.[84] The Longleat Psalter, illuminated by him before *c.* 1318–20, offers parallels for many of the Macclesfield Psalter's most unusual features.[85] Among them are the daisies, marigolds and bell-flowers sprouting out of the same stem or extending from the foliage border, and the charming pea plant with blossoms so real that one can almost smell their sweet aroma and pods so full that one expects them to pop open at any moment (fols. 4v, 8v, 41v–42r, 78v). The Ancient 6 Master was also one of the first artists, together with the Howard Master, to use mosaic gold in East Anglia as early as the 1310s. However, by 1335 he was probably working in Norwich, rather than Cambridge, as his latest extant work, a Book of Statutes of that year, suggests.[86]

The features mentioned above are not sufficient on their own to indicate a Cambridge origin for the Macclesfield Psalter. Even if they originated in Cambridge in the first decade of the 14th century, by the 1320s most of these features had been absorbed into the Norwich manuscripts closely related to the Macclesfield Psalter. The combination of the mosaic gold with dull green is ubiquitous in the Stowe Breviary, while the pea plant appears in the second campaign of the Ormesby Psalter. The translucent hues of violet, pink, pale green and grey are not found in Norwich manuscripts of the 1320s, but have become the speciality of the St Omer Master by the late 1330s. The Macclesfield Master may have been an important agent in the transmission of such artistic peculiarities between Cambridge and Norwich manuscripts of the 1320s and 1330s.

Likewise, the Macclesfield Psalter establishes a link between Norwich production of the 1330s and manuscripts associated with Cambridge in the 1340s.[87] The earliest of these, and the most intimately related to the Macclesfield Psalter, is a psalter of *c.* 1340

associated with Edward III.[88] Its artist, who was also responsible for a Cambridge charter of 1343,[89] borrowed individual motifs and mannerisms from the Macclesfield Psalter, and favoured an exaggerated version of the heavy white modelling and green shading used for the faces and flesh in some of the Macclesfield figures. Another aspect of the Macclesfield Psalter was developed in manuscripts of *c.* 1340. The heavily shaded, expressive faces, which hark back to the glum, brooding characters of the Jesse Master in the Ormesby Psalter and the anxious busts in the Stowe Breviary, culminated in the thickly modelled, mask-like, at times even grotesque features found in the Luttrell Psalter,[90] the Castle Acre Psalter,[91] the Brescia Psalter,[92] the Astor Psalter,[93] and the Psalter of Simon de Montacute, Bishop of Ely (1337–45).[94]

While these developments do not support a Cambridge origin for the Macclesfield Psalter, they emphasize its importance as a link between a large number of East Anglian manuscripts spanning the period from *c.* 1310 to *c.* 1340. They also place it at the height of a crucial, transitional and highly experimental stage in the development of East Anglian illumination during the 1330s. Furthermore, the presence in East Anglia in the 1320s and 1330s of illuminators, such as the Subsidiary Queen Mary Artist and the Ancient 6 Master, who had collaborated with the leading proponent of the court style in London, the Queen Mary Master, may account for one of the most striking dichotomies in the Macclesfield Psalter. Its bold East Anglian character notwithstanding, the manuscript also contains sinuous figures and sweet faces of remarkable delicacy. The lady in the *bas-de-page* of folio 58r and the angel playing a fiddle in the left border of folio 139v emulate the luxurious finesse of the most prestigious recent commissions in England and France. They recall manuscripts illuminated by the Queen Mary Master in London and Jean Pucelle in Paris, such as the Queen Mary Psalter of the 1310s, mentioned above, or the Hours of Jeanne d'Évreux of 1325–28.[95]

The impact of these celebrated masters on both sides of the Channel was swift. The truism about the frequent travel of scribes, artists, patrons and manuscripts is rendered concrete by a copy of Aristotle illuminated by English artists working in the Queen Mary style in Paris *c.* 1320–30,[96] by a deluxe Bible of 1327 illuminated by Jean Pucelle, but written and signed by the English scribe Robert Billyng,[97] and by the direct borrowings from Pucelle identified in contemporary English illumination.[98] The Macclesfield Psalter displays motifs that

feature in the Hours of Jeanne d'Évreux, such as the Green Man enclosed within initials, the man swinging from foliage, the grotesques making abusive or obscene gestures, or the facial type of a bald man with an oversized, strongly articulated ear (compare Macclesfield Psalter, fols. 14v, 120v, 180v, 89v, 98r, and Hours of Jeanne d'Évreux, fols. 83r, 149r, 62r, 166r, 34v).

However, these motifs appear in English manuscripts that predate the Hours of Jeanne d'Évreux and are intimately connected with the Macclesfield Psalter, such as the Gorleston Psalter and the Stowe Breviary. What we see in the Macclesfield's imagery is a repertoire of fashionable motifs and a taste for courtly aesthetics shared by deluxe English and French manuscripts rather than specific visual quotations from works of the Queen Mary Master or Jean Pucelle. In fact, the Macclesfield Psalter reveals a closer affinity with manuscripts illuminated by their associates, such as the Ancient 6 Master mentioned above and Jean Le Noir, Pucelle's most gifted follower.[99] In his earliest independent works, from *c.* 1334 onwards, Jean Le Noir displayed an interest in human affect, facial characterization and dramatic expression stronger than that found in Pucelle's works and comparable to that in the Macclesfield Psalter. This suggests parallel developments in Paris and East Anglia in the 1330s, which took the achievements of the previous two decades a step further.

The tendencies outlined above remind us how unhelpful geographical boundaries and categories like 'East Anglian' or 'court' style can be when applied to artists of such phenomenal versatility. The Macclesfield Psalter must be seen as the product of wide networks of artistic exchange, crossing chronological, geographic and stylistic divides. In order to appreciate its richness, diversity and penchant for virtuoso experimentation we need to cast our net beyond Norwich, beyond East Anglia and across the Channel, without assuming a one-way traffic of artistic ideas. The Macclesfield Psalter is best understood in the context of polyvalent artistic relationships.

The threads we have picked up so far have led us into the thicket of traditions and innovations woven into the Macclesfield Psalter. The wide range of theoretical approaches available today may open up new avenues of exploration. But they may also trap us within a maze if we have not familiarized ourselves with the manuscript's internal evidence and basic characteristics first. The remainder of this study will focus on the manuscript itself, and will attempt, on the basis of its texts and images, to reconstruct the psalter's historical, intellectual and artistic milieu.

THE MAKING OF THE MACCLESFIELD PSALTER

The appreciation of the Macclesfield Psalter begins with sight, touch and smell. The observation and analysis of its physical aspects, from the materials to the page design, reveal that the manuscript was conceived from the start as a private prayer book (its pages are only 170 mm tall and 108 mm wide) as well as an object of luxury and beauty. The parchment is creamy and supple, despite the numerous fingers that have thumbed it for seven centuries. The script is bold, crisp and elegantly strung, like black pearls suspended above the lines. The gold shimmers amid a rainbow of strikingly bright pigments and subtle pastel shades, never cleaned or retouched, preserving the sumptuous palette and delicate line of the original painting.

PARCHMENT AND STRUCTURE

The parchment, most probably calfskin, has been carefully treated and pared down to an even thinness; it is almost transparent and yet sturdy enough to support the solid pigments. Parchment made of calfskin and prepared to such high standards is often known as 'vellum'. It was cut down to small sheets. Each sheet was folded to create a bifolium – that is, two leaves or four pages. Several bifolia were then inserted inside one another to form the basic unit of the manuscript, the quire or gathering. All quires, except the first one, were originally quaternions – that is, gatherings consisting of four bifolia (eight leaves or sixteen pages) each (see Appendix 1). Quaternions are common in northern Gothic deluxe manuscripts, and the Stowe Breviary and the Gorleston, Douai and St Omer psalters all used them. Although the vellum of the Macclesfield Psalter is of such quality that there is hardly any perceptible difference in colour and texture between the hair and flesh sides of a sheet, the bifolia within each quire were still assembled according to a time-honoured rule: either the flesh or the hair side of the vellum was used for the facing pages at every opening. A quick look at the eighth quire, for instance, reveals the reason. The facing folios 65v–66r preserve the tiny follicles of the hair side, while their reverse pages and those facing them (folios 64v–65r and folios 66v–67r) are made up of the flesh side and are devoid of any 'blemishes'. This concern for aesthetic uniformity was extended beyond the quire. The more supple flesh side was used for the outer pages of every gathering.

(preceding page) 33 King conversing with a clerk: Macclesfield Psalter, folio 161v.

The quire was the basic working unit for scribes and artists. They could write or illuminate different quires at different times and the whole manuscript would be assembled only when the text and decoration were completed. To assist the binder in putting the quires together in the right order, the scribes wrote the first few words of the subsequent quire on the last page of the previous one. Only one instance of this practical device, known as a 'catchword', survives in the Macclesfield Psalter (fol. 221v), and even this is not complete. The rest were trimmed away when the manuscript was rebound in post-medieval times.

The Macclesfield Psalter came to the Fitzwilliam Museum broken in two, with no trace of its original binding. The plain early 18th-century binding (calf over pasteboards) had long been inadequate. To fit the manuscript within it, and presumably on a small shelf, the margins had been drastically trimmed. The spine had been chopped off too, destroying the original structure and reducing numerous bifolia to single leaves, which were then glued together. As this feeble structure began to fall apart, an expedient, homespun repair was carried out – the leaves were stab-stitched with thick green thread. The Fitzwilliam Museum's conservator, Robert Proctor, had to undo the post-medieval repairs and reconstruct the individual bifolia before he could reassemble the quires and sew the manuscript into a sturdy and flexible new binding (see Appendix 5).

The conservation of the Macclesfield Psalter confirmed the loss of six leaves: two after folio 1 (probably containing framed images comparable to those of Sts Edmund and Andrew on folios 1r and 1v); one after folio 95 (Psalm 68: 1–9, with a large historiated initial to Psalm 68); one after folio 117 (Psalms 79: 14–80: 5, with a large historiated initial to Psalm 80); one after folio 141 (Psalms 100: 3–101: 5, with a large historiated initial to Psalm 101); and one after folio 252 (most likely blank). They may have been removed at different times. The leaf with the beginning of Psalm 101 was already gone in the 17th century, when a reader recorded the loss on folios 141v and 142r. The number of leaves at the beginning was carefully planned to accommodate the prefatory images and text. The first quire (fols. 1–8) was originally a quinion, consisting of five bifolia – ten leaves or twenty pages. The first two leaves of the Confession prayer were bound out of order in the early 18th-century binding, if not earlier. They have now been restored to their original position, reuniting not only the Confession prayer (fols. 246r–248v), but also the last prayer for the dead (fols. 245v–246r) and the prayer recited on going to bed (fols. 251v–252r).

Page Design, the Script and the Scribe

A single scribe was responsible for the layout and script in the Maccles-field Psalter. First he would have rubbed the parchment with pumice or cuttle-fish and ground chalk to create a smooth and absorbent surface. Some pages – for instance, folio 48r – seem to preserve traces of this treatment. The scribe ruled the calendar in bright red and the rest of the volume in warm brown ink; the Stowe Breviary and the Gorleston and Douai psalters were ruled in carmine throughout. The Macclesfield Psalter's simple, clear and elegant grid, on a model that became increasingly popular in 14th-century manuscripts, is a conscious departure from the complexity of earlier patterns, which enclosed both the text space and the margins, often within double lines, as in the Gorleston Psalter. The Macclesfield pattern finds its closest parallel in the Douai Psalter. Despite the difference in size and colour, both volumes were ruled with sixteen lines per page. The ruling would have been guided by a set of marginal prickings, now trimmed away; these would have been made with a single application of a piercing tool through the entire quire to ensure a consistent pattern page after page. The central openings of the Macclesfield quires reveal that the horizontal lines of the frame were ruled across the fold.

Apart from the calendar and the rubrics, the main text was written in the iron-gall ink cherished by medieval scribes for its striking and lasting effect (see Appendix 4). The writing tool would have been a quill made from a goose or swan feather and cut with a medium nib to suit the scale of writing appropriate to a small volume, while producing both sufficiently solid main strokes and their calligraphic extension into delicate hairlines.

The text was written in the Gothic script *par excellence*, known as *textualis*.[1] After some two hundred years of development and experimentation, by the early 14th century *textualis* had reached a significant level of uniformity. Even the most experienced palaeographers agree that the style of decoration is often a more reliable criterion for the dating and localization of late medieval manuscripts than the script. The overall appearance of *textualis* is vertical, compressed and angular. This is achieved through the rhythmic alternation and strong contrast between thick vertical strokes and thin diagonal hairlines, the shortening of ascenders and descenders (the long vertical shafts of letters such as 'b' or 'p'), the replacement of the rounded arches of letters such as 'm' and 'n' with broken strokes, and the use of serifs, that is projecting, square or diamond-shaped strokes, to articulate the head- and baseline of their

minims (the short vertical strokes). The emphasis or absence of such articulations is one of the main criteria for distinguishing between several grades of *textualis*. The most peculiar category – and sometimes accorded the highest status – is *textualis praescissa* ('cut off') or *sine pedibus* ('without feet'), named after its vertical strokes which end flat on the baseline, with a projecting finishing stroke or serif. Particularly favoured in England since the 13th century, it was used in deluxe 14th-century manuscripts, such as the Queen Mary, Simon de Montacute, Ormesby and Luttrell psalters.[2] However, it is also found in less prestigious or refined contemporary volumes, for instance a Norwich Book of Hours,[3] which suggests that *textualis praescissa* was not reserved exclusively for commissions of the highest calibre. At the same time, some of the finest 14th-century manuscripts, including the Gorleston, Douai and St Omer psalters, are written in the other formal category of Gothic script, *textualis quadrata*, which vies with *textualis praescissa* for top rank.[4] Among its main characteristics are the square or diamond-shaped serifs, formed with a separate pen stroke, at the top and bottom ends of minims, which add a horizontal balance to the overall vertical emphasis of the script.

It is *textualis quadrata* that we see in the Macclesfield Psalter and in the Stowe Breviary. It has been suggested that the two manuscripts were written by the same scribe.[5] The identification of individual hands writing *textualis* is seriously problematic because of the high level of standardization achieved not only in the script's general characteristics mentioned above, but also in individual letter forms. For instance, the 'a' with two closed bows (fol. 8r, line 1), the uncial 'd' with a sloping shaft (fol. 8r, line 2), the marking of the 'i' with a thin diagonal stroke to distinguish it from adjacent 'u', 'm' or 'n' (fol. 8r, last line, *psalmi*), the 'f' and long 's' standing above the baseline (fol. 8r, line 7, *misero* and *infelice*), the final 's' shaped like 8 (fol. 8r, line 3), and the crossed 'x' (fol. 8r, line 14, *existo*) found in both volumes were the norm in *textualis quadrata*, especially after 1300. Likewise, the hairlines extending from the 'h', the 'x', the round 'r' (used mainly after 'o'), the tironian 'et', and the abbreviations for the *-bus* ending (shaped like a 3, fol. 8r, line 8) and for *con-/cum-* (shaped like a 2, fol. 8r, line 8, *consanguinibus*) are among the most common ornaments of formal *textualis*.

On the other hand, the Macclesfield Psalter displays some less usual features, such as the hairline of the 'y' curling up on itself (fol. 14v, line 2) or the cross shape formed by the *per-/par-* abbreviation (fol. 15r, line 2). Also, the 'g', while generally conforming to the 8-shaped type, does not have its top left and bottom right strokes executed in a single movement

of the pen; instead, the 'g' is made up of five individual strokes (fol. 14v, line 2). Last, but not least, a different, distinctly English cursive script *anglicana* was used for the Macclesfield catchwords. Although a trace of only one remains in the manuscript (fol. 221v), its calligraphic elaboration suggests close affinity with the numerous catchwords preserved in the Stowe and Gorleston manuscripts, and those in the Douai Psalter recorded in photographs taken before 1914. The peculiar letter forms mentioned above are also found in the Gorleston Psalter, the Stowe Breviary and the Douai Psalter, which were almost certainly the work of different scribes in the 1310s, 1320s and 1330s respectively.

These unusual features seem to represent mannerisms shared by scribes trained and/or working at the same location in close succession. This is not to suggest that they were members of a scriptorium. By the 14th century, organized scribal activities within a communal setting that resembled the monastic and cathedral scriptoria of the early Middle Ages would have been limited to a few religious foundations or to royal, aristocratic and episcopal courts, which attracted leading scholars, scribes and artists, both lay and religious. From the later 12th century, manuscript production was increasingly dominated by secular and, less often, religious professionals, working individually or in loose association, from home or at the estates of major patrons. The peculiarities shared by the scribes of the Gorleston, Stowe, Douai and Macclesfield volumes, like their close stylistic and iconographic similarities, suggest that the manuscripts were produced at the same location, which sustained certain traditions and standards at least over three decades.

Still, several idiosyncratic features recurring in the Stowe and Macclesfield volumes are not found in the Gorleston and Douai Psalters. The upper stroke of the 'a' has a central dip and a wavy, pointed right end (as in the Stowe Breviary, fols. 150v, 264v, and Macclesfield Psalter, fol. 11r). The sloping stroke of the 'd' appears in two variants, with or without a hairline at the end, but in both cases it usually takes a dip in the centre similar to that of the 'a' (compare Stowe Breviary, fol. 150v and Macclesfield Psalter, fol. 10r). Combined with the slight, but noticeable backward slope of the script, these features may suggest that the Macclesfield Psalter and the Stowe Breviary were indeed written by the same scribe. Unless he was a peripatetic professional, the localization of the Stowe Breviary in Norwich may suggest that the Macclesfield Psalter was also copied in that city.

Curiously, the scribal features shared by Macclesfield and Stowe are found in the only manuscript known to preserve the collaborative

34 Bede, 'Historia ecclesiastica', Prologue, TC MS R.7.3, folio 1r, showing the first eight lines copied by an expert scribe.

work of the Douai and Macclesfield masters apart from the Douai Psalter itself, the Trinity Bede mentioned earlier. Unlike the Stowe Breviary and the related psalters, it is a modest book, but it preserves intriguing aspects of the production process. Although the text was copied by four hands of varying confidence, the first eight lines of the prologue (fol. 1r [34]) and the first six of Book V (fol. 133v [35]) were penned by an expert scribe. It seems as if he were setting an example for the other copyists. His two samples display a highly competent and uniform *textualis quadrata*, which contains the 'y' curling up on itself, the cross-shaped 'p' and, more importantly, the dipped strokes of the 'a' and the 'd' found in the Macclesfield and Stowe volumes. Furthermore, all but one (fol. 2v) of the six illuminated leaves preserve contemporary inscriptions identifying them as, for instance, 'the tenth leaf of the third quire' or 'the eleventh leaf of the eighth quire' [32]. This suggests that after the scribes had copied the text of the manuscript the leaves were sent to a different location to be illuminated.

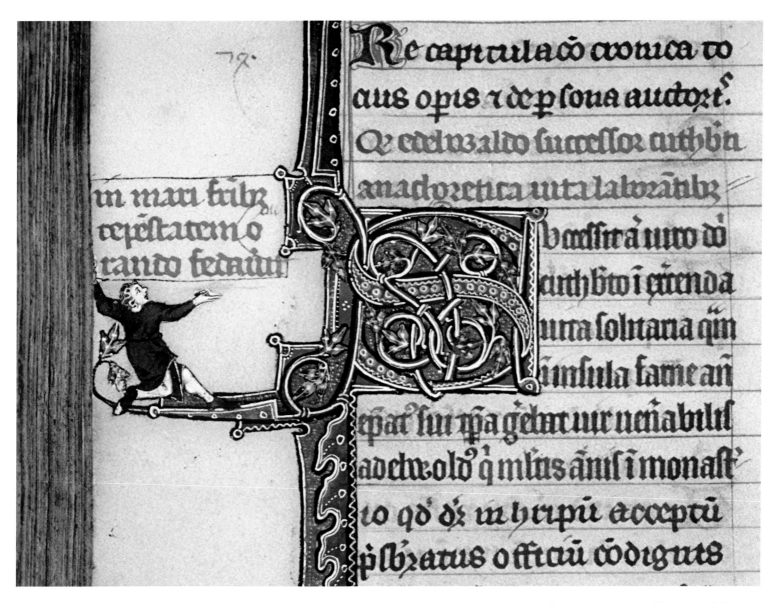

35 *Bede, 'Historia ecclesiastica', Book V, TC MS R.7.3, folio 133v, showing the first six lines copied by an expert scribe.*

The inscriptions ensured the correct reintegration of each illuminated leaf into the volume.

The nature of the expert scribe's relationship with the team producing the Trinity Bede is hard to determine. Was he a particularly skilled member of a religious community who helped his fellow brothers in between his own prestigious projects, a professional scribe training apprentices in a secular context, or a combination of the two? If he was the Macclesfield scribe, he may well have established the contact between the Trinity Bede team and the Macclesfield Master. In turn, he or the Macclesfield Master may have invited the Douai Master to make a guest appearance in the Trinity Bede, in the striking bust of St Augustine of Canterbury at Book II. We are in the dangerous and exciting realm of guesswork, but a hypothesis like this one may help us to appreciate the fluid, dynamic and highly personal nature of manuscript production in 14th-century East Anglia.

THE TEXTS

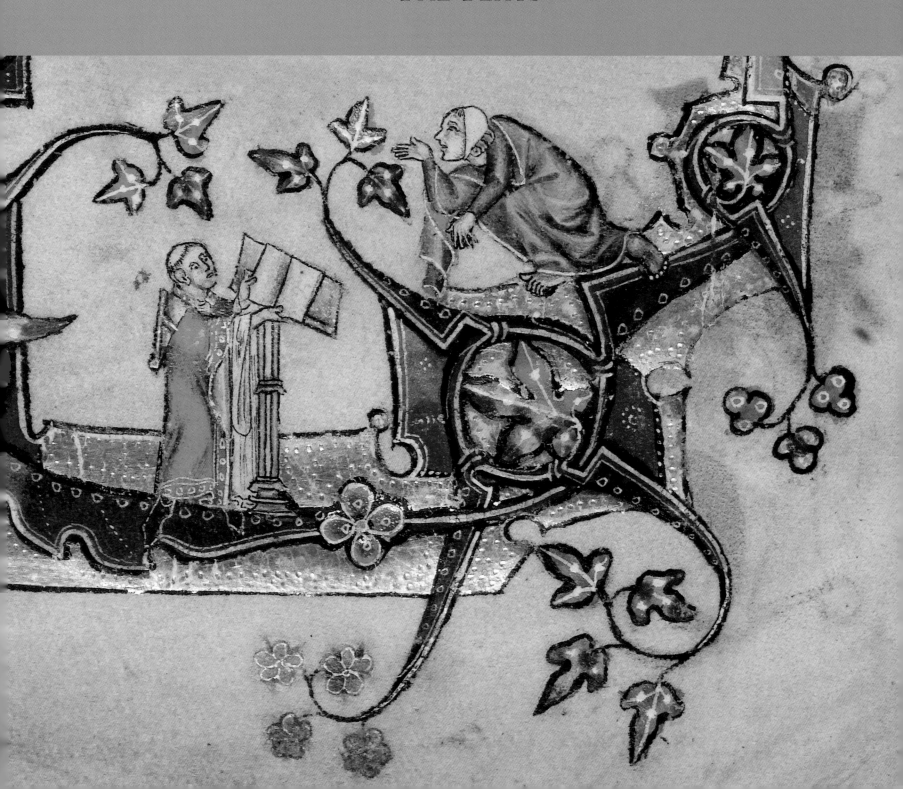

*I*n large part, the Macclesfield Psalter contains the texts typical of a late medieval psalter. It opens with a calendar, which lists the most important feasts of Christ, the Virgin and the saints for each month. Next comes a prayer for God's protection of the person reciting the psalms out of this very book (*Suscipere dignare domine*). The volume continues with the 150 psalms accompanied, as usual, by the biblical canticles for the weekly offices, the Litany of the Saints, and short prayers known as collects. They are followed by the Office of the Dead. The manuscript ends with more prayers, including the ultimate expression of penance and hope for forgiveness, the Confession prayer (*Confiteor tibi domine*).

THE CALENDAR AND THE LITANY
(FOLS. 2R–7V AND FOLS. 227V–235R)

The medieval calendar is a near equivalent of our modern diary. Both organize the year around major holidays, month by month and day by day. The main difference is in the content – overwhelmingly religious in a medieval calendar – and the proportion of official entries to private ones. Although medieval calendars could be personalized from the outset, to reflect their owner's preferences for particular saints, and were often supplemented by later users with the births, christenings, marriages and deaths (obits) of their family members, such individual features were vastly outnumbered by the church feasts celebrated across Christendom and in the diocese, town or religious order of the owner. A few of these numerous feasts survive among our public holidays, namely Christmas and Easter.

While calendars became an integral part of psalters, especially in England, from the early 11th century onwards and remained a common feature of books of hours until the Renaissance, their association with devotional texts has little to do with their original function. Having made their earliest appearance in the context of computistical material, calendars were first and foremost tools for keeping time. Their main function was to determine the days unsuitable for major endeavours or medical treatment, such as blood letting, and to calculate the dates of the movable church feasts, most importantly Easter, which fell on the first Sunday after the first full moon following the spring equinox on 21 March.

36 Cleric reading at a lectern, addressed by a crouching figure: Matins of the Office of the Dead, Macclesfield Psalter, folio 237v.

The short verses in leonine hexameters written in red or blue at the top of each page in the Macclesfield calendar are from a poem composed by Bede in the early 8th century. It identifies the 'bad days' (*dies aegri*) or 'Egyptian days' (*dies aegyptiaci*), by counting the first day of the verse forwards from the beginning of the month and the second day backwards from the end. For instance, in the January verse (fol. 2r), *Prima dies* is 1 January, while 'vii' (for *septima*) is the seventh day from the end, 25 January. By the 14th century the poem appeared, with textual variations, in most calendars. The version in the Macclesfield Psalter is identical with that in the three manuscripts most closely related to it in textual content, style and iconography, the Stowe Breviary and the Gorleston and Douai psalters (see Appendix 2). The rubricated 'D' (for *Dies*) commonly marking the Egyptian days is missing from both the Macclesfield and Douai psalters.

The first two columns of the calendar align the lunar and solar cycles used to calculate the date of Easter and other movable feasts. The first on the left contains the Roman numerals from I to XIX out of sequence. These are the 'golden numbers' or *litterae lunares*, which refer to the lunar cycle of nineteen years and, in relation to the second column, indicate the age of the moon on a particular day. The second column contains the dominical letters, from 'A' to 'g', for the days of the week. For the calendar to be relevant year after year, regardless of the day of the week that corresponds to a specific date, each year begins with a different dominical letter depending on the first Sunday of the year. If it falls on 1 January, the year begins with an 'A', as in the Macclesfield Psalter.

The next two columns accommodate the days of the month. Instead of using arabic numerals, the Macclesfield calendar, like all medieval calendars, adheres to the Roman system. It divides each month into periods articulated by the Kalends (KL), Nones (N) and Ides (ID), respectively the first, fifth and thirteenth days of the month, except in March, May, July and October when the Nones fall on the seventh day and the Ides on the fifteenth. The days after the thirteenth (or fifteenth) of each month are represented by a countdown to the Kalends of the following month. To signal this, February is penned on 14 January, March on 14 February, April on 16 March and so on.

Two other elements common in medieval calendars are the number of days in the solar and lunar months and the number of hours of daylight and darkness each day. Both are absent from the Macclesfield and Douai psalters.

Finally, the wide column contains the perpetual cycle of feasts held on fixed days throughout the liturgical year and the movable feasts indented to the right; for instance Pascha is shown, indented, on 22 March, the earliest date on which Easter could fall. The Macclesfield calendar does not mark the beginning of Septuagesima ('lxx', the 70th day before Easter) or Quadragesima ('xl', the 40th day before Easter, when Lent begins), although they feature in the Stowe Breviary, and in the Gorleston and Douai psalters.

The feasts in a medieval calendar are often graded according to importance, from *maius duplex festum* and *duplex festum*, celebrating the most important saints and events in the lives of Christ and the Virgin Mary, down to *memoria*, commemorating minor saints, marked only with a short prayer said at the beginning of Mass. The importance of the feast is indicated by the number of readings or lessons. While monks and nuns marked the most important feasts with twelve lessons, nine lessons was the highest number used by the secular clergy (that is, clerics in diocesan and parish churches), and by the regular canons and friars. The Macclesfield Psalter and the three most closely related manuscripts reflect the latter practice.

Major feasts are also signalled by their colour – red in the vast majority of medieval calendars, hence our 'red-letter days'. Deluxe manuscripts employ a more elaborate colour coding, with gold, blue, red and black used to grade the feasts in descending order. The Macclesfield Psalter shows a peculiar colour scheme of blue, carmine and red. Blue is used predominantly, but not exclusively, for major feasts. Carmine and red mark both major and minor saints. The colours do not correspond to the number of lessons. It is not so much the liturgical importance as the aesthetically pleasing alternation that seems to determine the choice of colours. The calendars of the Stowe Breviary and the Douai Psalter use the same colour scheme, but their choice of colour for individual feasts does not always match that in the Macclesfield Psalter.

In addition to the old and universally celebrated feasts, calendars often contain new and local ones, which may suggest an approximate date, place of origin or provenance – that is, the place where the manuscript was intended to be used. Such evidence needs to be interpreted with caution. Certain feasts were celebrated long before they became official. For instance, St Anne was venerated in England long before her feast (26 July) was formally established in 1383; she became particularly popular after 1300 and features in a number of 14th-century East Anglian manuscripts, including the Stowe Breviary, which is datable, on

internal evidence, to before 1325. On the other hand, newly promulgated feasts did not gain universal following immediately, and old feasts took a while to die out. For example, the Sarum Feast of Relics, observed on 15 September until 1319, was moved thereafter (because 15 September gained increasing importance as the Octave of the Nativity of the Virgin) to the Sunday after 7 July, the Translation of St Thomas Becket. As a movable feast it soon disappeared from most calendars, though it is still found in East Anglian manuscripts of the 1320s and 1330s, such as the Stowe Breviary and the All Souls Psalter. Its absence from the Macclesfield Psalter is, therefore, not sufficient on its own to date the manuscript to after 1319. A more reliable indicator of a post-1320 date may be the feast of St Thomas of Hereford (2 October) who was canonized in that year.

Feasts may also help with localization, but this needs to be treated with even greater caution. It is not always clear whether local saints in a calendar point to the manuscript's place of origin or to its provenance. Patrons from distant regions could order their manuscripts from an important centre of manuscript production. At the same time, professional artists, while trained at, or gravitating around, a major centre, might travel considerable distances to work on special commissions. A calendar for a new manuscript could follow an exemplar provided by the patron or one available to the scribe, or it might combine and adapt features from several exemplars.

The calendar of the Macclesfield Psalter conforms to the Use of Sarum – that is, the liturgical texts and practices of Salisbury Cathedral, which were adopted by most dioceses in the province of Canterbury during the second half of the 13th century and the early years of the 14th.[1] In the first half of the 14th century, some dioceses, notably Ely and Norwich, added local supplements to the Sarum calendar. The most important Norwich supplements were the feasts of St Felix of Dunwich, the Apostle of East Anglia (8 March), St Dominic (5 August) and the dedication of Norwich Cathedral (24 September), one of the few cathedral dedication feasts in England to be observed throughout the diocese. None of these appears in the Macclesfield calendar.

If the exclusion of particular feasts in the Macclesfield calendar is inconclusive, so too is the inclusion. Two saints who appear in the calendar may seem to suggest a strong East Anglian flavour, but this is misleading. The feast of St Edmund of Bury (20 November), the 9th-century king of East Anglia who was martyred by the Vikings and whose cult grew around his shrine at Bury St Edmunds, is entered in

blue, with nine lessons. But this is not sufficient to locate the psalter in East Anglia, as the feast received nine lessons in the Sarum calendar. St Edmund's Translation (29 April or 9 June), which might have strengthened the East Anglian connection, is not in the Macclesfield calendar. Likewise, the feast of St Etheldreda (23 June), the 7th-century founding abbess of Ely and one of the most popular Anglo-Saxon female saints, is in the Sarum calendar with three lessons. She receives no lessons in the Macclesfield Psalter, and her Translation (17 October), a supplement in the dioceses of both Ely and Norwich, is absent. The Macclesfield calendar lacks other characteristic Ely saints, such as Sexburga, Withburga, Eligius and Ermenilda.

The Macclesfield calendar contains two non-Sarum feasts, St Mary of Egypt (2 April) and St Botulph (17 June), but neither was specific to Norwich, Ely or East Anglia in general. St Botulph, the 7th-century East Anglian abbot, whose relics were shared by Ely, Bury St Edmunds and Thorney, appears in calendars from other dioceses, including London and Lincoln.

A comparison of Macclesfield's calendar with those in the Stowe Breviary and the Gorleston and Douai psalters, reveals close parallels, but also significant differences (see Appendix 2). The Gorleston calendar contains the largest number of saints not found in the Macclesfield Psalter and seems to be the earliest of the four. It lacks St Cuthburga (31 August), who was introduced into the Sarum calendar in the late 13th century. But it includes saints Cyriacus and Julitta on 16 June instead of Richard of Chichester, who is in the Sarum calendar, and St Leger on 2 October instead of St Thomas of Hereford, thus suggesting a date before 1320. The Stowe Breviary preserves certain old-fashioned features too, such as the feast of St Birinus (3 December), and shows a strong Norwich bias by including the feasts of saints Wynwaloe (3 March) and Felix of Dunwich (8 March) as well as the Sarum Feast of Relics (15 September). Despite these differences, the Gorleston and Stowe calendars are closer to each other than either of them is to the other two manuscripts. Where the Gorleston and Stowe calendars differ in the same feasts from the Macclesfield Psalter, the Douai calendar usually agrees with Macclesfield. Where the Stowe and Gorleston calendars differ from each other, the Macclesfield and Douai calendars agree in following either Stowe or Gorleston. Rather than direct dependence on one of them, they show a careful selection and combination of features from both.

The Macclesfield calendar is closer to Douai than to Stowe and Gorleston in the selection of feasts. However, it differs from all three manuscripts in several notable aspects. First, the Macclesfield scribe omits all liturgical instructions about the choir, the grading of less important feasts as *invitatorium duplex*, and the celebration of minor ones with a nocturnal reading, a prayer or a litany. Second, he adds the nine lessons to the major feasts, marked as *maius duplex festum* or *duplex festum* in all four manuscripts. Third, the Macclesfield calendar disagrees with the others in the number of lessons for certain feasts. It assigns no lessons to saints Sulpicius (17 January), Etheldreda (23 June) and Leo (28 June), who have three lessons in the other three manuscripts. More importantly, the Macclesfield calendar has no lessons for Thomas Becket's Octave (5 January) or Translation (7 July). While the latter may be accounted for by lack of space on the page, this is hardly the case for the former. It is possible that the Macclesfield scribe was uncertain about the grading, since the Douai calendar has three lessons for both feasts, while the Gorleston and Stowe calendars have only a *memoria* for the Octave, but nine lessons for the Translation.

Four other differences suggest that the Macclesfield calendar is not the result of direct copying, simplification or misunderstanding of the exemplar(s), but rather that it reflects the preferences and decisions of the manuscript's commissioner and/or owner. The Nativity of the Virgin (8 September) is elevated in the Macclesfield to a *maius duplex* from a *duplex festum* in the other three manuscripts. The feast of St Thomas of Hereford (2 October) has only three lessons in the Stowe and Douai calendars, but receives nine in the Macclesfield. Both may hint at the owner's strong personal devotion to St Thomas and the Virgin. The other two discrepancies, though arguments *ex silencio*, are just as important. The dedication of the church of St Andrew in Gorleston on the Suffolk–Norfolk border (8 March), entered in the Gorleston and Douai calendars, is the crucial evidence for the Gorleston provenance of both manuscripts. Its absence from the Macclesfield Psalter, despite the full-page miniature of St Andrew facing the calendar [37] and the fact that no other feast has been entered on 8 March, weakens any potential association of the manuscript with Gorleston. More puzzling is the absence of St Dominic, whose feast (5 August) features in the other three manuscripts and was among the non-Sarum feasts of the Norwich diocese, together with the less Norwich-specific feast of St Francis (4 October). Since the Macclesfield calendar preserves St Francis, the absence of Dominic is particularly striking, especially in view of the Dominican who is depicted in the manuscript and was in all likelihood the owner's confessor and perhaps closely

involved in the production of his prayer book. Admittedly, the Dominican Use had a fairly limited impact on the secular liturgy. Nevertheless, a number of contemporary manuscripts made for the laity contain mendicant features in their calendars, suggesting the involvement of the friars, even if they do not depict them as the owners' confessors. The Macclesfield Psalter represents a reversed situation.

The comparative study of the four related manuscripts, all of which conform to the Use of Sarum, reveals a process of gradual abbreviation, which is discernible in Douai and obvious in Macclesfield. This is hardly due to lack of space despite the small size of the Macclesfield by comparison with the imposing dimensions of the three other manuscripts. It may perhaps suggest that the Macclesfield postdates the Douai Psalter, or that both manuscripts drew on the Gorleston and Stowe calendars but adapted certain features to the requirements of their intended users. The overall simplification and the editing of liturgical details out of the Macclesfield calendar may imply lay ownership as opposed to a clerical one for the other three manuscripts.

The Macclesfield litany, which is not for the Use of Sarum, is even less specific and informative than the calendar. An integral part of medieval psalters, the litany consists of invocations – for mercy and deliverance – to the Trinity, the Virgin Mary, the archangels, and a long list of saints arranged in hierarchical groups: Old Testament patriarchs and prophets, apostles and evangelists, martyrs, confessors and virgins. Despite the inclusion of St Edmund of Bury among the martyrs, St Botulph among the confessors, and saints Osyth and Etheldreda among the virgins, which may suggest an East Anglian origin, the litany does not point to a specific location. It shows no bias towards any religious order and contains no mendicant saints. As with the calendar, the closest parallel is the Douai Psalter. The lists of

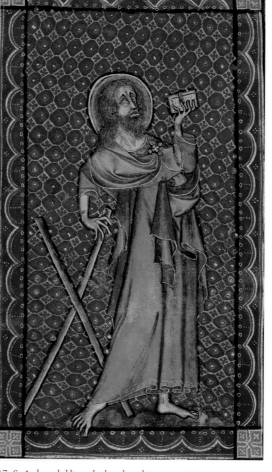

37 St Andrew, holding a book and a saltire cross: miniature, Macclesfield Psalter, folio 1v.

martyrs, confessors and virgins are identical in the two manuscripts. And so are the collects, or short prayers, at the end of the litany. All but one of them, *Fidelium deus*, feature in the Stowe Breviary as well.

While the petitions differ in all four manuscripts, those in the Macclesfield and Douai psalters share more features with the Stowe Breviary than with the Gorleston Psalter. By far the most numerous and elaborate, the Macclesfield petitions make no reference to a religious community. In a sweeping act of social inclusion, they request the protection of God for all the faithful, from the pope, kings and princes to bishops, abbots and all the people entrusted to them (fol. 234v). This reinforces the impression of intended lay ownership left by the calendar. We shall return to this question after we have considered the remaining texts in the Macclesfield Psalter.

THE PRAYER 'SUSCIPERE DIGNARE' (FOLS. 8R–8V)

While hardly a common feature of medieval psalters, this prayer seems to have enjoyed some popularity in the 14th century, particularly in deluxe psalters from East Anglia and the Fenlands made for the use of monastic or clerical patrons. It was added in the early 14th century to the psalter commissioned by Robert de Lindsey, Abbot of Peterborough (1214–22), shortly before his death.[2] It was an integral part of the psalter made before 1318 for another Abbot of Peterborough, Geoffrey of Crowland (1299–1321).[3] The prayer is also found in a 14th-century psalter made for Norwich Cathedral.[4] It opened the Douai Psalter and was penned by its scribe on the reverse of the Crucifixion miniature added to the Gorleston Psalter probably in the 1330s.[5] Its place in the two Peterborough volumes and in the Gorleston Psalter was carefully chosen so that it could face Psalm 1, the position it occupies in the Macclesfield Psalter as well. The *Suscipere dignare* amounted to a devotional preface to the

entire psalter, imploring God to grant the supplicant, his relatives and friends health of body and soul, true penitence and eternal life.

Despite the relatively small number of 14th-century manuscripts in which it appears, no two copies of the prayer are identical. Even the Gorleston version, which may have been particularly close in wording to that in the Douai Psalter (now illegible), displays considerable differences from the Macclesfield text. It petitions God on behalf of the king and the pope before turning to the supplicant's closer relatives. The Macclesfield version focuses on family, friends and benefactors, and implores Christ's mercy in honour not only of the Virgin but of St John the Baptist as well. The owner, the 'unworthy sinner' of the prayer, must have been specially devoted to the Baptist.

The Psalms (fols. 9r–207v)

The 150 psalms make up the biblical book most widely used in the Middle Ages for scholarly study and in the Divine Office. The summit of Hebrew poetry and a cornerstone of Judaic worship, the psalms were adopted by Christians as one of the most important books of the Old Testament. They were traditionally ascribed to King David and associated with specific events in his life, although some commentators, notably St Jerome (c. 342–420), realized that they were the work of different authors. Heavily drawn upon in theology, exegesis and liturgical practices, the psalter doubled as a religious encyclopaedia, seen as expressing Christian doctrine about sin, penance and salvation in a sublime poetic form, foreshadowing the coming of Christ through the life of David, and thus uniting the law of the Old Testament and the grace of the New.[6] It was the most popular devotional reading before the Book of Hours came of age in the course of the 14th century, and even after that, because of the overwhelming presence of the psalms in the core and optional texts of the hours.

There was hardly a text better known to medieval audiences, whether they were religious or lay, learned or barely literate. Being *psalteratus*, steeped in the psalms, was synonymous with being *litteratus*. Children's first encounter with the Bible was through the psalter, which often functioned as a primer. As wedding gifts, psalters sealed dynastic alliances through ostentatious armorial displays, sanctified the bond between bride and groom with shared devotions, and alluded to the more intimate aspects of marriage by the inclusion in their margins of secular and often erotically charged imagery.[7] Psalters also recorded the deaths of family members, preserving the memory of the departed and reminding the living of their own mortal nature.

The devotional use of the psalms cannot be divorced from their multifarious roles in everyday life, in war, diplomacy and superstition. Legend has it that an early 7th-century psalter was carried into battle as a talisman; it came to be known as the Cathach (Old Irish: 'battler') of St Columba (c. 521–597).[8] A deluxe psalter featured among the gifts sent to Mongol leaders in the 13th century during Louis IX's crusade in the Levant.[9] Psalm verses were the biblical texts most frequently inscribed on amulets, used in healing charms and employed in horoscopes. A Byzantine official used his psalter to predict the future amid the shifting climate of court politics in 11th-century Constantinople.[10] Monks at Winchester and Canterbury coupled the psalms with texts on onomancy and chiromancy.[11]

The psalter fully dominated the life of the religious. In its synthesis of the diverse traditions of those in monastic orders and in the secular Church, the Rule of St Benedict (c. 540) structured the offices so as to accommodate the reading of the entire psalter within a week. The resulting groups of psalms, known collectively as the 'monastic

38 Annunciation to the Shepherds: historiated initial, Psalm 97, Macclesfield Psalter, folio 139v.

division', were chanted daily at Matins and Vespers, the first and the penultimate of the eight liturgical hours celebrated in addition to the Mass by those in religious orders.[12] Like them, the clergy in secular cathedrals and parish churches recited all 150 psalms each week, but grouped them differently. Theirs was the so-called 'liturgical' (or 'eightfold') 'division'. Of the various systems of psalter division in the medieval period, this was the most common and received the most systematic figural decoration. It singled out the first psalm of the groups chanted at Matins on the days of the week (Psalms 1, 26, 38, 52, 68, 80 and 97 [38]) and at Vespers on Sundays (Psalm 109).[13] In Germany, the Southern Netherlands and especially in England, it was often combined with the traditional 'threefold division' (Psalms 1–50, 51–100, 101–150). Since Psalm 1 participated in both systems, the combination resulted in the so-called 'tenfold division' seen in the Macclesfield Psalter. The initials for Psalms 51 and 101, while still larger than those for the ordinary psalms, were often smaller than those for the psalms of the liturgically more important eightfold division.

The Latin psalter was known in four different versions in the medieval Insular world.[14] The Old Latin text, *vetus latina*, translated from the Greek and used by the early Church, was brought to Ireland in the 4th century. St Jerome, who complained that it was circulating in as many versions as there were copies, prepared a revised version in the early 380s at the request of Pope Damasus. Known as the 'Roman Psalter', it came to England with St Augustine of Canterbury in the late 6th century. Dissatisfied with his first revision, St Jerome moved to Bethlehem after the pope's death in 384 and embarked on a monumental editorial campaign. His second version of the Latin psalms, based on the Greek Septuagint, came to be known as the 'Gallican Psalter' because of its wide dissemination in Gaul. Introduced to northern England by Irish missionaries, it replaced the Roman Psalter from the mid-10th century onwards. Although St Jerome's crowning achievement was the 'Hebrew Psalter', his third Latin translation made directly from the Hebrew, it enjoyed success only among biblical scholars. The Gallican Psalter was the version preferred for the eclectic compromise that became the medieval Latin Bible, the so-called 'Vulgate', a century after St Jerome's death. The Gallican Psalter remained the standard Latin text in the medieval West, central to liturgical and devotional practices and the basis for later vernacular translations, notably the 14th-century English Psalter of Richard Rolle.

Like most late medieval psalters, the Macclesfield volume contains the Gallican Psalter. One can establish this quickly by checking, for instance, the opening verses of the first psalm (fol. 9r). The end of verse 1 and the beginning of verse 2 read 'et in cathedra *pestilencie* non sedit. Sed in lege *domini* voluntas eius.' The Hebrew Psalter has 'et in cathedra *derisorum*' instead, while the Roman Psalter reads 'Sed in lege domini *fuit* voluntas eius.' The Roman *fuit* has been added by a later medieval reader above the Gallican verse in the Macclesfield Psalter, suggesting that it was carefully studied by someone interested in the different editions of the psalm text.

In this commentary the Latin quotations from the Gallican Psalter and from the rest of the Bible are based on the 1983 Stuttgart edition of the Vulgate.[15] English quotations are from the Douai–Rheims translation, which follows the numbering of the psalms in the Vulgate.[16] These numbers have been inserted by an early modern owner in the margin beside each psalm in the Macclesfield Psalter – rather helpful for us, but unnecessary for medieval readers who remembered and referred to each psalm by its opening verse. The psalm numbers in the Macclesfield Psalter, in the Stuttgart edition and in the Douai–Rheims translation of the Vulgate differ from those in the Authorized Version and the Book of Common Prayer, both of which follow the numbering in the Hebrew Psalter and are for the most part one number ahead of the figures in the Macclesfield Psalter (see Appendix 3).

THE CANTICLES (FOLS. 207V–227R)

The Macclesfield Psalter contains the standard set of ten canticles found in most late medieval psalters, plus the *Te deum* hymn and the Athanasian Creed, *Quicumque vult* (see Appendix 3).[17] Like the psalms, the canticles were sung antiphonally – that is, verse by verse in turn by two choirs. Also like the psalms, which were distributed among the eight liturgical divisions, the canticles were part of the daily offices celebrated throughout the week. The first six, which draw on Old Testament texts, were used at Lauds (the early morning service) on weekdays from Monday to Saturday.

They are followed by the *Te deum*, one of the most popular hymns of the Christian Church.[18] Legend has it that it was composed spontaneously and chanted by St Ambrose and St Augustine on the night of St Augustine's baptism in 387. In reality the *Te deum* originated later, but its affinity with early Christian poetry composed in psalmodic style

between the 2nd and 4th centuries, and the fact that its final section is based almost exclusively on the psalms, made it a suitable component of psalters.[19] Its position in the Macclesfield Psalter has been carefully chosen. The *Te deum* was sung on feast days and Sundays at Matins (the midnight service).

Immediately after it comes the Canticle of Three Hebrew Youths in the Fiery Furnace used at Sunday Lauds, which started immediately after Matins. The last three canticles draw on St Luke's Gospel and were known as the 'great canticles', since they did not vary. Each was sung daily: the *Benedictus* at Lauds, the *Magnificat* at Vespers (the evening service) and the *Nunc dimittis* at Compline (the last office of the day).

The Macclesfield series ends with the Athanasian Creed, one of the three creeds of the early Church, which summed up its teaching about the three persons of the Trinity and Christ's divine and human natures. It was composed in rhythmical prose, like the *Te deum*, and originated probably in 5th- or 6th-century Gaul.[20] Although it was originally intended for private use, it came to be performed like a psalm on Sundays at Prime, the morning service after Lauds. The careful arrangement of the canticles, the *Te deum* and the *Quicumque vult* offered the Macclesfield Psalter's owner a round of devotions for the mornings and evenings throughout the week, culminating in a profession of faith that was intended to secure his eternal salvation.

The Office of the Dead (fols. 235v–246r)

Distinct from the Funeral Mass, the Office of the Dead originated as a text for private mourning.[21] The first of its three liturgical hours, Vespers, was effectively a vigil for the dead and was said over the body during the night before the burial. The other two services, Matins and Lauds, were recited in church the following morning. This public aspect required adherence to the liturgical practices of the diocese, and the text in the Macclesfield Psalter conforms to the Use of Sarum, mentioned above in the discussion of the calendar. However, in the late Middle Ages, the Office of the Dead became an integral part of individual devotional routine, a key stratagem for dying a good death. Before it was established as a core element of books of hours, the Office of the Dead became an increasingly regular feature in Gothic psalters, offering solace at the deathbed of relatives, prayers to relieve and shorten the trials of those in Purgatory, and hope for eternal salvation.

While the readings at Matins are from the Book of Job, which contains some of the most profound and moving reflections on man's mortal nature, the core text of the Office of the Dead consists of psalms chosen for their relevance to the theme of death.

Vespers begins with Psalm 114 (*Dilexi quoniam*), whose last verse provides the opening antiphon: 'I will please our Lord in the country of the living' ('Placebo domino in regione vivorum'). It continues with Psalms 119, 120, 129 and 137, followed by the *Magnificat*, and concludes with Psalm 145. All these are abbreviated down to the first few words in the Macclesfield Psalter, occupying no more than a page in total (fols. 235v–236r). The prayers, however, are written out in full. The same drastic abbreviation of the psalms (5, 6, 7, 22, 24, 26, 39, 40, 41) and their antiphons occurs at Matins, the second liturgical hour of the Office of the Dead, which begins 'Direct, O Lord, my God, my way in thy sight' ('Dirige domine deus meus in conspectu tuo viam meam', the source of the word 'dirge' in modern usage; fol. 237v). But the nine readings from the Book of Job are provided, complete with the responses and versicles, which identify the liturgical use as that of Sarum. Once again the psalms (50, 64, 62, 66, the Canticle of Hezekiah – *Ego dixi* – and Psalm 148) and antiphons at Lauds are listed only by their opening words (fols. 244v–245r), while the four prayers after them are written out in full.

The high level of abbreviation suggests that the manuscript was intended for a clerical reader who would have been familiar with the Office of the Dead and needed only brief prompts, the opening words of the relevant psalms. A prayer for a dead bishop after Vespers (fols. 236v–237r) and another one for a dead priest after Lauds (fol. 245r–v) reinforce this impression. It contradicts the preliminary conclusion about possible lay ownership based on the analysis of the calendar and litany.

The Confession Prayer, 'Confiteor tibi domine', and Other Prayers (fols. 246r–252r)

Towards the end of the volume we find the Confession prayer, followed by three prayers to Christ, requesting (respectively) protection against the temptations of the devil, support at the time of death so that the penitent can confess fully, and remission of sins after death (fols. 249r–251r). The next two prayers are to be recited as one wakes up or rises in the morning (fol. 251r–v). The manuscript concludes (appropriately) with a prayer to be said as one goes to bed (fols. 251v–252r).

Of all the texts in the Macclesfield Psalter, the Confession prayer is the most unusual, not simply because it is fairly uncommon in 14th-century psalters – it does not feature in any of the East Anglian manuscripts closely related to the Macclesfield Psalter – but also because it is fairly detailed and personalized. It begins:

> I confess to you, O Lord, Father of heaven and earth, and to you most merciful and good Jesus, together with the Holy Spirit, before your holy angels and before your altar here, because in sins was I conceived, in sins was I brought up, and in sins have I dwelled since my baptism until this hour.

The penitent then lists the numerous sins that he has committed himself or has allowed others to commit: pride, vainglory, envy, hatred, avarice, gluttony, drunkenness and fornication all loom large, and the excised section of the leaf, which we shall discuss later, may have deprived us of more. Next, towards the end of folio 246v, he blames himself for receiving communion, the Eucharistic body and blood of Christ, undeservedly, because of his sacrilegious and rapacious behaviour, perjury, megalomania, ignorance and neglect of God's commands (at the top of folio 247r). He is also guilty of denying alms and hospitality to the poor, respect to his relatives, visits to the sick and imprisoned, clothing to the naked, food to the hungry and drink to the thirsty. The confession resonates with the language and imagery of the gospels, evoking Christ's deeds of mercy as the model for the supplicant. He then acknowledges that he has failed to observe saints' days, Sundays and church feasts by living a sober and chaste life. He has consented to evil advisers, but turned a deaf ear to the pleas of poor beggars. On folio 247v he craves pardon for entering church, sitting, standing and exiting arrogantly, as well as for participating in 'dirty talk'.

Even worse, he has touched the holy vessels and the consecrated Host with filthy hands and impure heart, and has recited prayers and the Divine Office in church negligently, in a lukewarm and idle manner.

The litany of sins continues with perverse thoughts, false suspicions, rash judgment, ill advice, carnal desire and impure pleasure, superfluous and pompous speech, lies, false oaths and (fol. 248r) quarrels and disputes, derision and transgression of the faith, contempt for God and for his neighbour, and any possible sin that can be committed through the five senses – sight, hearing, taste, smell and touch – as well as through thought, speech, action, pleasure or desire. Finally (fol. 248v), before he expresses his hope for eternal joy in heaven, the penitent invokes the saints to witness his full confession and vouch for him at the Last Judgment, lest the devil claim that he had passed over something in silence and after all triumph over him. This is the common vocabulary and thematic range of confessional literature.[22] All but two of the sins listed were the stock-in-trade of late medieval preachers and confessors catering for the spiritual health of their lay audiences.

The two transgressions that stand out are the negligent recitation of the Divine Office and the impure touching of the Host and holy vessels. While lay people could take part in the Divine Office by following the text in a Book of Hours or chanting the psalms and prayers in their parish church or private chapel, the wording in the Macclesfield Psalter seems to imply the formal performance of clerical duties. Most revealing is the reference to the handling of the Host and holy vessels, the exclusive prerogative of the clergy. Despite the growing desire among late medieval congregations to see the elevated Host and chalice during Mass, it was unthinkable for lay people to touch the Eucharistic body and blood of Christ or their sacred receptacles, unless they practised heresy or dabbled in magic.[23] This seems to argue, together with the abbreviations and prayers of the Office of the Dead, that the Macclesfield Psalter was intended for a clerical owner. We are fortunate to have his image beneath the opening of the Confession prayer.

THE OWNERS OF THE MACCLESFIELD PSALTER

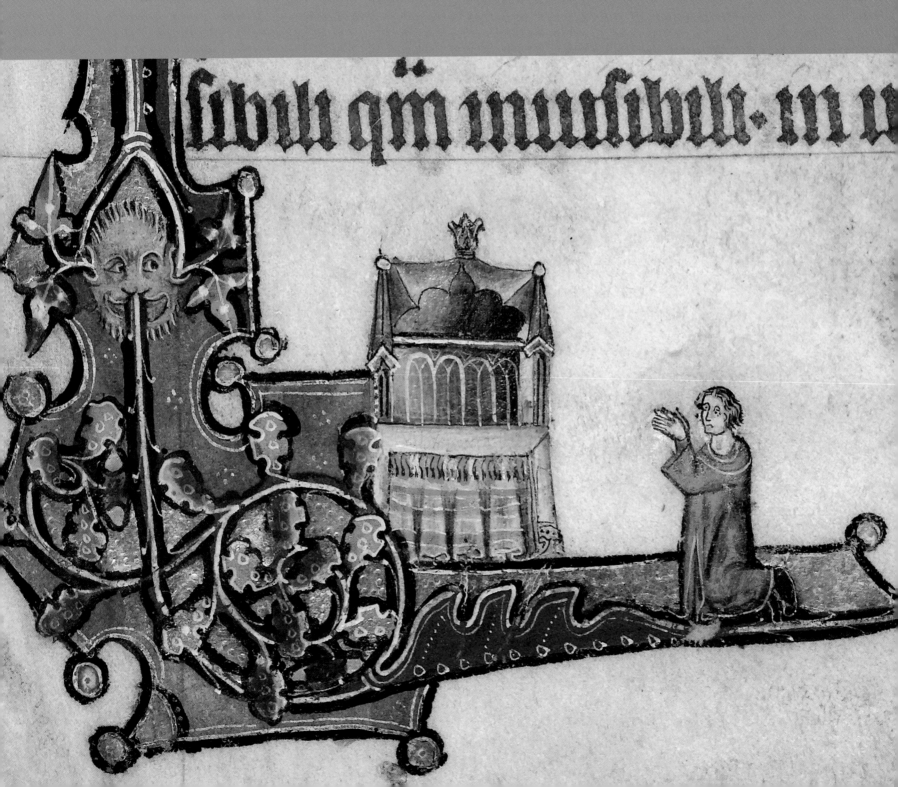

The man who kneels before an altar with a shrine — *coram praesenti altari tuo*, as the Confession prayer has it halfway up the page — is beardless [39]: that is, young according to medieval pictorial conventions. We probably see him again praying in bed at Psalm 114 (fol. 166v). More importantly, he has no tonsure and must be a layman. This agrees with the analysis of the calendar and litany, but contradicts the evidence from the Office of the Dead and the Confession prayer. It seems likely that the Macclesfield Psalter's intended owner was either in minor orders or at the very start of his training for a career in the Church.

The Original Owner and his Confessor

The depiction of the manuscript's owner at the Confession prayer is significant. In the century after the Fourth Lateran Council of 1215, prayer, confession and penance gained increasing importance in lay spirituality through religious teaching and preaching, not least by the mendicants. Seen as indispensable for the remission of sins, regular confession placed eternal salvation within the grasp, initiative and personal responsibility of the individual, given that he (and in the case of the Macclesfield Psalter we know that it is 'he') followed sound spiritual guidance.

We can be fairly certain that the Macclesfield Psalter's owner received such guidance. A Dominican friar is shown praying on folio 158r beneath Psalm 107, which opens 'Paratum cor meus deus', 'My heart is ready, O God', and whose third verse begins 'Confitebor', 'I shall confess'. He kneels in the fourth of St Dominic's nine prayer positions, discussed in the anonymous treatise *The Ways of Prayer of St Dominic, c.* 1280.[1] St Dominic's positions were exemplified by biblical texts, mostly the psalms, and illustrated in the earliest surviving copy of the treatise, made most probably in Avignon during the pontificate of John XXII (1314–34), not long after the canonization of Thomas Aquinas in 1325.[2] The fourth way of prayer, the treatise tells us, was taught by St Dominic more by example than by words. The friar in the Macclesfield Psalter conveys to the young fellow the paramount importance of confession by personal example. A Dominican also emerges from the foliage on folio 120v and looks across to folio 121r, which ends 'Domine deus virtutum exaudi orationem meam' ('O Lord, God of virtues, hear my prayer'; Psalm 83: 9).

(preceding page) 39 The owner of the psalter, praying before a shrine: Macclesfield Psalter, folio 246r.

The presence of the Dominican friar may help to explain the unusually detailed Confession prayer and the clerical elements in the manuscript. Since the calendar and the litany contain no Dominican saints, they would have been of little use to the friar. It seems far more likely that he was the mentor of the manuscript's intended recipient, offering spiritual guidance and perhaps training for the priesthood. The portraits of the owner and his confessor show the desire for self-representation blending into the metaphysical dimensions of the image. On the one hand the very depiction of the act of prayer would have intensified the experience every time the reader–viewer turned his eyes and mind to confession. On the other the real image would have registered the continuous presence of the owner on the Confession page, representing him, as it were, by proxy when the book was not in use. At the same time, the image imprinted on his memory together with the text, both vivid to his mind's eye, would have kept him in a constant readiness for confession. This was crucial in the case of a sudden death (*mors subita*), the end medieval people dreaded most as it denied them the last rites – namely, confession, extreme unction and the final communion known as the *viaticum* ('one for the road') – which ensured a safe journey into the beyond.[3] Eventually, the depiction of the supplicant would play a commemorative role: while serving the spiritual needs of future readers, it would solicit their prayers for the soul of the original owner, prayers that were considered particularly efficacious in accelerating the passage through Purgatory.

The image would have shared these devotional, commemorative and salvific functions with the owner's coat of arms,[4] which was most probably painted within the initial to the Confession prayer. It was cut out by a later owner. To him this would have been more than a gesture of material expropriation. It would have deprived the original owner and his descendents of the spiritually advantageous physical proximity between their family arms and the words of the prayer, and would have allowed the new owner to identify directly with the image and the prayer's beneficial effect. To us the excision is an act of vandalism that has destroyed crucial evidence. Without the coat of arms we cannot identify the original owner with any certainty.

Unlike other deluxe 14th-century manuscripts, notably the Gorleston Psalter, the Macclesfield does not contain a prominent display of coats of arms, a roll-call of the great and the good of the day. However, its decoration might have included some heraldic devices. This is suggested by the careful removal of small border sections at the splendid

openings of Psalm 1 (fol. 9r) and Psalm 38 (fol. 58r). The same was probably the case at the beginning of Psalm 101, whose initial in late medieval psalters often contained an image of the patron in prayer. As we saw (page 30), this leaf was already missing in the 17th century and may have been removed during the same campaign of expropriation to which the initial of the Confession prayer fell victim.

One coat of arms escaped the knife. Embedded in the border of folio 37v [40], it was either overlooked or not considered important enough to be removed. Its gold and blue lozenges, the latter decorated with white fleurs-de-lis, are easy to replicate as an ornamental pattern with no heraldic significance, of the kind seen in contemporary manuscripts, notably the Stowe Breviary. Yet, this is unlikely in the Macclesfield Psalter, which makes no use of quasi-heraldic decoration. The only exception is a line-filler on folio 19v, similar to, but not identical with, the tinctures on folio 37v. In any event, the shield on folio 37v is hardly prominent enough to suggest identification of the patron by itself. We cannot know whether the same arms were present at the Confession prayer and on the other mutilated leaves, and, if they were not, how the different arms in the manuscript might have related to one another.

40 Coat of arms: decorative border, Macclesfield Psalter, folio 37v.

To complicate matters further, the coat of arms on folio 37v has been associated with four families. The Warberton (or Warbleton, Werblinton or Worbolton) family of Hampshire and Sussex is recorded in only four rolls of arms dating from *c.* 1270 to *c.* 1285, but appears invariably with the lozengy or and azure charge.[5] By contrast, the Gorges family, who held lands in Somerset, Dorset, Devon and the Isle of Wight, appear in numerous rolls of arms between *c.* 1250 and *c.* 1340, but their armorials vary significantly. The gold and blue lozenges are associated with Sir Ralph Gorges (d. before 27 September 1323) in ten rolls, most of them dated after 1300.[6] Sir Ralph fought in France and Scotland under Edward I, who rewarded him with a knighthood after the siege of Caerlaverock in July 1300.[7] He served Edward II in the Welsh marches as a knight of Hugh Despenser the younger. In 1321 Edward II appointed him Justiciar of Ireland, a position held up to that point by Roger Mortimer who duly captured Sir Ralph and held him prisoner

until the king interfered. Sir Ralph's only son and heir, another Ralph, does not seem to have matched his father's distinguished career.

However, neither the Warberton nor the Gorges arms contain the fleurs-de-lis seen in the shield on folio 37v. Two other possibilities accommodating the fleurs-de-lis have been suggested. Neither is an exact match for the Macclesfield's shield, but since it is part of a decorative programme, not of a heraldic roll, one may allow for a degree of artistic licence, called for by aesthetic considerations, technical difficulties or historic references. David King proposed an identification with the family of Mortimer of Attleborough in Norfolk.[8] One version of their arms, azure semy de lys or, was recorded at the church at Attleborough, in the east window of the chapel of the Holy Cross founded by William Mortimer (d. 1297). The replacement of the Mortimer gold fleurs-de-lis with white ones on the blue lozenges may have been the Macclesfield artist's solution to working in gold leaf on such a minute scale. The alteration, which emphasizes the lozengy azure and or pattern, may have also been intended as an allusion to the checky azure and or arms of Warenne. As King pointed out, in 1263 William Mortimer was in the custody of John de Warenne, sixth Earl of Surrey and Sussex (1231–1304). In 1298 the earl, who was overlord of Attleborough, sued the king for the wardship of William's son, Constantine (d. 1334). If the Macclesfield Psalter had been commissioned by Constantine, who used a different version of the Mortimer arms, or floretty sable, the shield in the border would have been a commemorative reference to his father. Constantine's death in 1334 suggests a *terminus ante quem* for the psalter, which we shall test against the political events and cultural developments alluded to in the images.

Thomas Woodcock, Norroy and Ulster King of Arms, suggested that the arms in the Macclesfield Psalter should be blazoned lozengy azure, each lozenge charged with a fleur-de-lis argent and or over all fretty sable, and that they were intended to be those of the Morville family, which were azure semy-de-lis and fretty or.[9] If so the coat of arms must have offered a historical reference of some importance for the Macclesfield Psalter's commissioner or owner, since the Morvilles

were long extinct by the 14th century. The Norman Morville family rose to power under David I of Scotland, who made Hugh de Morville (d. 1162) Lord of Lauderdale, Cunningham and north Westmorland, and Constable of Scotland.[10] While one of his sons, Hugh (d. 1173/74), a prominent courtier of Henry II, is best known as one of Thomas Becket's murderers, his other son, Richard (d. 1189/90), married the granddaughter of William de Warenne, second Earl of Surrey (d. 1138), thus connecting the Morvilles to one of the greatest Anglo-Norman families. The Morvilles were related to the Gorges too, since Sir Ralph Gorges was the grandson of Ellen, daughter and coheir of Ives de Morville.[11]

The Morvilles became extinct when Richard's son William died in 1196 without a male heir, and the family estates passed through his sister's husband, Roland of Galloway, into the hands of another old Scottish family. If the coat of arms on folio 37v is to be identified with that of the Morvilles, so prominent in Anglo-Scottish politics of the past, it may account for the choice of St Andrew, the patron saint of Scotland, for one of the prefatory miniatures. In 1200 Roland of Galloway was buried at the Cluniac Abbey of St Andrew in Northampton, which subsequently benefited from the generous patronage of his wife and son. As this son died without a male heir, the massive Morville–Galloway establishment that straddled the English–Scottish border was split up between his three daughters. One of them married Roger de Quincy (d. 1264), second Earl of Winchester, whose sister's husband was Hugh de Vere, Earl of Oxford and ancestor of John de Warenne, seventh Earl of Surrey and Sussex (1286–1347). John's grandfather and namesake, the sixth Earl of Surrey and Sussex (1231–1304), had married his daughter Isabella to the future king of Scotland, John Balliol, in 1279, and in 1295 was appointed custodian of Scotland by Edward I.[12] With or without the Morville connection, St Andrew would have been important to the Warennes because of their strong interests in Scotland.

John de Warenne, the seventh earl, was one of the most powerful magnates during the reign of Edward II, with whom he had been knighted at the same grand ceremony in 1306, and whose niece, Joan de Bar, he had married in the same year.[13] A key figure in contemporary politics, the earl was implicated in the death of the king's favourite, Piers Gaveston, in 1312. In 1322 he was involved in the execution of Thomas of Lancaster, leader of the baronial opposition against the king. He was also instrumental in the arrangements for Edward II's abdication and Edward III's succession in 1326–27. After an opportunistic acquiescence to the regime of Isabella and Mortimer, John de Warenne supported Edward III at the beginning of his independent rule in 1330. As the young king sailed for Flanders at the outbreak of the Hundred Years' War in 1338, he left the earl as one of the principal guardians of the realm.

His military and political exploits aside, John de Warenne was a major patron of the arts in East Anglia. He was almost certainly the commissioner of the Gorleston Psalter, which displays his arms prominently and has more than 120 images of rabbits, many in their warrens, a visual pun on the earl's name that is well attested in his seals.[14] The rabbits, common symbols of fertility and promiscuity, may also refer to John de Warenne's unsuccessful attempts, between 1313 and 1316, to end his childless marriage to Joan de Bar, Edward I's granddaughter, as well as to his adulterous relationship with Maud (or Matilda) Nereford of Castle Acre in Norfolk, by whom he had children already. John's scandalous private life and suit for divorce provoked his excommunication by Pope John XXII; the earl's reconciliation was achieved probably with support from the clergy at St Andrew's Church in Gorleston, to whom the Gorleston Psalter was most likely presented. The dedication of their church is written in gold in its calendar.

It has been suggested that John de Warenne might have been the commissioner of the Macclesfield Psalter as well, mainly because of the presence of rabbits and the full-page miniature of St Andrew.[15] We have already noted that, despite the close relationship between the Gorleston and Macclesfield calendars, the dedication of St Andrew's, Gorleston, was not included in the Macclesfield. A large number of medieval churches and chapels were dedicated to St Andrew, including one each in Norwich and Cambridge. The Dominican priories in both cities were in the parishes of St Andrew. That said, the image of a saint in a manuscript need not be linked exclusively with a church or a chapel. St Andrew and St Edmund could have been of special importance to the manuscript's commissioner, intended recipient or his confessor. Besides, the two leaves lost between St Andrew's image and the calendar may have contained miniatures of other saints to whom the manuscript's patron was particularly devoted.

At the time the psalter was made rabbits were a fairly recent import from the continent. Still a luxury in early 14th-century England, the ownership of warrens was a jealously guarded aristocratic privilege. Rabbits proliferated in the margins of deluxe manuscripts produced on both sides of the Channel in the late 13th and 14th centuries. Among the factors that may account for this popularity were current aristocratic

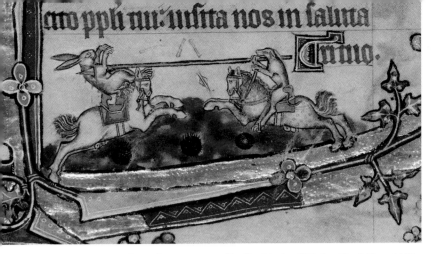

41, 42 Death and funeral procession of a noble rabbit: Macclesfield Psalter, folios 151r and 152r.

fashions, popular beliefs about the promiscuity of rabbits – hence the hound–rabbit chase alluding to sexual pursuit[16] – and a long rhetorical tradition, going back to St Augustine's *Confessions*, which used the rabbit hunt as a metaphor for retrieving memories.[17] Rabbits, both hunted and hunting, abound in the splendid volumes commissioned by the noble Bar family of Lorraine (John de Warenne's in-laws), such as the Pontifical of Renaud de Bar.[18] Admittedly, the Gorleston's rabbits far outnumber those in most contemporary manuscripts. They appear rather seldom in the Macclesfield's marginalia, yet at least four out of the eleven compositions containing rabbits (fols. 15r, 122r, 151v, 152r) replicate those in the Gorleston Psalter (fols. 88v, 95v, 106v, 117v, 129v, 133r, 138r, 164r, 202v)[19] so faithfully as to suggest a visual quotation. No other two manuscripts show such closely related, indeed almost identical, rabbit scenes. Three of the images also constitute one of the very few pictorial narratives that unfold on successive pages in the Macclesfield Psalter. On folio 151r a rabbit is killed by a hound in a joust [41]. Overleaf, his coffin, surrounded by candles, sits on top of a warren while two mourning rabbits read the Office of the Dead out of their tiny manuscripts. The funeral procession advances across the facing page, led by a bell-ringing rabbit and ending with another one asperging the bier with holy water [42]. In 1304 John de Warenne inherited the family title and estates directly from his grandfather, John de Warenne, the sixth earl, and not from his father, William de Warenne, who had been killed at the Croydon tournament in 1286. In the Gorleston Psalter the rabbit's funeral (fol. 133r) may be a heraldic pun on this tragic event in the earl's family history. It might have been relevant to the young owner of the Macclesfield Psalter too.

While John de Warenne had no legitimate children, he had two sons, John and Thomas, by Maud Nereford and a son named William by his second mistress, Isabella Holland. He had made generous provisions for Maud and her sons in 1316, but changed his will in 1345 in favour of Isabella Holland, since by then Maud was dead, and John and Thomas had joined the priory of St John's, Clerkenwell, near London, the main house of the Knights Hospitaller in England.[20] It is possible that John and Thomas were already being prepared for religious life in the 1330s and that the Macclesfield Psalter was made for one of them. The special devotion to St John the Baptist demonstrated by his depiction on folio 133r and the invocation in the *Suscipere dignare* prayer may point to the elder son, John. By 1340 John de Warenne was granting land to Isabella's son, and among the items left to William in the earl's will was a French Bible, not so far identified with an extant manuscript.[21] Apart from that, we know too little about John de Warenne's illegitimate sons to identify any of them as the Macclesfield Psalter's intended recipient.

Alternatively, the psalter may have been associated with John de Warenne's legitimate heir, his nephew Richard Fitzalan (*c.* 1313–1376), son of John's sister Alice and Edmund Fitzalan, second Earl of Arundel (1285–1326).[22] Although Richard did not succeed to the Warenne estates until John's death in 1347 and only assumed the title (as eighth Earl of Surrey and Sussex) after Joan de Bar's death in 1361, his reversionary right in the Warenne inheritance was confirmed in 1326 and vigorously defended in the 1340s, as the old earl tried to provide for Isabella Holland.[23] The significance of the rabbit's fatal accident would not have been lost on Richard Fitzalan, the grandson of the jousting victim, William de Warenne.

At least one contemporary illuminated manuscript has been associated with both John de Warenne and the Fitzalan earls of Arundel, a two-volume copy of John Duns Scotus's commentary on Peter Lombard's *Sentences*.[24] It was written by a French scribe, probably in Paris, but illuminated by an English artist. The opening page of the first volume displays the arms of Warenne suspended from a herald's

trumpet, and a lozenge showing a red lion on a yellow ground. While Lucy Sandler identified the latter tentatively with the Fitzalan arms, gules a lion rampant or (a gold lion on a red background),[25] Margot McIlwain Nishimura suggested the royal arms of Scotland instead, or a lion rampant gules (a red lion on a gold background).[26] David King has now offered support for the earlier association with the Arundel earls through an ingenious interpretation of the marginalia on the same leaf.[27] These include an oak branch with acorns and a centaur resting his front hoofs on a hillock – all elements of the Fitzalans' crest, on a mount vert a horse passant argent in the mouth an oak branch proper.[28]

John de Warenne and Edmund Fitzalan had been close allies during the turbulent reign of Edward II. Both had been defeated by Piers Gaveston at the tournament at Wallingford in 1307 and were instrumental in his demise in 1312. Both were among the magnates who condemned Thomas of Lancaster to death in 1322. Supporter of the young Edward II at first, in 1310 Edmund joined the other twenty Lords Ordainer who were gathered to reform the realm. However, shortly afterwards Edmund switched over to the king's side and allied himself with Edward II's new favourites, Hugh Despenser the elder and his son Hugh the younger. In 1321 he married his son and heir, Richard, to Isabella, the daughter of the younger Despenser. Edmund was one of the most powerful magnates of the realm, appointed Warden of the Scottish March in 1316, Justice of Wales in 1322 and Warden of the Welsh Marches in 1325. He was a sworn enemy of the Mortimers and received large portions of their forfeited estates when Roger Mortimer fled to France in 1322. When Mortimer returned as Queen Isabella's lover and co-ruler in 1326, he had Edmund Fitzalan executed and seized his property.

In the early 1330s Edward III restored Richard Fitzalan to his father's title and estates, as third Earl of Arundel. He was one of the few members of the old nobility who benefited from royal generosity on a par with the king's new men.[29] Richard was to become the richest lord in England, the most powerful moneylender to royalty, nobility and gentry alike, Edward III's chief financial supporter during the Hundred Years' War, and the owner of vast estates in Wales, Sussex and Surrey. The realizable assets at the time of his death in 1376 reached the colossal sum of £72,245.[30] His rise to power and wealth are first documented in 1337, when his son by Isabella Despenser, named Edmund after his deceased grandfather, was around ten years old. The young Edmund's age and family background make him a likely recipient of the Macclesfield Psalter.

The earls of Arundel seem to have favoured the Dominican order. The Blackfriars were brought to Arundel by Isabel, Countess of Arundel, some time before 1253, when Bishop Richard of Chichester left them a small sum and one of his manuscripts. Despite royal gifts in 1297 and 1324, the friary was small and poor. Its only revival occurred after 1324 when Edmund, the second earl, noted that the building had become inadequate for the growing number of friars and gave them 2 acres of land adjoining their precincts.[31] As a result, the friary began to attract zealous young men, and the ordination lists of the bishops of Chichester reveal that it continued to supply newly trained priests for some time. The Macclesfield's visual evidence of the young priest-to-be and his Dominican tutor seems to fit into this picture.

The earls of Arundel were not among the major landlords in East Anglia. However, the church of St John the Baptist at Mileham, one of their five Norfolk manors, was the focus of their patronage from the late 13th century onwards. In the 1340s, a splendid west window was inserted and its glazing was probably commissioned, as Claire Daunton proposes convincingly, by Richard Fitzalan, the third earl.[32] The features of Christ, St John the Baptist and St Catherine are strongly reminiscent of the finest facial types in the Stowe Breviary, a Norwich manuscript of the 1320s. This is significant because no 14th-century stained glass is known to survive from Norwich,[33] and because it suggests that artists familiar with earlier Norwich production were working for the Earl of Arundel in the 1340s.

Although there are no coats of arms extant in the Macclesfield Psalter to support a Fitzalan patronage, there may be other, more subtle heraldic references that have remained intact. While oak leaves and acorns feature throughout the Macclesfield Psalter and are part of the common ornamental vocabulary in contemporary East Anglian manuscripts, it is worth noting that an oak branch with acorns extends from the mouth of the lion mask that observes the owner in the *bas-de-page* of the Confession prayer (fol. 250r). More importantly, the banner suspended from one of the heralds' trumpets in the lower border of folio 39r combines gold, red and white. The Arundel arms, a gold lion on a red background, are well documented. Medieval livery colours, which the heralds would have worn and hung from their trumpets, are less systematically recorded and still poorly researched. But Michael Siddons has found sound 14th-century evidence for red and white as the livery colours of the Fitzalans.[34] Edmund's father, Richard Fitzalan, purchased

red and white cloth for his Welsh troops in 1342, while his son and heir, Richard (Edmund's half-brother) mentioned in his will, dated 1382, 'un grande sale blanc et rouge', decorated in the borders with arms and 'babewynes', the medieval term for what we now call grotesques. Red, white and gold also feature in the swags of fabric that complete numerous lines of text throughout the manuscript (e.g. fols. 91v, 95r, 97v, 120r, 122v, 126v), notably on the pages showing St John the Baptist (fol. 133r) and the Dominican in prayer (fol. 158r). They are often combined with violet or blue, thus matching the heralds' costume on folio 39r.

It is perhaps significant that the heralds appear beneath the anointing of the young King David within the initial for Psalm 26. David, who at his first consecration was only anointed, is here being anointed and crowned at his second consecration. It was on this occasion that he was thought to have composed Psalm 26. He thanks God for protecting him against his enemies and announces that he has nothing to fear. The last two lines on the page, immediately above the heralds, read: 'Qui tribulant me inimici mei ipsi infirmati sunt et ceciderunt' ('My enemies that trouble me have themselves been weakened and have fallen'). For Richard Fitzalan and his son Edmund, the biblical text would have resonated with memories of the family's recent tribulations and with hope for a revival of their power and prosperity. The miniature of St Andrew would have been relevant to Edmund's grandfather's wardenship in Scotland. The image of St Edmund of Bury, the king martyred by the Danes, with which the Macclesfield Psalter opens, was probably chosen as a special focus of devotion for the young Edmund and as a commemoration of his grandfather, a political martyr himself.

Richard Fitzalan divorced Isabella Despenser in 1344 and married Eleanor, daughter of Henry, third Earl of Lancaster, in 1345. This bastardized Edmund and transferred the Arundel title and estates to his half-brother Richard, Eleanor's first-born son. Edmund never reconciled himself to the fact and until his death (some time before 1382) continued to contest Richard's inheritance. The first extant record of his protest dates to 1347, when he complained to the pope. By then he had been knighted and had married Sibyl, daughter of William de Montacute, first Earl of Salisbury (1301–1344).[35] This was a hugely advantageous match. One of Edward III's closest political allies and personal friends, William served on the king's first Scottish campaign in 1327 and again in the Scottish wars of 1333–38. He was Edward's envoy in secret diplomatic missions to Paris and Avignon in 1329, ensuring, together with Richard Bury, the confidentiality of the king's correspondence with the pope.

William was also the leading figure in Edward's *coup d'état* of 1330 which removed Queen Isabella and Roger Mortimer from power. Edward III rewarded William with the Earldom of Salisbury, one of six new earldoms created in 1337 for the king's staunchest supporters. In the same year Edward secured the lucrative bishopric of Ely for William's brother, Simon de Montacute (1304?–1345), who had been a clerk in the royal household and papal chaplain in 1332.[36] Simon was an important patron of the arts, as the Lady Chapel at Ely Cathedral begun during his time demonstrates. It is perhaps no coincidence that one of the earliest examples of the emulation of the Macclesfield Psalter's style in manuscripts assigned to Cambridge in the 1340s is a psalter commissioned by Sibyl's uncle, Simon de Montacute.[37] Sibyl had another distinguished ecclesiastic in her family. Her mother was the sister of John Grandison, chaplain to John XXII, papal legate to England in 1327, Bishop of Exeter (1327–69) and an art patron with a pronounced taste for Italian works.[38] It is also worth noting that the largest group of deluxe manuscripts, which carried the East Anglian style into the second half of the century, was that made for the Bohun family.[39] William de Bohun, Earl of Northampton (c. 1312–1360), and his wife, Elizabeth, who commissioned the Dominican Astor Psalter and left a generous bequest to the Cambridge Blackfriars in 1356, married their children to the son and daughter of Richard Fitzalan, third Earl of Arundel.

The speculation about the young Edmund Fitzalan's ownership of the manuscript needs to be qualified in view of the clerical features in the Office of the Dead and the Confession prayer. It is unlikely that the heir of the Earl of Arundel, as Edmund was until his parents' divorce in 1344, would have been trained for the priesthood. He had no brothers, only two sisters. All that we can be certain about is that the Macclesfield Psalter was intended for a young cleric-to-be tutored by a Dominican and closely associated with the earls of Warenne and Arundel.

LATER PROVENANCE

By the 15th century, the Macclesfield Psalter was in the hands of a nun, who signed her name beneath the opening miniature of St Edmund and again beneath the image of Christ at the prayer *Suscipere dignare*, no doubt positions chosen for devotional reasons as much as for the sake of recording ownership. Although erased by a subsequent owner, the inscriptions are still legible under ultraviolet light: 'Sister Barbara Booke' on folio 1r and 'Barbara Boke' on folio 8v. Sister Barbara added a

number of saints to the *Suscipere dignare* prayer on folio 8r: John the Evangelist, George, Denis, Leonard, Birinus, Anne, Mary Magdalene, Catherine, Margaret, and, last but not least, Barbara. Beneath her name on folio 1r there is a verse signed 'B' and partially readable under ultraviolet light: 'Multa cadunt inter [...] / super [...] labea.'

She also adapted the secular liturgical division of the psalter to that used in a monastic house. The marginal annotations 'Dominica' (Sunday), 'feria IIa' (Monday), 'feria IIIa' (Tuesday) and 'feria IIIIa' (Wednesday) mark Psalms 109, 118, 119 and 134, which were recited in Benedictine houses at Vespers on Sunday, Terce on Monday, Terce on Tuesday and Vespers on Wednesday respectively. The last three annotations – 'feria Va' (Thursday) at Psalm 143, 'feria VIa' (Friday) at the Canticle of Isaiah (fol. 207v) and 'Sabbatum' (Saturday) at the *Te deum* hymn (fol. 219v) – do not correspond to the Benedictine Use. We cannot be certain, therefore, that Sister Barbara belonged to a Benedictine nunnery, although St Benedict's Rule had allowed for some degree of variation in the psalms chosen for the monastic daily offices. Either Barbara or (more likely) another late medieval owner penned the prayer on folio 252v, composed of abbreviated psalm verses and voicing the supplicant's plea for eternal salvation.

Unlike many English manuscripts, which had their images of saints defaced or removed and the mention of popes and St Thomas Becket in the calendar or litany crossed out or erased during the Reformation, the Macclesfield Psalter shows no signs of Protestant iconoclastic zeal. It must have remained in Catholic hands during the religious and social upheavals of Henry VIII's reign. The next person to leave his name in the manuscript, above St Edmund on folio 1r, was one of Elizabeth I's trusted bishops. Anthony Watson, fellow of Christ's College in Cambridge (1573–83), acquired the psalter while he was Bishop of Chichester (1596–1605). It was probably he who noted, on folios 141v and 142r, the absence of the leaf containing the beginning of Psalm 101.

Later in the 17th century the manuscript belonged to one John Smeaton, the last owner to sign his name, also on folio 1r. The psalter was in the library of the earls of Macclesfield by 1860 at the latest, when the bookplate and pressmark 3.C.11 were added. But it is not known when or how it came to Shirburn Castle. It may have been acquired by the first earl, Thomas Parker (1667–1732), who laid the foundations of the great library, or by the third earl, Thomas Parker (1723–1795), who consolidated it. It is also possible that the Macclesfield Psalter was already at Shirburn Castle in 1716 when the first earl purchased the house, together with the remains of a library that had belonged to the previous owners, the recusant Chamberlayne family.[40]

Although the manuscript, tucked away on a high shelf at Shirburn Castle, was all but forgotten by the 20th century, it must have been heavily thumbed in the previous two hundred years or so. Its early 18th-century binding was broken, stitched up and broken again. A rare insight into what might have made it so popular in the 1700s and 1800s is offered by the Gorleston Psalter, to which, as we have seen, the Macclesfield Psalter is closely related. In 1800 Lord Cornwallis showed it to a young couple, the Kerrs, who were staying with him in Suffolk.[41] Lord Mark Kerr (1776–1840) was the third son of the fifth Marquess of Lothian, second cousin of the Duke of Wellington, and one of Nelson's most gifted captains at Trafalgar, destined to become a vice-admiral. He was also an artist with a quirky sense of humour and unorthodox imagination. Fascinated by the marginal grotesques in Lord Cornwallis's Gorleston Psalter, he made sketches of them, and they became the models for the surreal drawings, visual 'conundrums', puns and parodies that Kerr called his 'monsters' and produced for the rest of his life, to the amusement or embarrassment of his family and friends. The Kerrs' eldest son married the daughter of the fourth Earl of Macclesfield, George Parker (1755–1842). No sketches of Macclesfield motifs have come to light (Kerr's extant drawings are a small fraction of his prodigious output), but given his taste for medieval marginalia and fame for visual parodies it seems reasonable to expect that his in-laws would have entertained him with the Macclesfield Psalter, just as Lord Cornwallis did with the Gorleston Psalter, only more frequently, since they were neighbours. Undoubtedly, the Gorleston and Macclesfield marginalia would have been shared with, and admired by, other members of the overlapping artistic, literary and social circles that enjoyed Kerr's 'monsters'.

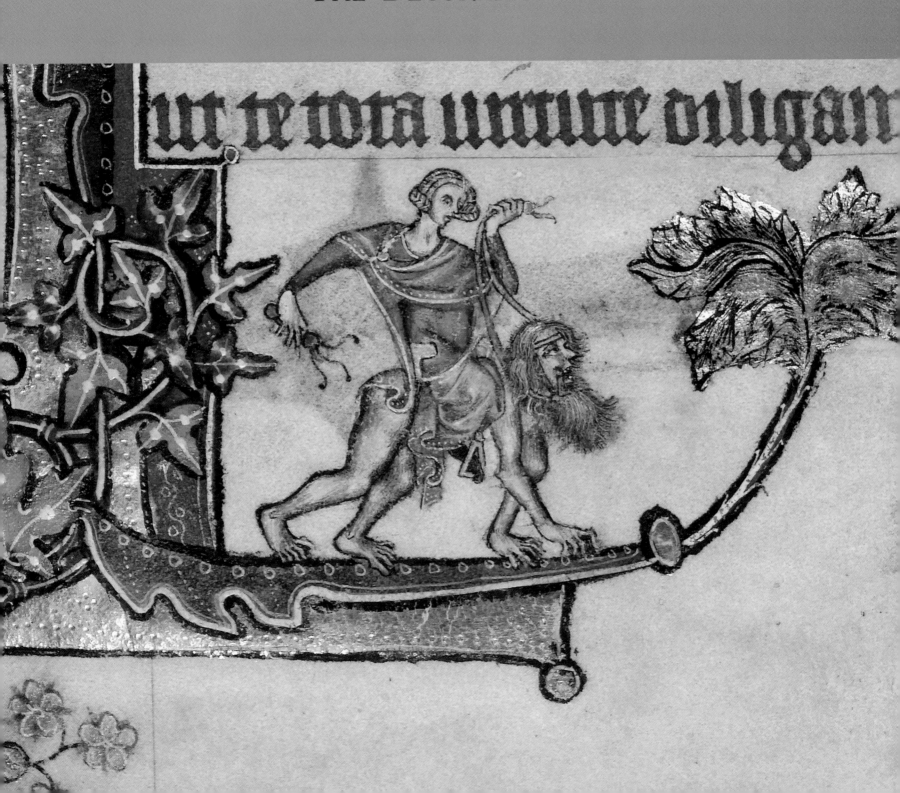

The original owner of the Macclesfield Psalter had no page, folio or psalm numbers to guide him through his prayer book. He had a time-honoured navigation tool – the systematic arrangement of the decoration.

ORDER AND HIERARCHY

A grand entrance into the book, the full-page prefatory miniatures of St Edmund and St Andrew (fols. 1r and 1v), set two distinct devotional tones for the reading of the psalter, while the half-page miniature of Christ as Judge (fol. 8v [44]) focused the owner's thoughts on eternal salvation, pleaded for in the introductory prayer, *Suscipere dignare.*

The main text divisions in the rest of the manuscript announce themselves through richly decorated pages. Each of these contains the giant first letter of the first word of the new text section, filled with a visual story and known as a 'historiated initial'. The historiated initials vary slightly in size, indicating the relative importance of the texts they mark. Psalm 1, the introduction to the entire psalter, receives a nine-line initial and occupies half of the page. The remaining psalms of the eightfold division that survive in the manuscript (Psalms 26, 38, 52, 97 and 109) and Vespers of the Office of the Dead have initials eight lines high. The initial for Matins of the Office of the Dead occupies seven incomplete text lines. Those for Psalm 51, which was part of the threefold division, Psalm 119, the first of the fifteen Gradual psalms (119–33), and the first canticle take up six lines and just over half of the text column width. It is likely that the excised initials to Psalms 68 and 80 of the eightfold division were eight lines high and the one to Psalm 101, part of the threefold division, took up only six lines.

44 *Christ as Judge: miniature, Macclesfield Psalter, folio 8v.*

(preceding page) 43 Phyllis riding on the back of the philosopher Aristotle: Macclesfield Psalter, folio 233v.

Solid bands of gold, blue and dark red extend from the historiated initials, sprout foliage and twist into an interlaced frame for the entire page, which engulfs figures in its lush foliage or erects a stage for the scenes unfolding in the margins. The ornamental borders contain foliage and plants typical of 14th-century English illumination, such as the enormous acanthus leaves shown in full face or cross-section (fol. 13v), the stylized ivy leaves, trilobes, daisy buds and marigolds (fol. 1v), and the oak leaves complete with acorns (fol. 44v). They also include motifs specific to East Anglian manuscripts, such as the green or orange leaves with a peculiar web of white veins (fol. 13r [45]), the pink cinquefoils or their buds (fol. 1v [46]) and the green sprigs with tiny violet or pink bell-flowers (fols. 47r and 50v [47]), which are also found in the Stowe Breviary. The Macclesfield's borders incorporate charmingly naturalistic motifs, such as the pea plant [48], which appears in only a very few manuscripts of an earlier date, notably those on which the Ormesby and Ancient 6 masters worked; but by the late 1330s, like the pink cinquefoils, it had invaded the borders of the Douai and St Omer psalters, demonstrating the continuous development of the ornamental vocabulary in East Anglian manuscripts from the first into the second quarter of the 14th century.

The remaining initials in the Macclesfield Psalter mark the start of smaller text units and contain no historiation. They are filled with foliage or human busts and profiles, or, if they happen to be the letter 'I', they are often formed of a human or hybrid figure, such as the jester on folio 37v, the bird–man on folio 43v or the praying men on folios 50r and 98v. The only exception may have been the initial to the Confession prayer, which probably contained armorial decoration (see page 44) and is the largest of the non-historiated initials, occupying four lines. The six prayers following it are introduced by three-line initials, while the ordinary psalms, canticles, prayers, collects, the litany and each month in the calendar are marked by two-line initials. Finally, each verse or new sentence in the manuscript

begins with a one-line gold initial set against a blue and dark red ground decorated with delicate white patterns, using floral, geometrical and occasionally zoomorphic or anthropomorphic motifs.

Every single page in the Macclesfield Psalter, whether it contains an ornamental initial or simply one-line gold initials, has a side border identical with those found around the historiated initials, sprouting rich foliage into the upper and lower margins, and often supporting figures or scenes that pun on the adjacent text or play out a scene with their fellows on the opposite page. This is one of the aspects that make the Macclesfield Psalter stand out among the East Anglian manuscripts of the period. Even the finest of its contemporaries, the Douai or St Omer psalters, have fairly restrained ornamental borders on their ordinary pages. Only the Gorleston Psalter boasts the wealth and range of marginal figures and scenes found throughout the Macclesfield Psalter.

One final element of the decoration completes the Macclesfield's page layout. Rectangular multicoloured bands fill up text lines left partially blank by shorter psalm and canticle verses or by the invocations in the litany (fols. 38v and 230r). The text space is invaded by geometric or floral patterns, by swags of delicately modelled fabric and by animal and human heads and figures, such as the leopards' heads sticking out their tongues at the reader–viewer. The fabric and leopard motifs must have been particularly popular with East Anglian artists and patrons, as they feature in deluxe contemporary manuscripts, including the Douai and St Omer psalters. Known as 'line fillers' or 'line endings', these delightful gap-fillers are indicative of the medieval dislike for empty spaces, the so-called *horror vacui*, and played a crucial role in manuscript design.

Fascinating as it is, the neat hierarchical structure provides only one way into the decoration in the Macclesfield Psalter. It should not obscure the almost organic symbiosis between the different types and areas of imagery. The initials, large and small, flow in and out of the borders. The borders terminate in hybrids, which glance back at the initials. The line fillers pick up motifs from all other elements of the decoration. The marginalia gloss the main images in unexpected ways, converse across the page, pun on nearby text, echo or anticipate words on neighbouring pages. This integrated page design and intimate text–image relationship are the results of the artists' close collaboration throughout the volume and their adoption of the same strategies for psalter illustration.

THE ARTISTS

The Macclesfield Master has been identified, as already mentioned, with the Douai Assistant, who designed and painted most of the Douai Psalter and the Trinity Bede, and illuminated single-handedly a copy of John of Freiburg's *Summa confessorum*. He was responsible for the overall design of the Macclesfield Psalter, from the initials to the borders and the marginalia. He painted the miniatures of St Edmund of Bury, St Andrew and Christ as Judge; all but one of the historiated initials; most of the busts and profiles inside the ordinary psalm initials; the majority of the borders with the figural decoration embedded in, or extending from, them; and most of the marginalia, both single figures and scenes.

This artist worked with an assistant, who executed the one-line verse initials, the line fillers, some of the small initials, and the borders on pages with no major decoration (fols. 33v, 37r, 104r). The assistant also coloured in the foliage and the minor hybrids in numerous borders already sketched by the master, but left to him the large human figures and hybrids terminating, supported by, or integrated in the borders. This is obvious in the few cases where a border figure has been left uncoloured (fol. 45r).

The Macclesfield Master shows immense versatility and taste for experimentation. He was capable of painting conventionally sweet, deli-

45–48 Floral and foliage motifs, Macclesfield Psalter (left to right from the top), folios 13r, 1v, 47r and 42r.

cate faces, with hair meticulously articulated and neatly styled. But he was also responsible for the grave, surly, hirsute and shaggy characters, heavily modelled in grey, whose predecessors we find in the Stowe Breviary and the Ormesby Psalter. Both types can often be seen on the same page (fols. 11r, 139v). The display of character and emotion is one of the Macclesfield Master's specialities. He does not rely simply on the habitual raised eyebrows, furrowed brow and downturned mouth, pugnaciously thrust forward. The eyes are particularly expressive, with an elongated almond shape reminiscent of the Ormesby Psalter's Jesse Master, strong double outlines for the upper lid familiar from the Stowe Breviary, and pronounced eyelashes. The Macclesfield Master paints well-proportioned figures, except for the hands and ears, which are often enlarged (fol. 158r). His marginal characters can be short and stocky, at times even dumpy, though we might suspect the hand of the assistant in some of them. The Macclesfield Master is particularly adept at rendering human anatomy with precision and startling naturalism. His nudes, reminiscent of those painted by the Ormesby Master, are well built, strong and agile (fols. 223r, 236r, 240v). Their contortions and balancing acts exemplify the artist's delight in taking up challenges and displaying his virtuosity (fols. 28v, 184v, 221r). Even when clothed, the figures preserve the dynamics of movement. The delicate white edges and hems of the carefully modelled drapery are found together with solid black outlines, especially of white areas, sometimes on the same figure (fol. 1v). Such discrepancies may be due to the qualities of pigments and media, but are more likely to be a matter of choice, another example of the experimen-

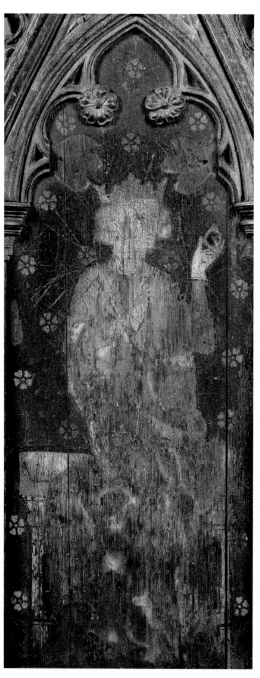

49 St Edward the Confessor: painted panel, discovered at Kingston Lacy, Dorset, on loan to the British Museum.

tal nature of this artist's work. The same is true of the playful application of different types of gold. The handling of gold leaf and mosaic gold (see Appendix 4) is brought to perfection, notably in the rich texture of St John the Baptist's camel shirt (fol. 133r). The artist revels in the bravura display of difficulty, diversity and virtuosity. Such qualities were admired in medieval thought and aesthetics, as they stimulated the senses and the mind, and kept them alert. They called for concentration, close observation, swift recollection, associative thinking and ingenuity. We shall find them also in the artist's choice of subject matter for the historiated initials and the marginalia.

The Macclesfield Master collaborated with an artist whose contribution, though limited, is of exceptional quality. He illustrated only one of the major text divisions, the Anointing of David and the border figures at Psalm 26 (fol. 39r), and we shall name him the Anointing Master. He did not paint any of the marginal scenes, but was responsible for some of the figural decoration integrated in borders (fols. 20v, 42r, 43v, 52r, 53r, 66v, 68v, 89r, 98v, 108r). It is here that the close collaboration between the two artists poses insoluble problems of identification. It is often hard to tell whether one of them painted the design of the other or whether they worked together on the same page. It is also possible that the two of them experimented and learned from each other in a playful way.[1]

The Anointing Master surpassed the Macclesfield Master in subtle modelling. His drapery eschews dependence on patterns and outlines, except for delicate white hems (fol. 109v). The figures and limbs are slender and refined, with slightly elongated proportions (fols. 18v, 110v). This is particularly

noticeable in the nudes, which lack the athletic muscle structure of the Macclesfield Master's bodies. They are thinner and more wiry, and are sometimes shaded in green. The use of grey and the combination of violet and green, favoured by the Macclesfield Master as well, are exceedingly delicate, almost translucent at times, probably through tempering with substantial amounts of gum. The faces are pallid, lyrical and melancholic, modelled in thick white and tan, with luminous white highlights shaping the eye sockets, defining the nose and mouth and even suggesting wrinkles. Although the Anointing Master's mode of painting is analogous with that of the Douai and St Omer masters, a search for his hand in surviving manuscripts has proved futile. The closest parallels seem to be with panel painting.

Michael Michael has drawn attention to the panels of *c.* 1320–30 of uncertain origin and early provenance, which were discovered in Kingston Lacy, Dorset, and are now deposited at the British Museum.[2] They show strong similarities to the work of the Macclesfield Master in ornamental vocabulary and architectural details, as well as in proportions, physiognomy, treatment of hair, and use of prominent outline, notably in the figure of St Edward [49]. Sadly the panels' poor condition and heavy loss of pigment limit the scope for further analysis.

Another parallel is the best-preserved English medieval panel painting, the Thornham Parva Retable of the 1330s.[3] A comparison between St Paul on the retable [50] – the most accomplished of the figures – and one of the border hybrids by the Anointing Master (fol. 20v [51]) is particularly revealing. While the hybrid is based on a workshop pattern re-used in the Stowe Breviary (fols. 116v, 150v), the Macclesfield Psalter (fol. 162v) and the Douai Psalter (fol. 150v), this is its

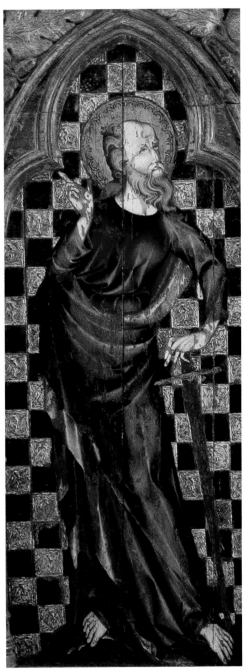

50 *St Paul: retable, St Mary, Thornham Parva, Suffolk.*
(above right) 51 *Hybrid border figure by the Annointing Master, Macclesfield Psalter, folio 20v.*

finest rendition. It shows a closer affinity with the work of the artist responsible for St Paul than any other extant manuscript or monumental painting.

Like the Anointing Master, the Macclesfield Master was intimately familiar with the Thornham Parva Retable or with workshop models used for its images of the saints. The figures of St Edmund of Bury in the two works are remarkably close [52, 53]. The correspondences extend from postures, gestures, attributes and facial expressions (see also the marginal busts on folio 77r) to modelling technique and colour scheme. The artists' preference for azurite over ultramarine, which results in the greenish nuance of the blues in both works, has been established through technical analysis.[4] The peculiar manner of painting the eyes on the retable, namely the light blue, somewhat eerie irises and the white area separating them from the pupils, is replicated in the work of both Macclesfield artists (fols. 20v, 77r). Their close collaboration, often found on the same page, is matched in the retable, where the two main artists are thought to have worked together on some of the figures. It must be stressed that the resemblance concerns working procedures, not actual hands: we do not have enough of the Anointing Master's work to propose

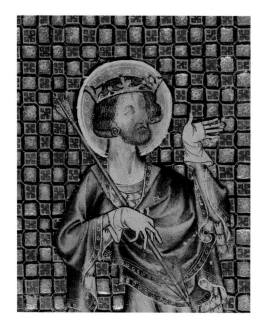

a firm identification with the retable artist responsible for St Paul's figure. As for the Macclesfield Master, his hand is not found in the retable. Although he knew it or had access to workshop models used for it, he was not convinced by its exaggeratedly tall figures. While we cannot, on the available evidence, identify the hand of either of the Macclesfield artists in the Thornham Parva Retable, we can be fairly certain that the two works were produced in the same artistic milieu.

The Macclesfield's close textual, stylistic and iconographic links with the Stowe Breviary and the Ormesby Psalter, as well as the likely identification of the Macclesfield's scribe with the copyist of the Stowe Breviary, strongly suggest that it was made in Norwich. The origin and provenance of the Thornham Parva Retable remain the subject of scholarly debate. Paul Binski found the closest stylistic parallels for the retable in the work of the Ormesby Master of the 1320s.[5] However, the mannered poses and gestures of the retable's figures led him to suggest a date in the 1330s, while the absence

(above left) 52 St Edmund of Bury: miniature (detail), Macclesfield Psalter, folio 1r.

(above) 53 St Edmund of Bury: retable, St Mary, Thornham Parva, Suffolk.

of Italianisms, so prominent in contemporary Norwich manuscripts, such as the Douai and St Omer psalters, made him favour an origin outside Norwich. He suggested Thetford on the basis of the retable's likely provenance.

The depiction of St Dominic and St Peter Martyr on the outer panels reveals that the retable was intended for a Dominican house. All of the remaining images could be accounted for by such a destination, except the unusual pairing of St John the Baptist with St Edmund of Bury. Christopher Norton offered an explanation by pointing out that the Dominican friary at Thetford was founded in 1335 by Edmund Gonville (d. 1351), then rector of Rushforth near Thetford and the future founder of Gonville Hall, Cambridge, on land given by John de Warenne, seventh Earl of Surrey and Sussex, and Henry Grosmont (c. 1310–1361), soon to become fourth Earl (and subsequently first Duke) of Lancaster.[6] While Henry of Lancaster is not accommodated by Christopher Norton's hypothesis, his role as a founder was admittedly less prominent: Edmund Gonville needed no more than his consent to the donation, since the ownership of the land was to revert to Lancaster upon Warenne's death.

The suggestions about the retable's date, origin and Thetford provenance are supported by the results of the conservation project carried out at the Hamilton Kerr Institute between 1994 and 2003. It established, among other important facts, that the panels came from trees felled some time after 1317, the chalk ground was sourced from an area near Thetford, and the greenish blue pigment is azurite.[7] Drawing on this last fact, David King has now strengthened the retable's association with Thetford and John de Warenne through an ingenious analysis of heraldic motifs and allusions to the earl's personal affairs.[8]

The stylistic and iconographic peculiarities, the Dominican connection and Warenne's presumed patronage, all shared by the Thornham Parva Retable and the Macclesfield Psalter, may prompt one to associate the psalter with the Dominican friary at Thetford or with Edmund Gonville or both. Given the place of honour occupied by St Edmund in the Macclesfield's first miniature, the prominence of St John the Baptist in the *Suscipere dignare* prayer and the marginal imagery [54], and Gonville's future foundation of a Cambridge college specifically for the theological education of young priests, this is a tempting hypothesis. However, to accept it runs the risk of creating a circular argument, since the retable's Thetford provenance is not unanimously accepted.

Pamela Tudor-Craig conjectured, largely on the basis of stylistic comparisons, that the retable might have been commissioned for the church of the Cambridge Dominicans no later than *c.* 1320, but this would have left insufficient time for the panels to mature for painting in view of the post-1317 felling established by the dendrochronology.[9] Julian Gardner suggested the Norwich Blackfriars instead;[10] the main arguments in favour of his proposition are the building of the new Dominican church between 1325 and 1345, and the prominence in the retable's design and iconography of St John the Baptist, to whom the Norwich friary was dedicated.[11] By way of counter-argument, Paul Binski pointed out that the retable would not have survived the fire that destroyed the Norwich friary in 1413, that a bequest for a new reredos was made in 1458, and that a Norwich association could not account for the pairing of St John the Baptist with St Edmund of Bury.[12] However, he admitted that the lack of Italianisms, which were sporadic rather than pervasive in Norwich manuscripts of the 1330s, does not argue against a Norwich origin for the retable, and that Norwich artists could easily have been entrusted with a commission in Thetford.

54 St John the Baptist pointing to the symbol of the lamb: Macclesfield Psalter, folio 133r.

Nicholas Rogers has now presented fresh evidence in support of the retable's Norwich provenance.[13] He suggests that the retable is likely to have been rescued from the fire as one of the most precious items in the church and that by 1458 it may no longer have been placed above the main altar. Most importantly, he finds a historic explanation for the pairing of St John the Baptist with St Edmund, which is as convincing as that advanced for Thetford. While the Dominicans were given the church of St John the Baptist over the Water in Colegate when they first settled in Norwich in 1226, in 1307 they acquired a new, more central property in St Peter Hungate parish. This site had belonged to the recently suppressed Friars of the Sack, whose house was dedicated to St Edmund of Bury. It seems likely that the Dominicans would have honoured this dedication, as they did the earlier one. They may well have paired their saintly patrons on a retable commissioned for their church built on the new site between 1325 and 1345. A Norwich provenance would argue strongly for a Norwich origin of the retable.

Whatever the intended destination of the Thornham Parva Retable may have been, its intimate relationship with the Macclesfield Psalter reveals that both were contemporary products of the same workshop, if not the same artists. Given the Macclesfield's textual, palaeographic, stylistic and iconographic links with Norwich manuscripts of *c.* 1320–40, it seems highly probable that the workshop was based in that city, although individual artists may have travelled to complete special commissions elsewhere. In view of the retable's Dominican context, the friar depicted in the Macclesfield Psalter and the Macclesfield Master's work in the copy of the *Summa confessorum* by the Dominican John of Freiburg acquire special significance. It seems safe to propose that the psalter, the retable, and probably the *Summa confessorum* as well, were produced by Norwich-trained artists in the 1330s, perhaps for different patrons and destinations, but invariably with Dominican involvement.

Moving Pictures

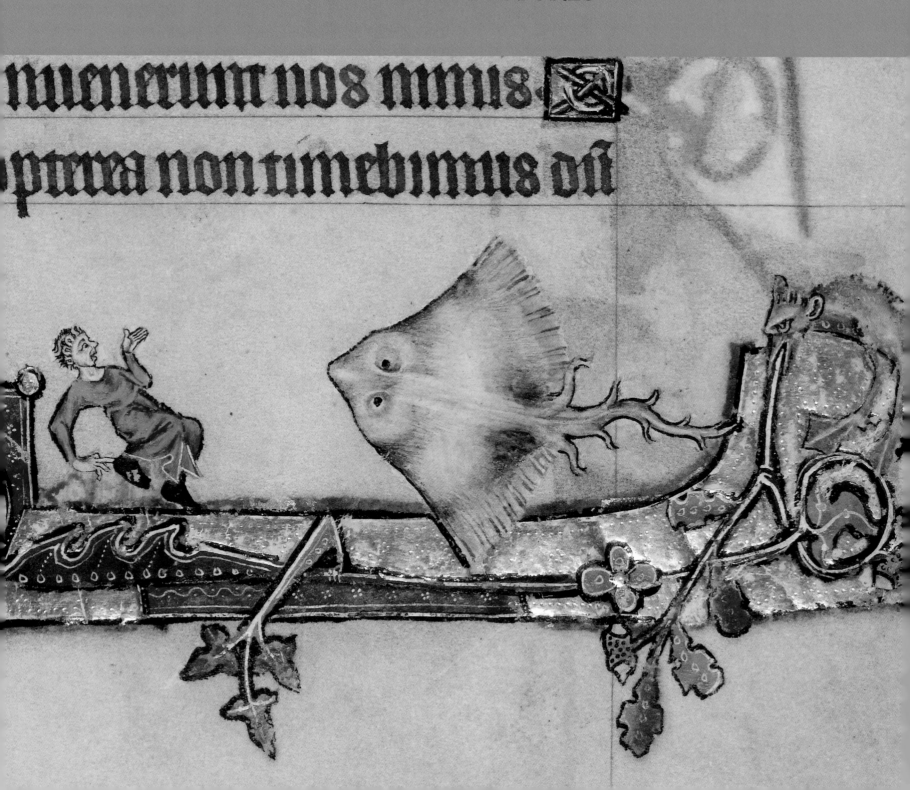

Despite their subtle differences of style and scale, the Macclesfield Master and the Anointing Master adopted the same approach to the decoration of the Macclesfield Psalter – a dazzling experimentation with iconographic motifs, verbal and visual sources and strategies of text illustration. This can be observed on all levels, from the major historiated initials to the marginal grotesques. Although the psalter was one of the most frequently and most richly decorated books in the Middle Ages, numerous studies remark on the challenge its poetical, non-narrative text presented to medieval illuminators. However, the Macclesfield Psalter reveals that the challenge its artists faced was not the lack of clues as to how to interpret and illustrate the psalter, but rather the plethora of choices. These were choices of texts and images as well as opportunities to allude to social realities, political events, religious controversies or personal circumstances.

TRADITIONAL ICONOGRAPHY

The surviving historiated initials to the psalms of the tenfold division in the Macclesfield Psalter differ considerably from those found in the majority of 14th-century English psalters. No two identical psalters survive from the medieval period, but the closest we can come to a standard 'iconographic programme' – a term that, in itself, suggests a more formal arrangement than may be altogether justified – is found in manuscripts created in Paris from c. 1200 onwards. There the stimulus for the iconographic choices came directly from the biblical text, and the eight initials marking the liturgical divisions of the psalter were illustrated with subjects suggested by the heading or opening verses of each of the psalms concerned. Physically bound by the letter, the psalmist David points to his eyes, while exclaiming 'The Lord is my light' at Psalm 26, or to his mouth at Psalm 38, which reads 'I said: I will take heed to my ways that I sin not with my tongue.' He confronts a fool at Psalm 52, which begins 'The fool said in his heart: There is no God,' and, submerged under water, he prays 'Save me, O God: for the waters are come in even unto my soul' at Psalm 68. At Psalm 80 David plays bells in response to the psalm's exhortation to praise the Lord in music, while at Psalm 97 clerics chant the opening verse 'Sing a new song to the Lord.'

The establishment of this programme, with its preference for the *ad verbum* technique, coincided with the rise of Paris as the leading

55 Man frightened by a giant skate: Macclesfield Psalter, folio 68r.

university centre of the time and with a major revision of the biblical text. The first three decades of the 13th century, the formative period of the Parisian cycle of initials, were crucial for the emergence of the one-volume university Bible, which resulted from close study, editing and standardization of the sacred text.[1] At the same time, the burgeoning book trade of the early 13th century was transforming Paris into Europe's leading centre of manuscript production,[2] and the increasing demand for multiple copies of Scripture and the small size of the university bibles called for the adoption of a straightforward programme.[3] The artists' knowledge of established schemes and acceptable variations ensured its fast and accurate reproduction. By mid-century the standardized text and its uniform cycle of illustrations was the norm throughout the Latin West.

The Parisian cycle of historiated initials was assembled for the Bible in its entirety. In a large-scale programme, intended for mass production, an individual artistic response to a wide spectrum of stimuli, resulting in infinite variations, was impractical. But it was conceivable within the limits of a single book, such as the psalter, especially if it was a prestigious commission. Deluxe 13th-century psalters introduced variations into the Parisian programme and often drew on local traditions, which flourished in Flanders, the Mosan valley, Germany and England.

By c. 1200 English psalters associated with Winchester and Oxford were beginning to display a complete set of historiated initials for the tenfold division.[4] These books include liturgical features that suggest the involvement of Augustinian canons in the provision of textual models and perhaps visual ideas, too. Perceived as an order with a wide social function, to which the *cura animarum* ('cure of souls') was entrusted from an early stage, the Augustinian canons were among the agents of the educational and pastoral reforms codified by the Fourth Lateran Council.[5] Their approach combined close attention to the biblical text with a tendency to extend its literal meaning through reading and interpretation into biblical commentaries, dogmatic theology, liturgical practices and devotional needs.[6] Psalm 1 was understood to contain the essence of the whole psalter, whose main themes were interpreted as the history of salvation and the doctrine of Christ's divine and human natures. Its most common illustration from the early 13th century onwards was the Tree of Jesse, which linked the blessed man and fruitful tree of Psalm 1 with Christ's ancestors, David and his father, Jesse. Drawing on the biblical headings that associate individual psalms with events in David's life, the initials to Psalms 26 and 51 showed (respectively) the Anointing of David and Doeg

slaying the priests of Nob. The fool who declares at the beginning of Psalm 52 'There is no God' was transmuted into the devil in representations of the Temptation of Christ, which were used to illustrate this text. The depiction of Jonah at Psalm 68 was suggested by the nearly identical wording of the psalm's second verse and Jonah's prayer ('Save me, O God: for the waters are come in even unto my soul,' Psalm 68: 2; 'The waters compassed me about even to the soul,' Jonah, 2: 6). The ordeal of Jonah, swallowed by a great fish and regurgitated after three days and nights, was commonly taken, on Christ's own authority (Matthew 12: 39–41), to prefigure the Passion, which is also foreshadowed in verse 22 of the psalm ('they gave me gall for my food, and in my thirst they gave me vinegar to drink'), and Resurrection. The connection of the Judgment of Solomon to Psalm 38 and Jacob's encounter with the angel to Psalm 80 was more tenuous and relied primarily on commentaries. The Annunciation to the Shepherds depicted at Psalm 97 drew on a long tradition of understanding this psalm as a prophecy about Christ's Incarnation, as well as on the use of the verse 'Notum fecit dominus' as an antiphon at the feast of the Nativity. Psalm 101 was interpreted as the appeal to God by the Church (*Ecclesia*), on behalf of all the faithful gathered in her. Its most frequent illustration in the early 13th century was the personification of Ecclesia, holding a chalice or a miniature church, and often accompanying Christ as her bridegroom, an image imbued with sacramental and sponsorial symbolism. The subject matter chosen for Psalm 109 blended biblical text, commentary and doctrine. Central to the Trinitarian dogma, the psalm was commonly illustrated with an image inspired by its opening verse: 'The Lord said to my Lord: Sit at my right side', and showing God the Father and Christ the Son enthroned, usually with the Holy Spirit descending in the form of a dove between them.

From the second quarter of the 13th century onwards, the impact of the Parisian programme resulted in combinations of English and French iconography. By the early 14th century, the English programme, like other local traditions, had all but succumbed to the Parisian cycle. This was probably due as much to the ubiquitous Parisian Bible as to the Book of Hours, which was beginning to marginalize the psalter as a devotional book, especially on the continent. In England the psalter endured as a prayer book, particularly for a male audience. The Macclesfield Psalter is a good example.

The vast majority of 14th-century English psalters, including deluxe copies and regardless of their intended use – secular or religious – show the images familiar from the Parisian programme. The only

English motifs that survive with some frequency are the Tree of Jesse at Psalm 1 and the story of Jonah at Psalm 68. By comparison, the Macclesfield Psalter is remarkably faithful to the English programme. The only other 14th-century manuscripts with similarly consistent traditional English images are the Gorleston, Ormesby and Douai psalters. The iconography of the historiated psalm initials in the four psalters confirms their intimate relationship, already evident in their textual content and style of illumination. It also demonstrates a revival of what was by then a century-old tradition.

The Tree of Jesse illustrates Psalm 1 in all four manuscripts and conforms to the same design in each, with Old Testament kings (Christ's ancestors) and prophets (who foretold his coming) enclosed in foliage medallions within the tree's main stem and in the borders. No two images are identical, however. The Macclesfield's Jesse Tree (fol. 9r) is closest to that in the Douai Psalter[7] in shaping the initial 'B' (for *Beatus*) out of the same interlaced branches that form its infill and border medallions, in positioning David immediately above Jesse within the initial, and in placing the Virgin and Child at the top. But it owes the larger prophet figures in the upper part of the 'B' to the Ormesby Psalter (fol. 9v [27]). Some of these figures and the members of the main ascending line, David, Solomon, and the Virgin and Child, show remarkable affinity in iconographic detail, if not in style, with what is the finest wall painting surviving from 14th-century East Anglia, the Tree of Jesse in the church of All Saints in Weston Longville, Norfolk, probably painted towards the middle of the century.[8] But the Macclesfield Psalter differs from all these examples in the design of the Jesse Tree as part of a diptych. It faces the half-page miniature of Christ as Judge on folio 8v, which illustrates the prayer *Suscipere dignare*. Most unusually for a Gothic manuscript, the miniature is placed neither at the beginning nor at the end of the text, but in a position that creates a direct relationship between it and the *Beatus* initial. As mentioned above, Psalm 1 was considered a summary of the entire psalter and a prophecy of the Incarnation more direct than any other uttered in the Old Testament. The fruitful tree of the psalm text was associated with the rod of Jesse, which would grow, flower and receive the Lord's spirit (Isaiah 11: 1). Christ's genealogy and the accompanying prophets in the vigorously sprouting Tree of Jesse were the concise pictorial equivalent of volumes of biblical exegesis. However, some commentators expanded the meaning of the tree in Psalm 1 to embrace the Tree of the Cross and the Tree of Life in the Apocalypse (Revelation 22: 2), thus linking the

Incarnation to the Passion, the Resurrection and the Last Judgment. These three themes are not present in the Macclesfield Tree of Jesse, but they are the focal point of the facing miniature. While contemplating the two images as a prefatory diptych, the manuscript's owner would have perceived the full meaning of Psalm 1 and the entire psalter, the story of humankind's salvation.

The initial for Psalm 26 (fol. 39r, see frontispiece) shows the Anointing of David in line with the biblical heading, which states that the young David composed it before his anointing by the prophet Samuel (I Samuel 16: 6–13). However, there was no consensus among medieval commentators as to which of David's three anointings the psalm referred to. The man standing on the left and holding a crown refers to the second anointing and crowning of David as king of Juda, which took place in Hebron after Saul's death (II Samuel 2: 1–7). As in the case of Psalm 1, the other three psalters show the same subject matter and the Macclesfield's image comes closest to that in the Douai Psalter (fol. 30r [28]), although the position of the figures flanking David is reversed there and, because of the poor condition of the manuscript, we cannot be certain that the second attendant was holding a crown.

The most significant differences between the four psalters appear in the initials for Psalm 38. The image typical of the 13th-century English programme was the Judgment of Solomon. Instead, the Gorleston and Douai masters favoured the literal French subject matter of David pointing to his mouth, while the Ormesby Master showed Christ before Pilate. The Macclesfield's image is most unusual (fol. 58r, [79]). The king dispatching a knight could be David sending Bathsheba's husband Uriah to the front line in the hope of his being killed so that David could take Bathsheba for himself (II Samuel 11).[9] If so, the subject matter would harmonize with the innuendos of the *bas-de-page* scene, but it would be a unique occurrence at Psalm 38 in English psalters. It seems more likely that the initial shows King Saul ordering the murder of Achimelech and the priests of Nob, who had offered David refuge, hospitality and Goliath's sword (I Samuel 22: 9–18). At first Saul gave orders to his soldiers, but after they declined, he sent out his servant Doeg of Idumea. In the Macclesfield initial we see the reluctant knight and the eager Doeg, already on his way to Nob and depicted as a brutish servant, in clear distinction from the knight. This contrast would not have been lost on the manuscript's reader–viewer and may well have alluded to the tension between the established nobility and the over-zealous 'new men' in Edward III's circle. English psalters of the 13th century normally show Doeg killing the priests within the initial for Psalm 51, the heading of which sums up the story. They sometimes combine it with Saul dispatching Doeg, often depicted as a knight. This is what we see at Psalm 51 in the Gorleston Psalter. In the Macclesfield (fol. 76r) and Ormesby initials for Psalm 51 we witness only the murder, while the Douai initial shows Doeg preparing to slaughter the citizens of Nob after he has killed the priests. The scenes for Psalm 51 in the four manuscripts vary considerably not only in composition, but also in their choices of specific parts of the story. The Macclesfield and Douai initials reveal an unusually close attention to the biblical account, expecting – or testing and teasing – the reader–viewer to identify the particular episode in the narrative. The savage Doeg, shown ready to behead Achimelech, may have alluded to recent events, if the Macclesfield Psalter was associated with the Fitzalans. In 1326 Edmund Fitzalan was beheaded by a supporter of Roger Mortimer's; chronicles recount that it took twenty blows to sever the earl's head.

Psalm 52 displays the only example of the literal French programme found in the Macclesfield Psalter: King David and the fool who denies God's existence in the first verse (fol. 77r [56]). Of the other three psalters, only the Douai initial for Psalm 52 (fol. 65v [57]) shows the same subject. While the poses and gestures of the figures differ, the composition and the emphasis on the fool's nudity, perhaps originally complete with an erection, are comparable. (The marginal imagery requires special attention and will be treated separately.) The Macclesfield initials for Psalms 68, 80 and 101 are lost. We may never know whether they showed (respectively) Jonah and the whale, Jacob and the angel, and Ecclesia, as in the other three psalters.

The next extant initial – that to Psalm 97 (fol. 139v) – returns to the traditional English cycle in portraying the Annunciation to the Shepherds. The Gorleston initial combines this scene with the standard French motif of chanting clerics, while the Ormesby Psalter shows only the clerics. The closest parallel to the Macclesfield initial is that in the Douai Psalter (fol. 124v [29]), which shows the angel, the three shepherds and the shepherds' dog on a hillock, though the poses, proportions, gestures and attributes of the figures are different.

The illustration of Psalm 109 (fol. 161v) shows Christ seated to the Father's right in line with the psalm's opening verse. The *bas-de-page* scene of a king conversing with a clerk sitting on his right side [33] is perhaps a secular parallel to the hieratic image within the initial, and the bird between them, with its black and white feathers, may have Dominican

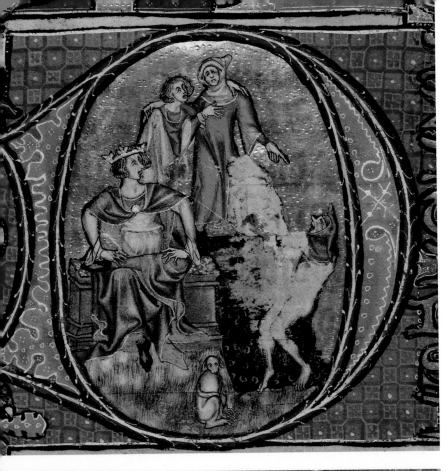

56, 57 King David and the fool: historiated initials, Psalm 52, Macclesfield Psalter, folio 77r, and Douai Psalter, Bibl. Mun. MS 171, folio 65v.

connotations. The initial for Psalm 109 offers the most fruitful comparison among the four manuscripts. While the Ormesby initial seems somewhat removed, the Macclesfield initial combines the salient features of the Gorleston and Douai compositions. It borrows Christ's *orans* ('praying') gesture from the Gorleston, but leaves out the dove of the Holy Spirit and the Father's orb, replacing the latter with the book held by the Father in the Douai initial. The bench in the Macclesfield is an almost exact copy of that in the Douai Psalter. This seems to suggest that the Macclesfield post-dates the Douai Psalter, an impression left also by the comparison of their calendars and by the last two historiated initials in the psalter section of the manuscripts. The Macclesfield Master follows the Douai Master's designs for Psalm 119 and the Canticle of Isaiah, depicting David and Isaiah praying. The final historiated initial, that for the Office of the Dead, shows different iconographic choices in the Gorleston, Douai and Macclesfield psalters. The Macclesfield initial will be discussed later, together with its marginal decoration.

The Gorleston, Ormesby, Douai and Macclesfield psalters share many of the traditional English subjects for the psalms of the tenfold division and a few of the French literal illustrations, but their artists rarely show slavish dependence on earlier models or on one another. Their responses to the same subject matter are often highly individual, even when they are aware of their counterparts' decisions. This is particularly obvious in the relationship between the Macclesfield and Douai masters. There is a strong sense of experimentation, even with the most traditional subjects. The one point on which the four artists seem to agree is the preference for images of the early 13th-century English programme. Since the compositions and iconographic details vary in the four manuscripts, it is unlikely that the artists followed a single model. Rather, they were familiar with the English subjects, probably from a number of earlier manuscripts. The decision to include them in their deluxe new psalters may reveal an archaizing taste among the artists or their patrons. At the same time it may have been part of their search for diverse and unusual motifs, whether novel or old-fashioned, and their attempt to tease out disparate meanings from the text–image relationship. This tendency to probe the visual–verbal matrix and to make multiple forays into its semantic layers is reminiscent of an old metaphor used by Cassiodorus in his commentary on Psalm 51. He compared Scripture with a pearl that 'can be pierced on every side'.

The Omnivorous Marginalia

The Macclesfield marginalia receive the same level of attention in terms of artistic accomplishment and technical virtuosity as the major illuminations. We observe the wondrous hybrids flow out of, and back into, the lush foliage (fols. 47v, 64r), metamorphose from beast into human or from male into female (fols. 66v–67r, 86v, 164v), blend with one another (fol. 41v), devour themselves (fol. 56r), grow several heads at once (fols. 64v, 95v, 118v, 194v), and exchange hands for feet (fol. 20v), noses for tails (fol. 15v) or heads for bottoms (fol. 11r). Their structural principles[10] are as fascinating as their potential use as mnemonic tools.[11] Their composite, dynamic and interactive nature renders them striking, elusive and versatile, the ideal material for the art of memory.

The marginalia also reveal the same healthy appetite for diverse approaches to the text that we observed in the main images. While we can often construe their relevance to texts, both present (the psalms, canticles and prayers) and absent (the liturgy, biblical commentaries or literary works), just as often they seem to pun on individual words, syllables or even letters without offering a meaningful comment on the text as a whole. We scan the adjacent text for clues and the verbal sources of visual tricks, examining phrases, words and syllables. The images bring us closer to the text, which is analysed and dissected by the imagery, and thus internalized and remembered. The effort and the pleasure of recognition create memorable visual–verbal amalgams. Such 'word-images' intensify the reader's experience by inviting a slow, careful examination of the text and reflection on its structural units.[12] This effect is compatible not only with medieval mnemonic techniques, but also with the basic strategies of medieval reading, composition and interpretation, which placed the ascending order of letters, syllables, words and phrases at the heart of both elementary education and learned etymology.[13] The contortionist on folio 221r mimics the shape of the letter 'y' immediately above him. The grotesque with a face in his bottom, whose nose sprouts a flowering branch, points to the last line of text on the page, which contains the word *extendant* ('they stretch out') right above him (fol. 185r). One of the faces of the two-headed 'push-me-pull you' on folio 71v looks at a mirror beneath the verse of Psalm 48, which denounces those who cause scandal and then delight in their own image.

The game becomes particularly absorbing, when we begin to follow the vivid exchange between the marginal protagonists (fols. 11r, 11v, 14r, 22r, 29r, 65v–66r, 89v–90r). Recognizing the often synaesthetic nature of such images, we strain to hear their dialogue, as if hoping to penetrate through a soundproof screen into the secrets shared beyond. The satisfaction of decoding the more transparent word-images prepares us for the sophisticated puns; as seasoned players we may move to the next level of the game.

The censored image of a man whose behind is being manipulated on folio 167v may have originally represented a doctor administering a clyster, or enema, the treatment recommended in medical texts for the common medieval complaint of constipation and often represented rather graphically.[14] The prompt was perhaps a syllable in the last line of text from Psalm 117 above the image, the *cul* (Old French: 'bottom') contained within *seculum* ('century'). Such vernacular punning on Latin texts, a word-game favoured by poets, preachers and artists, brings to mind a popular medieval riddle: What is the dirtiest word in Latin? The answer was *con-cul-ca-vit* — that is, *cul* flanked by the Old French words for the female and male genitalia. An image with more piquant flavour, duly smudged by a post-medieval owner, shows a woman peering into a man's anus. Is the line immediately above them, 'pater meus et mater mea' ('my father and my mother'), meant to be read as a caption? The same motif, but acted out by an ape and a young man, appears with more overtly obscene connotations at Psalm 31. Its opening verse, referring to the blessed ones, ends right above the odd couple with the words 'whose sins are covered' (fol. 45v). The man's cloak is lifted up to uncover his posterior. It is possible that the artist here put a quirky twist on the famous story of the boorish scoundrel Marcolf who tricked the wise Solomon to look into his anus.[15] The Macclesfield Master would have been familiar with Marcolf, not least from the depictions in the Ormesby Psalter (fol. 72r) and the Douai Psalter (fols. 65v, 124v), the latter being his own work. But the image here seems to touch a different nerve. The last verse of Psalm 30, four lines up from the image, advises 'Viriliter agite' ('Behave in a man-like fashion') and reinforces the message of the 'covered sins'. To medieval audiences, sodomy was a vice worse than any other sexual transgression.[16] Sensitivity to such issues was particularly heightened during the reign of Edward II (1307–27). His close relationship with Piers Gaveston continued to spice up chronicles long after the Gascon's execution in 1312 and the king's death in 1327. Jean Froissart (*c.* 1337–*c.* 1404), whose patron during his formative period as a chivalric chronicler, between 1361 and 1369, was Edward III's queen, Philippa of Hainault, did not hesitate to describe their relationship as 'sodomitic'. We should not be surprised if the perfectly innocent verses of Psalms 30 and 31 pressed the artist's and viewer's topical button.

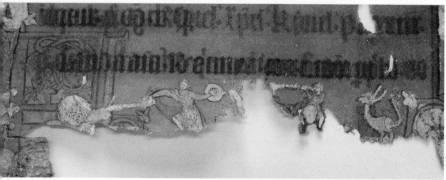

58, 59 Knight and snail in combat: Macclesfield Psalter, folio 76r, and Douai Psalter, Bibl. Mun. MS 171, folio 211r.

The presence of sexually charged, obscene and scatological imagery in late medieval literature and art is an enormous topic, which is attracting increasing scholarly attention.[17] The same is true of marginalia in general, whose spheres of reference are thought to range from the literary, moralizing, political and social to the ludic, mnemonic, wondrous and amuletic, to mention but a few.[18] With an ever growing number of published texts and the flowering of multi-disciplinary approaches, which offer potential sources and interpretations for the images of the 'secret Middle Ages', we need to be cautious and open-minded at the same time. Ready to consider the theoretically endless possibilities for hidden semantics, we must remain alert to the specific meanings that the artist and the intended reader—viewer might have activated in a given set of circumstances. This is particularly important in the case of common motifs.

For instance, the indecent exposure on folio 138v, a visual *topos* in cathedral sculpture, on city gates, and on the façades of apothecaries' shops, could be seen as deriding ('mooning'), obscene, scatological, diarrhetic or apotropaic,[19] but here it is most probably a visual injunction against idolatry, as the text of Psalm 96 above it suggests. Another popular

motif, the knight engaged in combat with a snail, has been interpreted as referring to various social types, from the mighty in his castle or the social climber to the cowardly Lombard despised as a pawnbroker in northern Europe.[20] With three major Italian banking families financing Edward II and the young Edward III, the last might be an appropriate reading of the knight and snail images in the Gorleston (fols. 146r, 162v, 170r, 179r, 185v, 193v, 213v), Douai (fol. 211r) and Macclesfield (fol. 76r) psalters [58, 59]. It may be particularly relevant to the Macclesfield Psalter if the manuscript was associated with the earls of Arundel. Richard Fitzalan, the third Earl of Arundel, was Edward III's main creditor. His grandmother was Italian, the daughter of Thomas, Marquess of Saluzzo in Piedmont, and one chronicler remarked that his father, Edmund Fitzalan, the second earl, was descended from 'the impious Lombards'.[21] In addition, the marginal snail combat in the Macclesfield Psalter may be seen as a reversal of the initial to Psalm 51 above. Doeg's murder of the priests might have resonated with memories of Edmund's savage beheading in 1326, but at the same time the earl could have been identified with the cowardly Lombard confronting the snail in the *bas-de-page*. That this redistribution of roles between the meek and the powerful belongs to the *monde renversé* is made explicit by the squirrel, carefully observing the combat, and the man tumbling down the tree beside it, squirrel-like.

The miniature man terrified by the giant skate on folio 68r is a variation on the theme of cowardice [55]. The text of Psalm 45 above it focuses on fear and tribulations. The admirable naturalism of the skate is hardly surprising as it was common off the coast of East Anglia until a century ago. The species is known as the common skate (*Raja batis*), somewhat ironically since it is now locally extinct.[22] An easy prey for fishermen's nets, it would have been familiar to the Macclesfield Master. While its impressive size seems to justify the man's fear, its vulnerability turns it into a joke as big as the fish.

The Macclesfield marginalia make us laugh or cringe at medieval stereotypes. Doctors are depicted as infamous apes or cunning foxes (fols. 22r, 98r) in line with the accusations of avarice and hypocrisy levelled at them in contemporary satire and literature of social protest. The misfortune of beggars and cripples is punishment for their sins or for the sins of their promiscuous parents. However, it is also a call for charity and compunction, as contemporary preachers and the last word on folio 85 advised (fols. 85r, 98r, 168r). Medieval attitudes towards beggars were particularly ambivalent in the 1320s when Pope John XXII ruled against the Franciscan doctrine of voluntary poverty and the order split in two,

the dissident group supporting Emperor Louis of Bavaria and his antipope against John XXII. While the Dominicans sided with the pope officially, their priories were a popular gathering place for beggars.

The images in the Macclesfield Psalter hint at an urban context. Professionals and outcasts mingle on the pages as they would have on the streets of a busy town. The Macclesfield marginalia urge us to step out into the marketplace and witness the skills of musicians, acrobats and contortionists, who entertained townsfolk and nobility alike, and were increasingly mimicked by preachers (fols. 132v, 176v). They invite us to hear – in our mind's ear – the sounds of a transverse harmonic flute (fol. 188r, an exceptionally rare depiction of the instrument identified by Jeremy Montagu)[23] and the noise of the pipe and tabor (fol. 187v) accompanying a group of mummers probably engaged in a sword dance.[24] Nor can we miss the joke of the blessing hand–nose of the one-man (or rather one-hybrid) orchestra (fol. 130r). Another visual reference to folk festivals may be the image of the goat and ape kissing on folio 155r [2]. It is hard to tell whether they are humans in animal costume or animals masquerading as humans. The visual conundrum is the artist's brilliant response to these common allegories of human lust. An allusion to mummers may be

hiding in the hobby-horse on folio 55r, a common feature of wooing and hero-combat ceremonies.[25] But it was also an attribute of court jesters, as the wardrobe accounts for Edward III's feasts in 1334–35 reveal.[26]

The explosion of marginalia in manuscripts of the late 13th and early 14th centuries has been related to the new socio-economic climate of cities in the Franco-Flemish area;[27] the same changes were taking place in towns in southern England and East Anglia, which were at the forefront of economic and artistic developments. Numerous motifs in the Macclesfield Psalter find striking analogues in contemporary Flemish manuscripts, notably in an early 14th-century Book of Hours from Ghent[28] whose margins teem with entertainers, cripples, games, mock performances, hunting scenes, obscenities, caryatid-like figures supporting the initials, and profiles emerging from the foliage (compare fols. 5v–6r, 7r, 8v, 11r, 15r, 37r, 91v, 148r and 213r in the Book of Hours with fols. 19r, 48v, 82v, 120v, 122v, 185r, 207v, 221r in the psalter [60–65]). Such correspondences are indicative of the parallel artistic developments that accompanied the active political, economic and cultural exchanges between England and the Low Countries in the 14th century, especially after Edward III's marriage to Philippa of Hainault

60, 61 Caryatid figures supporting illuminated initials, Ghent Book of Hours, TC MS B.11.22, folio 15r, and Macclesfield Psalter, folio 207v.

62–65 Border motifs, (left above and below) Macclesfield Psalter, folios 48v and 185r; (right above and below) Ghent Book of Hours, TC MS B.11.22, folios 15r and 148r.

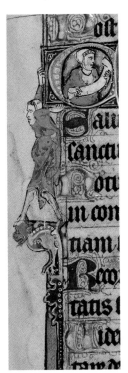
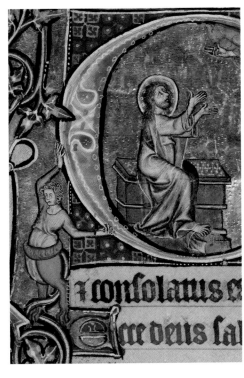

in 1327.[29] East Anglia enjoyed particularly close connections with Flanders through the cloth industry that flourished under royal patronage. By 1335 Queen Philippa had established a colony for weavers from the Low Countries in Norwich. It is hardly surprising that Flemish manuscripts share marginal motifs with the Macclesfield Psalter, given its production by Norwich-trained artists at just this period.

However, the 14th-century East Anglian predilection for exuberant marginalia was not limited to manuscript illumination or to urban centres. Some of the Macclesfield's border hybrids find their counterparts in the stone and wood carving at Ely Cathedral, and in the stained glass at St Peter's Church in Ringland, Norfolk, whose patrons were families with strong Norwich connections.[30] The endless variations on stock motifs that reappear in different media reveal a vibrant community of local artists aware of contemporary developments on the continent and imaginatively adapting workshop patterns to individual projects carried out at major economic, ecclesiastical and artistic centres, such as Norwich or Ely, and in the surrounding areas.

LITERARY CONCEITS

Folk tales of wise fools like Marcolf, proverbs, fables and beast epics were integral parts of the oral, written and visual culture of the Middle Ages and common to craftsmen working in all media and for patrons at all social levels.[31] Misericords — for instance, those in Wells Cathedral of *c.* 1330[32] — and stained glass — notably the Pilgrimage Window of *c.* 1325 at York Minster[33] — show many of the motifs found in the Gorleston, Douai and Macclesfield psalters. These include the ape doctor (fol. 22r) and the rabbit funeral (fol. 152r) or its ape version; the ape or grotesque with an owl on its wrist (fol. 91r);[34] the stag hunt (fols. 46v, 193v); the man stripped naked and riding a donkey backwards (fol. 183r), a customary punishment under the law for adulterers, antipopes, traitors and heretics;[35] the nut-cracking squirrel (fol. 39v), which stands for sexual intercourse in the *Roman de la rose*, contemporary fabliaux and early 14th-century English seals, as well as in manuscript marginalia;[36] the cat and the mouse (fols. 79v, 106r); and the fox preaching to the cockerel (fols. 162v–163r) or running away with the farmer's wife's goose (fol. 134r). The last two are among the most famous episodes in the career of a notorious medieval scoundrel, Reynard the Fox.[37] The ape and fox doctors mentioned above may also be an example of artistic licence, imaginative conflations of the ape, the commonest imitator of human follies,[38] and Reynard's quasi-healing of the bear Brun or the lion King Noble.

The Macclesfield Psalter's literary conceits are not confined to the characters of contemporary stories but extend to whole romances and fabliaux. Let us return to the splendid opening for Psalm 38. The figures in the margin of folio 39r mimic the pointing gesture of the king within the initial above, drawing the viewer's attention back to the first theme of Psalm 38, 'I will take heed to my ways.' But they also weave a dynamic narrative of their own. The lady with her furry pet, the young knight and the wildman may be acting out the tale of Enyas rescuing the maiden from the wildman, which was told in visual form in various media but has no extant textual source except the Anglo-Norman captions in the Taymouth Hours of *c.* 1325–30.[39] After his chivalrous service to the lady, the old Enyas is rejected by her in favour of a younger knight. He is reconciled to this typical display of female ingratitude, but when the young knight claims his dog as well Enyas is not prepared to give up his faithful friend. He kills his opponent and abandons the maiden. While the story unfolds as a continuous pictorial narrative in the Taymouth Hours and in the Smithfield Decretals illuminated in London *c.* 1340,[40] in the Macclesfield Psalter it features in this single *bas-de-page*. Moreover, the scene is not consistent with the extended narratives in the two manuscripts mentioned above. It seems to show the wildman with the young knight, rather than with his vanquisher, Enyas. The absence of an identified textual source and the strong possibility of oral dissemination may account for the confusion. But it seems equally possible that the scene was only an allusion, which freed the viewer to reconfigure the original story, most probably a fabliau. This was certainly the intention of the numerous depictions in contemporary manuscripts of the exploits of Yvain, the Arthurian knight and hero of romances.[41] The Macclesfield's *bas-de-page* scene is a glimpse, a snapshot, a pictorial reminiscence of disparate motifs and moments, which the reader–viewer is invited to reconstruct and perhaps reinterpret.

The *bas-de-page* composition at Psalm 97 catches the reader–viewer in an even more intricate web of allusions, both literary and visual (fols. 139v–140r). On the right, beneath the opening of Psalm 98, we see St Dunstan (d. *c.* 988) pinching the devil's nose with his smith's tongs. Abbot of Glastonbury and Archbishop of Canterbury, St Dunstan was praised by his 12th-century biographer, William of Malmesbury, as a blacksmith and a painter of exceptional skills, particularly adept at emulating nature. Although St Dunstan is thought to have been overshadowed by saints of national repute, such as Thomas Becket, his stories appeared in chronicles, roll genealogies of the English

kings and collections of Marian miracles, and were also depicted in manuscripts contemporary with the Macclesfield Psalter.[42] The second of the two extensive pictorial cycles devoted to St Dunstan's life and miracles in the Smithfield Decretals includes the pinching of the devil's nose (fol. 250v). The scene is also found in the Luttrell Psalter in a *bas-de-page* cycle of events from the lives of the saints (fol. 54v).

In the Macclesfield Psalter, the pinching of the devil's nose is the only Dunstan episode. One of the most famous events in St Dunstan's life, it was chosen primarily as an amusing story and perhaps to draw attention to his skills as a blacksmith. Its position in the manuscript seems related to the surrounding texts and images. St Dunstan's blessing hand emphasizes the opening verse of Psalm 98, *Dominus regnavit*, 'The Lord has reigned'. On the opposite page the illuminated initial at the start of Psalm 97 shows the Annunciation to the Shepherds, an image that stemmed from a long exegetical and liturgical tradition that associated God's miracles, the *mirabilia* of the first verse, with Christ's Incarnation. The image of St Dunstan may take its cue from the mention of *mirabilia* in the psalm text but also from the angel, who represents the heavenly choir that announced Christ's birth. Two other well-known stories from Dunstan's life involved angelic choirs: in a dream angels appeared from heaven and sang the *Kyrie eleison* to him; and on another occasion, at St Augustine's, Canterbury, after he had finished reciting the psalms, he had a vision of a heavenly choir surrounding the Virgin and praising Christ. At the same time, the scene may relate to the facing marginal image of the courting couple: the devil got his nose pinched because he tried to tempt St Dunstan with thoughts of carnal pleasure and female company.

The courting couple is a stock motif in late 13th- and 14th-century manuscripts on both sides of the Channel.[43] But the closest parallel for the Macclesfield image is the 'bawdy betrothal' in the Ormesby Psalter (fol. 131r [66]).[44] The general composition and the man's intention, revealed by his suggestively projecting dagger, are identical in the two manuscripts. The woman's reaction, however, differs considerably. In the Ormesby Psalter she reaches out eagerly for the ring, the official symbol of engagement and the unofficial metonymy for the female genitalia. By contrast, in the Macclesfield Psalter her body language speaks rejection [67]. If we decompose the first words on the last line, [*Re-*]*cor-datus est* ('It is remembered'), we get her speech bubble: 'my heart is given' – by implication 'to another'. The Macclesfield Master has adapted a popular visual motif in immediate response to the adjacent text.

Creating a memorable (*recordatus*) visual–verbal compound, he has manipulated the biblical text as well, turning it into a caption for his image and perhaps into a pun on secular texts as well, a strategy with an exact musical parallel at the heart of *ars nova*, with its combination of secular tunes and religious texts.

A well-read viewer may have detected further levels of meaning in this pictorial word-play. In a famous line of *Tristan*, Isolt agrees to give her body to Mark, although her heart belongs to Tristan.[45] By contrast with this compromise, Fénice in Chrétien de Troyes's *Cligès* declares to her lover: 'Vostre est mes cuers, vostre est mes cors' ('Yours is my heart, yours is my body').[46] The same line, word for word, is put into the mouth of the blacksmith's wife as she cries out to her lover, the lecherous priest, in the fabliau *Connebert*.[47] The Macclesfield scene and its caption reverse the message of the Ormesby image and pun on a famous theme of courtly literature turned upside down in a fabliau. This play of words and images promises an ever increasing pleasure of recognition, while testing the reader–viewer's knowledge, memory and associative thinking. The woman's rejection of her eager suitor is paralleled in St Dunstan's resistance to temptation. Ultimately, the rejection of carnal pleasures harks back to the main theme of Psalm 97 celebrated in the large initial above, the virginal conception and birth of Christ.

A moral, rather banal but perhaps considered necessary for the young recipient of the Macclesfield Psalter, is thus communicated through curious images. They take their cues from various textual and visual sources, but weave their own spicy stories. Like verbal puns and musical forms, the Macclesfield images are essentially hybrid gestures. They thrive on ambiguities and depend on the imaginative reconstruction of their hidden messages.

THE DYNAMICS OF READING

Medieval manuscripts are replete with *manicula*, the marginal hands inserted by scribes or readers, pointing at important passages of text, and serving as markers or reminders. In the Macclesfield Psalter, as in other contemporary manuscripts,[48] they are often disguised as hybrids (fols. 66v, 76v, 185r [68]) or developed into human figures (fols. 52r, 110v [69]). On folio 133r a *maniculum* is impersonated by a biblical character. St John the Baptist points simultaneously at the lamb, at the end of Psalm 90 beside it, which reads 'ostendam illi salutare meum' ('I will show him my salvation'), and at the beginning of Psalm 91, 'Bonum est

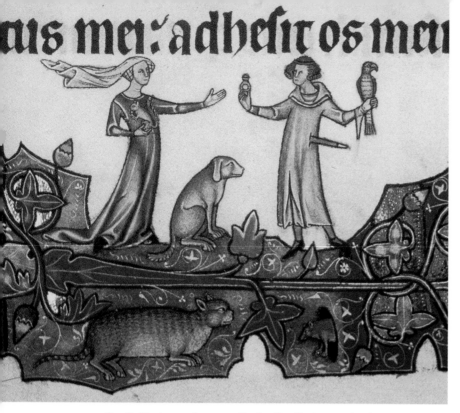

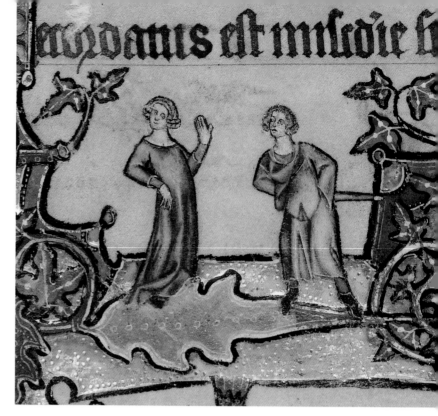

66, 67 Courting couples: Ormesby Psalter, BodL MS Douce 366, folio 131r, and Macclesfield Psalter, folio 139v.

confiteri' ('It is good to confess'). Confession and salvation, central themes in the manuscript, are linked through the last in a long line of prophets to recognize Christ and announce his coming. Apart from St Dunstan, St John the Baptist is the only saint depicted in the Macclesfield's margins. We have already noted his prominence in the *Suscipere dignare*, the prayer that prefaced the entire psalter (fol. 8r; see page 39). The manuscript's young recipient or his Dominican tutor must have been specially devoted to the saint as a personal or institutional patron. Given the emphasis on confession, spiritual guidance and salvation explicit in the image and the adjacent text, it seems likely that it was the friar who identified with the Baptist. The church of the Norwich Blackfriars, which was dedicated to St John the Baptist, may well have been the house of the Dominican depicted in the Macclesfield Psalter.

In some cases it is not a hand, but a nose that gestures and the nose is in fact a monster's tail (fols. 15v, 68v, 122v [**10**]). To medieval readers, a monster was a natural pointer, since a great authority, Isidore of Seville, had used it to explain the etymology of *monstrare* ('to point', 'to demonstrate'). Nose–tail hybrids appear occasionally in the Stowe Breviary (fol. 136r), but are ubiquitous in the Macclesfield and Douai psalters. The humorous effect is generated by the conflation of human and animal forms; the opposition between front–top and back–bottom parts; the popular association of the length of a man's nose with his sexual endowment;[49] and the double implication of the senses of smell and sound, a reminder of the synaesthetic principle which made word-images all the more memorable.

Amusing word pointers, or *notae* as the classical and medieval grammarians, rhetoricians and logicians called them, the nose–tail push-me-pull-yous may have been employed as more than simply mnemonic tools. They might have functioned as rhetorical devices of a more subtle nature. By encouraging us to reconsider both textual and visual elements on the page, across the opening and overleaf, they navigate the kind of reading typical of the devotional use of the psalms: back and forth, up and down, over and over again. They may also add an ironic comment on an injunction in the key texts that medieval rhetoric inherited from antiquity. Aristotle, Cicero and Quintilian strongly disapproved of excessive gestures and grimacing. But they were particularly intolerant of facial expressions involving the nose. Given the clerical associations of the Stowe Breviary and the Macclesfield and Douai psalters, we may suspect that the gestures of the marginal hybrids reflect, structure and encourage specific paradigms of reading or pun on the axioms of ancient and medieval rhetoric. Whether this is the case in other manuscripts that use the same motifs depends entirely on the knowledge and disposition of their artists and intended readers.

The hands and noses in the Macclesfield Psalter are joined by another monster–pointer, the hybrid profile (fols. 20v, 162v [19, 23]). It appears twice in the Stowe Breviary, painted by two of its leading artists (fols. 116v, 150v [18, 22]), and then in the Douai Psalter (fol. 150v), in the hand of the Macclesfield Master. He painted the second hybrid in the Macclesfield Psalter (fol. 162v), but the first one (fol. 20v) was the work of the Anointing Master. The motif recurs emphatically enough to become a pictorial cross-reference. Like the *maniculum* and the nose–*nota*, it may be an artistic elaboration of a rhetorical and mnemonic symbol, the round brackets often inserted in the margins of Gothic manuscripts beside important passages. Every now and again such brackets metamorphose into profiles of varying aesthetic appeal, depending on the scribe's or reader's artistic aspirations or degree of boredom. Here we see the culmination of this process. What makes such images particularly memorable is the double pleasure of recognition and surprise. Their overall similarity throws into relief their differences and prompts one to go back to the earlier encounter and forward again, to compare and examine the images and their surrounding texts closely and repeatedly, searching one's memory for

associative links or teasing one's imagination to create them. Surprise and delight, pattern and differentiation are among the basic principles of inventive mnemonics.[50] The Macclesfield's word-images include another ingenious device, the pictorial catchword. On folio 10r the dog jumping free from the foliage acts out the word broken between this and the previous page, *proi-ciamus iugum*, 'let us throw – off the yoke'. The last word on folio 11r, *mendacium* ('a lie'), is echoed in the man pulling out the tongue of a grotesque at the top of the next page. In the lower left margin of folio 48v a face emerges from foliage ready to swallow three orange biscuits [62] and looks up to the top of the facing page which begins *Gustate*, 'Taste'. Such visual connections encourage continuous reading. We cannot put the book down at the end of a page, a psalm or a prayer. We want to find out what that funny creature in the margin is all about.

Not only gestures, but gazes too can catch the reader's eye and guide it around the text. The depiction of a bishop blessing a woman at the beginning of Psalm 118, *Beati immaculati* ('Blessed are the undefiled'), needs no explanation and hardly makes one pause for thought (fols. 169v–170r), until one notices that the hybrid across the page competes for the woman's attention and mimics the bishop's blessing with an obscene gesture. His face–bottom stares at the last word on the line,

68, 69 *Pointing figures, Macclesfield Psalter, folios 66v and 52r.*

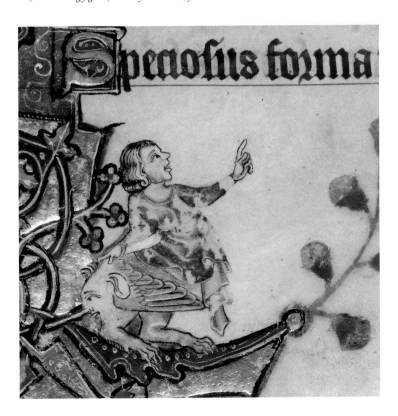

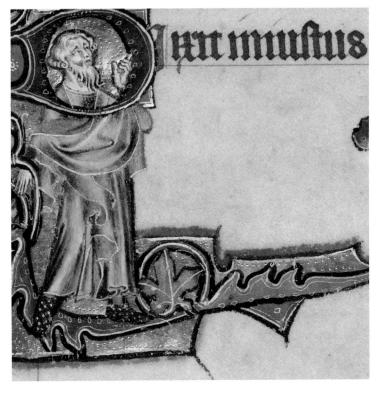

'sermon'. We feel compelled to reconsider the *beati immaculati* ('the blessed undefiled ones') and to ponder the implications of the woman poised between chastity and temptation, between the spiritual and the obscene, between the bishop's blessing and the demon's parody.

The initial to Psalm 119, the first Gradual psalm, demands the viewer's active participation (fol. 182v [70]). The second verse reads: 'O Lord, deliver my soul from wicked lips and a deceitful tongue.' While praying to God above, David is being kicked forward by the giant bird–dragon–cat that shapes the initial. Its leg begins the horizontal stroke of the 'A', but the viewer's eye has to complete it. And as soon as it does so, it meets the hybrid's dragon-head which is sticking out its deceitful tongue, the *lingua dolosa*, at David – or at the viewer. The letter is transformed into a picture, which brings one back to the text. The gradual metamorphosis that takes place on the page reflects a distinct medieval attitude towards word and image. Seeing, reading, comprehension and reflection were all parts of the same seamless mental process.

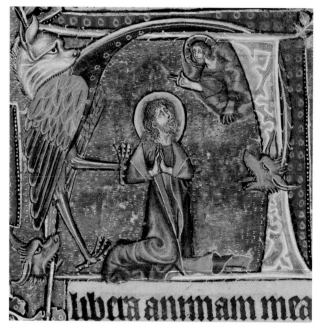

Accustomed to the dynamics of pointing hands, nose–tails, the direction of gazes and the numerous alert heads depicted with eyes wide open within the initials to the ordinary psalm, we are startled by the sleeping head inside the initial for Psalm 53 (fol. 77v [71]). It echoes the dozing face in the initial for the feast of St Nicomede in the Stowe Breviary (fol. 251r [72]). The deep slumber of the image has an awakening effect on the reader–viewer, not least by implicating him in an unflattering way. One is reminded of Gregory the Great's famous definition of reading in the preface to his *Moralia in Job*: 'Reading', he says, 'presents a kind of mirror to the eyes of the mind, that our inner face may be seen in it.' It is the intensive, deeply internalized, meditative, self-reflective reading, rich in mental images and associative networks that Gregory embodies in the metaphor of the mirror. This is the kind of reading the Macclesfield Master activates by using the initial as a frame for the mirror held up to the reader. His intentions are made explicit in another rendition of the

70 King David at prayer: historiated initial, Psalm 119, Macclesfield Psalter, folio 182v.

same face (fol. 34v). This time the eyes are open and looking back at the reader–viewer, who therefore sees not only his own reflection, but also himself looking at his reflection. Reading could not be more internalized than that – it has become literally a self-reflection. Gregory's mirror image is no longer seen only in the mind's eye – it stares us in the face.

TOPICAL IMAGES

Two of the historiated initials mentioned briefly above, that for Psalm 52 and the one introducing the Office of the Dead, deserve to be considered in more detail and in conjunction with their marginal imagery.

Psalm 52 opens with an initial showing King David and the fool, one of the most common images in Gothic psalters, a literal illustration of the Psalm's opening words: 'The fool said in his heart: There is no God' (fol. 77r). The text goes on to deplore the fallen nature of humankind. 'They are corrupt and abominable in their injustice, there is none that does good.' As God looks from above he can see no one who understands or searches for him, all have turned away from him, all have failed to fulfil their role in society and in the larger scheme of things. In the late Middle Ages, the psalms were read increasingly as moral discourse, blending ethics with eschatology.[51] In periods of major political and social turmoil, such as the reign of Edward II, the Bible was regarded as a political prophecy and received topical interpretation.[52] The makers of the Macclesfield Psalter may have construed the psalmist's lament on the corrupt state of humanity as a commentary on recent events, the political crisis that led to Edward II's deposition in 1326, his death the following year and the terror and corruption of Isabella and Mortimer's regency. If the marginal busts were seen as a portrait gallery of the main protagonists at court, the biblical, verbal prophecy of Psalm 52 would appear to be framed visually by the agents of its current fulfilment.

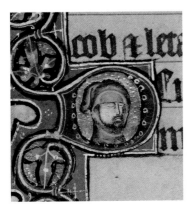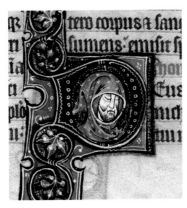

71, 72 Sleeping heads: ornamental initials, Macclesfield Psalter, folio 77v, and Stowe Breviary, BL MS Stowe 12, folio 251r.

The last years of Edward II's rule and the first decade of Edward III's saw the rise of a remarkably topical literature of social protest. John Maddicott has demonstrated just how specific this literature could be, despite its recourse to traditional literary *topoi*.[53] The *Poem on the Evil Times of Edward II*, also known as *The Simonie*, dissected society in the conventional manner of estates satire, but found the moral degradation of each station guilty for the very specific signs of God's wrath in the 1310 and 1320s: the heavy rains, poor harvests and famine, the cattle epidemics, Edward II's military fiascos, the Scottish raids, the civil war and even the execution of Thomas of Lancaster. The evils of royal purveyance were denounced around 1331 in William of Pagula's *Speculum regis Edwardi Tertii* and around 1340 in the *Song of the Husbandman* and the *Song Against the King's Taxes*. Composed by the educated elite, by clerics and friars, these texts focused on moral corruption, which is the central motif of Psalm 52. The two men discussing it inside the initial gesture in a way that links the marginal busts and the fool who denies God. The musician playing his citole beneath the portrait gallery seems in agreement with modern scholars, who have remarked on the musical qualities of the rhythm, rhyme and alliteration of the political songs. The Macclesfield Master's interest in affect colours the topical allusions with emotional overtones, inviting a deeper reflection and personal response to the text. If the manuscript was associated with Richard Fitzalan, third Earl of Arundel, a strong engagement with the topicality of the images would have been inevitable, given the family's ordeal and involvement in royal politics in the late 1320s. A similar correlation between manuscript illumination, contemporary events and a patron's personal engagement in both has been detected in the Queen Mary Psalter of the 1310s[54] and in the

manuscripts commissioned by the Bohun earls of Hereford between the 1350s and 1390s.[55]

In a seemingly stark contrast with the royal gallery, which passes moral judgment on those in high places, is the ploughing scene in the *bas-de-page* [73]. The motif was well known from popular literature. In the 13th-century *Vision of Thurkill*, a simple peasant from Essex visits Purgatory and Hell and sees their inhabitants perform a theatre of their sins for the demons.[56] The lazy and conceited peasants who refused to work their lord's land parade with their plough and oxen in a humiliating mock spectacle.

The ploughing scene was a stock motif in the visual realm, too. It is found in the Gorleston, Douai and Luttrell psalters. In the Gorleston Psalter (fols. 15v, 153v) it seems to bear no apparent connection to the text. In the Douai Psalter (fol. 64v [74]) it forms the *bas-de-page* at Psalm 51, *Quid gloriaris in malitia tua* ('Why do you glory in malice'), and may allude to the vice of pride. In the Luttrell Psalter (fol. 170r), it is part of a *bas-de-page* cycle of nine agricultural scenes, which have received an illuminating commentary in line with current social realities and Sir Geoffrey Luttrell's enhanced wealth and status.[57] We can never be certain that the same motif travelled from one manuscript to another invested with the same meaning, even when it was the work of the same artist, as in the Macclesfield and Douai psalters. In the Macclesfield Psalter the peasants, like the royals, are unworthy of God's creation and of their role in society. The last line on the page, right above them, reads: 'All have gone aside and become useless' (*inutiles*); *inutiles* is the word that takes us from this to the following page. The scene amounts to a visual catchword (ploughing was a common medieval metaphor for writing). The peasants plough their way through the *bas-de-page* towards the word that sums up their very nature. This seems to have been the view of the manuscript's makers and it is compatible with the harshening attitudes towards the poor in the later Middle Ages, which modern historians accept as a general trend, although they disagree as to its timing, extent and relation to so-called 'compassion fatigue', the decline in charitable will and deeds among the wealthy.[58] If the Macclesfield scene constituted a socio-ideological statement and a moral judgment on two of society's orders, those who fought and those who worked, it was integrated with the biblical text and the main image on the page so as to make them relevant to, and consonant with, the owner's memories, ideas and sentiments.

Finally, we come to the Office of the Dead whose image for Vespers is one of the most striking and innovative in the Macclesfield Psalter

73, 74 Ploughing scenes: Macclesfield Psalter, folio 77r, and Douai Psalter, Bibl. Mun. MS 171, folio 64v.

(fols. 235v–236r). There was no established pictorial subject matter for the opening of the Office of the Dead in the early 14th century. The coffin surrounded by candles pictured in the initial at Matins (fol. 237v) would become the standard image for Vespers by the end of the century, usually set in a chapel, surrounded by officiating clerics or mourners. The Macclesfield image for Vespers does not show the aftermath of death, with angels fighting demons for the dying man's soul or carrying it up to heaven, as in the Douai Psalter (fol. 211r) and in numerous later examples. Instead, it depicts the very moment of death, as the nightmarish skeleton delivers the last blow with a grin of triumph – we can almost feel the impact [75]. The literary personification of death goes back to *c.* 1200 or earlier, but its actual depiction did not become common until the 15th century.[59] The Macclesfield image is one of the earliest examples. Its English precursors and contemporaries depict the story of the Three Living and the Three Dead, but the first true characterization of death striking, death in action, is the blood-curdling cycle of frescoes in the Camposanto in Pisa, dating to the 1330s.[60] They were painted during the

episcopate of the Dominican Simone Saltarelli (1323–42), ambassador and personal adviser of Pope John XXII.[61]

The dying man is watched over by his wife, whose gesture and facial expression convey the tragic despair of bereavement, adding a new dimension to the viewer's experience. As one's empathy shifts back and forth between the dying man and his wife, the scene of an individual instant of death becomes the stage of a timeless, universal drama.

There is hope for salvation, though, as Christ extends a blessing hand from the top left. His presence may be more than a general promise of the heavenly kingdom. It may refer to the major controversy over the beatific vision provoked by Pope John XXII in 1331.[62] Although the idea that the blessed dead encounter the divine essence face to face immediately after death, or at least after Purgatory, had been widely accepted since the 11th century on the authority of St Ambrose and Gregory the Great, Pope John XXII argued that the beatific vision would not be experienced until the reunification of body and soul at the Last Judgment, and that only the blessed would witness Christ's divine nature. The opposition to the pope's views was fierce, as they contained potentially heretical elements, threatened the effectiveness of prayer, intercession and indulgences, and undermined the prospect of immediate reward for penance and confession. The Dominicans were particularly concerned and one of them, an Englishman, became one of the pope's most vociferous opponents. Thomas Waleys, chaplain of the Dominican Cardinal Matteo Orsini, attacked John XXII's views in a sermon he preached in 1333 in Avignon, and for which he was imprisoned until 1342. At least one English Dominican reacted against this demonstration of papal authority, alluding to John XXII's training as a lawyer rather than a theologian. In his famous commentary on the Book of Wisdom, Robert Holcot stated that law should serve theology rather than pronounce on doctrinal matters, including the beatific vision, 'as has happened recently'.[63] This has suggested a date after the pope's death in 1334 for Holcot's work and, since two copies style him a Cambridge doctor, there is a general consensus that he held his regency at the Cambridge Blackfriars in 1334–36.

John XXII renounced his ideas on his deathbed in 1334 and in January 1336 his successor, Benedict XII, published the *ex cathedra* constitution *Benedictus Deus*. It confirmed the official position of the Western Church that the 'souls even before the resumption of their bodies and the general judgment…see the divine essence by intuitive vision, and even face to face…immediately revealing itself plainly, clearly and openly'.[64]

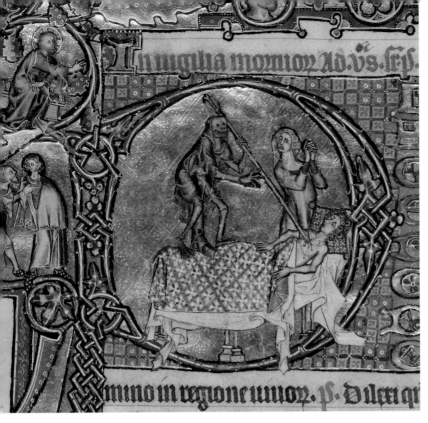

75 *Death strikes his victim, whom Christ blesses from above: historiated initial, Vespers of the Office of the Dead, Macclesfield Psalter, folio 235v.*

It is this immediate encounter with God that the dying man in the Macclesfield Psalter is about to experience. Since the beatific vision was still inspiring images in the 1360s,[65] it is hardly surprising to find an allusion to it in a manuscript of the 1330s, especially one produced in a Dominican context. The Macclesfield Psalter was probably painted towards the end of the controversy, around 1334–36, or immediately after. This would make it contemporary with Robert Holcot's Cambridge regency.

The marginalia surrounding the historiated initial are of interest, too. The two men debating on the left appear in the Douai Psalter beside the historiated initial for Psalm 38 (fol. 48v). We witness the Macclesfield Master's re-use of his own device for drawing the viewer within the pictorial space, a device we have noted already at Psalm 52. The man falling off his horse in the lower margin is a common allegory of pride [76], a suitable moralization in the spirit of the main theme, the *memento mori*. By contrast, the putto on the right urinating into a bowl held by a grotesque might seem out of place [77]. It would be easy to dismiss him as frivolous or meaningless if we did not remember him from ancient sarcophagi. He is a stock motif in Hellenistic funerary sculpture, and as such more than relevant to the Office of the Dead. Few objects survived from antiquity into the Middle Ages in greater numbers than sar-

cophagi.[66] Displayed in medieval churches and halls, they were also re-used through the centuries. In 695 the incorrupt body of St Etheldreda of Ely was placed in a Roman sarcophagus, found, as Bede tells us in his *Historia ecclesiastica* (IV, 19–20), in Cambridge.[67] Greco-Roman sarcophagi were among the richest sources of antique imagery for medieval artists; floor mosaics would have been equally important in England. The Macclesfield Master was probably familiar with both media. The image showcased his wide repertoire and perhaps tested the young reader's knowledge of classical art as well as the swiftness of his associations.

CLASSICIZING MOTIFS

The urinating putto at the Office of the Dead is not the only classicizing image in the Macclesfield Psalter. Creatures inspired by mythology populate the borders: for instance, the siren-like men–birds (fols. 43v, 96r), the centaur (fol. 121v), and the hybrids derived from chimera (fols. 101r, 137r). The Dominican Vincent of Beauvais used them as examples of the *phantasmata* that our imagination conjures up with no help from the five senses.[68] The initials and borders accommodate busts and figures of ancient sages – as, for instance, the medallion beside the philosophical discussion of *substantia* and *vanitas* on folios 58v–59r.

The prayer *Deus qui caritatis dona* on folio 233v pleads for physical and spiritual wellbeing, 'salutem mentis et corporis'. Reminiscent of the ancient maxim 'mens sana in corpore sano', it may have prompted the depiction of Aristotle beneath. He appears not as the great philosopher on a pedestal, but on all fours. Phyllis is riding a senile, lust-driven, beast-like philosopher, who represents a complete reversal of the ancient maxim [43]. The story was well known, not least from the popular fabliau of Henri d'Andeli, *Le lai d'Aristote*, whose courtly style and refined language contrast comically with the base subject matter.[69] One day Aristotle advised his illustrious pupil Alexander the Great not to succumb to women's charms. Alexander's concubine overheard the conversation and swore to bewitch the philosopher. Aristotle let her ride on his back in exchange for certain favours. The sexually charged metaphor of riding, common in medieval literature and art, has undergone a gender reversal. Alexander saw the humiliation of his tutor and Aristotle had to withdraw his advice. Lilian Randall noted the rarity of classical motifs in manuscript marginalia, listing Phyllis and Aristotle as one of the few examples.[70] It is perhaps significant that a pictorial representation of the story

was described in a commentary on Ecclesiastes, which has been attributed to Robert Holcot.[71]

The ancient gymnasium also found its way into the Macclesfield Psalter. Folio 28v preserves the charming figure of a young athlete [78]. The boy's right hand is engaged in a scatological activity perhaps suggested by a word in the last verse on the previous page: *lutum* ('dirt' or 'filth'). His left hand carries our eyes from the end of folio 28v to the top of the next folio, before dropping us onto the initial and guiding us into the first line of text. We may laugh at the dirty joke or admire the clever design of the visual catchword. Or we may go a step further and try to understand what his left hand is really doing.

Lutum was the technical term for the dust with which ancient athletes and wrestlers sprinkled their bodies. The Macclesfield athlete seems to be rubbing the dust into his foot. This meaning of *lutum* would have been known to an educated elite – for instance, from Seneca, the favourite moralist of the Middle Ages, whose works enjoyed an ever growing readership from the 12th century onwards. In one of his *Letters to Lucilius* (letter 88, 18), Seneca referred to *lutum* in its technical meaning, as used by wrestlers in the games.[72] The first eighty-eight letters to Lucilius survive in a large number of copies.[73] They also furnished numerous excerpts in encyclopaedias, notably the mid-13th-century *Speculum historiale* of the Dominican Vincent of Beauvais and the most popular anthologies of the early 14th century, the *Manipulus florum* composed by Thomas of Ireland in 1306 and the *Auctoritates Aristotelis*

compiled in Paris by Marsilio of Padua shortly after 1312.[74] Moreover, letter 88 circulated separately as a treatise on the liberal arts, *De liberalibus studiis*, and would have enjoyed an even wider readership.[75] Seneca's *Letters to Lucilius* would have been well known to the Cambridge Dominicans, although no copies survive from their library.[76] Their regent in 1334–36, Robert Holcot, was a keen collector of little-known ancient texts. He discovered thirty-six of Seneca's letters to Lucilius, which were exceedingly rare even among bibliophiles.[77]

The Macclesfield Psalter's athlete conveys not simply a command of classical Latin or Seneca's text, but interest in the cultural *realia* of the ancient world. The image may have been intended to enforce a moral, since Seneca mentioned *lutum* in a contemptuous reference to wrestlers. He excluded their skills from the study of the liberal arts, together with those of painters, sculptors and 'other servants of luxury' (letter 88, 18–19). If the Macclesfield Master was aware of this context, the depiction of the athlete, like that of Aristotle, seems tongue-in-cheek. It is the consummate skill of the artist, scorned by the ancient sage, that prompts the reader to check his own knowledge of classical *realia*, technical terms and moral philosophy. If the artist could conjure up such multi-layered visual responses to the text, one may suspect that there is much more to the 'Italianisms' in his work than first meets the eye. Perhaps his interest in the naturalistic depiction of the human body, at least in this case, went beyond the borrowing of Italianate style or motifs.

76 *Pride falling from his horse: Macclesfield Psalter, folio 235v.*

77 *Urinating putto and grotesque: Macclesfield Psalter, folio 236r.*

78 Young athlete: Macclesfield Psalter, folio 28v.

The image of the athlete is a new, pictorial response to the old question raised by St Jerome in his letter 22, 29: 'What does Horace have to do with the Psalter?'[78] The classicizing friars gave their own answer to this anxiety about the place of pagan heritage in Christian culture. Ancient works and the biblical text were equally valued as educational tools, whether for the memorizing of Latin grammar and vocabulary or for moral edification. As tutor and confessor to the Macclesfield Psalter's young owner, the Dominican friar would have pressed both text and pictures into service. He was most probably responsible for the concepts behind many of the Macclesfield's word-images, if not for their execution. A connection with Cambridge during, or shortly after, Robert Holcot's sojourn there is not inconceivable. This is not to suggest that the Dominican depicted in the Macclesfield Psalter was Robert Holcot himself or that the manuscript was made in Cambridge. Although neither possibility should be ruled out completely, the allusions to ancient *realia* may be an indication of the spread of classicizing tendencies beyond Cambridge to other centres in East Anglia, not least Norwich, which had the second most important Dominican house in the visitation. The dissemination may have reached further and may have affected not only the mendicant orders. One possible clue is the fact that the monks who initiated another classicizing revival – that at St Albans *c.* 1350–1440 – notably William Binham, Simon Southery and perhaps Thomas Walsingham as well, were recruited from the Norfolk dependences of the abbey.[79] As the head of the East Anglian visitation, the Cambridge Dominican house would have been not only a magnet, but also a store house for talent and ideas that would have radiated out into the region.

CONCLUSION

Although we have now examined the Macclesfield Psalter in detail – when, where, by whom and for whom it may have been made, its materials, content and structure, its texts and images – we still do not know the names of its scribe, artists, commissioner and original owner. If we had expected to identify them, this conclusion may seem anticlimactic. The feeling of disappointment is understandable in an art world dominated by the names of famous artists and patrons. Yet the study of medieval art has moved out of the shadow of Giorgio Vasari's *Lives of the Artists*, all named and immortalized. It is no longer marred by an artificial divide between the Middle Ages and the Renaissance; and the anonymity of the vast majority of medieval artists is no longer an obstacle to our appreciation of their mastery and ingenuity, a circumstance perfectly exemplified by our reaction to the Macclesfield Psalter.

The sumptuous materials and exquisite technique reveal the consummate skill of the two illuminators, the Macclesfield Master and the Anointing Master. Their impressive iconographic repertoire draws on earlier and contemporary material from a wide range of media and geographical areas. The artists display familiarity with panel painting and manuscript illumination, with century-old English traditions and current trends in Italy, France and Flanders.

The comparisons with 14th-century East Anglian manuscripts, stained glass and monumental painting confirm that the Macclesfield Psalter was produced in the mid- or late 1330s, most probably in Norwich. The scribe was almost certainly responsible for the Stowe Breviary made in Norwich *c.* 1322–25 and may have contributed to the Trinity Bede as well. The Macclesfield Master illuminated a copy of John of Freiburg's *Summa confessorum* and collaborated with the Douai

Master on the Trinity Bede and the Douai Psalter. The work of the second Macclesfield artist, the Anointing Master, finds its closest parallel in the finest surviving 14th-century East Anglian panel painting, the Thornham Parva Retable, produced in the 1330s for the Dominican house at Thetford or Norwich. The Macclesfield Master himself was intimately familiar with the retable or with workshop models used for it. It seems reasonable to conclude that the psalter and the retable were painted by a close-knit group of Norwich-trained artists, associated with the Dominican order in East Anglia and with some of the wealthiest art patrons of the time.

The young man depicted at the opening of the Confession prayer, in all likelihood the manuscript's intended recipient, was being trained for a career in the Church, as the texts of the prayer and the Office of the Dead reveal. The visual allusions to recent events in political and ecclesiastical history, the classicizing images and the heraldic material in the Macclesfield Psalter allow us to posit a date, a connection with the Dominican order, and (tentatively) an association with the earls of Warenne and Arundel. The illustration of Vespers in the Office of the Dead seems to refer to the major controversy over the beatific vision, which ended in 1334 with the death of its instigator, Pope John XXII, and was formally resolved in 1336. Several images in the Macclesfield Psalter preserve echoes from the short-lived flowering of classicism in Cambridge during the second quarter of the 14th century and, more specifically, from the activities of Robert Holcot, who held his regency at the Cambridge Blackfriars between 1334 and 1336. The Dominican depicted in the psalter and presumably involved in its design, if not its actual execution, must have been familiar with current developments in Cambridge and the papal curia, and interested in recent politics. The

illustration of Psalms 51 and 52 seems to recall the dramatic events of 1326, the deposition of Edward II and the execution of his close ally, Edmund Fitzalan, second Earl of Arundel, at the command of Queen Isabella's lover, Roger Mortimer. While the only coat of arms extant in the Macclesfield Psalter (fol. 37v) has been associated with four families – the Warbertons, the Gorges, the Morvilles, and the Mortimers of Attleborough – the livery colours displayed on folio 39r and in numerous line fillers may be those of the earls of Arundel.

The Arundel association is not incompatible with the striking textual, stylistic and iconographic connections between the Macclesfield Psalter and the Gorleston Psalter, which was commissioned *c.* 1316 by John, seventh Earl of Warenne. John de Warenne and Edmund Fitzalan were political allies and close relatives. Edmund was married to John's sister, Alice, and their son, Richard Fitzalan, third Earl of Arundel, succeeded to the Warenne estates and title when John died without legitimate heirs. The place of honour occupied by St Edmund of Bury, patron of East Anglia, at the very beginning of the psalter, may have referred to two Edmunds in the Fitzalan family, Richard's father and first-born son. The possibility of a Warenne–Fitzalan patronage accommodates both the East Anglian style of illumination and the lack of East Anglian liturgical features in the Macclesfield Psalter. It also reconciles the absence from its calendar of any reference to St Andrew's Church in Gorleston with the visual prominence of St Andrew at the beginning of the manuscript. The latter may have reflected the key role played by the earls of Warenne and Arundel in the Scottish campaigns of Edward I and Edward III, or the association of the intended recipient or his confessor with the Dominican priory in Norwich or Cambridge, in each case situated in the parish of St Andrew. Finally, the Dominican house at Arundel had only two documented patrons in the 13th and 14th centuries, Bishop Richard of Chichester and the Fitzalan family. Perhaps the Macclesfield Psalter was still near Arundel or somewhere in the diocese when a later Bishop of Chichester, Anthony Watson, acquired it between 1596 and 1605. The various strands of our enquiry seem to meet in the possibility that the manuscript was made around, or shortly after, 1334–36 by a scribe and two major artists, all trained in Norwich, with the strong input of a Dominican from the Norwich or Cambridge Blackfriars, for a young cleric-to-be associated with Richard Fitzalan, heir of the second Earl of Arundel and the seventh Earl of Warenne.

We have a few names after all. The claim that the Macclesfield Psalter is 'a window into the world of Medieval England' (see page 11) seems justified. In fact, we are offered a choice of vantage points, a range of medieval imaging strategies. The dynamic communication between all elements on the page invites an integrated way of reading and looking at the psalter. It undermines the boundaries between major historiated initials in the centre of the sacred text and secular marginalia outside it. The distinction between 'high' and 'low', official and subversive, essential and frivolous is suspended. This reminds us that *gravitas* was not always the default of medieval thought, let alone art. Moreover, the centrality or liminality of an image and its meanings are determined not so much by its position on the page or by its subject matter as by the onlooker's ability to place it within a larger scheme. The discourse between the individual components on the page absorbs the reader–viewer in a continuous dialogue with other texts and images, as well as memories, beliefs and aspirations that reflect and shape his or her social, political and cultural milieu.

This active participation involves the mind and all of the senses, not just sight. The synaesthetic, the emotional and the cognitive converge in

the word–image amalgam. The illustration of the Macclesfield Psalter reveals close attention to the texts present in the manuscript and considerable knowledge of external texts, ranging from saints' lives to romances and from classical works to fabliaux. However, the textual sources hardly dominate the imaging strategy in the Macclesfield Psalter. On the contrary, the pictures often transform a syllable, a word or a phrase into a caption, a topical allusion or a pun on secular literature. Texts are treated not as the main source and focus of illustration proper but as prompts for visual experimentation, which free the artists and viewers to reconfigure narratives and reinvent meanings. The attitudes towards the text–image relationship are admirably playful and highly intellectual at the same time. This is hardly surprising in view of the Dominican friar who is depicted in the manuscript and was probably the owner's spiritual tutor.

However, not all meanings can be recovered, traced back to identified sources or ordered into a neat scheme. One reason is our distance from the time and ethos of the manuscript's makers and intended users. We cannot hope to discern their attitudes and expectations in the Macclesfield's imagery except by aligning it with 14th-century events and their resonance with the manuscript's original users. Moreover we must not lose sight of the fact that some images were not intended to convey specific meaning, but simply to draw attention to the text or to aid the memory.

Finally, many bigger questions remain. The principal objective of this commentary – as is often the case with the first examination of a recently discovered manuscript – has been to outline the essentials, working from the surviving evidence or through informed guesses. A few of these guesses may be supported by future research, some will be rejected, while many may never be established as facts. Yet, establishing the facts is only the starting point, not the ultimate goal of the study of art. It is hoped that this enquiry has provided a useful basis for the investigation of larger issues, such as gestures and emotions, antiquarianism, classicism and illusionism, to name but a few. How much should we read into the bodily movements and facial expressions of the Macclesfield's figures? Does the recourse to a century-old iconographic scheme for the major initials indicate antiquarian tastes on part of the artists and patrons of 14th-century East Anglian psalters, or is it just one of the various sources quarried for the diverse illustration of these deluxe manuscripts? Do the classicizing images celebrate a revival of classical learning among those involved in the production of the Macclesfield Psalter, or are they random echoes from ancient lore encountered through Latin classes, preachers' anecdotes and entertainment literature? Is the naturalistic depiction of human, animal and vegetative forms an exuberant display of artistic skill, a serious endeavour to break the temporal and physical barriers between the viewer and the work of art, or a pictorial joke acknowledging the artifice of such attempts in the face of a superior, eternal reality? The rich collage of texts and images in the Macclesfield Psalter raises numerous questions by inviting the reader–viewer to forge endless connections between the verbal and the visual, the literal and the metaphorical, the past and the present. The call of the imagination creates a stronger bond between medieval and modern viewers than the certainty of facts, names and dates. Its freedom and ingenuity are as infectious as they are timeless.

79 *Saul ordering the killing of the priests of Nob: historiated initial, Psalm 38; and (in the border) a knight, a lady, a wildman and a dog: Macclesfield Psalter, folio 58r.*

(pages 80–81) 80 *Archer mounted on a hybrid, aiming at an unsuspecting rabbit: Macclesfield Psalter, folio 143v.*

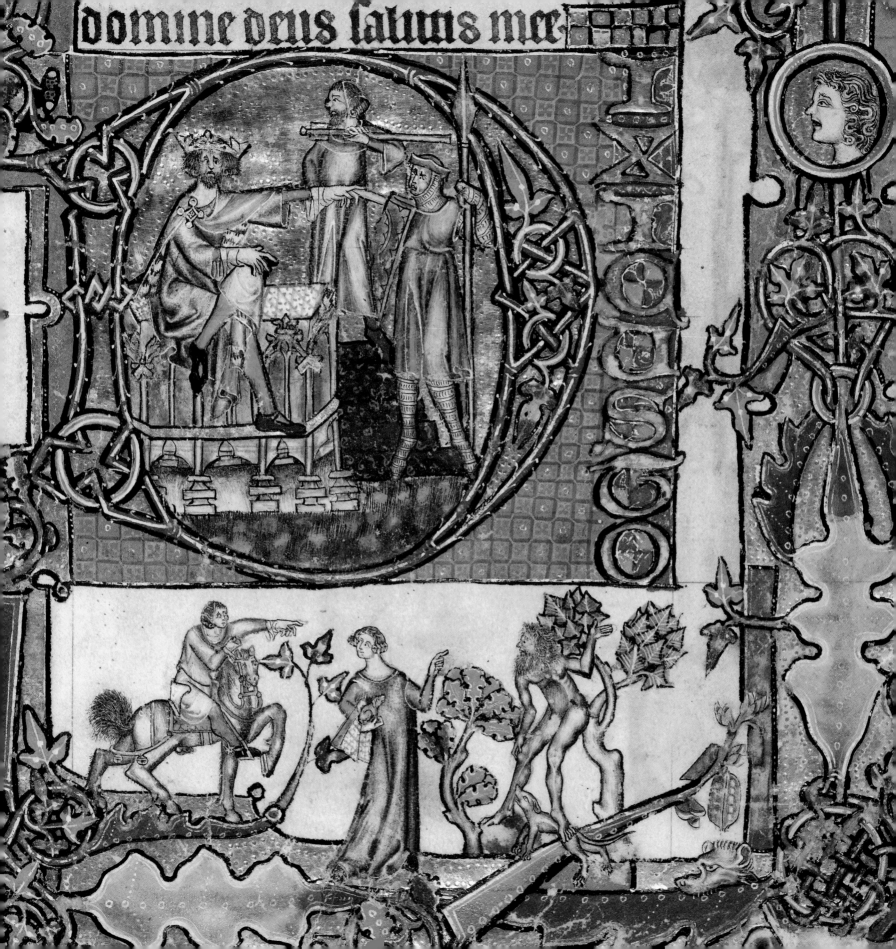

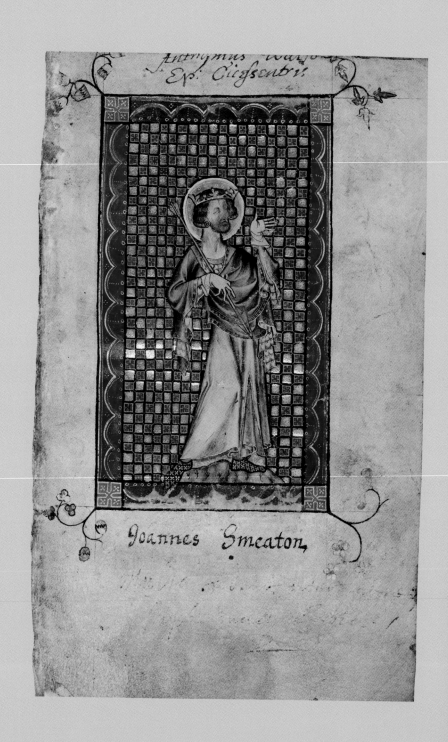

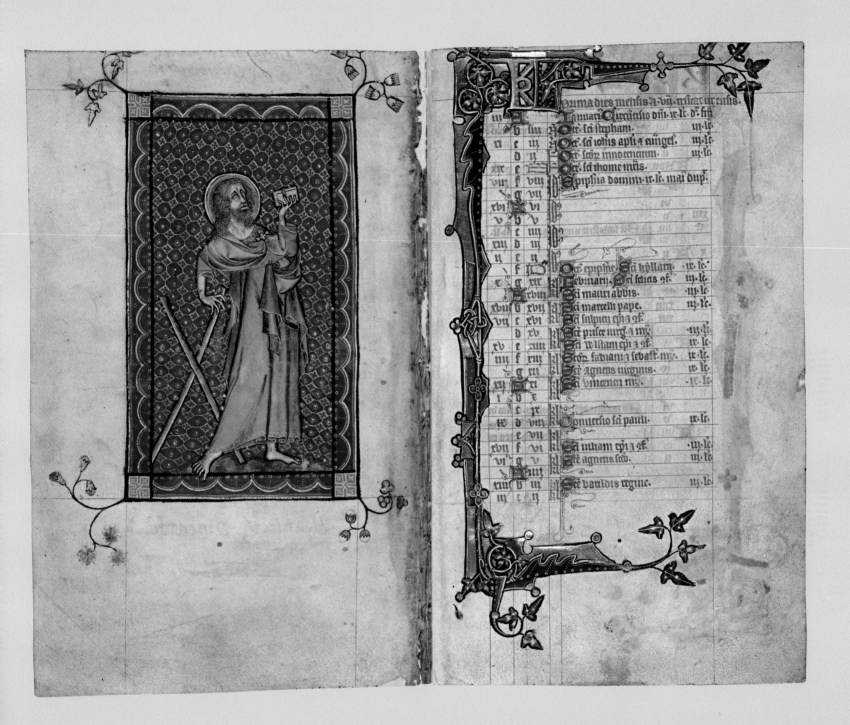

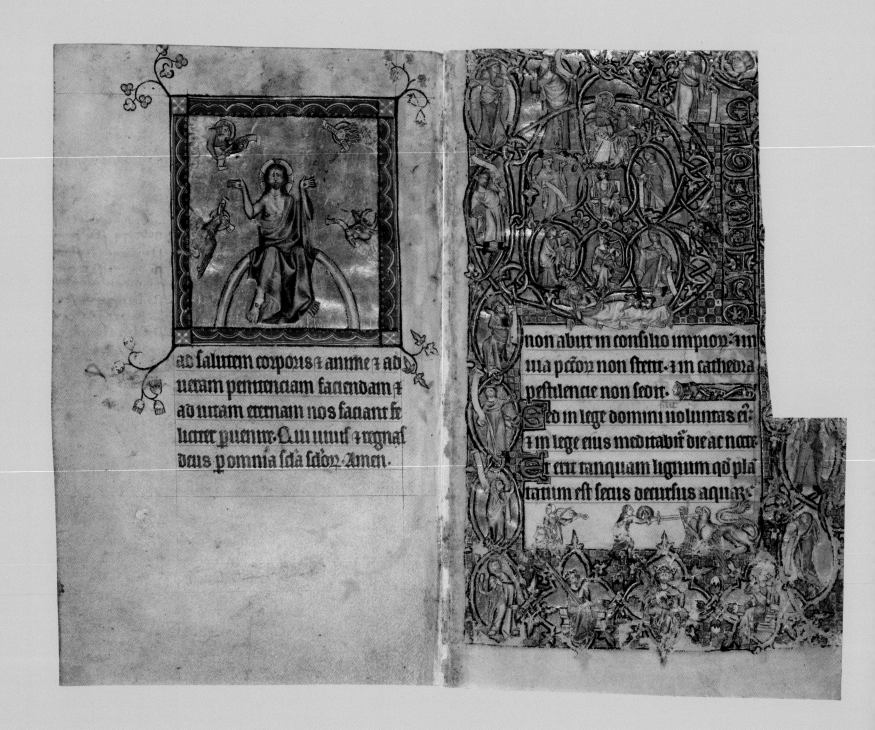

ad salutem corporis t anime t ad
ueram penitenciam faciendam t
ad uitam eternam nos faciant fe
liciter puenire. Qui uiuit t regnat
deus p omnia scla sclor. Amen.

non abiit in consilio impiou: t in
uia pctoy non stetit. t in cathedra
pestilencie non sedit. Sed in lege domini uoluntas ei:
t in lege eius meditabit die ac nocte
t erit tanquam lignum qd pla
tatum est secus decursus aquau:

ego fructum suum dabit in tempore suo.
Et folium eius non defluet: et
omnia quecumque faciet prosperabuntur.
Non sic impii non sic: sed tanquam
pulvis quem proicit uentus a facie terre.
Ideo non resurgunt impii in iu
dicio: neque peccatores in consilio iustorum.
Quoniam nouit dominus uiam iustorum.
et iter impiorum peribit.
Quare fremuerunt gentes: et
populi meditati sunt inania.
Astiterunt reges terre et
principes conuenerunt in unum
aduersus dominum et aduersus
christum eius.
Dirumpamus uincula eorum: et pro

iciamus a nobis iugum ipsorum.
Qui habitat in celis irridebit eos:
et dominus subsannabit eos.
Tunc loquetur ad eos in ira sua: et
in furore suo conturbabit eos.
Ego autem constitutus sum rex
ab eo super sion montem sanctum eius:
predicans preceptum eius.
Dominus dixit ad me filius me
us es tu: ego hodie genui te.
Postula a me et dabo tibi gentes
hereditatem tuam: et possessionem
tuam terminos terre.
Reges eos in uirga ferrea: et tanquam
uas figuli confringes eos.
Et nunc reges intelligite: erudi

Et scitote qui mirificauit dominus
sctm suum: dominus exaudiat me
cum clamauero ad eum.

Irascimini + nolite peccare: que
dicitis in cordibz uris. + in cubili
bz uris conpungimini.

Sacrificate sacrificium iusticie: +
sperate in domino: multi dicunt
quis ostendit nobis bona.

Signatum est sup nos lumen
uultus tui domine: dedisti leti
ciam in corde meo.

A fructu frumenti uini + olei sui
multiplicati sunt.

In pace in idipm: dormiam et
requiescam.

Quoniam tu dne singulariter
in spe constituisti me.

Verba mea auribz percipe dne
intellige clamorem meum.

Intende uoci orationis mee: rex
meus + deus meus.

Quoniam ad te orabo domine:
mane exaudies uocem meam.

Mane astabo tibi + uidebo: quon
iam non deus uolens iniquitate tu es.

Neque habitabit iuxta te malig
nus: pmanebit mihi ante oculos tuos.

Odisti omnes qui opant iniqui
tatem: perdes omnes qui loquunt mendaci
um sanguinum + dolosum
abhominabitur dns: ego autem

in multitudine misericordie tue. Introibo in domum tuam: adorabo ad templum sanctum tuum in timore tuo. Domine deduc me in iustitia tua: propter inimicos meos. dirige in conspectu tuo viam meam. Quoniam non est in ore eorum veritas: cor eorum vanum est. Sepulcrum patens est guttur eorum: linguis suis dolose agebant: iudica illos deus. Decidant a cogitationibus suis secundum multitudinem impietatum eorum expelle eos: quoniam irritauerunt te domine. Et letentur omnes qui sperant in te

in eternum exultabunt et habitabis in eis. Et gloriabuntur in te omnes qui diligunt nomen tuum: quoniam tu benedices iusto. Domine ut scuto: bone voluntatis tue coronasti nos. Domine ne in furore tuo arguas me: neque in ira tua corripias me. Miserere mei domine quoniam infirmus sum sana me domine: quoniam conturbata sunt ossa mea. Et anima mea turbata est ualde: et tu domine usquequo. Conuertere domine et eripe animam meam: saluum me fac propter misericordiam tuam.

Quoniam non est in morte qui memor sit tui: in inferno autem quis confitebitur tibi.

Laboraui in gemitu meo lauabo per singulas noctes lectum meum: lacrimis meis stratum meum rigabo.

Turbatus est a furore oculus meus: inueteraui inter omnes inimicos meos.

Discedite a me omnes qui operamini iniquitatem: quoniam exaudiuit dominus uocem fletus mei.

Exaudiuit dominus deprecationem meam: dominus orationem meam suscepit.

Erubescant et conturbentur uehementer omnes inimici mei: conuertantur et erubescant ualde uelociter.

Domine deus meus in te speraui: saluum me fac ex omnibus persequentibus me et libera me.

Nequando rapiat ut leo animam meam: dum non est qui redimat neque qui saluum faciat.

Domine deus meus si feci istud: si est iniquitas in manibus meis.

Si reddidi retribuentibus michi mala: decidam merito ab inimicis meis inanis.

Persequatur inimicus animam meam: et apprehendat et conculcet in terra uitam meam et gloriam meam in puluerem deducat.

Exurge domine in ira tua: et exaltare in finibus inimicorum meorum.

ex ore infancium z lactencium p-
fecisti laudem ppter inimicos tuos:
ut destruas inimicum z ultorem
Qm uidebo celos tuos opa digi
tozu tuoz: lunã z stellas q tu fudasti
Quid est homo qd memor es ei
aut filius hois qm uisitas eum.
Minuisti eum paulominus ab
angelis glã z honoze coronasti ei
z constituisti eum super opera ma
nuum tuarum. ▨▨▨▨
Omnia subiecisti sub pedibz ei:
oues z boues uniuersas insup et
pecoza campi. ▨▨▨▨▨
Volucres celi z pisces maris: qui
parambulant semitas maris ▨▨▨

Domine dominus noster: quam
admirabile est nomen tuum in
uniuersa terra. ▨▨▨▨▨
Confitebor tibi domine in
toto cozde meo: narrabo omniã mi
rabilia tua. ▨▨▨▨▨
Letabor z exultabo in te: psallam
nomini tuo altissime. ▨▨▨
In conuertendo inimicum meu
retrozsum: infirmabuntur z peri
bunt a facie tua. ▨▨▨▨▨
Quoniam fecisti iudicium meu
z causam meam: sedes super thro
num: qui iudicas iusticiam. ▨▨
Increpasti gẽs z piit impi[us] nomẽ
eozu delesti in eternum z in secm secli.

inimici defecerunt framee in fi
nem: z ciuitates eoy destruxisti.
perijt memoria eoy cum sonitu
z dominus ineternum pmanet.
parauit in iudicio thronü suü.
z ipe iudicabit orbem tre in eqtate:
iudicabit populos in iustitia.
Et fes est dns refugium paupi:
adiutor in oportunitatib; z tribulacoe.
Et sperent in te qui nouerunt no
men tuum: quoniam non dere
liquisti querentes te domine.
Psallite dno qui habitat in syon:
annunciate inter gentes studia eius.
Qui reqrens sanguinem eoy recor
datus est: ñ est oblitus clamore pauperü.

Miserere mei domine: uide humi
litatem meam de inimicis meis.
Qui exaltas me de portis mortis:
ut annunciem omnes laudacoes
tuas in portis filie syon.
Exultabo in salutari tuo: infixe
sunt gentes in interitu quem fecerunt.
In laqueo isto quem absconderunt
comprehensus est pes eorum.
Cognoscetur dominus iudicia
faciens: in opib; manuum suar.
comprehensus est peccator.
Conuertantur peccatores in infer
num: omnes gentes que obliuiscuntur dei.
Quoniam non in finem obliuio
erit paupis: paciencia paupium

non perbit in finem.

Surge domine non confortet
hō: iudicentur gēs in ēspectu tuo.
Constitue domine legis latorē
super eos: sciant gēs qm hōes sūt.
Et quid domine recessisti longe:
despitis in oportunitatibz: i tbtacē
nū suptit impius incendūr
pauper: comprehendūtur in cō
silijs quibus cogitant.

Qm laudatur pecōr in desiderijs
anime sue: ⁊ iniquus benedicitur.
Exacerbaunt dnm pecōr: secundū
multitudinem ire sue non queret.
Non est deus in conspectu ei: inq
nate sūt uie illius in omni tēpe.

Inseruntur iudicia tua a facie eī:
oīm inimicoz suoz dominabit.
Dixit enim in corde suo non mo
uebor. a generacione in generacio
nem sine malo.

Cuius maledicōe os plenum
est ⁊ amaritudine ⁊ dolo: sub lin
gua eius labor ⁊ dolor.

Sedet in insidijs cum diuitibz: i
occultis: ut interficiat innocentē.
Oculi eius in pauperem respicit:
insidiatur in abscondito: quasi
leo in spelunca sua.

Insidiatur ut rapiat pauperem:
rape pauperem dum attrahit eum.
In laqueo suo humiliabit eū:

inclinabit se 4 cadet cum domina
tus fiut pauperum.

Dixit enim in corde suo oblitus
est deus: auertit faciem suam ne
uideat in finem.

Exurge dne deus 4 exaltetur ma
nus tua: ne obliuiscaris paupum.

Propt' quid irritauit imps deu:
dixit enim in corde suo non requi
res.

Vides qm tu laborem 4 dolorem con
sideras: ut tradas eos in manu tuas.

Tibi derelictus est pauper: orpha
no tu eris adiutor.

Contere brachium peccatoris 4
maligni: queretur peccatum illi'
4 non inuenietur.

nis regnabit in eternum 4 in sclm
seli: pibitis gentes de terra illius.

Desiderium pauperum exaudiuit
dominus: preparaconem cordis
eorum. audiuit auris tua.

Iudicare pupillo 4 humili: ut
non apponat ultra magnificare
se homo super terram.

In domino confido: quomodo
dicitis anime mee: transmigra in
montem sicut passer.

Quoniam ecce peccatores intende
runt arcum: parauerunt sagittas
suas in pharetra: ut sagittent in
obscuro rectos corde.

Quoniam quem perfecisti destrux

10

erunt: iustus autem quid fecit.
Dominus in templo sco suo.:
dominus in celo sedes eius.
culi eius in paupem respiciunt:
palpebre ei interrogant filios hoim.
Dominus interrogat iustum et
impium: qui autem diligit mi
quitatem: odit animam suam.
luet sup peccatores laqueos ignis:
sulphur et sps procellarum. pars
calicis eorum.
Quoniam iustus dominus et
iustitias dilexit: equitatem iudicit
vultus eius.
Saluum me fac dne quoniam de
fecit scs: quia diminute sunt veri

taces a filiis hominum.
Vana locuti sunt unusquisq;
ad proximum suum: labia dolosa
in corde et corde locuti sunt.
Disperdat dns universa labia do
losa: et linguam magniloquam
qui dixerunt linguam nostram
magnificabimus: labia nostra a no
bis sunt: quis noster dominus est.
Propter miseriam inopum. et ge
mitum paupum: nunc exurgam dicit do.
Ponam in salutari: fiducialiter
agam in eo.
Eloquia domini eloquia casta.
argenti igne examinatum: proba
ter purgatum septuplum.

ad nichilum deductus est in con
spectu eius malignus: timentes
autem dominum glorificat.
Qui iurat proximo suo ⁊ non dec
ipit: qui pecuniam suam non de
dit ad usuram. ⁊ munera super i
nocentem non accepit.
Qui facit hec: non mouebit in eternu.
Conserua me domine quoniam
speraui in te. dixi domino
deus meus es tu: quoniam bono
rum meorum non eges.
Sanctis qui sunt in terra eius: mirifi
cauit omnes uoluntates meas in eis.
Multiplicate sunt infirmitates e
orum: postea accelerauerunt.

25.

Non congregabo conuenticula eor
de sanguinibus: nec memor ero no
minum eorum per labia mea.
Dominus pars hereditatis mee
⁊ calicis mei: tu es qui restitues he
reditatem meam michi.
Funes ceciderunt michi in preclaris:
etenim hereditas mea preclara est mi
Benedicam dominum qui tribuit m
intellectum: insuper ⁊ usque ad nocte
increpuerunt me renes mei.
Prouidebam dominum in con
spectu meo semper: quoniam a dex
tris est michi ne commouear.
Propter hoc letatum est cor me
um ⁊ exultauit lingua mea: insuper

z caro mea requiescet in spe·
Quoniam non derelinques a
nimam meam in inferno· nec da
bis scm tuum videre corrupcoem·
Notas michi fecisti vias vite adim
plebis me leticia cu vultu tuo· delec
tacoes in dextra tua vsq in finem·
Exaudi dne iusticiam meam· intende 16·
deprecacoem meam·
Auribus pape oronem meam· n in labiis
dolosis· Doclitu videatur eqtates·
De vultu tuo iudicium meum pdeat·
Probasti cor meum z visitasti noc
te· igne me examinasti z non est in
uenta in me iniquitas·
Vt non loquatur os meum opa

hoīm· ppt verba labioꝛ meoꝛ e
go custodiui vias duras·
Perfice gressus meos in semitis
tuis· vt n moueantr vestigia mea·
Ego clamaui qm exaudisti me
dens· inclina aurem tuam m et
exaudi verba mea·
Mirifica mias tuas· qui saluos
facis sperantes in te·
A resistentibz dextere tue custodi
me· vt pupillam oculi·
Sub umbra alaꝝ tuaꝝ ꝓtege me
a facie impioꝝ qui me afflixerūt·
Inimici mei aiam meam circū
dederūt· adipem suum ꝫclusert·
os coꝝ locutū est superbiam·

ouientes me nunc circunde
derunt me. oculos suos statuerūt
declinare in terra.
Susceperūt me sicut leo parat
ad predam. ↄ sicut catulus leonis
habitans in abditis.
Exurge domine preueni eum ↄ
supplanta eum: eripe animam
meam ab impio frameam tuam
ab inimicis manus tue.
Domine a paucis de tra diuide
eos in uita eorū: de absconditis
tuis adimpletus est uenter eorū.
Saturati sunt filijs: ↄ dimiserūt
reliquias suas paruulis suis.
Ego autem iustitia apparebo

in conspectu tuo: saciabor cum ap
paruit glona tua.
Diligam te domine fortitu
do mea: dīis firmamentū
meum ↄ refugium meum ↄ libe
rator meus.
Deus meus adiutor meus: ↄ spe
rabo in eum.
Protector meus ↄ cornu salutis
mee: ↄ susceptor meus.
Laudans inuocabo dīm: ↄ ab
inimicis meis saluus ero
Circumdederunt me dolores mor
tis: ↄ torrentes iniquitatis ↄturbauerūt
dolores inferni circūdederūt Sie
me: preocupauerūt me laqi mortis.

In tribl̄acõe mea muocaui to
minuʒ: ⁊ ad deum meū clamaui·
Et exaudiuit de templo sc̄o suo
uocem meā: ⁊ clamor m̄s in cõ-
spectu eᵭ introiuit in aures eiꝰ·
Commota est ⁊ ʒtremuit terra:
fundam̄ta moncium conturba-
ta sunt ⁊ cõmota sunt quoniam
iratus est eis·
Ascendit fumus in ira eiꝰ ⁊ ig-
nis a facie eiꝰ exarsit: carbones
succensi sunt ab eo·
Inclinauit celos ⁊ descendit: et
caligo sub pedibʒ eiꝰ·
Et ascendit sup cherubyn ⁊ uo-
lauit: uolauit sup pēnas uẽtoꝛ·

Et posuit tenebras latibl̄m suū
in circuitu eius: tabernacl̄m eiꝰ
tenebꝛosa aqua in nubibʒ aeris·
Pꝛe fulgore in ʒspectu eiꝰ: nubes
tr̄sierunt grando ⁊ carbones ignis·
Et intonuit de celo dominus: ⁊
altissimus dedit uocem suam gꝛ-
do ⁊ carbones ignis·
Et misit sagittas suas ⁊ dissipa-
uit eos: fulgura multiplicauit ⁊
conturbauit eos·
Et apparuerūt fontes aquaꝛ: ⁊
reuelata s̄t fundam̄ta oꝛbis traꝛ·
Ab increpacõe tua domine: ab ī-
spiracione sp̄s īre tue·
Misit de sūmo ⁊ accepit me: ⁊ as

sumpsit me de aquis multis. ☒
eripuit me de inimicis meis for
tissimis. ⁊ ab hijs qui oderūt me
qui confortati sunt super me. ☒
preuenerūt me in die afflictoīs
inee. ⁊ fcs est dominus protector mis.
⁊ eduxit me in latitudinem. sal
uum me fecit qm noluit me. ☒
⁊ retribuet michi dns secdm iusti
ciam meā.⁊ secdm puritatem ma
nuum mearum retribuet michi.
Quia custodiui uias domini: nec
impie gessi a deo meo. ☒
qm omia iudicia eius in conspectu
meo.⁊ iusticias ei nõ repuli a me
⁊ ero immaculatus cum eo. et

observabo me ab iniquitate mea.
et retribuet michi dns secdm ius
ticiam meam: ⁊ secdm puritatem
manuum mearū in conspectu oclor eī.
cum sco scs eris: ⁊ cum uiro ino
cente innocens eris. ☒
Et cum electo electus eris. ⁊ cum
puerso perueris. ☒
qm tu ppłm humilem saluum
facies: ⁊ oclos superbor humiliabis
qm tu illuminas lucnam meā.
dne ds ms illumina tenebs meas.
qm in te eripiar a temptacōe ⁊ in
deo meo trāsgrediar murum. ☒
deus meus impolluta uia eius.
eloquia dni igne exaīnata ptec

tor est oim sperancium in se
ñ quis ds preter dnm: aut qs
deus preter deum nostrum.
eus qui precinxit me uirtute.
a posuit inmaculatam uiã meã.
ui pfecit pedes meos tanquã
ceruoz: a sup excelsa statuens me.
ui docet manus meas ad pre
lium: a posuisti ut arcum ereum
brachia mea.
t dedisti michi pretcõem salutis me
t dextera tua suscepit me.
t disciplina tua correxit me in
finem: a disciplina tua ipsa me do
cebit. ui latasti gressus meos sub
subtus me: a non sunt infirma

ta uestigia mea.
ersequar inimicos meos a cõ
prehendam illos: a non conuer
tar donec deficiant.
onfringam illos nec poterunt
stare: cadent subtus pedes meos.
t precinxisti me in uirtute ad bellũ:
a supplantasti insurgentes in me
subtus me.
t inimicos meos dedisti michi
dorsum: a odientes me disperdisti.
lamauerunt nec erat qui saluos
faceret: ad dominũ nec exaudiui eos.
t comminuam eos ut puluerem
ante faciem uenti: ut lutum plate
arum delebo eos.

exultauit ut gigas ad currendā
uiam: a summo celo egressio eius.
Et occursus eius usq; ad sūmū
eius: nec est qui se abscondat a ca
lore domini immacula Lore ci
sta conuertens animas: testimoni
um domini fidele sapienciam pr
tans paruulis.

Iusticie domini recte letificātes
corda: preceptum domini lucidū
illuminans oculos.

Timor domini sc̄s pmanet in
sclm scli: iudicia domini uera i
iustificata in semetipa.

esiderabilia sup aurum 4 lapi
dem pciosum multum: 4 dlciora

super mel 4 fauum.
tenim seruus tuus custodit ea:
in custodiendis illis retribucio mlta.
elicta quis intelligit ab occultis
meis munda me: 4 ab alienis par
ce seruo tuo.

Si mei non fuerint dominati
tūc immaculatus ero 4 emunda
bor a delicto maximo.

Et erunt ut complaceant eloqa
ciōis mei: 4 meditacio cordis mei in
conspectu tuo semper:

sie adiutor mis: 4 redemptor mis.
Exaudiat te dn̄s in die tri
bulacois: ptegat te nomē
dei iacob. 19

ittat tibi auxilium de scō: et de
syon tueatur te. ▣▣▣ ◇◇◇◇◇
emor sit omis sacrificii tui: et
holocaustum tuum pingue fiat.
ribuat tibi scdm cor tuum: et oē
consilium tuum confirmet.
etabimur in salutari tuo: et in
nomine dei nri magnificabim.
mpleat dns omnes petices
tuas. nūc cognoui quoniam sal
uum fecit dominus xpm suum.
xaudiet illum de celo scō suo:
in potentatibz salus dexterre eius.
i in curribz et hii in equis: nos
autem in nomine domini dei nri
inuocabimus. ▣▣▣ ▣▣▣

pi obligati sunt et ceciderunt:
nos aūt surreximus et erecti sum.
omine saluum fac regē: et exau
di nos in die qua inuocauerim te
Omine in uirtute tua leta
bitur rex: et sup salutare tu
um exultabit uehementer: ◇◇◇
esiderium cordis eius tribuisti
ei: et uoluntate labiorum eius nō
fraudasti eum. ◇◇◇◇◇
m preuenisti eum in benedicti
onibz dulcedinis: posuisti in capi
te eius coronam de lapide pretioso.
itam petiit a te tribuisti ei: lon
gitudinem dier: in sclm et in sclm scli.
agna est glā eius in salutari tuo

glam ⁊ magnum decorem impo
nes sup eum.
Quoniam dabis eum in bene
dicoem in seculum seculi: lerifica
bis eu in gaudio cum uultu tuo.
Qm rex sperat in dno: ⁊ in mia
altissimi non comouebitur.
Inueniatur manus tua omnibz
inimicis tuis: dextera tua inueni
at omnes qui te oderunt.
Pones eos ut clibanum ignis i
tempore uultus tui: dns in ira su
a conturbabit eos ⁊ deuorabit eo
fructum eoz de terra pdes: ⁊ Signu
des: ⁊ semen eoz a filiis hominu.
Quoniam declinauerunt in te

mala: cogitauerunt consilia q
non potuerunt stabilire.
Quoniam pones eos dorsum:
in reliquiis tuis pparabis uultu eoz
Exaltare dne in uirtute tua: can
tabim̅ ⁊ psallemus uirtutes tuas.
Deus deus m̅s respice in me
quare me dereliquisti lon
ge a salute mea uerba delictoz me
Deus meus clamabo p
diem ⁊ non exaudies: ⁊ nocte ⁊ n
ad insipienciam michi.
Tu autem in sco habitas laus
isrl: in te sperauerunt pres nostri
sperauerunt ⁊ liberasti eos.
Ad te clamauerunt ⁊ salui fci st:

in te sperauerūt ⁊ non sunt confusi.
Ego autem sum uermis ⁊ non
homo: obpobrium hominum ⁊ ab
iectio plebis.
Omnes uidentes me deriserūt me:
locuti sūt labiis ⁊ mouerūt caput.
Sperauit in dūo eripiet eum: sal
uum faciat eum quoniam uult e
um.
Quoniam tu es qui extraxisti me
de uentre. spes mea ab uberibus mris
mee in te proiectus sum ex utero.
De uentre mris mee deus meus
es tu. ne discesseris a me.
Quoniam tribulacio proxima est:
quoniam non est qui adiuuet.

circumdederunt me uituli multi:
tauri pingues obsederunt me.
Aperuerunt sup me os suum. sicut
leo rapiens ⁊ rugiens.
Sicut aqua effusus sum: ⁊ dispsa
sunt omnia ossa mea.
Factum est cor meum tanquam
cera liquescens: in medio uentris mei
Aruit tanquam testa uirtus mea:
⁊ lingua mea adhesit faucibus meis.⁊
in puluerem mortis deduxisti me.
Quoniam circumdederūt me canes multi:
concilium malignantiū obsedit me.
Foderunt manus meas ⁊ pedes
meos. dinumerauerunt omnia
ossa mea.

hii vero consideraverunt et inspex
erunt me. diviserunt sibi vestime
ta mea. et super vestem meam miserunt sorte.
Tu autem domine ne elongave
ris auxilium tuum a me. ad defe
sionem meam conspice.
Erue a framea deus aiam meam. et
de manu canis unicam meam.
Salua me ex ore leonis. et a corni
bz unicornium humilitatem meam.
Narrabo nomen tuum fribz meis.
in medio ecce laudabo te.
Qui timetis dominum laudate
eum. universum semen iacob glo
rificate eum.
Timeat eum omne semen isrł. qm

non sprevit neqz despexit deprea
tionem pauperis.
Nec avertit faciem suam a me. et
cum clamarem ad eum exaudivit me.
Apud te laus mea in ecca magna.
vota mea reddam in conspectu ti
mencium eum.
Edent paupes et saturabuntur.
et laudabunt dominum qui reqz
runt eum. vivent corda eoz i scłm
Reminiscentur et convertent ‖ scłi.
ad dominum: universi fines terre.
Et adorabunt in conspectu eius.
universe familie gencium.
Quoniam domini est regnum.
et ipse dominabitur gencium.

anouauerur ↑ adozauerunt
omnes pingues terre: in confpec
tu eus cadent omnes qui deſcen
dunt in terram.
Et anima mea illi unuet: ↑ ſeme
meum ſeruiet ipſi.
Annunciabitur dño generacio
uentura: ↑ annunciabunt celi iuſ
ticiam eus. populo qui naſcet
quem fecit dominus.
Dominus regit me ↑ nichil **22.**
michi deerit: in loco paſcue
ibi me collocauit.
Sup aquam refectois educauit
me: aiam meam conuertit.
Deduxit me ſup ſemitas iuſticie

ppter nomen ſuum.
Nam ↑ ſi ambulauero in medio
umbre morus: non timebo ma
la quoniam tu mecum es.
Uirga tua ↑ baculus tuus: ipſa
me conſolata ſunt.
Paraſti in conſpectu meo menſa:
aduiſus eos qui tribulant me.
Impinguaſti in oleo capit me
um: ↑ calix meus inebrians quin
preclarus eſt.
Et miſa tua ſubſequetur me
omnibz diebz uite mee.
Et ut inhabitem in como dñi
in longitudinem dierum.
Domini eſt terra ↑ plenitu **23**

as tuas domine demonstra
michi. 7 semitas tuas edoce me.
irige me in ueritate tua 7 doce
me. quia tu es deus saluator m's
7 te sustinui tota die.
eminisce miseracionum tuax
dne. 7 miax tuax que a seclo sunt.
elicta iuuentutis mee 7 ignox
cias meas. ne memineris.
edm miam tuam merito me
tu. ppt bonitatem tuam domine.
ulcis 7 rectus dominus: ppt
hoc legem dabit delinquentibus
in uia.
iriget mansuetos in iudicio.
docebit mites uias suas.

niuerse uie domini misericor
dia 7 ueritas: requirentibz testa
mentum eius 7 testimonia eius.
ropter nomen tuum domine
propiciaberis peccato meo: mul
tum est enim.
uis est homo qui timet dñm:
legem statuit ei in uia qm elegit.
nima eius in bonis demorabi
tur. 7 semen eius hereditabit tram.
irmamentum est dominus ti
mentibz eum: 7 testamentum ip
sius ut manifestetur illis.
culi mei semper ad dñm. qm ipe
euellet de laqueo pedes meos.
espice in me 7 miserere mei: qa

uinicis 7 pauper sum ego
tribulacdes cordis mei multiplica
te sunt: de necessitatib; meis erue
de humilitatem me me
am 7 laborem meum: 7 dimitte
uniuersa delicta mea
espice inimicos meos quon
iam multiplicati sunt: 7 odio ini
quo oderunt me
ustodi aiam meam 7 erue me
non erubescam qm speraui in te
Innocentes 7 recti adheserut m:
quia sustinui te
ibera deus isrl: ex omnibz tri
bulacionibz suis
Iudica me domine quoniam ego 25.

in innocencia mea ingressus su:
m domino sperans n infirmabor
roba me domine 7 tempta me
ure renes meos 7 cor meum
quoniam misericordia tua ante
oculos meos est: 7 complacui in
ueritate tua
on sedi cum consilio uanitatis:
7 cum iniqua gerentib; non in
troiui ecciam malignan ds odi
cum: 7 cum impiis non sedebo
auabo inter innocentes ma
nus meas: 7 circumdabo altare
tuum domine
audiam uocem laudis: 7 e
narrem uniuersa mirabilia tua

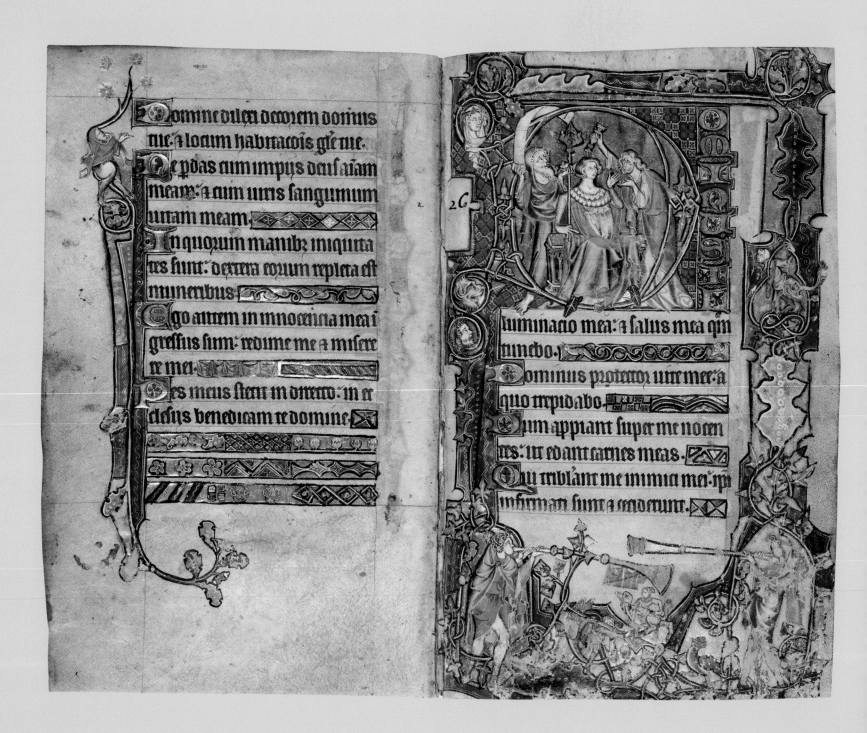

omine dilexi decorem domus
tue: z locum habitacois glie tue.
Ne pdas cum impijs deus aiam
meam: z cum uiris sanguinum
uitam meam. In quorum manibz iniquita
tes sunt: dextera eorum repleta est
muneribus. Ego autem in innocentia mea in
gressus sum: redime me z misere
re mei. Pes meus stetit in directo: in ec
clesijs benedicam te domine.

uminacio mea: z salus mea qm
timebo. Dominus protector uite mee: a
quo trepidabo. Dum appiant super me nocen
tes: ut edant carnes meas. Qui tribulant me inimici mei: ipsi
infirmati sunt z ceciderunt.

i consistant aduersum me castra
non timebit cor meum.
Si exurgat aduersum me prelium
in hoc ego sperabo.
Unam petij a dno hanc requira
ut inhabitem in domo domini
omnibz diebz uite mee.
Ut uideam uoluntatem domini
et uisitem templum eius.
Quoniam abscondit me in tab
naculo suo in die malorum: protexit
me in abscondito tabnaculi sui
In petra exaltauit me. 4 nunc ex
altauit caput meum super inimi
cos meos.
Circuiui 4 immolaui in taber

naculo eius. hostiam uociferacois
cantabo 4 psalmum dicam dno.
Exaudi dne uocem meam q cla
maui ad te. miserere mei 4 exaudi me:
Tibi dixit cor meum exquisiuit te
facies mea. faciem tuam dne requira
Ne auertas faciem tuam a me. ne
declines in ira a seruo tuo.
Adiutor meus esto domine ne de
relinquas me. neqp despicias me
deus salutaris meus.
Quoniam pater meus 4 mater
mea dereliquerunt me. dominus
autem assumpsit me.
Legem pone michi domine in
uia tua: 4 dirige me in semita re

...a ppter inimicos meos. //////
e tradideris me in aias tribu
lancium me: qm insurrexerunt i
me testes iniqui. 4 mentita est ini
redo uidere bona [T]cetas sbi.
domini: in terra uiuencium [X]
rpecta dnm uiriliter age: 4 co
fortetur cor tuum 4 sustine dnm.

D te dne clamabo ds ms 27.
ne sileas a me: nequdo ta
ceas a me 4 assimsabor descenden
tibz in lacum. //////// [R] ////
raudi dne uocem depcacois
mee: dum oro ad te dum extollo
manus meas ad templu sem tuu.
e simul tradas me cu pctoribz.

cium opantibz iniqtatem ne per
Qui loquuntr pace cu [T]das me
pximo suo: mala aut in cordibz eor
Da illis scdm opa eor: 4 scdm ne
quiciam aduinenconum ipor.
scdm opa manuum cor tribue
illis: rede retribucoem eor ipis.
Quoniam non intellexerut opa
domini: 4 in opa manuum eius
destrues illos 4 no edificabis eos.
Benedictus dominus: quoniam
exaudiuit uocem depcacois mee
Dominus adiutor meus 4 pte
ctor meus: 4 in ipo sperauit cor me
um 4 adiutus sum [G]
Et refloruit caro mea: 4 ex uolu

42v

cos meos super me
omine deus meus clamaui
ad te: ⁊ sanasti me
omine eduxisti ab inferno a
nimam meam: saluasti me a des
cendentibz in lacum
sallite domino sci eius: ⁊ con
fitemini memorie sctatis eius.
quoniam ira in indignacione
eius: ⁊ uita in uoluntate eius.
in uespum demorabitur fletus:
⁊ ad matutinum leticia
go autem dixi in habundancia
mea: non mouebor ineuum
omine in uoluntate tua psti fisti
decori meo uirtutem

43r

uertisti faciem tuam a me: et
factus sum conturbatus.
o te domine clamabo: ⁊ ad deu
meum deprecabor.
ue utilitas in sanguine meo:
dum descendo in corrupcionem.
uncqd confitebitur tibi puluis:
aut annunciabit ueritatem tua.
audiuit dominus ⁊ misertus e
mei: dominus frs est adiutor ms.
onuertisti planctum meum i
gaudium michi: conscidisti sacm
meum ⁊ circumdedisti me leticia.
t cantet tibi gla mea ⁊ non co
pungar: domine deus meus in
eternum confitebor tibi.

N te domine spaui non confundar
ineternum: in iusticia tua libera me.
Inclina ad me aurem tuam: ac-
celera ut eruas me.
Esto michi in deum protectorem:
in domum refugii ut saluum me
facias. Quia fortitudo mea. Thanas.
refugium meum es tu: appter no-
men tuum deduces me et enutries me.
Educes me de laqueo quem absco-
derunt michi: quoniam tu es pro-
tector meus.
In manus tuas commendo spiritum
meum: redemisti me domine de-
us ueritatis.
Odisti obseruantes uanitatem

supuacue.
Ego autem in domino speraui: exul-
tabo et letabor in misericordia tua.
Qui respexisti humilitatem mea:
saluasti de necessitatibus animam me-
am et conclusisti me in ma. Cam-
nibus inimici: statuisti in loco spa-
cioso pedes meos.
Miserere mei domine quoniam
tribulor: conturbatus est in ira oculus
meus. anima mea et uenter meus.
Quoniam defecit in dolore uita
mea: et anni mei in gemitibus.
Infirmata est in paupertate uirtus
mea: et ossa mea conturbata sunt.
Super omnes inimicos meos fa-

sum opbrium: uicinis meis ual
de: & timor notis meis.

Qui uidebant me foras fugieri
a me: obliuioni datus sum tanq;
mortuus a corde.

Factus sum tanquam uas pditi:
quia audiui uituparacionem mlton
comorancium in circuitu.

In eo dum connenirent simul ao
uersum me: accipe aiam meam q
siliati sunt.

Ego autem in te spaui domine
dixi deus meus es tu: in manibz
tuis sortes mee.

Eripe me de manu inimicor me
or: & a psequentibz me.

Illustra faciem tuam sup ser
uum tuum: saluum me fac in
misa tua domine non confundar
quoniam inuocaui te.

Erubescant impii & deducantur
in infernum: muta fiant labia
que locuntur aduer dolosa.
sus iustum iniquitatem: in superbia
& in abusione.

Quam magna multitudo dul
cedinis tue domine: quam absco
disti timentibz te.

Perfecisti eis qui spant in te: in q
spectu filior hominum.

Abscondes eos in abscondito fa
ciei tue: a conturbacoe hominu.

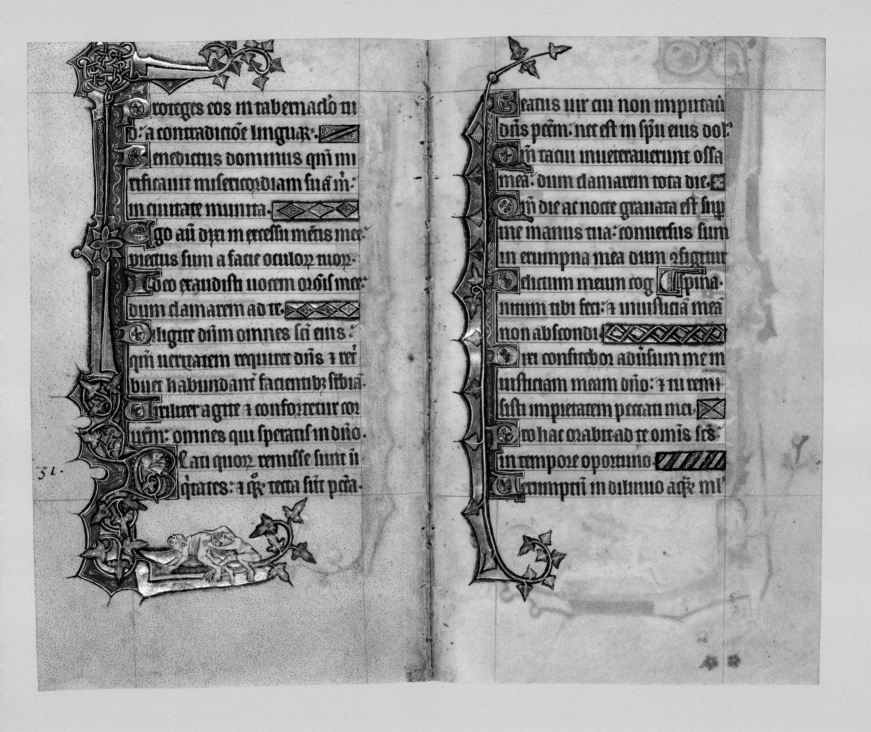

proteges eos in tabernaclo in
o: a contradicoe linguax·
Benedictus dominus qui mi
rificauit misericordiam suam m̄:
in ciuitate munita·
Ego au dixi in excessu mētis mee
piectus sum a facie oculox̄ tuox̄·
Ideo exaudisti uocem orōis mee:
dum clamarem ad te·
Diligite dn̄m omnes scī eius·
qm̄ ueritatem requiret dn̄s ⁊ re
buet habundan̄ facientibus sb̄ia·
Viriliter agite ⁊ confortetur cor
ur̄m: omnes qui speratis in dn̄o·
Beati quox̄ remisse sunt in
qtates: ⁊ qx̄ tecta sut pc̄a·

51·

Beatus uir cui non imputaū
dn̄s pcc̄m: nec est m spū eius dol·
qm̄ tacui inueterauerunt ossa
mea· dum clamarem tota die·
qm̄ die ac nocte grauata est sup
me manus tua: conuersus sum
in erumpna mea dum c̄figitur
dictum meum cog Spina
nium tibi feci: ⁊ iniusticia mea
non abscondi·
Dixi confitebor aduūsum me in
iusticiam meam dn̄o: ⁊ tu remi
sisti impietatem peccati mei·
Pro hac orabit ad te omis scē s
in tempore oportuno·
Verumptn̄ in diluuio aqx̄ mr̄·

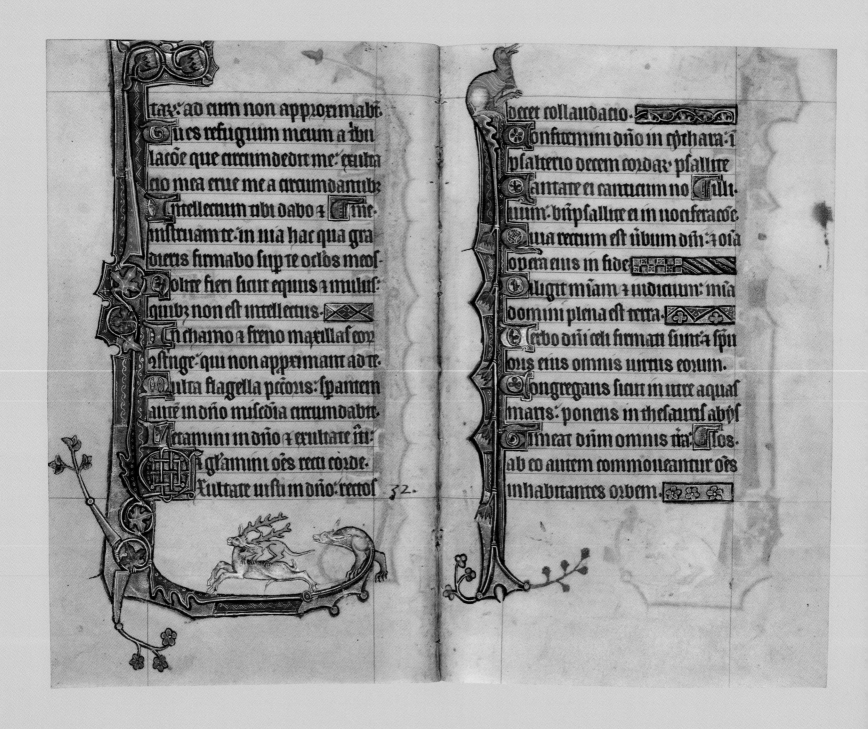

tax: ad eum non approximabit.
Tu es refugium meum a tribu
lacōe que circumdedit me: exulta
cio mea erue me a circumdantibz;
Intellectum tibi dabo et Ime.
instruam te: in via hac qua gra
dieris firmabo sup te oclos meos.
Nolite fieri sicut equus et mulus:
quibz non est intellectus.
In chamo et freno maxillas eoz
astringe: qui non appiniant ad te.
Multa flagella pctoris: sparantem
aute in dno miscōia circumdabit.
Letamini in dno et exultate iu:
Et gloriamini oēs recti corde.
Exultate iusti in dno: rectos 32

decet collaudacio.
Confitemini dno in cythara: in
psalterio decem cordar psallite
Cantate ei canticum no Iubil
uium: bñ psallite ei in vociferacōe.
Quia rectum est vibum dñi: et oīa
opera eius in fide
colligit miam et iudicium: mia
domini plena est terra.
Verbo dñi celi firmati sunt: et spu
oris eius omnis virtus eorum.
Congregans sicut in utre aquas
maris: ponens in thesauris abys
Timeat dñm omnis tra. Quos
ab eo autem commoueantur oēs
inhabitantes orbem.

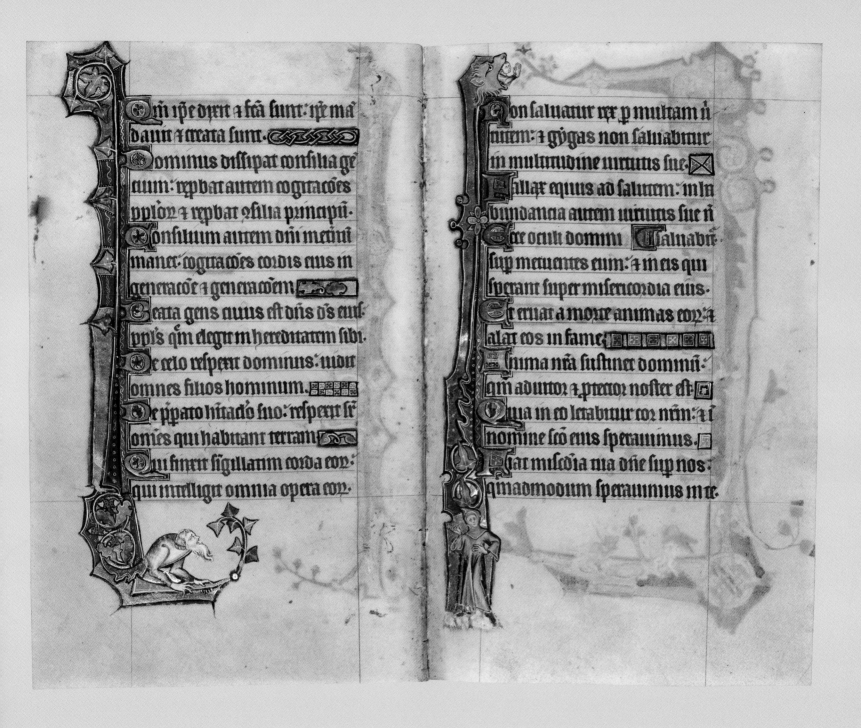

[Left column — 47v]

rñi ipe dyrit 4 fra suñt: ipe ma
dauit 4 creata suñt. Dominus diſſipat conſilia ge
tium: repzbat autem cogitacões
pploz 4 repzbat qſilia principu.
Conſilium autem dñi metnū
manet: cogitacões cordis eius in
generacôe 4 generacôem. Geata gens cuius eſt dñs ds eiuſ
ppis qm elegit in hereditatem ſibi.
De celo reſpexit dominus: uidit
omnes ſilios hominum. De pparato hitaclo ſuo: reſpexit ſr
omnes qui habitant terram. Qui ſinxit ſigillatim corda eoz.
qui intelligit omnia opera eoz.

48r

Qon ſaluatur rex p multam ñ
uirtutem: 4 gygas non ſaluabitur
in multitudine uirtutis ſue. Fallax equus ad ſalutem: in ha
bundancia autem uirtutis ſue ñ
ſer oculi domini. Ecce oculi domini Tſaluabit
ſup metuentes eum: 4 in eis qui
ſperant ſuper miſericordia eius. Et eruat a morte animas eoz 4
alat eos in fame. Inima ña ſuſtinet dominū:
qm adiutor 4 ptector noſter eſt. Quia in eo letabitur coz nrm: 4 i
nomine ſco eius ſperauimus. Fiat miſcdia tua dñe ſup nos:
qmadmodum ſperauimus in te.

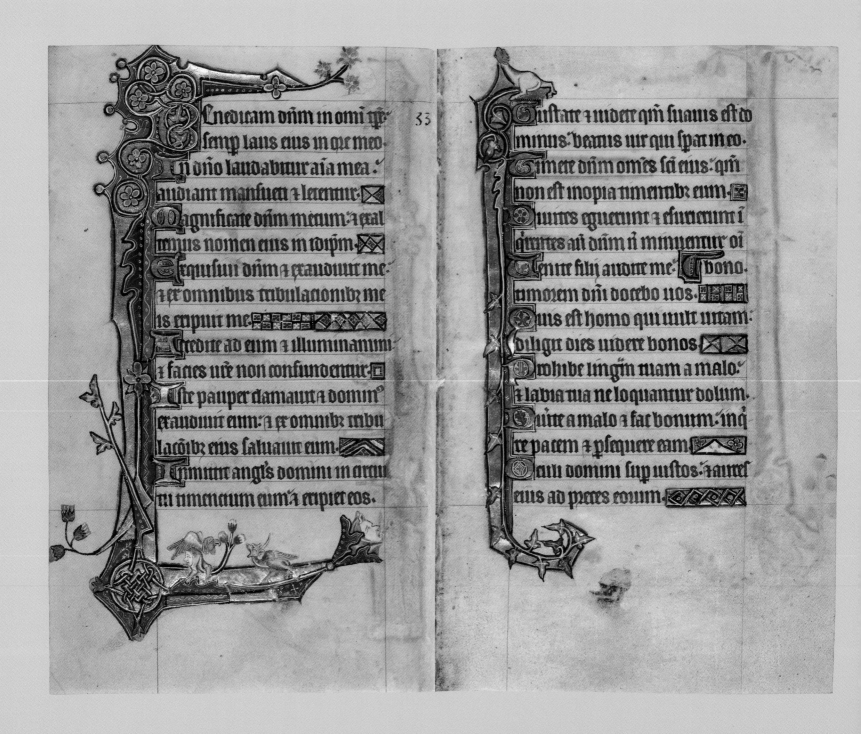

michi in inctentu laquei sun. sup
uacue expbrauerunt aiam mea.
Deniat illi laqueus qin ignozat.
et captio qin abscondit apphendat
eum. et in laqueum cadat in ipm.
Anima autem mea exultabit in
domino. et delectabitur sup salu
tari suo. Omnia ossa mea dicent.
domine quis similis tui.
Eripiens inopem de manu for
ciozum eius. egenum et paupem a di
ripientibz eum.
Surgentes testes iniqui. que ig
nozabam interrogabant me.
Retribuebant michi mala p bonis
sterilitatem anime mee.

Ego autem cum michi molesti eent.
induebar cilicio.
Humiliabam in ieiunio aiam
meam. et ozo mea in sinu meo con
quasi primum qn frem ten
nim sic complacebam. quasi luges
et contristatus sic humiliabar.
Et aduersum me letati sunt et con
uenerunt. congregata sunt super
me flagella et ignozaui.
Dissipati sunt nec compuncti sep
tauerunt me. subsannauerunt me
subsannatoe frenduerunt super me
dentibz suis.
Domine quando respicies restitu
e animam meam. a malignitate

in semerpo: ñ est timor dei ante
oculos eius.
ñ dolose egit in conspectu eius:
ut inueniatur iniquitas eius ad odui.
erba oris eius iniquitas ⁊ dolus:
noluit intelligere ut bene agere.
niquitatem meditatus est in cu
bili suo: astitit omni uie non bone
maliciam autem non odiuit.
omine in celo misericordia tua: ⁊ ueritas
tua usque ad nubes.
usticia tua sicut montes dei: iu
dicia tua abyssus multa.
omines ⁊ iumenta saluabis do:
quemadmodum multiplicasti mi
sericordiam tuam deus.

lii autem hominum: in tegmi
ne alarum tuarum sperabunt.
nebriabuntur ab ubertate do
mus tue: ⁊ torrente uoluptatis tue
potabis eos.
oni apud te est fons uite: ⁊ in lu
mine tuo uidebimus lumen.
etende misericordiam tuam sci
entibus te: ⁊ iusticiam tuam hiis qui
recto sunt corde.
on ueniat michi pes superbie: ⁊ manus
peccatoris non moueat me.
bi ceciderunt qui operantur iniquitatem
expulsi sunt nec potuerunt stare.
oli emulari in malignan
tibus: neque zelaueris facientes

iniquitatem. Quoniam tanquam fenum ue
locirer arefcent: a quemadmodu
olera herbarz cito decident. Spera in dno a fac bonitatem:
a inhabita tram a pafceris indiui
delectare in dno: a dabit tibi peticiones cordis tui. Reuela domino uiam tuam: a spera in eo a ipfe faciet. Et educet quasi lumen iusticiam tuam: a iudicium tuum tanquam miidie fubditus esto dno a ora eum. Noli emulari in eo qui psparatur i uia sua: a in homine faciente in iusticias.

efine ab ira a derelinque furore: noli emulari ut maligneris. Quoniam qui malignantur ex terminabuntur: sustinentes aute dñm ipi hereditabunt terram. Et adhuc pusillum a non erit pecor: a qrens locum eius a ñ inuenies. Mansueti autem hereditabunt tram: a delectabuntur in multitudine pacis. Obseruabit pecor iustum: a stridebit super eum dentibus suis. Dñs aut irridebit eum: qm pspicit qd ueniet dies eius. Gladium euaginauerunt pecores: tetenderunt arcum suum. Ut decipiant pauperem a inope

[54v]

ut trucidant rectos corde.
Gladius eorum intret in corda ipsorum:
et arcus eorum confringatur.
Melius est modicum iusto: super
divicias peccatorum multas.
Quoniam brachia peccatorum conterentur:
confirmat autem iustos dominus.
Novit dominus dies immaculatorum: et
hereditas eorum in eternum erit.
Non confundentur in tempore
malo: et in diebus famis saturabuntur.
quia peccatores peribunt.
Inimici vero domini mox ho
norificati fuerint et exaltati: deficien
tes quemadmodum fumus deficient.
Mutuabitur peccator et non solvet: iustus

[55r]

autem miseretur et retribuet.
Quia benedicentes ei hereditabunt
terram: maledicentes autem ei disperibunt.
Apud dominum gressus hominis di
rigetur: et viam eius volet.
Cum ceciderit iustus non collidetur:
quia dominus supponit manum suam.
Iunior fui etenim senui: et non
vidi iustum derelictum: nec semen
eius querens panem.
Tota die miseretur et commodat: et
semen illius in benedictione erit.
Declina a malo et fac bonum: et
inhabita in seculum seculi.
Quia dominus amat iudicium: et
non derelinquet sanctos suos in eternum

conseruabunt.
ius iusti punientur: 4 semen im
pior peribit.
usti aut hereditabunt terram: 4
inhitabunt in scdm sci sup eam.
os iusti meditabitur sapiam: 4
lingua eius loquetur indicium.
ex dei eius in corde ipius: 4 non
supplantabuntur gressus eius.
onsiderat peccor iustum: 4 que
rit mortificare cum.
ominus aut non derelinquet eu
in manibz eius: nec dampnabit
eum cum iudicabitur illi.
xpecta dnm 4 custodi uiam ei
4 exaltabit te ut hereditate capies

iam cum pierint pctores uidebis.
idi impium superaltatum: 4 ele
uatum sicut cedros libani.
et transiui: 4 ecce non erat: quesiui
eum: 4 non est inuentus locus eius.
ustodi innocenciam: 4 uide e
quitate: qm sunt relique hoi pacifico.
iusti autem disperibunt: simul
relique impiorum interibunt.
alus aut iustor a dno: 4 prector
eor in tempore tribulacois.
et adiuuabit eos dns: 4 liberabit
eos: 4 eruet eos a pctoribz: 4 saluabit
eos. quia sperauerunt in eo.
omine ne in furore tuo ar
guas me: neqz in ira tua

37·

corripias me
In sagitte tue infixe sunt m: et
firmasti super me manum tuam.
Non est sanitas in carne mea a fa
cie ire tue: non est pax ossibz meis.
a facie peccatoz meoum
Quoniam iniquitates mee supgresse
sunt caput meum: sicut onus grane
gravate sunt super me
Putruerunt et corrupte sunt cica
trices mee: a facie insipiencie mee.
Miser factus sum et curuatus sum
usqz in finem: tota die contristat
ingrediebar.
Quoniam lumbi mei impleti
sunt illusionibz: et non est sanitas

in carne mea
Afflictus sum et humiliatus sum
nimis: rugiebam a gemitu cordis
Domine ante te omne
desiderium meum: et gemitus me
us a te non est absconditus.
Cor meum conturbatum est de
reliquit me virtus mea: et lumen ocu
lorum meorum et ipsum non est mecum.
Amici mei et proximi mei: adversum
me appinquauerunt et steterunt.
Et qui iuxta me erant de longe
steterunt: et vim faciebant qui que
rebant aiam meam.
Et qui inquirebant mala michi
locuti sunt vanitates: et dolos to

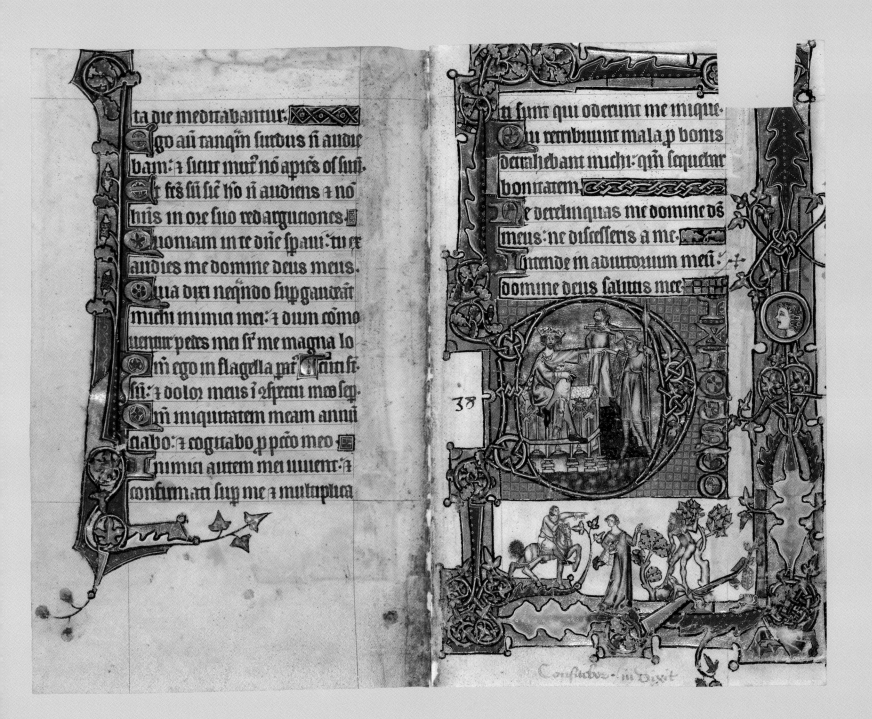

...viam uias meas: ut non deliq̄ i li-
gua mea.
Posui ori meo custodiam: cum con-
sisteret peccator aduersum me.
Obmutui ⁊ humiliatus sum:
⁊ silui a bonis: ⁊ dolor m̄s renoua...
concaluit cor meum... cus est.
...tra me: ⁊ in meditacōe mea ex-
ardescet ignis.
Locutus sum in lingua mea:
notum fac michi dn̄e finem meu.
Et numerum dierum meoꝝ qs
est: ut sciam quid desit michi.
Ecce mensurabiles posuisti dies
meos: ⁊ substancia mea tanqm
nichilum ante te.

...erumptamen uniuisa uanitas:
omnis homo uiuens.
...erumpti in ymagine p̄rtsit
homo: sed ⁊ frustra conturbatur.
Thesaurizat ⁊ ignorat: cui cong
gabit ea.
Et nunc que est expectacio mea:
nonne dominus: ⁊ substanciam me-
a apud te est.
Ab omibz iniquitatibz meis e-
rue me: obprbrium insipiēti cōdisti
Obmutui ⁊ non aperui os me-
um: quoniam tu fecisti amo-
ue a me plagas tuas.
...fortitudine manus tue ego de-
...: in increpacōibz ppter iniqui...

tatem corripuisti hominem.
et tabescere fecisti sicut araneam
animam eius: uerumptm uane
conturbatur omnis homo
Exaudi orōnem meam domine
et deprecacōem meam: auribz percipe
lacrimas meas.
Ne sileas quoniā aduena ego su
apd te: et pegrinus sic oēs pres mei
Remitte michi ut refrigerer priusqz
habeam: et amplius non ero
Expectans expectaui dñm:
et intendit michi.
Et exaudiuit preces meas: et eduxit
me de lacu miserie et de luto fecis.
Et statuit supra petram pedes

meos: et direxit gressus meos.
Et immisit in os meum canticū
nouum: carmen deo nro.
Uidebunt multi et timebunt: et
sperabunt in domino.
Beatus uir cuius est nomen do
mini spes eius: et non respexit in
uanitates et in sanias falsas.
Multa fecisti tu domine ds ms
mirabilia tua: et cogitacōibz tuis
tñ est quis similis sit tibi.
Annunciaui et locutus sum: mul
tiplicati sunt super numerum
Sacrificiū et oblacōem noluisti:
aures autem perfecisti michi.
Holocaustum et p pcō ñ postulas

tu: nunc dixi ecce nemo.
In capite libri scriptum est de
me: ut facerem uoluntatem tuam
deus meus uolui + legem tuam
in medio cordis mei.
Annunciaui iusticiam tuam
in ecta magna: ecce labia mea ñ
phibebo domine tu scisti.
Iusticiam tuam non abscondi
in corde meo: ueritatem tuam et
salutare tuum dixi.
Non abscondi miam tuam + ue
ritatem tuam: a consilio multo.
Tu autem dñe ne longe facias
miseracões tuas a me: mia tua +
ueritas tua semp susceperunt me.

Qui circumdederunt me mala
quoy non est numer: apphenderūt
me iniquitates mee: + non potui
ut uiderem.
Multiplicate sunt sup capillos
capitis mei: + cor meū dēliqt me.
Complaceat tibi dñe ut eruas me
dñe ad adiuuandum me respice.
Confundantur + reuereātur sil'
qui querunt animam meam ut
auferant eam.
Conuertantur retrorsum + reuereā
tur: qui nolunt michi mala.
Ferant confestim confusionem suā:
qui dicunt michi euge euge.
Exultent + letentur sup te omēs

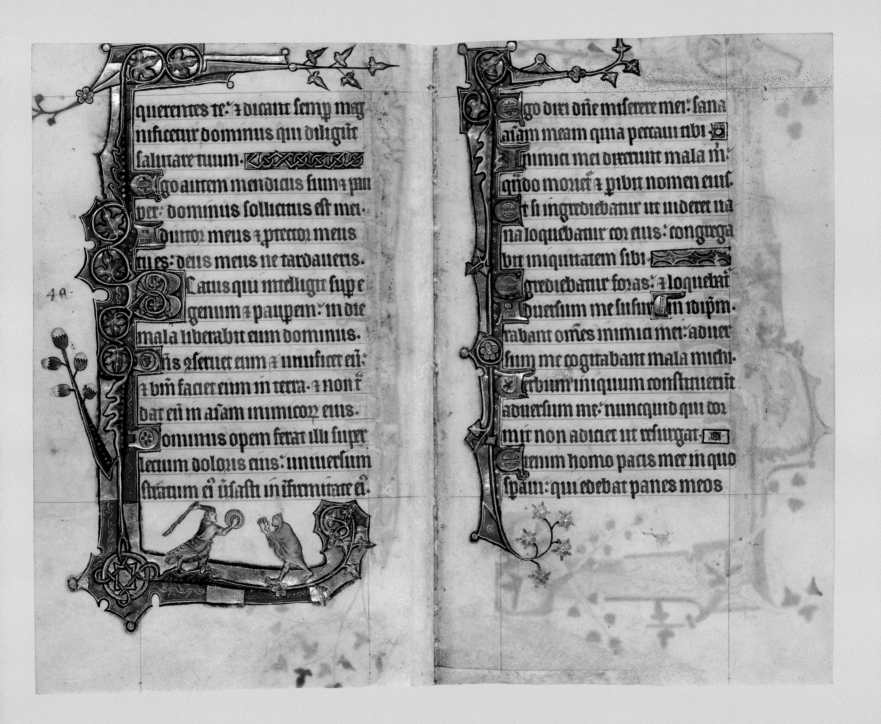

querentes te: 7 dicant semp mag
nificetur dominus qui diligit
salutare tuum.

Ego autem mendicus sum 7 pau
per: dominus sollicitus est mei
adiutor meus 7 protector meus
tu es: deus meus ne tardaueris.

Beatus qui intelligit super
egenum 7 pauperem: in die
mala liberabit eum dominus.

Dominus conseruet eum 7 uiuificet eum:
7 beatum faciet eum in terra. 7 non
tradat eum in animam inimicorum eius.

Dominus opem ferat illi super
lectum doloris eius: uniuersum
stratum eius uersasti in infirmitate eius.

49

Ego dixi domine miserere mei: sana
animam meam quia peccaui tibi.

Inimici mei dixerunt mala m
quando morietur 7 peribit nomen eius.

Et si ingrediebatur ut uideret ua
na loquebatur cor eius: congrega
uit iniquitatem sibi.

Egrediebatur foras: 7 loquebatur
aduersum me susurrabant in idipsum
rabant omnes inimici mei: aduer
sum me cogitabant mala michi.

Verbum iniquum constituerunt
aduersum me: nunquid qui dor
mit non adiciet ut resurgat.

Etenim homo pacis mee in quo
speraui: qui edebat panes meos

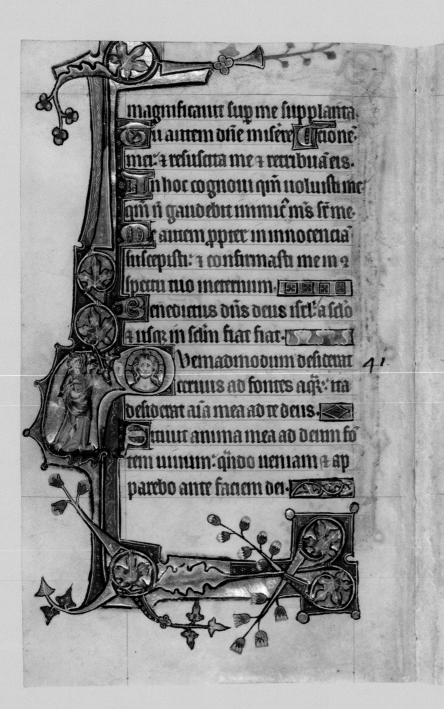

magnificauit sup me supplanta
qui autem die miseri[cor][t]ione
mea: 7 resuscita me 7 retribua eis.
In hoc cognoui qm noluisti me
qm n gaudebit inimic[us] m[eu]s sup me
Me autem ppter innocencia[m]
suscepisti: 7 confirmasti me in co
spectu tuo in eternum.
Benedictus d[omi]n[u]s deus isrl' a s[e]clo
7 usq[ue] in s[e]c[u]l[u]m fiat fiat.
Quemadmodum desiderat
ceruus ad fontes aq[ua]r[um]: ita
desiderat a[n]i[m]a mea ad te deus.
Sitiuit anima mea ad deum fo
tem uiuum: q[ua]ndo ueniam 7 ap
parebo ante faciem dei.

fuerunt michi lacrime mee pa
nes die ac nocte: dum d[icitu]r michi co
tidie ubi est deus tuus.
H[ec] recordatus sum 7 effudi in
me anima[m] meam: quoniam
transibo in locum tabernaculi ad
mirabilis: usq[ue] ad domum dei.
In uoce exultac[i]o[n]is 7 confessio
nis: sonus epulantis.
Quare tristis es anima mea: et
quare conturbas me.
Spera in deo quoniam adhuc
confitebor illi: salutare uultus
mei 7 deus meus.
Ad me ip[su]m anima mea contur
bata est: ppt[er]ea memor ero tui de

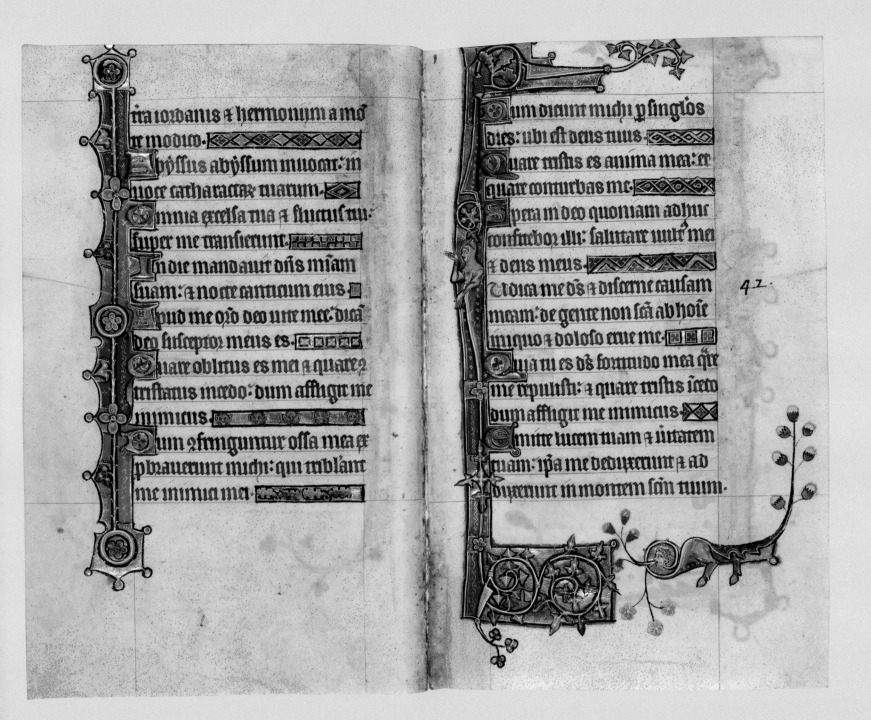

ira ioɩdanıs ⁊ ħermonıɩm a mõ
re moɗıco · ⟨pattern⟩

byssus abyssum ınuocat · ın
uoce catharactar tuarum · ⟨pattern⟩

omnıa excelsa tua ⁊ fluctus tu
super me transıerunt · ⟨pattern⟩

ın ɗıe manɗauıt ɗñs mıam
suam · ⁊ nocte cantıcum eıus · ⟨pattern⟩

puɗ me oɩõ ɗeo uıte mee · ɗıcã
ɗeo suſceptoɩ meus es · ⟨pattern⟩

uare oblıtus es meı ⁊ quare
trıstıs ıncedo · ɗum affligıt me
ınımıcus · ⟨pattern⟩

um confrınguntur ossa mea ex
pɩobauerunt mıchı · quı trıblant
me ınımıcı meı ⟨pattern⟩

um ɗıcunt mıchı p sıngɩos
ɗıes · ubı est ɗeus tuus · ⟨pattern⟩

uare trıstıs es anıma mea · et
quare conturbas me · ⟨pattern⟩

pera ın ɗeo quonıam aɗhuc
confiteboɩ ıllı · salutare uult meı
⁊ ɗeus meus · ⟨pattern⟩

uɗıca me ɗs ⁊ ɗıscerne causam
meam · ɗe gente non sc̃a ab hoĩe
ınıquo ⁊ ɗoloso erue me · ⟨pattern⟩

uıa tu es ɗs foɩtıtuɗo mea quɩe
me repulıstı · ⁊ quare trıstıs ıceɗo
ɗum affligıt me ınımıcus · ⟨pattern⟩

mıtte lucem tuam ⁊ uerıtatem
tuam · ıpsa me ɗeɗuxerunt ⁊ aɗ
ɗuxerunt ın montem scm̃ tuum ·

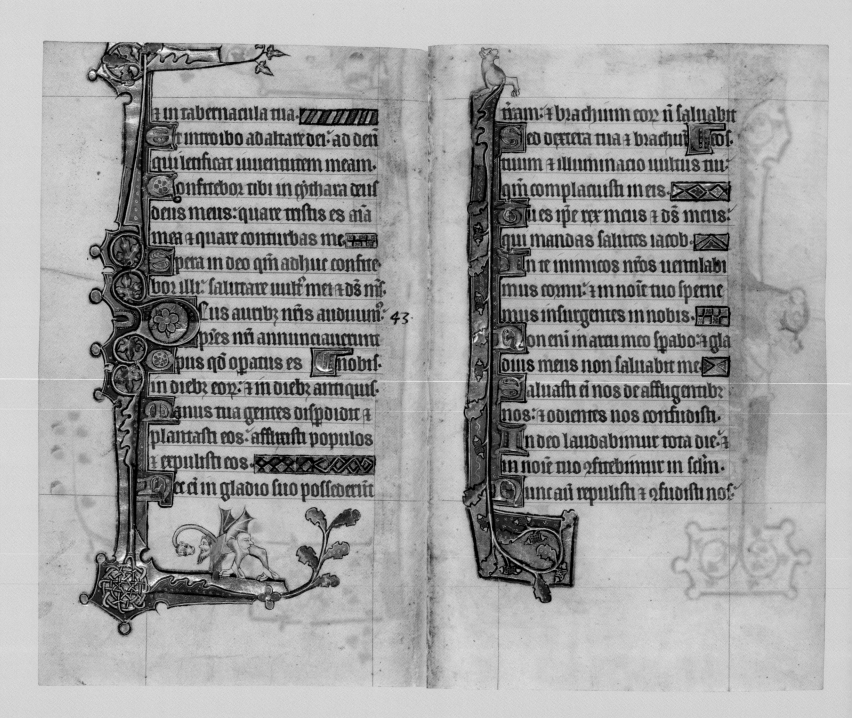

in tabernacula tua.

Et introibo ad altare dei: ad deū
qui letificat iuuentutem meam.

Confitebor tibi in cythara deus
deus meus: quare tristis es aīa
mea & quare conturbas me.

Spera in deo qm adhuc confite
bor illi: salutare uult' mei & dñ mī.

Deus auribz nris audiuim'
pres nri annunciauerunt
opus qd opatus es nobis
in diebz eoꝝ: & in diebz antiquis.

Manus tua gentes disposdit &
plantasti eos: afflixisti populos
& expulisti eos.

Nec eī in gladio suo possederūt

43·

ram: & brachium eoꝝ ñ saluabit

Sed dextera tua & brachiū eos
tuum & illuminacio uultus tui:
qm complacuisti in eis.

Tu es ipe rex meus & dñ meus:
qui mandas salutes iacob.

In te inimicos nros uentilabi
mus cornu: & in noīe tuo sperne
mus insurgentes in nobis.

Non eī in arcu meo spabo: & gla
dius meus non saluabit me.

Saluasti eī nos de affligentibz
nos: & odientes nos confudisti.

In deo laudabimur tota die: &
in noīe tuo ꝯfitebimur in sclm.

Nunc aū repulisti & ꝯfudisti nos.

occisionis.
Exurge quare obdormis dñe
exurge + ne repellas in finem.
Quare faciem tuam auertis ob
liuisceris inopie nñe. + tribl'acois
Quoniam humiliata Enim
est in puluere anima nña. agluti
natus est in terra uenter noster.
Exurge dñe adiuua nos. + redie
nos ppter nomen tuum.
Ructauit cor meum uerbu
bonum. dico ego opera
mea regi
Lingua mea calamus scribe
uelociter scribentis.
Speciosus forma pre filijs hoim.

44

Diffusa est gña in labijs tuis ppte
rea bñdixit te deus ineternum.
Accingere gladio tuo. super fe
mur tuum potentissime.
Specie tua + pulchritudine tua
intende pspe procede + regna.
Propter ueritatem + mansuetu
dinem + iusticiam. + deducet te
mirabiliter dextera tua.
Sagitte tue acute. popli sub te ca
dent in corda inimicorum regis.
Sedes tua deus in sclm scli. uir
ga directois uirga regni tui.
Dilexisti iusticiam + odisti iniqtate
ppta unxit te ds ds tuus oleo le
ticie pre consortib; tuis.

mirra ⁊ gutta ⁊ casia a uestime
tis tuis: a domib; eburneis ex q
b; delectauerunt te filie regum i
honore tuo. Astitit regina a dextris tuis: i
uestitu deaurato: circumdata ua
rietate filia ⁊ uide ⁊ in clina
aurem tuam: ⁊ obliuiscere
ppłm tuum ⁊ domum patris tui
⁊ concupiscet rex decorem tuum
quoniam ipe est dns deus tuus
⁊ adorabunt eum. Et filie tyri in munerib;: uultu
tuum deprecabunt omnes diuites pleb
Omnis gła eius filie regis ab in
tus in fimbrijs aureis: circuma

mictam uarietatib; Adducentur regi uirgines post
eam: proxime eius afferentur tibi
Afferentur in leticia ⁊ exultacõe
adducentur in templum regis. Pro patrib; tuis nati sunt tibi fi
lij: constitues eos principes super
omnem terram. Memores erunt nois tu dne
in omni generacõe ⁊ geriacõem. Propterea popli confitebunt tibi
in eternum ⁊ in scłm scłi. Deus noster refugium ⁊ ui
tus: adiutor in tribłacõib;
que inuenerunt nos nimis. Propterea non timebimus du

45

turbabitur terra: ⁊ transferentur
montes in cor maris.
Sonuerunt ⁊ turbate sunt aq
eoꝝ: conturbati sunt montes in
fortitudine eius.
Fluminis impetus letificat cui
tatem dei: sctificauit tabernacului
suum altissimus.
Deus in medio ei̅ no̅ commoue
bitur: adiuuabit eam deus mane
diluculo.
Conturbate sunt gentes ⁊ incli
nata sunt regna: dedit uocem su
am mota est terra.
Dominus uirtutum nobiscu̅:
susceptor noster deus iacob.

Uenite ⁊ uidete opa domini: q̅
posuit pdigia super terram.
Auferens bella usq̅ ad finem tre
arcum conteret ⁊ confringet arma
⁊ scuta comburet igni.
Uacate ⁊ uidete quoniam ego su̅
deus: exaltabor in gentib; ⁊ exalta
bor in terra.
Dominus uirtutum nobiscum:
susceptor noster deus iacob.
Omnes gentes plaudite ma
nib;: iubilate deo in uoce
exultacionis.
Qm̅ do̅s excelsus: terribilis rex
magnus super omnem terram.
Subiecit populos nobis: ⁊ g̅

sup pedibʒ nr̄s. Elegit nobis hereditatem sua̅ speciem iacob quem dilexit. Ascendit deus in iubilo: ⁊ dr̄s in uoce tube. psallite deo nr̄o psallite. psalli te regi nr̄o psallite. Quoniam rex omnis terre deus: psallite sapienter. Regnabit deus super gentes: ds̄ sedet sup sedem sc̄am suam. Principes populo̅ congregati st̄ cum deo abraham: qm̄ dii fortes terre uehementer eleuati sunt. Magnus dominus ⁊ laudā bilis nimis: in ciuitate dei

nr̄i in monte sanct̄o eius. Fundatur exultacōe uniuse tre: mons syn latera aquilonis ciui tas regis magni. Deus in domibʒ eius cognosce tur cum suscipiet eam. Quoniam ecce reges terre cong gati sunt: conuenerunt in unu. Ipsi uidentes sic admirati sunt: conturbati sunt. commoti sunt. tremor apprehendit eos. Ibi dolores ut parturientis: in spiritu uehementi conteres naues tharsis. Sicut audiuimus sic uidimus in ciuitate dr̄i uirtu: in ciuitate dei nr̄i ds̄ fundauit e̅. Ineunt

Suscepimus deus miam tuam:
in medio templi tui.

Scom nomen tuum deus sic z
laus tua in fines terre. iusticia ple
na est dextera tua.

Letetur mons syon z exultent
filie iude: ppt iudicia tua dne.

Circumdate syon z complectimi
ni eam narrare in turribz eius.

Ponite corda nostra in virtute ei.

Et distribuite domos eius ut enar
retis in progenie altera.

Quoniam hic est deus deus nr
in eternum z in secula seculi: ipse reget
nos in secula.

Audite hec omnes gentes:

48.

auribz percipite qui habitatis orbem.

Quique terrigene z filii hominum:
simul in unum diues z pauper.

Os meum loquetur sapiam: z
meditacio cordis mei prudencia.

Inclinabo in parabolam aurem
meam: apiam in psalterio proposi
cionem meam.

Cur timebo in die mala: iniqtas
calcanei mei circumdabit me.

Qui confidunt in virtute sua:
z in multitudine diuiciarum suar.

Frater non redimit redimet
homo: non dabit deo pla
cacionem suam.

Et precium redempcois anime

sue: a laborabit ineternum z ui
uer adhuc in finem.

Non uidebit interitum cum ui
derit sapientes morientes: simul
insipiens z stultus peribunt.

Et relinquent alienis diuicias
suas: z sepulcra eorum domus illor
ineternum.

Tabernacula eorum impgenie zp
genie: uocauerunt nomina sua
in terris suis.

Homo cum in honore eet non in
tellexit: comparatus est iumentis i
sipientibz z similis fcus est illis.

Et uia illor scandalum ipsis: z
postea in ore suo complacebunt.

sicut oues in inferno positi sc:
mors depascet eos.

Et dominabunt eor iusti i ma
tutino: z auxilium eor ueterasset
in inferno a gloria eorum.

Verumptn deus redimet aiam
meam: de manu inferi cum accipit
me cum uiueris cum diues. Ne
ss fuerit homo: z cum multipli
cata fuerit gloria domus eius.

Quoniam cum interierit no su
met omnia: neq; descendet cum eo
gloria eius.

Quia anima eius in uita ipsius
benedicetur: confitebitur tibi cu
benefeceris ei.

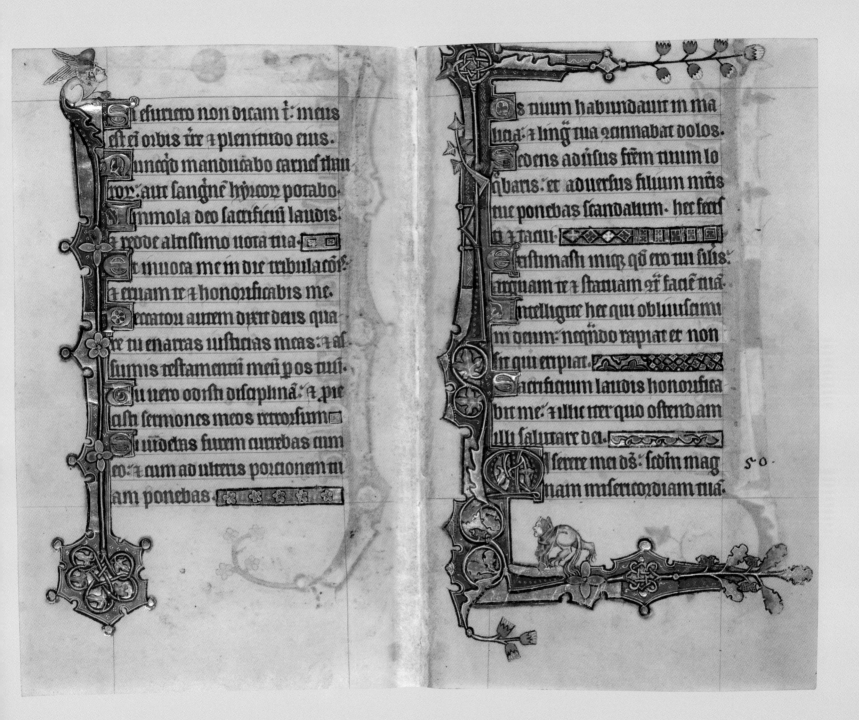

Si esuriero non dicam t: meus
est et orbis tre a plenitudo eius.
Nunc qd manducabo carnes tau
rox: aut sangne hircox potabo
Immola deo sacrificui laudis:
a rede altissimo uota tua. ◻ ▨
Et inuoca me in die tribulacois:
eruam te a honorificabis me.
Peccatoli autem dixit deus qua
re tu enarras iusticias meas: a as
sumis testamentui meui p os tui.
Tu uero odisti disciplinā. a pie
casti sermones meos retrorsum ◻
Si uidebas furem currebas cum
eo: a cum adulteris porcionem tu
am ponebas. ▨▨▨▨▨▨

os tuum habundauit in ma
litia: a lingua tua ccinnabat dolos.
Sedens aduisus frem tuum lo
qbaris: et aduersus filium mris
tue ponebas scandalum. hec feci
sti a tacui ◼◻◻◼◻
Existimasti inique qd ero tui silis:
arguam te a statuam ea facie tua.
Intelligite hec qui obliuiscimi
ni deum: nequando rapiat et non
sit qui eripiat. ◼◼◼◼
Sacrificium laudis honorifica
bit me: a illic iter quo ostendam
illi salutare dei. ◻◼◻
Miserere mei ds: secdm mag
nam misericordiam tuam.

5 o·

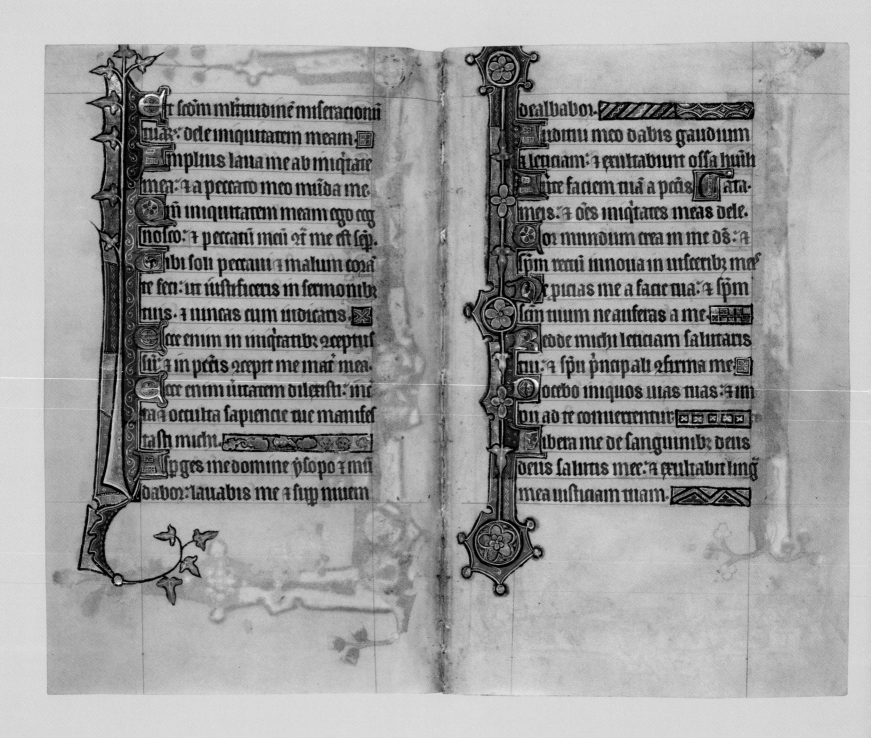

Et secundum multitudinem miseracionum
tuarum: dele iniquitatem meam. Am
plius lava me ab iniquitate
mea: et a peccato meo munda me.
Quoniam iniquitatem meam ego cog
nosco: et peccatum meum contra me est semper.
Tibi soli peccavi et malum cora
te feci: ut iustificeris in sermonibus
tuis: et vincas cum iudicaris. Ecce
Ecce enim in iniquitatibus conceptus
sum: et in peccatis concepit me mater mea.
Ecce enim veritatem dilexisti: incer
ta et occulta sapiencie tue manifes
tasti michi. Asperges me domine ysopo et mun
dabor: lavabis me et super nivem

dealbabor. Audi
tui meo dabis gaudium
et leticiam: et exultabunt ossa humi
liata. Averte faciem tuam a peccatis
meis: et omnes iniquitates meas dele.
Cor mundum crea in me deus: et
spiritum rectum innova in visceribus me
is. Ne proicias me a facie tua: et spiritum
sanctum tuum ne auferas a me.
Redde michi leticiam salutaris
tui: et spiritu principali confirma me.
Docebo iniquos vias tuas: et im
pii ad te convertentur. Libera
me de sanguinibus deus
deus salutis mee: et exultabit lingua
mea iusticiam tuam.

74v 75r

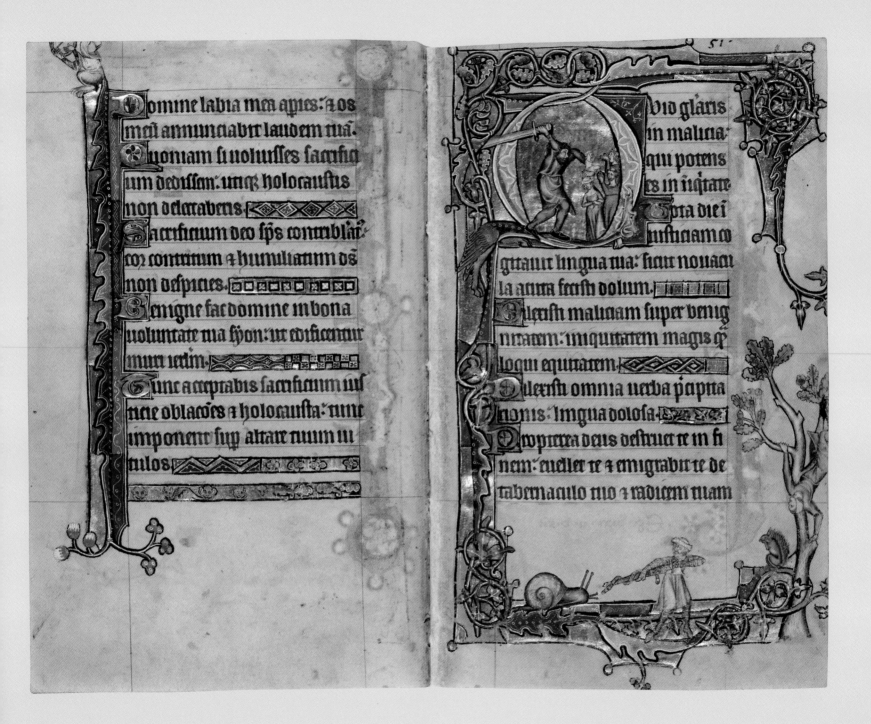

omine labia mea aperies: + os
meū annūciabit laudem tuā.
Quoniam si noluisses sacrifi
um dedissem: utique holocaustis
non delectaberis.
Sacrificium deo spūs contribulatus
cor contritum + humiliatum dſ
non despicies.
Benigne fac domine in bona
voluntate tua syon: ut edificentur
muri ierlm.
Tunc acceptabis sacrificium iust
icie oblacōes + holocausta: tunc
imponent sup altare tuum ui
tulos

uid glaris
in malicia
qui potens
es in iniqtate
Tota die in
iusticiam co
gitauit lingua tua: sicut nouacu
la acuta fecisti dolum.
Dilexisti maliciam super benig
nitatem: iniquitatem magis q̄
loqui equitatem.
Dilexisti omnia uerba precipita
tionis: lingua dolosa.
Propterea deus destruet te in fi
nem: euellet te + emigrabit te de
tabernaculo tuo + radicem tuam

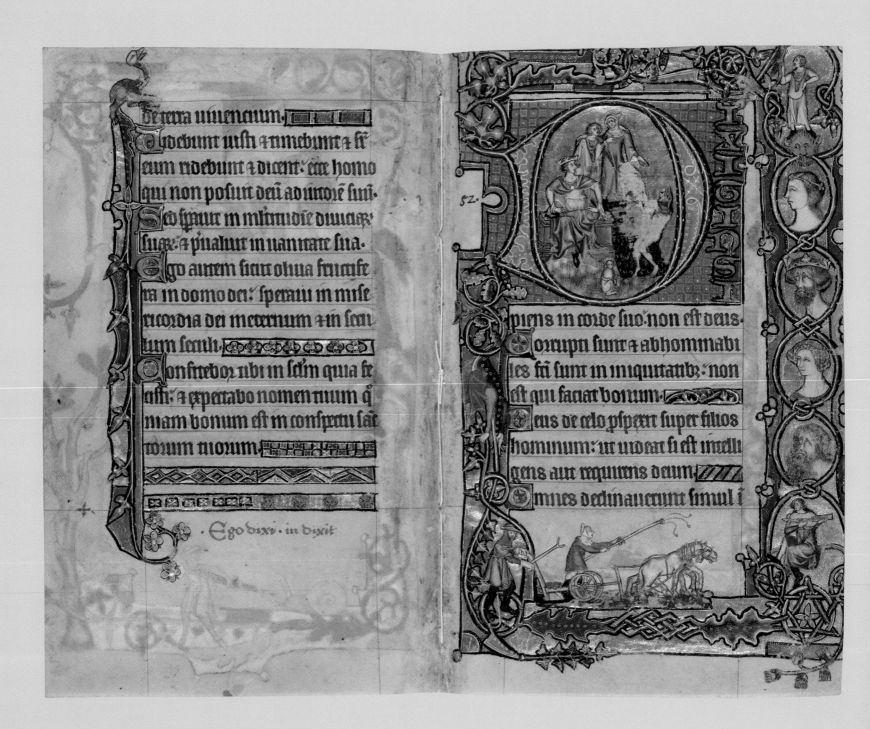

de terra uiuentium·

Uidebunt iusti 4 timebunt 4 sup
eum ridebunt 4 dicent· ecce homo
qui non posuit deii adiutorē suū·
Sed sperauit in mltitudine diuiciax
suax· 4 pualuit in uanitate sua·
Ego autem sicut oliua fructife
ra in domo dei· speraui in mise
ricordia dei in eternum 4 in secu
lum seculi·

Confitebor tibi in secm quia fe
cisti· 4 expectabo nomen tuum quo
niam bonum est in conspectu sanc
torum tuorum·

· Ego dixi· in dixit

piens in corde suo· non est deus
Corrupti sunt 4 abhominabi
les fri sunt in iniquitatibz· non
est qui faciat bonum·

Deus de celo prospexit super filios
hominum· ut uideat si est intelli
gens aut requirens deum·

Omnes declinauerunt simul i

uirales fii sunt: non est qui faciat
bonum. non est usqz ad unum.
onne sciant omnes qui opant
iniquitatem: qui deuorant plebē
meam ut cibum panis.
enim non inuocauerunt illuc
trepidauerunt timore: ubi non sūt
quoniam deus dissi t timor.
pauit ossa eoz qui hominib; pla
cent: cōfusi sūt qm ds spreuit eos.
uis dabit ex syon salutare isrl:
cum conuerterit dominus capti
uitatem plebis sue exultabit ia
cob z letabitur isrl.
eus in nomine tuo saluū
me fac: z in uirtute tua in

53.

dica me.
eus exaudi oroem meam: au
ribz percipe uerba oris mei
uoniam alieni insurrexerunt
aduersum me: z fortes quesierunt
animam meam: z non pposueri
deum ante conspectū suum.
cce enim deus adiuuat me: z
dns susceptor est anime mee.
uerte mala inimicis meis: z i
uritate tua disperde illos.
oluntarie sacrificabo tibi: z cō
fitebor noi tuo qm bonum est
uoniam ex omni tribulacōe
eripuisti me: z sup inimicos me
os despexit oculus meus

diffem me forlitan ab eo.
u vero homo unanimis: dux
meus ⁊ notus meus.
ui simul mecum dulces capi
ebas cybos: in domo dei ambu
lauimus cum consensu.
eniat mors sup illos: ⁊ descen
dunt in infernum uiuentes.
honiam nequicie inhitaculis
eo~um: in medio eo~um.
go autem ad dominum clama
ui: ⁊ dominus saluabit me.
espe ⁊ mane ⁊ meridie: narrabo
⁊ annunciabo ⁊ exaudiet uocem mea.
edimet in pace animam mea.
ab his qui appinquit michi qm

uper multos erant mecum.
xaudiet deus ⁊ humiliabit il
los: qui est ante secula.
Non enim est illis comutacio ⁊
non timuerunt deum extendit
manum suam in retribuendo.
ontaminauerut testamentu
eius: diuisi sunt ab ira uultus e⁵
⁊ appinquauit cor illius.
Molliti sunt sermones el super
oleum: ⁊ ipi sunt iacula.
Iacta sup dominum curam tu
am ⁊ ipe te enutriet: non dabit i
eternum fluctuacoem iusto
u vero deus deduces eos: in
puteum in interitus.

onfitebor tibi in ppl's due: et
psalmum dicam tibi in gentibz.
Quoniam magnificata est usz
ad celos misericordia tua: et usza ad
nubes veritas tua.
Exaltare sup celos deus: et supr
oem terram gloria tua.
ut liuere unigz iusticiam loq
mini: recte iudicate filii ho
minum.
Etenim in corde iniqtates opa
mini in terra: iniusticias manus
ure concinnant.
Alienati sunt peccores a uulua:
errauerunt ab utero locuti sunt
falsa.

furor illis secdm similitudine
serpentis: sicut aspidis surde et
obturantis aures suas.
Que non exaudiet vocem inca
tantis: et venefici incantantis sa
pienter.
Deus conteret dentes eorum in ore ipsor: molas leonum
confringet dominus.
Ad nichilum deuenient tancz
aqua decurrens: intendit arcum
suum donec infirmentur.
Sicut cera que fluit auferentur:
supcecidit ignis et non viderunt sole.
Priusquam intelligerent spine
ure ramprum: sicut viuentes sic
in ira absorbet eos.

...erabmur uiftus cum uidern
iudictam: manus suas lauabit
in sanguine peccatoris. ·[]·
r diret homo si uruqz est fruct
iusto: uruqz est deus iudicans eos
ripe me de in []in iia· 58
mias deus meus: 7 ab in
surgentibz in me libera me.·[]·
ripe me de opantibz inichtate:
7 de uiris sanginum salua me.
quia ecce ceptunt aiam meam:
irruerunt in me fortes. ·[]·
eqz iniquitas mea neqz pctm
meum domine: sine iniquitate
cucurri 7 direxi·[]·
urge in occursum meum 7

uoc. · 7 tu dne deus uirtutu dns isrl·
ntende ad uisitandas omnes
gentes: non miserearis omnibz
qui opantur iniquitatem []·
onuertantur ad uespam 7 fa
mem pacient ut canes: 7 circuibt
cce loquentur in []ciuitate.
ore suo: 7 gladius in labiis eoz
quoniam quis audiuit.·[]·
t tu dne deridebis eos. 7 ad ni
chilum deduces omnes gentes.
ortitudinem meam ad te cus
todiam: quia deus susceptor ms
deus meus misa eius puentet me.
eus ostendit michi sup inimi
cos meos: ne occidas eos neqnco

obliuiscantur populi mei ✠
dispge illos in uirture tua: 7 de
pone eos pretor meus domine.
Delictum oris eop sermonem
labiop ipopum: 7 comprehenda
tur in superbia sua.
Et de execracoe 7 mendacio: an
nunciabunt in osummacione.
In ira consummacois: 7 non
erunt: 7 scient quia deus domi
nabitur iacob 7 finium terre.
Conuertentur ad uespam 7 fa
mem pacientur ut canes: et cir
cuibunt ciuitatem.
Ipsi dispgentur ad manduca
dum: si uero non fuerint satu

rem 7 murmurabunt.
Ego autem cantabo fortitudine
tuam: 7 exaltabo mane mia tua.
Quia frs es susceptor ms: 7 resu
gium meum in die triblacois mee.
Aiutor meus tibi psallam: qa
deus susceptor meus es deus ms
misericordia mea.
Eus repulisti nos 7 destrux
isti nos: iratus es 7 miser
tus es nobis.
Commouisti terram 7 conibas
ti eam: sana contricoes eius qa
comota est.
Ostendisti ppló tuo dura: potasti
nos uino compuncionis.

59.

Quoniam tu deus meus exaudi
ti orationem meam: dedisti heredi
tatem timentibz nomen tuum.
Dies sup dies regis adicies an
nos eius usqz in diem generacio
nis z generacionis.

Permanet ineternum in conspec
tu dei. misericordiam z veritatem
eius quis requiret.

Sic psalmum dicam noi tuo i
sclm scli: ut reddam nota mea de
die in diem.

Nonne deo subiecta erit aia
mea: ab ipso eni salutare
meam z ipse deus meus z meu.
z salutaris meus: susceptor ms

61.

non mouebor amplius.
Quousqz irruitis in hominem
interficitis univsi uos: tanquam
pieti inclinato z macerie depulse.
Verumptn precium meum co
gitauerunt repellere: cucurri insi
ti ore suo benedicebant: z corde suo
maledicebant.
Verumptn deo subiecta esto aia
mea: qm ab ipso paciencia mea.
Quia ipse deus meus z salutaris
meus: adiutor meus n emigbo.
In deo salutare meum z gloria
mea: deus auxilii mei z spes mea
in deo est.
Sperate in eo omnis congegacio

popuh: effundite coram illo cor
da uña deus adiutor nr meinñ
Jerumptñ uani filu hominū
mendaces filu hominum in sta
teris: ut decipiant de uanitate i
Qolite sparē inichtate Jdoipm.
ñ sapmas nolite apipiscere: diuiae
si affluant nolite cor apponere
Semel locutus est deus duo hec
audiui: quia potestas dei est ñ n
bi dñe mīa. quia tu reddes unicui
ep uprta opera sua
Dus deus meus: ad te de
luce uigilo
Siuiuit inte anima mea: quā
multiplicter ubi caro mea

In terra deserta inuia ñ maēfla
sic in seō apparui ubi: ut uiderem
uirutuem tuam ñ gloriam tuam.
Quoniam melior est mīa tua se
uitas: labia mea laudabunt te
he bñdicam te in uita mea: ñ in
noīe tuo leuabo manus meas.
Sicut adype ñ pmguedine reple
atur anima mea: ñ labiys ēultā
tiois laudabit os meum.
Sic memor fui tui sup stratum
meum in matutinis meditabor
in te: quia fuisti adiutor meus.
Et in uelamento alarū tuarū eaul
tabo: adhesit anima mea post te
me suscepit derxtra tua.

88v (left column):

Ipi uero in uanum quesierūt
aīam meam: introibunt in
inferiora terre. tradentur in mañ
gladii. partes uulpiū erūt.
Rex uero letabitur in deo lauda
buntur omnes qui iurant in eo:
quia obstructū est os loqnetiū iniq.
Exaudi deus orōem meam
cum deprecor: a timore ini
mici eripe anima meam.
Protexisti me a conuentu malig
nanciū: a multitudine opāte
ium iniquitatem.
Quia exacuerunt ut gladium liñ
guas suas: intenderunt arcū rem
amaram. ut sagittent in occultis

63.

89r (right column):

immaculatum.
Subito sagittabunt eum a nō
timebunt: firmauerunt sibi ser
monem nequam.
Narrauerunt ut absconderēt laqōs
dixerunt quis uidebit eos.
scrutati sunt iniquitates: defece
runt scrutantes scrutinio.
Accedat homo ad cor altum: a ex
altabitur deus.
Sagitte paruulor fce sunt plage
eorū: a infirmate sunt contra eos
lingue eorum.
Conturbati sunt omēs qui uide
bant eos: a timuit omnis homo.
Et annunciauerunt opa dei: a

facta eius intellexerunt.
Letabitur iustus in domino et
sperabit in eo: et laudabuntur om
nes recti corde.
Te decet ympnus deus in
syon: et tibi reddetur uotum in ie
rusalem. Exaudi orationem meam. Iherusale.
ad te omnis caro ueniet.
Uerba iniquorum preualuerunt
sup nos. et impietatibus nostris tu p
piciaberis.
Beatus quem elegisti et assump
sisti: inhabitabit in atriis tuis.
Replebimur in bonis domus
tue. sanctum est templum tuum mi
rabile in equitate.

Exaudi nos deus salutaris nr̄:
spes omnium finium trē et in mari lon
preparans montes in ui. Prege
num tua: accinctus potencia qui
turbas profundum maris. sonum
fluctuum eius.
Turbabuntur gentes et timebi
qui habitant terminos a signis
tuis: exitus matutini et uespe delec
Uisitasti terram et inebri. Et abis
asti eam: multiplicasti locupletare
flumen dei repletum. Eam
est aquis: parasti cibum illorum quo
niam ita est preparacio eius.
Riuos eius inebrians multipli
ca germina eius: in stillicidiis ei

letabitur germinans. Benedices coronे anni benigni
tatis tue: ꝗ campi tui replebuntur
ubertate. Pinguescent speciosa deserti: ꝗ ex
ultacōe colles accingentur. Induti sunt arietes ouium: ꝗ ual
les habundabunt frumento: cla
mabunt etenim ꝗ ympnum dicent. Iubilate deo omnis terra: psalmū
dicite nomini eius · date gloriam
laudi eius. Dicite deo quam terribilia sunt
opa tua domine: in multitudine
uirtutis tue mencientur tibi ini
mici tui.

Omnis terra adoret te deus ꝗ psal
lat tibi: psalmū dicat noī tuo. Uenite ꝗ uidete opa domini: ter
ribilis in ꝓsiliis sup filios hoīm. Qui ꝗuertit mare in aridam: in
flumine ꝓsibunt pede ibi letabi
mur in ipo. Qui dominatur in uirtute sua
in eternum: oculi eius sup gentes
respiciunt. qui exasparunt non ex
altentur in semetipis. Benedicite gentes deum nm̄: ꝗ
auditam facite uocem laudis eī. Qui posuit aīam meam ad ui
tam: ꝗ non dedit in commociōē
pedes meos.

uoniam pbasti nos deus ig
ne nos exammasti: sicut examina
tur argentum·

nduxisti nos in laqueum: po
suisti tribulacoes in dorso nro: im
posuisti homines sr capita nra·

ransiuim p ignem z aqm: et
eduxisti nos in refrigerium·

ntroibo in domum tuam in
holocaustis: reddam tibi uota
mea que distinxerit labia mea·

t locutum est os meum: in tri
bulacione mea·

olocausta medulla offeram t
cum incenso arietum: offeram ti
bi boues cum hyrcis·

enite audite z narrabo omes
qui timetis deum: quanta fecit a
nime mee·

d ipm ore meo clamaui: z exul
taui sub lingua mea·

niqtatem si aspexi in corde meo:
non exaudiet dominus·

ropr ea exaudiuit deus: z atte
dit uoci deprecacois mee·

enedictus deus qui non amouit
oronem meam: z miam suam a me

eus misereatur nri z bene
dicat nobis: illuminet uul
tum suum sup nos z misereat nri·

t cognoscamus in terra uiam
tua: in omib; gentib; salutare tu
um·

66

onfiteantur tibi populi deus:
confiteantur tibi populi omnes.
Letentur 7 exultent gentes. qm
iudicas populos in equitate 7 gē
tes in terra dirigis.

onfiteantur tibi populi deus
confiteantur tibi populi omnes:
terra dedit fructum suum

enedicat nos deus deus noster
benedicat nos deus: 7 metuant eū
omnes fines terre.

xurgat deus 7 dissipentur 67
inimici eius: 7 fugiant qui
oderunt eum a facie eius.

cut deficit fumus deficient: si
cut fluit cera a facie ignis. sic pe

ant peccatores a facie dei.
t iusti epulentur 7 exultent in
conspectu dei: 7 delectentur in leticia.
antate deo psalmum dicite no
mini eius: iter facite ei qui ascen
dit sup occasum dominus nomen illi.
xultate in conspectu eius turba
buntur a facie eius patris orphanoz
7 iudicis uiduarum.
eus in loco sancto suo: deus qui in
habitare facit unius morris in domo.
ui educit uinctos in fortitudine:
similiter eos qui exasperant qui ha
bitant in sepulcris.
eus cum egredereris in conspectu
ppli tui: cum pertransires in deserto.

Left column (93v):

Terra mota est: etenim celi distillauerunt. a facie dei synay· a facie dei isrł·

Pluuiam uoluntariam segregabis deus hereditati tue: z infirmata est: tu uero pfecisti eam·

Animalia tua habitabunt i ea:
pasti in dulcedine tua paupi deus·

Dominus dabit uerbum euuāgelizantibz: uirtute multa·

Rex uirtutum dilecti dilecti: z speciei domus diuidere spolia·

Si dormiatis intr medios cleros
penne columbe deargentate: z posteriora dorsi eius in pallore auri·

Dum discernit celestis reges sup

Right column (94r):

eam: niue dealbabuntur in selmō
mons dei mons pinguis·

Mons coagulatus mons pinguis:
ut quid suspicamini montes coagulatos·

Mons in quo bene
placitum est deo habitare in eo: et
enim dominus habitabit in fine·

Currus dei decem milibz multiplex milia letantium: dominus
in eis in syna in sancto·

Ascendisti in altum cepisti captiuitatem: accepisti dona in hoibz·

Etenim non credentes. inhabitare
dominum deum·

Benedictus dominus die cotidie: pspum
iter faciet deus salutarium nrōz·

deus noster deus saluos facien
di: + domini domini exit mortis.
Verumptn deus confringet ca
pita inimicorum suorum: verti
cem capilli pambulancium in
delictis suis.
Dixit dominus ex basaan con
uertam. conuertam in pfundū maris.
Et intinguatur pes tuus in sā
guine: lingua canum tuorum ex ini
micis ab ipso.
Viderunt ingressus tuos deus:
ingressus dei mei regis mei qui
est in sancto.
Preuenerunt pncipes coniuncti
psallentibz: in medio iuuencula̅

tympanistriarum.
In ecclesijs benedicite deo: domi
no de fontibz isrl.
Ibi beniamin adolescentulus:
in mentis excessu.
Principes iuda duces eorum: pin
cipes zabulon + principes neptali.
Manda deus uirtuti tue: confir
ma hoc deus quod operatus es
in nobis.
A templo tuo in ierlm: tibi offe
rent reges munera.
Increpa feras arundinis cong
gatio tauror in uaccis populorū:
ut excludant eos qui probati sūt
argento.

ssipa gentes que bella nolu[n]t
uenient legati ex egypto ethiopia
preueniet manus eius deo ·
Regna terre cantate deo : psallite
domino.
Psallite deo qui ascendit super
celum celi : ad orientem ·
Ecce dabit uoci sue uocem uir
tutis : date gloriam deo sup isr[ahe]l ·
magnificencia eius + uirtus eius
in nubibus.
Mirabilis deus in s[an]c[t]is suis : d[eu]s
isr[ahe]l ip[s]e dabit uirtutem + forti[tu]
dinem plebis sue benedictus d[eu]s·

Exultauit . in dixit

Q[u]oniam zelus domus tue co[n]
medit me : + obprobria exp[ro]brantiu[m]
tibi ceciderunt super me ·
Et operui in ieiunio anima[m] mea[m] :
+ factum est in obprobrium michi.
Et posui uestimentum meum cili
cium : + factus sum illis in pabola[m] ·
Aduersum me loquebantur qui
sedebant in porta : + in me psalle
bant qui bibebant uinum.
Ego uero orationem meam ad te
domine : tempus beneplaciti d[eu]s·
In multitudine m[isericordi]e tue exaudi
me : in ueritate salutis tue ·
Eripe me de luto ut non infigar :
libera me ab his qui oderunt me

a deplidois aquax.
Non me demergat tempestas a
que. neqz absorbeat me pfundu:
neqz urgeat sup me puteus os su
Exaudi me domine qm. Tuum
benigna est msa tua. scdm mul
titudmem miseracionum tuax:
respice in me.
Et ne auertas faciem tuam a
puero tuo: quoniam tribloz ue
lociter exaudi me
Intende anime mee a libera e
am: ppter inimicos meos erype
Tu scis imppium me. Tme
um a confusionem meam: a re
uerenciam meam.

En conspectu tuo sunt omnes
qui tribl'ant me. imppium erpe
tauit cor meum a miseriam.
Et sustinui qui simul contristare
tur a non fuit: qui consolaretur
a non mueni.
Et dederunt in escam meam fel:
a in siti mea potauerunt me aceto.
Fiat mensa eoz coram ipis in
laqueum. a in retribuciones a in
scandalum.
Obscurentur ocli eoz ne uideant
a dorsum eoz semper incurua.
Effunde sup eos iram tuam. a
furoz ire tue comprehendat eos.
Fiat hsitacio eoz deserta: a in ta

bernaclis eor ñ sit qui inhabitet.
Quoniam qm tu pcussisti psecuti sunt: ᴣ sup dolorem uulnez eorum addiderunt.
Appone miquitatem sup miquitatem eorum: ᴣ non intrent in usticiã tuã.
Deleantur de libro uiuencium: ᴣ cum ustis non scribantur.
Ego sum paup ᴣ dolens salus tua deus suscepit me.
Laudabo nom dei cum cantico: ᴣ magnificabo eum in laude.
Et placebit deo sup uitulu nouellui: cornua poucentem ᴣ unglas.
Uideant paupes ᴣ letentur: qri

re deum ᴣ uiuet anima uestra.
Quoniam exaudiuit paupes dominus: ᴣ uinctos suos ñ despexit.
Laudent illum celi ᴣ terra: mare ᴣ omnia reptilia in eis.
Quoniam deus saluam faciet syon: ᴣ edificabuntur ciuitates iudee ᴣ inhabitabunt ibi: ᴣ heredicate adquirent eam.
Et semen seruoz eius possidebit eam: ᴣ qui diligunt nomen eius habitabunt in ea.
Deus in adiutorium meum intende: domine ad adiuuandum me festina.
Confundantur ᴣ reuereantur:

69.

qui querunt animam meam · ✶
uertantur retrorsum ꝫ erubes
cant: qui uolunt michi mala ✶
uertantur statim erubescētes:
qui dicunt michi euge euge
exultent ꝫ letentur in te omnes
qui querunt te: ꝫ dicat semp magnifietur
dominus qui diligunt salutare tuum
ego uero egenus ꝫ paup sum:
deus adiuua me ·
adiutor meus ꝫ liberator meus
es tu: domine ne moreris ·
In te domine spaui non confū
dar ineternum: in iusticia tua li
bera me ꝫ eripe me ·
Inclina ad me aurem tuam ꝫ

70·

ꝫ salua me ·
Esto michi in deum protectorem·
ꝫ in locum munitum ut saluū
me facias ·
Quoniam firmamentum meum·
ꝫ refugium meum es tu ·
deus meus eripe me de manu
peccatoris: ꝫ de manu contra legē
agentis ꝫ iniqui ·
Quoniam tu es paciencia domine · do
mine spes mea a iuuentute mea·
In te confirmatus sum ex utero
de uentre matris mee tu es protector
In te cantacio mea sem͂ [t]ms·
per tanquam prodigium factus su
multis: ꝫ tu adiutor fortis ·

99v

Repleatur os meum laude: ut
cantem glam tuam tota die mag
nitudinem tuam.
Ne prieias me in tempore senectu
tis: cum defecerit uirtus mea ne
derelinquas me
Quia dixerunt inimici mei m
et qui custodiebant animam meam
consilium fecerunt in unum
dicentes deus dereliquit eum?
persequimini + comprehendite eu
quia non est qui eripiat
deus ne elongeris a me: deus
meus in auxilium meum respice
confundantur + deficiant det
hentes anime mee: opiantur co

100r

fusione + pudore qui querunt ma
la michi
Ego autem semp sperabo: et
adiciam sup oem laudem tuam.
Os meum annuntiabit iustici
am tua: tota die salutare tuum.
Quoniam non cognoui litte
raturam introibo i potencias dni
memorabor iusticie tue soli.
deus docuisti me a iuuentute
mea: + usque nunc pronunciabo mi
rabilia tua
Et usque in senectam + senium:
deus ne derelinquas me
donec annuncie brachium tuum:
generacoi omni que uentura est.

habundancia pacis: donec aufe-
ratur luna.
Et dominabitur a mari usque
ad mare: et a flumine usque ad ter-
minos orbis terrarum.
Coram illo procident ethiopes:
et inimici eius terram lingent.
Reges tharsis et insule munera
offerent: reges arabum et saba
dona adducent.
Et adorabunt eum omnes reges:
omnes gentes servient ei.
Quia liberavit pauperem a po-
tente: et pauperem cui non erat adiu-
tor pauperi et inopi. Cro-
taias pauperum salvas faciet.

ex usuris et iniquitate redi-
met animas eorum: et honorabile no-
men eorum coram illo.
Et vivet et dabitur ei de auro a-
rabie: et adorabunt de ipso semp
tota die benedicent ei.
Et erit firmamentum in terra in su-
mis moncium: superextolletur
super libanum fructus eius: et flo-
rebunt de civitate sicut fenum ter-
Et nomen eius benedictum in
secula: ante solem permanet nomen e-
Et benedicentur in ipso omnes
tribus terre: omnes gentes magnificab
Benedictus dominus deus israel: Qui
qui facit mirabilia solus.

Et benedictum nomen maiestatis eius in eternum: et replebitur maiestate eius omnis terra fiat fiat.

Quam bonus israel deus: his qui recto sunt corde.

Mei autem pene moti sunt pedes. pene effusi sunt gressus mei.

Quia zelaui super iniquos pacem peccatorum videns.

Quia non est respectus morti eorum: et firmamentum in plaga eorum.

In labore hominum non sunt: et cum hominibus non flagellabuntur.

Ideo tenuit eos superbia: operti sunt iniquitate et impietate sua.

Prodijt quasi ex adipe iniquitas

eorum: transierunt in affectum cordis.

Cogitauerunt et locuti sunt nequitiam: iniquitatem in excelso locuti sunt.

Posuerunt in celum os suum: et lingua eorum transiuit in terra.

Ideo conuertetur populus meus hic: et dies pleni inuenientur in eis.

Et dixerunt quomodo scit deus: et si est scientia in excelso.

Ecce ipsi peccatores et habundantes in seculo: optinuerunt diuicias.

Et dixi ergo sine causa iustificaui cor meum: et laui inter innocentes manus meas.

Et fui flagellatus tota die: et castigacio mea in matutinis.

eus autem rex nr ante secula: operatus est salutem in medio tre. Tu confirmasti in uirtute tua mare: contribulasti capita draconum in aquis.

Tu confregisti capita draconis: dedisti eum escam populis ethiopum.

Tu disrupisti fontes ⁊ torrentes: tu siccasti fluuios ethan.

Tuus est dies ⁊ tua est nox: tu fabricatus es auroram ⁊ solem.

Tu fecisti omnes terminos terre: estatem ⁊ uer tu plasmasti ea.

Memor esto huius inimicus improperabit domino: ⁊ populus insipiens incitauit nomen tuum.

Ne tradas bestiis animas confitentes tibi: ⁊ animas pauperum tuorum ne obliuiscaris in finem.

Respice in testamentum tuum: quia repleti sunt qui obscurati sunt terre domibus iniquitatum.

Ne auertatur humilis factus confusus: pauper ⁊ inops laudabit nomen.

Exurge deus iudica causam tuam: memor esto improperiorum tuorum eorum que ab insipiente sunt tota die.

Ne obliuiscaris uoces inimicorum tuorum: superbia eorum qui te oderunt ascendit semper.

Confitebimur tibi deus

74

confitebimur: 1 innocabimus
nomen tuum.
Narrabimus mirabilia tua cū
accepo tempus: ego iusticias iu
Liquefca est terra 1 oēs. Idicabo.
qui habitant in ea: ego confirma
ui columpnas eius.
Dixi iniquis nolite inique age
a delinquentibz nolite exaltare
Nolite extollere in altū. Ticōmu
comu urm: nolite loqui adusus
deum iniquitatem.
Quia neqz ab oriente neqz ab oc
cidente: neqz a desertis montibz
quoniam deus iudex est.
Dunc humiliat 1 hūc exaltat.

quia calix in manu domini uini
meri plenus mixto
Et inclinauit ex hoc in hoc ue
rūptn fex eius non est exinani
ta bibent ex eo omēs pctōres terre.
Ego autem annunciabo i scm:
cantabo deo iacob.
Et omsa cornua pctōr confringā
a exaltabuntur cornua iusti
Onis in iudea dūs: in irkl
magnum nomen eius.
Et fcs est in pace locus eius: et
habitacio eius in sŷon.
Ibi confregit potencias: arcū
scutum gladium a bellum.
Illuminans tu mirabiliter a

cognaui dies antiquos: 7 annos
eternos in mente habui.
Et meditatus sum nocte cu cor
de meo: 7 exercitabar 7 scopebam
spiritum meum.
Nunquid ineternum piiciet ds:
aut non apponat ut complaci
or sit adhuc.
Aut in finem misediam sua ab
scidet: a generacoe in geriacoem.
Aut obliuiscetur miseri deus:
aut continebit in ira sua mias su
Et dixi nunc cepi. hec mu Cas.
tacio dextere excelsi.
Memor fui opum domini: quia
memor ero ab inicio mirabiliu
Cmor

Et meditabor in omib3 opib3
tuis: 7 in adinuenconib3 tuis exer
Deus in sco uia tua q̄s U for
deus magnus sicut deus nr. tu
es deus qui facis mirabilia.
Notam fecisti in popilis uirtute
tuam: redemisti in brachio tuo po
pulum tuum filios iacob 7 ioseph.
Uiderunt te aque ds uiderunt
te aque: 7 timuerunt 7 turbate sunt
Multitudo sonus aq̄z: Uabissi.
uocem dederunt nubes.
Etenim sagitte tue tūseunt uor
contrua tui in rota.
Illuxerunt chozuscacoes tue oz
bi terre: cōmota est 7 cōtreuuit tra.

In mari uia tua & semite tue in
aquis multis: & uestigia tua non
cognoscentur. ⊠⊠⊠⊠⊠⊠
Deduxisti sicut oues ppl'm tuu:
in manu moysi & aaron.

Attendite pople m's legem 77
meam: inclinate aurem
uram in uerba oris mei ⊠⊠⊠
Apiam in pabolis os meum:
loquar pposicoes ab inicio. ⊠
Quanta audiuimus & cognouim'
ea: & p'res n'ri narrauerunt nobis.
Non sunt occultata a filys eor:
in generacione altera ⊠⊠⊠⊠
Narrantes laudes d'ni & uirtutes
ei: & mirabilia eius que fecit. ⊠

Et suscitauit testimonium i ia
cob: & legem posuit in isr'l: ⊠⊠
Quanta mandauit p'rib; n'ris:
nota facere ea filys suis. ut cog
noscat generacio altera. ⊠⊠⊠
 Filii qui nascentur & exurgent:
enarrabunt filys suis. ⊠⊠⊠
Et ponant in deo spem suam: &
non obliuiscantur opum dei. et
mandata eius exquirant. ⊠⊠⊠
Et fiant sicut p'res eor: genera
cio praua & exasperans. ⊠⊠⊠
Generacio que n direxit cor suu:
& n est creditus cum deo sp's eius. ⊠
Filii effrem intendentes & mitte
tes arcu: uersi sunt in die belli.

Non cuſtodierunt teſtamenti
dei: ⁊ in lege eius noluerunt am
Et obliti ſunt bene bolare
factoz eius: ⁊ mirabilium eius
que oſtendit eis.
Cozam patrib; eozum fecit mirabili
a: in tra egypti in campo taneos.
Interrupit mare ⁊ poduxit eos: ⁊
ſtatuit aquas quaſi in utre
Et deduxit eos in nube diei: ⁊ to
ta nocte in illuminacoe ignis.
Interrupit petram in heremo: ⁊
adaquit eos uelut in abyſſo multa.
Et eduxit aquam de petra: ⁊ deduxit
tanquam flumina aquas.
Et appoſuerunt adhuc peccare

ei: in iram excitauerunt excelſum
in aquoſo.
Et temptauerunt deum in cozdi
b; ſuis: ut peterent eſcas aiab; ſuis.
Et male locuti ſunt de deo: dix
erunt nunqd poterit deus pare
menſam in deſerto.
Qm perſit petram ⁊ fluxerunt
aque: ⁊ torrentes inundauerunt.
nunqd ⁊ panem poterit dare
aut pare menſam populo ſuo.
Ideo audiuit dominus ⁊ diſtu
rignis accenſus eſt in iacob ⁊ ira
aſcendit in iſrl̃
Quia non crediderunt in deo:
nec ſperauerunt in ſalutare eius.

111v

r mandauit nubibʒ defup: ꝗ
ianuas celi aperuit ·

Et pluit illis manna ad man
ducandum: ꝗ pane celi dedit eis.

Panem angeloꝛ manducauit
homo: cybaria misit eis in habũ
dancia ·

Transtulit austrum de celo: ꝗ in
duxit in uirtute sua affricum

Et pluit sup eos sicut puluerem
carnes: ꝗ sicut arenam maris uo
latilia pennata.

Et ceciderunt in medio castroꝛ
eoꝛ: circa tabernacula eorum.

Et manducauerunt ꝗ saturati sr
nimis: ꝗ desiderium eoꝛ attulit

112r

eis non sunt fraudati a desidio suo.

Adhuc esce eoꝛ erant in ore ipm
ira dei ascendit super eos.

Et occidit pingues eoꝛ: ꝗ electos
isrl impediuit

In omnibʒ hiis peccauerunt ad
huc: ꝗ ñ crediderunt in mirabilibʒ ei.

Et defecerunt in uanitate dies eoꝛ
ꝗ anni eoꝛ cum festinacione

Cum occideret eos querebant ei
ꝗ reuertebantur ꝗ diluculo uenie
bant ad eum.

Et rememorati sunt quia ds ad
iutoꝛ est eoꝛ: ꝗ ds excelsus redemp
tor eorum est

Et dilexerunt eum in ore suo: et

lingua sua mentiti sunt ei

Cor autem eoǧ non erat rectū cum eo: nec fideles habiti sunt in testamento eius

Ipse autem est misericors: ⁊ propicius fiet peccatis eoǧ ⁊ non disperdet eos

Et habundauit ut auerteret irā suam: ⁊ non accendit omnem irā suam

Et recordatus est quia caro sunt: spūs uadens ⁊ non rediens

Quociens exacerbauerunt eum in deserto: in iram concitauerūt eum in inaquoso

Et conuersi sunt ⁊ temptauerūt

deum: ⁊ sctm ihsr exacerbauerunt

Non sunt recordati manus eius: die qua redemit eos de manu tribulantis

Sicut posuit in egypto signa sua: ⁊ prodigia sua in campotaneos

Et conuertit in sangnē flumina eoǧ: ⁊ ymbres eoǧ ne biberent

Misit in eos cynomiam ⁊ comedit eos: ⁊ ranam ⁊ disperdidit eos

Et dedit erugini fructus eoǧ: ⁊ labores eoǧ locuste

Et occidit in grandine uineas eoǧ: ⁊ moros eoǧ in pruina

Et tradidit grandini iumenta eoǧ: ⁊ possessionem eoǧ igni

misit in eos iram indignationis
sue: indignacoem 4 iram 4 tribu
lacoem in missiones p angelos
malos.

Uiam fect semite ire sue: non p
pcit a morte aiax eox: 4 iumenta eox
in morte concludit.

Er percussit omie primogenitum
in terra egypti: primicias omis
labous eox in tabernaclis cham.

Et abstulit sicut oues populu
suum: 4 porxit eos tanquam g
gem in deserto.

Er deduxit eos in spe 4 n timuerit
4 inimicos eox opuit mare.

Er induxit eos in montem scti

tacois sue: montem qn adqsiuit
dextera eius.

Et eiecit a facie eox gentes: 4 sor
te diuisit eis iram in funiculo dis
tribucionis.

Et habitare fect in tabernaclis
eox: tribz isrl.

Et temptauerunt 4 exacerbauerit
deum excelsum: 4 testimonia eius
non custodierunt.

Et auerterunt se 4 non seruaueri
pactum: qmadmodum pres eox
conuersi sunt in arcum prauum.

In ira zetauerunt eum in colli
bz suis: 4 in sculptilibz suis ad e
mulacionem eum puocauerunt.

uidonur deus 4 spreuit: 4 ad ni
chilum redegit ualde ister.
Et repulit tabernaclm sylo: ta
bernaclm suum ubi habitauit
in hominib;.
Et tradidit in captiuitatem uir
tutem eoz: 4 pulchritudinem eor
in manus inimici.
Et concludit in gladio suo plm
suum: 4 hereditatem suam spreuit.
Iuuenes eoz commedit ignis:
4 uirgines eoz ñ sunt lamentate.
Sacerdotes eoz in gladio cecide
runt: 4 uidue eoz ñ plorabantur.
Et excitatus est tanquam dormi
ens dominus: tanquam potens

crapulatus a uino.
Et percussit inimicos suos in pos
teriora: opbrium sempiternum
dedit illis.
Et repulit tabernaclm ioseph: 4
tribum effrem non elegit.
Sed elegit tribum iuda: monte
syon quem dilexit.
Et edificauit sicut unicornium
sctificium suum in terra: quam fu
dauit in secula.
Et elegit dauid seruum suum:
4 sustulit eum de gregib; ouium.
de post fetantes accepit eum
pascere iacob seruum suum: 4
isrl' hereditatem suam.

er pauit eos in innocencia cordis
sui: 7 intellectibz manuum suarum
deduxit eos.

Dus uenerunt gentes inhe
reditatem tuam. polluerunt
templum scm tuum. posuerunt
ierlm in pomor custodiam.

Posuerunt mortiana seruorum
tuor: escas uolatilibz celi. carnes
scor tuorum bestiis terre.

Effuderunt sanguinem eor tan
qm aquam in circuitu ierlm: 7 n
erat qui sepeliret.

Facti sumus obprobrium uicinis
nris: subsanacio 7 illusio hiis qui
in circuitu nro sunt.

Vsquo domine irasceris in fi
nem: accendetur uelut ignis zelus
tuus.

Effunde iram tuam in gentes
que te non nouerunt: 7 in regna
que nomen tuum non inuocauerunt.

Quia commederunt iacob: 7 lo
cum eius desolauerunt.

Ne memineris iniquitatum nra
rum antiquarum: cito anticipent nos mie
que qa pauperes facti sumus nimis.

Adiuua nos deus salutaris nr:
7 ppter glam nominis tui domine
libera nos 7 ppicius esto peccatis
nris ppter nomen tuum.

Ne forte dicant in gentibz: ubi est

deus eorum: 4 innotescat in nacio
nibz coram oculis nris. ❧
Gemitus langwinis seruorum tuorum
qui effusus est: introeat in conspec
tu tuo gemitus compeditorum. ❧
Scdm magnitudinem brachii
tui. posside filios mortificatorum.
Et redde uicinis nris septuplum
in sinu eorum: inpropium ipsorum qd ex
probauerunt tibi domine. ❧
Nos autem ppls tuus 4 oues pas
cue tue: confitebimur tibi in sclm.
In generatioem 4 generatioem: anu
ciabimus laudem tuam.
Qui regis isrl intende: qui 79
deducis uelut ouem ioseph. ❧

qui sedes sup cherubyn manifes
tare coram effraym: beniamin et
manasse. ❧
Excita potenciam tuam 4 ueni:
ut saluos facias nos. ❧
Deus uirtutum conuerte nos: 4
ostende faciem tuam 4 salui erimus.
Domine deus uirtutum quousq
es irasceris: super oracionem ser
ui tui.
Cibabis nos pane lacrimarum: 4
potum dabis nobis in lacrimis
in mensura.
Posuisti nos in contradicioem
uicinis nris: 4 inimici nri subsa
nauerunt nos.

eus uirtutum conuerte nos: 7
ostende faciem tuam 7 salui erim'.
Uineam de egypto transtulisti:
eiecisti gentes 7 plantasti eam.
Dux itineris fuisti in conspectu
eius: 7 plantasti radices eius 7 im
pleuit terram.
Operuit montes umbra eius: et
arbusta eius cedros dei.
Extendit palmites suos usq3 ad
mare: 7 usq3 ad flumen ppagine
eius.
Ut quid destruxisti maceriam ei':
7 uindemiant eam omnes qui
pretergrediuntur uiam.
Exterminauit eam aper de silua:

Testimonium in ioseph posuit
illud: cum exiret de terra egypti.lin
guam quam non nouerat audiuit.
Diuertit ab oneribz dorsum ei':
manus eius in cophino seruier't.
In tribulacoe inuocasti me: et
liberaui te 7 exaudiui te in absco
dito tempestatis: pbaui te apud
aquam contradicois.
Audi pps meus 7 contestabor
te: isrt si audieris me non erit inte
deus recens neq3 adorabis deum
alienum.
Ego enim sum dominus deus
tuus qui eduxi te de tra egypti: di
lata os tuum 7 implebo illud.

Et non audiuit ppls ms uocē
meam: 1 isrl' non intendit michi.
Et dimisi eos scdm desideria cor
dis eor: ibūt in ad inuencōib; suis.
Si popl's meus andiss; me. isrl'
si in uiis meis ambulasset.
Pro nichilo forsitan inimicos eoy
humiliassem: 1 sup tribulantes e
os misissem manum meam.
Inimici domini mentiti sunt ei
1 erit tempus eoum in secula
Et cybauit illos ex adype frume
ti: 1 de petra melle saturauit eos.
Deus stetit in synagoga de
oy: in medio autem deos
diiudicat.

$ \times 1 $

Usq quo iudicatis iniquitatē:
1 facies peccatoum sumitis.
Iudicate egeno 1 pupillo: humi
lem 1 pauperem iustificate.
Eripite pauperem 1 egenum: de
manu peccatoris liberate.
Nescierunt neq; intellexerunt in
tenebris ambulant: mouebuntur
oomnia fundamenta terre.
Ego dixi dii estis: 1 filii excelsi oēs.
Uos autem sicut homines mon
emini: 1 sicut unus de principibus
cadetis.
Surge deus iudica terram: quo
niam tu hereditabis in omnib;
gentibus.

et sicut flamma comburens mō
tes: ita persequeris illos in tempesta
te tua: et in ira tua turbabis eos.
Imple facies eorum ignominia:
et querent nomen tuum domine.
Erubescant et conturbentur in
seculum seculi: confundantur et pereant;
Et cognoscant quia nomen tibi
deus: tu solus altissimus in om̄ ter
ra. Quam dilecta tabernacula
tua domine virtutum: con
cupiscit et deficit anima mea in a
tria domini. Cor meum et caro mea: exultaue
runt in deum viuum.

Etenim passer inuenit sibi do
mum: et turtur nidum sibi ubi
reponat pullos suos. Altaria tua domine virtutum:
rex meus et deus meus. Beati qui habitant in domo tu
a domine: in secula seculorum laudabunt te. Beatus vir cuius est auxilium
abs te: ascensiones in corde suo
disposuit in valle lacrimarum in lo
co quem posuit. Etenim benedictiones dabit legis
lator: ibunt de virtute in virtutem:
videbitur deus deorum in syon. Hic deus virtutum exaudi ora
tionem meam: auribus percipe deus iacob.

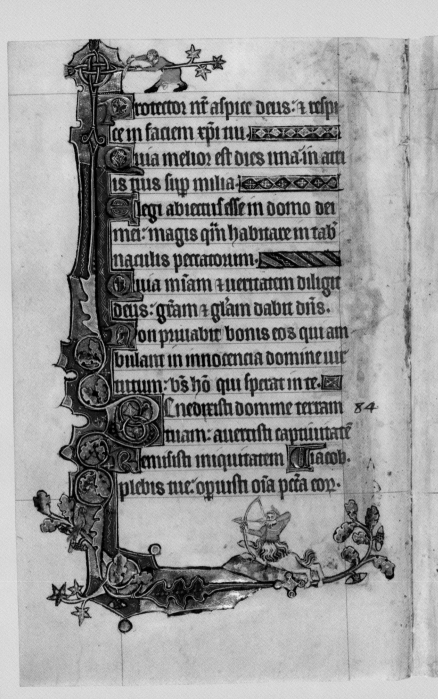

rotector nr aspice deus: ꝉ respi
ce in faciem xpi tui.
Quia melior est dies una in atri
is tuis sup milia.
Elegi abiectus esse in domo dei
mei: magis qin habitare in tab
naculis peccatorum.
Quia miam ꝉ ueritatem diligit
deus: gram ꝉ glam dabit diis.
Non priuabit bonis eos qui am
bulant in innocencia domine uir
tutum: bs ho qui sperat in te.
Benedixisti domine terram 84
tuam: auertisti capuitatem
Remisisti iniquitatem Iacob.
plebis tue: operuisti oia pcta eor.

Mitigasti omnem iram tuam:
auertisti ab ira indignacois tue.
Conuerte nos deus salutaris nr:
ꝉ auerte iram tuam a nobis.
Nunquid ineternum irasceris
nobis: aut extendes iram tuam a
generacione in generacionem.
Deus tu conuersus uiuificabis
nos: ꝉ plebs tua letabitur in te.
Ostende nobis dne miam tuam:
ꝉ salutare tuum da nobis.
Audiam quid loquatur in me
dominus deus: quoniam loque
tur pacem in plebem suam.
Et super scos suos: ꝉ in eos qui
conuertuntur ad cor.

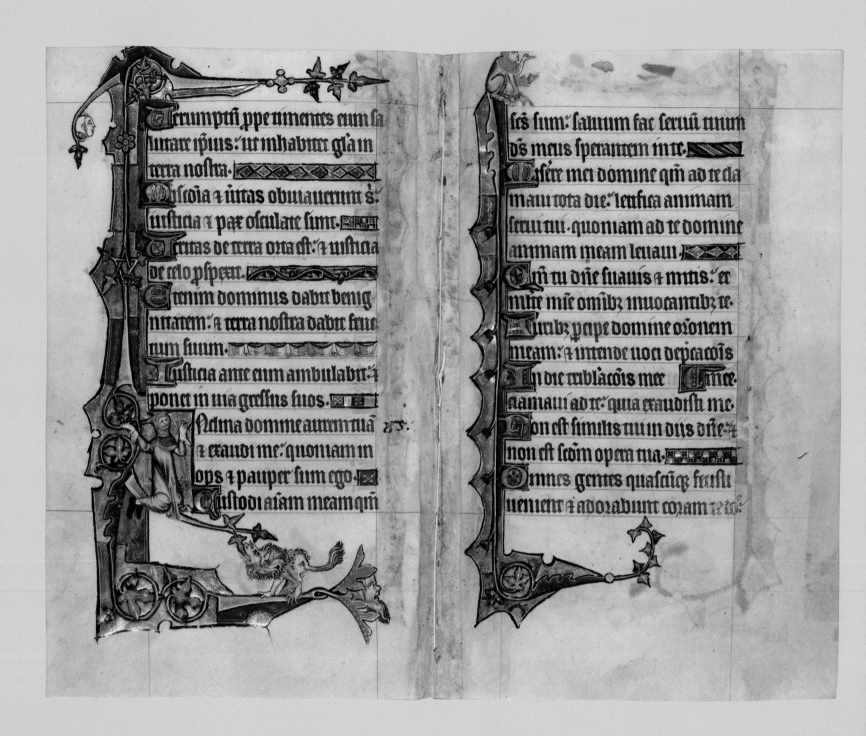

terumptű ppe ūmentes eum sa
lutare ipius: ut inhabitet gła in
terra nostra.

Misericoia ⁊ ūitas obuiauerunt s:
iustitia ⁊ pax osculate sunt.

Ueritas de terra orta est: ⁊ iustitia
de celo pspexit.

Etenim dominus dabit benig
nitatem: ⁊ terra nostra dabit fruc
tum suum.

Iustitia ante eum ambulabit: ⁊
ponet in uia gressus suos.

Inclina domine aurem tuā
⁊ exaudi me: quoniam in
ops ⁊ pauper sum ego.

Custodi aiam meam qm

ses sum: saluum fac seruū tuum
dūs meus sperantem in te.

Misere mei dōmine qm ad te cla
maui tota die: letifica animam
serui tui: quoniam ad te domine
animam meam leuaui.

Qm tu dńe suauis ⁊ mitis: et
multe mie omibz inuocantibz te.

Auribz pcipe domine orōnem
meam: ⁊ intende uoci deprecaōis

In die tribłaōis mee clame
tiam aui ad te: quia exaudisti me.

Non est similis tui in diis dńe: ⁊
non est secm opera tua.

Omnes gentes quascūcz fecisti
uenient ⁊ adorabunt coram te dńe

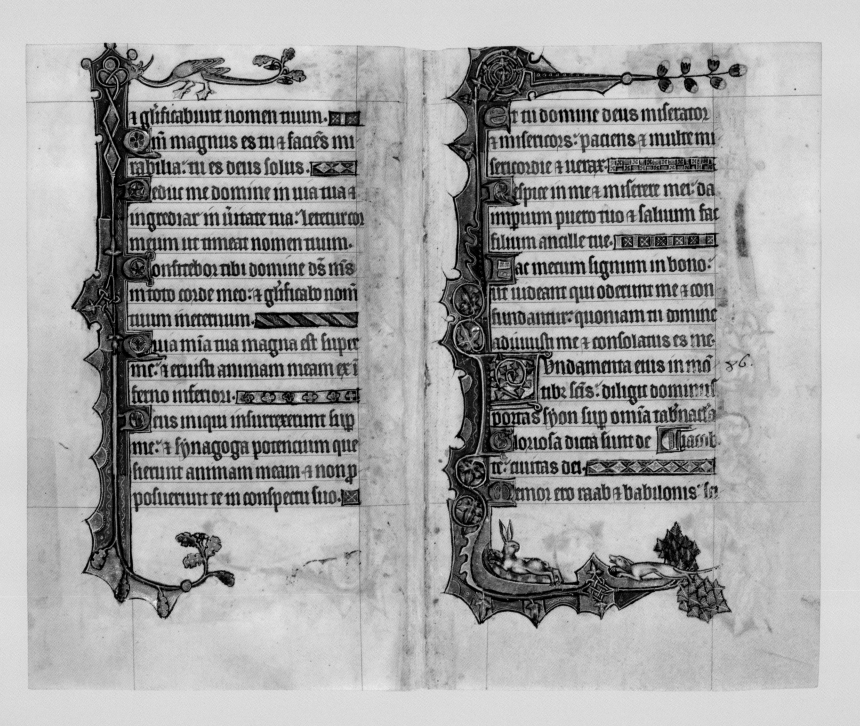

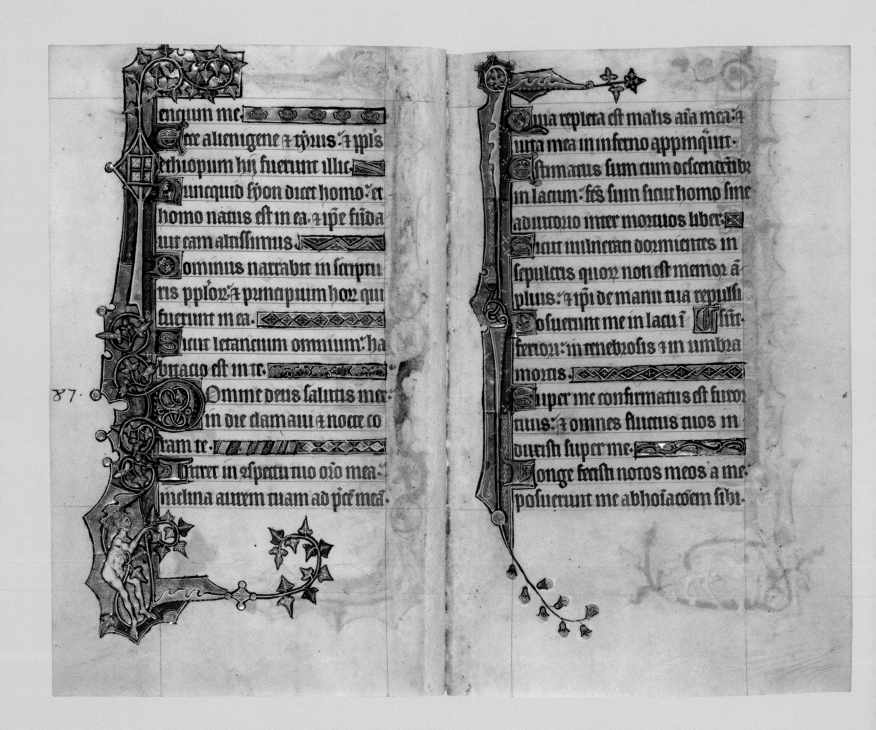

…tas tua in eis.

Disposui testamentum electis meis: iuraui dd seruo meo usq; meum. prepabo semen tuum.

Et edificabo in generacōe ↄ generaccōm: sedem tuam.

Confirebuntur celi mirabilia tua domine: etenim ueritatem tuam in ecclesia sanctorum.

Quoniam quis in nubibz equa buntur domino: similis erit deo in filijs dei.

Deus qui glisicat in consilio scōm: magnus ↄ terribilis sup omnes qui in circuitu eius sunt.

Domine deus uirtutum quis si

…milis tibi: potens es domine ↄ ueritas tua in circuitu tuo.

Tu dominaris potestatis ma ris: motum autem sluctuum eius tu mitigas.

Tu humiliasti sicut uulneratum supbum: in brachio uirtutis tue dispsisti inimicos tuos.

Tui sunt celi ↄ tua est terra: orbē terre ↄ plenitudinem eius tu fun dasti aquilonem: ↄ mare tu ĉasti.

Thabor ↄ hermon in noie tuo ex ultabunt: tuum brachium cum potencia.

Firmetur manus tua ↄ exaltet dextera tua: iusticia ↄ iudicium p

paracio sedis tue.

Misericordia & ueritas precedent faciem tuam: beatus populus qui scit iubilacionem.

Domine in lumine uultus tui ambulabunt: & in nomine tuo exultabunt tota die & in iustitia tua exaltabuntur.

Quoniam gla uirtutis eoy tu es: & in beneplacito tuo exaltabitur cornu nostrum.

Quia domini est assumpcio nsa: & sci isrl' regis nri.

Tunc locutus es in uisione scis tuis: & dixisti posui adiutorium i potente: & exaltaui electum de plebe mea.

Inueni dauid seruum meum: oleo sco meo unxi eum.

Manus enim mea auxiliabitur ei: & brachium meum confirmab.

Nichil pficiet inimicus in eo: & filius iniquitatis non apponet nocere ei.

Et concidam a facie ipsius inimicos eius: & odientes eum in fugam conuertam.

Et ueritas mea & misericordia mea cum ipso: & in nomine meo exaltabitur cornu eius.

Et ponam in mari manum eius: & in fluminibz dexteram eius.

Ipse inuocauit me pater meus

es tu. deus meus ⁊ susceptor sa
lutis mee.
Et ego primogenitum ponam
illum: excelsum pre regibz terre.
In eternum seruabo illi miseri
cordiam meam: ⁊ testamentu me
um fidele ipi.
Et ponam in seclm scli semen ei: ⁊
thronum eius sicut dies celi.
Si autem dereliquerint filij eius
legem meam: ⁊ in iudicijs meis n
ambulauerint.
Si iusticias meas pphanauerint
⁊ mandata mea non custodierint.
Visitabo in uirga iniquitates eor.
⁊ in uerberibz peccata eorum.

Misericordiam autem meam no
dispgam ab eo: neqz nocebo in ueri
tate mea.
Neqz pphanabo testamentu me
um: ⁊ que pcedunt de labijs meis
non faciam irrita.
Semel iuraui in sco meo: si dauid
menciar semen eius in eternum
manebit.
Et thronus eius sicut sol in con
spectu meo: ⁊ sicut luna pfecta in e
ternum ⁊ testis in celo fidelis.
Tu uero repulisti ⁊ despexisti: dis
tulisti xpm tuum.
Euertisti testamentum serui tui: p
phanasti in tra sctuarium eius.

estruxisti omnes sepes eius: po
suisti firmamentum ei formidinem

Irripuerunt eum omnes transe
untes uiam: factus est obprobrium ui
cinis suis.

Exaltasti dexteram deprimenciu
eum: leuificasti omnes inimicos ei

Auertisti adiutorium gladii ei: et
non es auxiliatus ei in bello.

Destruxisti eum ab emundacone:
et sedem eius in terram collisisti.

Minorasti dies temporis eius: p
fudisti eum confusione.

Usquequo domine auertis in finem: et
ardescet sicut ignis ira tua.

Memorare que mea substancia

nunquid enim uane constituisti
omnes filios hominum.

Quis est homo qui uiuet et non
uidebit mortem: eruet animam
meam de manu inferi.

Ubi sunt mie tue antique domine:
sicut iurasti dauid in ueritate tua.

Memor esto domine obprobrii ser
uorum tuorum: quod continui in sinu
meo multarum gencium.

Quod exprobrauerunt inimici tui
domine: quod exprobrauerunt commu
tacionem xpi tui.

Benedictus dominus ineternum
fiat fiat.

Domine refugium factus es

89.

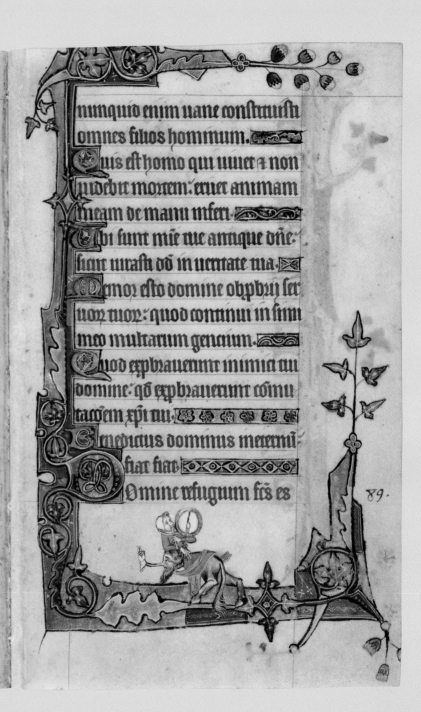

nobis. a generacõe in generacõem.
Priusqm montes fierent aut for
maretur terra ⁊ orbis: a seclo ⁊ usk
in seclm tu es deus.
Ne auertas hoiem in humilitatê
⁊ dixisti cõuertimini filij hominum.
Quoniam mille anni ante oclos
tuos: tanqm dies hesterna q preterijt
⁊ custodia in nocte que p nichilo
habentur: eorum anni erunt.
Mane sicut herba trãseat mane flo
reat ⁊ trãseat. vespe decidat induret
⁊ arescat.
Quia defecimus in ira tua: ⁊ in
furore tuo turbati sumus.
Posuisti iniquitates nras in ⁊

spectu tuo: secm nrm in illumina
cione vultus tui.
Quoniam dies nri defecerunt:
⁊ in ira tua defecimus.
Anni nri sicut aranea medita
buntur: dies annor nror in ipis
septuaginta annis.
Si autem in potentatibz octogi
ta anni: ⁊ amplius eor labor ⁊ do
Quoniam superuenit mã Con
suetudo: ⁊ corripiemur.
Quis nouit potestatem ire tue ⁊
pre timore tuo irã tuã dinumare
Dexteram tuam sic notam fac
⁊ eruditos corde in sapiencia.
Conuertere domine usqquo ⁊

despicabilis esto sup seruos tuos.
Repleti sumus mane misericor-
dia tua: a exultauimus a delectati
sumus in omnibz diebz nris. ⊠
Letati sumus p diebz quibz nos
humiliasti: annis quibz uidim
mala. ~~~~~~~~~~~~~~~~
Respice in seruos tuos a in opa
tua: a dirige filios eorum. ⊠
Et sit splendor domini dei nri sup
nos: a opa manuum nrax dirige
sup nos a op manuu nrax dirige~
Qui habitat in adiutorio
altissimi: in ptecoe dei celi
commorabitur. ⊠⊠⊠⊠⊠
Dicet domino susceptor mis es

tu: a refugium meum deus ms
sperabo in eum. ◇◇◇◇
Quoniam ipse liberauit me de
laqueo uenanciu: a a uibo aspo.
Scapulis suis obumbrabit t:
a sub penis eius sperabis. ⧄
Scuto circumdabit te ueritas ei
non timebis a timore nocturno.
A sagitta uolante in die a negoci
o pambulante in tenebris: ab in
cursu a demonio meridiano. ⊠
Cadent a latere tuo mille a deceni
milia a dextris tuis: ad te autem n
appinquabit ◇◇◇◇◇◇
Uerumptn oculis tuis considera
bis: a retribucoem pctorx uidebis.

Qin tu es domine spes mea: al
tissimi posuisti refugium tuũ.
Non accedat ad te malum: ↄ fla
gellum non appinquabit taber
naculo tuo.
Quoniam angelis suis manda
uit de te: ut custodiant te in oĩbz
uiis tuis.
In manibz portabunt te ne fo
te offendas ad lapidem pedem tuũ.
Sup aspidem ↄ basiliscum ambu
labis: ↄ conculcabis leonem ↄ dconē.
Quoniam in me sperauit liberabo
eum: pgam eum qm cognouit
nomen meum.
Clamauit ad me ↄ ego exaudia

eum cum ipso sum in tribulacōe: e
ripiam eum ↄ glificabo eum.
Longitudine dierx replebo eum:
ↄ ostendam illi salutare meum.
Bonum est confiteri dño: ↄ
psallere noĩ tuo altissime.
Ad annunciandum mane mise
ricordiam tuam: ↄ ueritatem tuā
p noctem.
In decacordo psalterio: cum ca
tico in cythara.
Qua delectasti me dñe in factura
tua: ↄ in opibz manuu tuarx exulta
Quam magnificata sunt opa
tua domine: nimis pfunde
fctē sunt cogitaciones tue.

Thr insipiens non cognoscet: 7
stultus non intelliget hec.
Cum exorti fuerint peccatores sicut
senum: 7 apparuerint omnes qui
operantur iniquitatem.
Ut intereant in seculum seculi: tu autem
altissimus ineternum domine.
Quoniam ecce inimici tui domi
ne qm ecce inimici tui peribunt: et
dispergentur omnes qui operantur
iniquitatem.
Et exaltabitur sicut unicornis cor
nu meum: 7 senectus mea in mise
ricordia uberi.
Est despexit oculus meus inimicos me
os: 7 insurgentibus in me malignan

tibz audiet auris mea.
Iustus ut palma florebit: sicut
cedrus libani multiplicabitur.
Plantati in domo domini: in atriis
domus dei nostri florebunt.
Adhuc multiplicabuntur in senecta
uberi: 7 benepacientes erunt ut an
nunciem.
Quoniam rectus dominus deus
noster: 7 non est iniquitas in eo.
Dominus regnauit decore
indutus est: indutus est
dominus fortitudinem 7 precinxit se.
Etenim firmauit orbem terre: qui
non commouebitur.
Parata sedes tua deus extunc:

92

a seculo tu es. ❚❚❚❚❚❚

lenauerunt flumina dne: cle
nauerunt flumina uocem suam.

lenauerunt flumina fluctus
suos. a uoabz aquaz multarum

urabiles elacoes maris. mira
biles in altis dominus. ❚❚❚

estimonia tua credibilia facta
sunt nimis. domum tuam dect
seitudo dne in longitudinē diez.

Eus ulaonum dns: deus 93
ulaonum libere egit. ❚❚❚

raltare qui iudicas terra: redde
retribuconem superbis. ❚❚❚

Usqz quo peccores dne: usqz quo
peccatores glonabuntur. ❚❚❚

ffabuntur 4 loquentur iniqui
tatem: loquentur omnes qui ope
rantur iniusticiam. ❚❚❚

opulum tuum domine humi
liauerunt: 4 hereditate tuā uexaue

duonam 4 aduenam inī ❚❚
ferecunt: 4 pupillos occiderunt.

t direcunt non uidebit domini
nec intelliget deus iacob. ❚❚❚

ntelligite insipientes in pplo:
4 stulti aliquando sapite ❚❚❚

Qui plantauit aurem non audi
et: aut qui finxit oclm nō considerat.

Qui corripit gentes non arguet:
aut qui docet hominem scienciā.

ominus seit cogitacoes hoīm.

quoniam uane sunt.

Beatus homo quem tu erudieris
domine: 7 de lege tua docueris eu.

Vt mitiges ei a diebz malis: do
nec fodeatur peccatori fouea.

Quia non repellet dominus ple
bem suam: 7 hereditatem suam
non derelinquet.

Quo adusqz iusticia conuertat
in iudicium: 7 qui iurta illam oms
qui recto sunt corde.

Quis consurget michi aduersus
malignantes: aut quis stab me
cum: aduersus operantes iniqtatem

nisi quia dominus adiuuit me:
paulominus habitasset in infer

no anima mea.

Si dicebam motus est pes ms:
misa tua domine adiuuabat me.

Scdm multitudinem dolor meor
in corde meo: consolacoes tue let
ficauerunt animam meam.

Nunqd adheret tibi sedes iniq
tatis: qui fingis dolorem in pre
cepto.

Captabunt in aiam iusti: 7 san
guinem innocentem condempnabut.

Et fcs est michi dominus in re
fugium: 7 deus meus in adiutori
um spei mee.

Et reddet illis iniqtatem ipor:
7 in malicia eor disperdet eos disp

der illos dominus deus noster·
Enite exultemus dño· in
bilem deo salutari nõ·
rocupemus faciem eius in cõ
fessione· ꞇ in psalmis iubilem ei
m deus magnus dominus· ꞇ
rex magnus sup omnes deos·
quia in manu eius sunt omes
fines terre· ꞇ altitudines monciu
ipius sunt·
quoniam ipius est mare ꞇ ipe fe
cit illud· ꞇ siccam manus eius for
mauerunt·
enite adoremus ꞇ pcidamus
ante deum ploremus coram dño
qui fecit nos· qa ipe est dñs ds nr·

Er nos ppls pascue eius· ꞇ oues
manus eius·
odie si uocem eius audieritis·
nolite obdurare corda nra·
icut in irritacoe· scõm diem tep
tacois in deserto·
bi temptauerunt me pres uri·
pbauerunt ꞇ uiderunt opa mea·
uadraginta annis offensus
fui generacoi illi· ꞇ dixi semp hii er
rant corde·
er isti non cognouerunt uias me
as· ut iuraui in ira mea si introibi
in requiem meam·
Antate dño canticum no
uu· cantate dño omis tra·

Cantate domino ⁊ benedicite
nomini eius: annunciate de die
in diem salutare eius.
Annunciate int gꝫ glam eius: ⁊
omnibꝫ populis mirabilia eius.
Qm magnus dñs ⁊ laudabilis
nimis: terribilis est sup oēs deos.
Quoniam omnes dij gentiu de
monia: dñs autem celos fecit.
Confessio ⁊ pulchritudo in con
spectu eius: sctimonia ⁊ magnifice
cia in sctificacoē eius.
Afferte domino patrie gentium af
ferte dño glam ⁊ honorem: affer
te dño glam nomini eius.
Tollite hostias ⁊ introite in atria

eius: adorate dominum in atrio
sancto eius.
Commoueatur a facie eius uni
uersa terra: dicite in gentibꝫ quia
dominus regnauit.
Etenim correxit orbem terre qui
non commouebitur: iudicabit po
pulos in equitate.
Letentur celi ⁊ exultet terra com
moueatur mare ⁊ plenitudo eius:
gaudebunt campi ⁊ omnia que
in eis sunt.
Tunc exultabunt omnia ligna
siluarū a facie dñi quia venit: qm
venit iudicare terram.
Iudicabit orbem terre in equita

mino canticum nouum: quia mi
rabilia fecit.

Saluauit sibi dexrta eius: 7 bra
chium scm eius.

onum fecit dns salutare suu:
in conspectu gencium reuelauit i
ticiam suam.

ecordatus est misedie sue: ex

uertatis sue domui isrl
adoerunt omnes termini tre sa
lutare dei nri: iubilate deo omis
terra. cantate 7 exultate 7 psallite.

psallite domino in cithara in ci
thara 7 uoce psalmi. in tubis duc
tilib; 7 uoce tube cornee

Iubilate in conspectu regis dni
moueatur mare 7 plenitudo eius:
orbis trax 7 qui habitant in eo.

lumina plaudent manu simul
montes exultabunt a conspectu dni
qim uenit iudicare terram.

Iudicabit orbem terre in iusti
tia: 7 pplos in equitate.

Ominus regnauit irasci

opulus eius ⁊ oues pascue ei:
introite portas eius in confessio
ne atria eius in ympnis confite
mini illi.

audate nomen eius quoniam
suauis est dominus: in eterni mi
sericordia eius ⁊ usq; in generacoe ⁊
generacionem ueritas eius.

 m sericordiam ⁊ iudicium 100
cantabo tibi domine: psal
lam ⁊ intelligam in uia immacu
lata quando uenies ad me.
erambulabam in innocencia
cordis mei. in medio domus mee:
on pponebam ante oclos meos
rem iniustam: facientes preuari

commedere panem meum.
 uoce gemitus mei adhesit os
meum carni mee.
 Similis factus sum pellicano so
litudinis: fcs sum sicut nicticorax
in domicilio.
 ugilaui: ⁊ fcs sum sicut passer
solitarius in tecto.
 ota die exprobabant michi inimi
ci mei: ⁊ qui laudabant me aduer
sum me iurabant.
 Quia cinerem tanquam panem
manducabam: ⁊ potum meum
cum fletu miscebam.
 a facie ire indignacois tue: quia
eleuans allisisti me.

ies mei sicut umbra declinaue
runt: 4 ego sicut fenum arui.

Tu autem domine in eternum p
manes: 4 memoriale tuum in ge
neracione 4 generacionem.

Tu exurgens domine misereberi
ris syon: quia tempus miserendi
eius quia uenit tempus.

Qm placuerunt serius tuis lapi
des eius: 4 terre eius miserebunt.

Et timebunt gs nomen tuum domine:

Et omnes reges terre glouam tuam.

Quia edificauit dominus syon:

Et uidebitur in glouam sua.

Respexit in orationem humilium: 4
non spreuit precem eorum.

ervantur hec in generacione al
tera: 4 populus qui creabitur laudabit
dominum.

Quia prospexit de excelso sancto suo:
dominus de celo in terram aspexit.

Et audiret gemitus compeditor
ut solueret filios interemptorum.

Et annunciet in syon nomen
domini: 4 laudem eius in ierlm.

In conueniendo populos in u
num: 4 reges ut seruiant domino.

Respondit ei in uia uirtutis sue:
paucitatem dierum meorum nuncia m.

Ne reuoces me in dimidio dierum
meorum: in generacione 4 generacio
nem anni tui.

uoniam secm altitudinem ce
li a terra: corroboranit miscoiam
suam super omnes se.
uantum distat ortus ab occi
dente: longe fecit a nobis iniqui
tates nras.
uomodo miseretur pater fili
orum misertus est dominus ti
mentibz se: quoniam ipse cognon fig
mentum nostrum.
ecordat est qm puluis sumus:
homo sicut fenum dies eius tan
quam flos agri sic efflorebit.
uoniam sps pransibit in illo
et non subsistet: et non cognoscet
amplius locum suum.

Misericordia aut dm ab eterno: et
usq; in eternum sup timentes eum
et iusticia illius in filios filiorum:
his qui seruant testamentum ei.
et memores sunt mandator ip
sius: ad faciendum ea.
ominus in celo parauit sedem
suam: et regni ipsius oibz dnabit.
enedicite domino omnes an
geli eius: potentes uirtute facietes
uerbum illius ad audiendam uo
cem sermonum eius.
enedicite domino omnes uirtu
tes eius: ministri eius qui facitis
uoluntatem eius.
enedicite dno omnia opera ei.

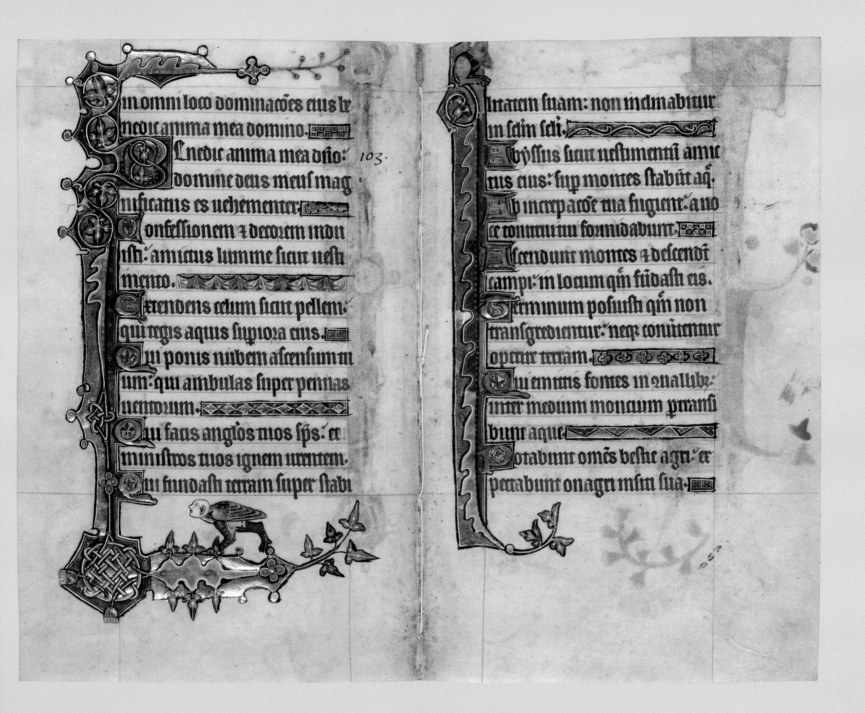

in omni loco dominacões eius be
nedic anima mea domino.
Lnedic anima mea dño:
domine deus meus mag
nificatus es uehementer.
onfessionem 7 decorem indu
isti. amictus lumine sicut uesti
mento.
Extendens celum sicut pellem.
qui regis aquis superiora eius.
ui ponis nubem ascensum tu
um: qui ambulas super pennas
uentorum.
ui facis angelos tuos sps: et
ministros tuos ignem urentem.
ui fundasti terram super stabi

103.

litatem suam: non inclinabitur
in seculum seculi.
byssus sicut uestimentum amic
tus eius: sup montes stabunt aq.
b increpacõe tua fugient: a uo
ce tonitrui tui formidabunt.
Ascendunt montes 7 descendi
campi: in locum quem fundasti eis.
erminum posuisti quem non
transgredientur: neque conuertentur
operire terram.
ui emittis fontes in conuallibus:
inter medium moncium pransi
bunt aque.
otabunt omnes bestie agri: ex
pectabunt onagri in siti sua.

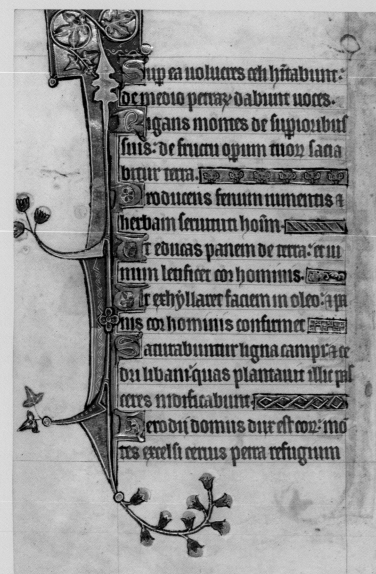

sup ea uolucres cdi hitabunt:
de medio petray dabunt uoces.

igans montes de superioribus
suis: de fructu opum tuoy sacia
bitur terra.

roducens fenum iumentis t
herbam seruituti hoim.

t educas panem de terra: et ui
num letificet cor hominis.

t exhyllaret faciem in oleo: t pa
nis cor hominis confirmet

aturabuntur ligna campi: ce
dri libani: quas plantauit illic pas
seres nidificabunt.

erodii domus dux est eorum: mo
tes excelsi ceruis petra refugium

hericiatis

ecit lunam in tempora: sol cog
nouit occasum suum.

osuisti tenebras t facta est nox:
in ipsa ptransibunt omnes bestie sil
uarum leonum rugientes

ut rapiant: t querant a deo escam s.

rtus est sol t congregati sunt:
t in cubilibus suis collocabuntur.

xibit homo ad opus suum: t
ad operacoem suam usque ad uespam.

uam magnificata sunt opera
tua domine: omnia in sapiencia

fecisti impleta est terra possessione

oc mare magnum et tua.
spaciorum manibus: illic reptilia

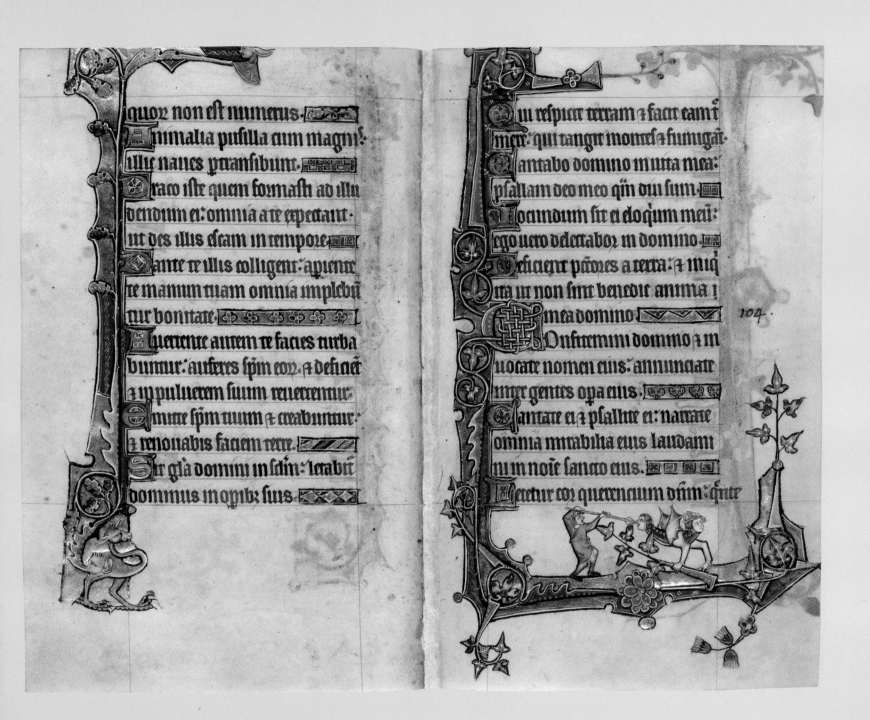

quox non est numerus·
animalia pisilla cum magnis·
illuc naues pransibunt·
draco iste quem formasti ad illu
dendum ei: omnia a te expectant·
ut des illis escam in tempoze·
dante te illis colligent: apiente
te manum tuam omnia implebu
ntur bonitate·
auertente autem te facies turba
buntur: auferes spm eox· a deficiet
a ip puluerem suum reuertentur·
mitte spm tuum a creabuntur·
a renouabis faciem terre·
Sit gla domini in scłm· letabit
dominus in opibz suis·

qui respicit terram a facit eam t
mere: qui tangit montes a fumigat
antabo domino in uita mea·
psallam deo meo qm diu sum·
Iocundum sit ei eloqum meu·
ego uero delectabor in domino·
Deficient pcoxes a terra: a iniq
ita ut non sint benedic anima
mea domino
Onfitemini domino a in
uocate nomen eius: annunciate
inter gentes opa eius·
antate ei a psallite ei: narrate
omnia mirabilia eius laudam
ni in noe sancto eius·
etetur cor querentium dm: quer

104·

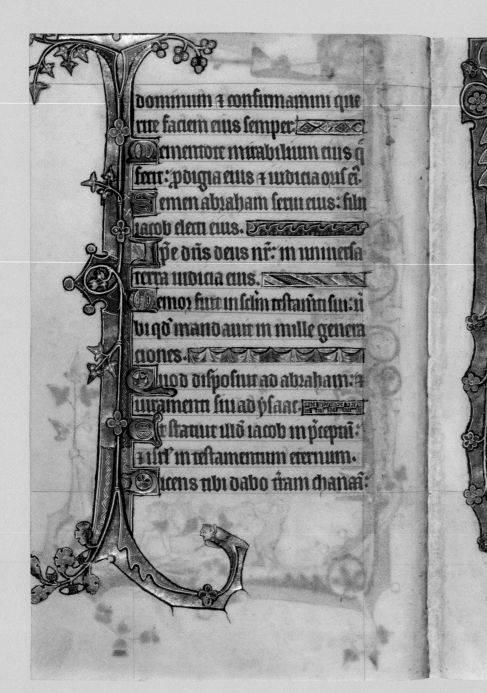

dominum + confirmamini que
rite faciem eius semper ▨▨▨
Mementote mirabilium eius q
fecit: prodigia eius + iudicia ouſ eſ.
Semen abraham ſerui eius: filii
iacob electi eius. ▨▨▨▨▨
Ipſe dominus deus noſter: in uniuerſa
terra iudicia eius. ▨▨▨▨
Memor fuit in ſeculum teſtamenti ſui: ii
bi qd mandauit in mille genera
ciones. ▨▨▨▨▨
Quod diſpoſuit ad abraham: +
iuramenti ſui ad yſaac ▨▨▨▨
Et ſtatuit illud iacob in precepm:
+ iſrl in teſtamentum eternum.
Dicens tibi dabo terram chanaan.

ſuſcipiendum hereditatis uſtre ▨▨▨
Cum eſſent numero breui: pauci
ſint + incole eius ▨▨▨▨
Et pertranſierunt de gente in gen
tem: + de regno ad poplm alteri
Non reliquit hominem nocere eis:
+ corripuit pro eis reges ▨▨▨
Nolite tangere christos meos: + in
prophetis meis nolite malignari ▨
Et uocauit famem ſuper terram: et
omne firmamentum panis contriuit.
Misit ante eos uirum: in ſeruum
uenundatus eſt ioſeph. ▨▨▨
Humiliauerunt in compedibus pe
des eius: ferrum pertranſiit animam
eius donec ueniret uerbum eius ▨

ra eorum: 7 commedit omne fruc
tum terre eorum.

Et percussit omne primogenitum
in terra eoy: primicias omis la
boris eorum.

Et eduxit eos cum argento 7 au
ro: 7 non erat in tribubz eorum i
firmus.

Letata est egyptus in pfectoe eoy:
quia incubuit timor eoy sup eos.

Expandit nubem in ptectoem
eoy: 7 ignem ut luceret eis p nocte

Petierunt 7 uenit coturnix: 7 pa
ne celi saturauit eos.

Disrupit petram 7 fluxerunt aq:
abierunt in sicco flumina.

Quoniam memor fuit uerbi sci
sui: qd habuit ad abraha puim suu.

Et eduxit pplm suum in exulta
cione: 7 electos suos in leticia

Et dedit illis regiones gentium:
7 labores populoy possederunt.

Ut custodiant iustificacoes eius:
7 legem eius requirant.

Confitemini domino qm
bon9: qm in sclm mia eius.

Quis loquetur potencias domini:
auditas faciet omes laudes eius.

Beati qui custodiunt iudicium:
7 faciunt iusticiam in omni tpe.

Memento nri domine in benepla
cito ppli tui: uisita nos in salutari

tuo. Gloria.

105

ad uidendum in bonitate elec
torum tuoz: ad letandum in leti
cia gentis tue ut lauderis cum here
ditate tua. ◆◆◆◆◆◆◆◆◆
Peccauimus cum patribus nris: in
iuste egimus iniquitatem fecimus.
Patres nri in egypto non intellex
erunt mirabilia tua: non fuerunt
memores multitudinis mie tue.
Et irritauerunt ascendentes in
mare mare rubrum: ⁊ saluauit
eos ppter nomen suum ut notam
faceret potenciam suam. ◆◆◆◆◆
Et increpauit mare rubrum ⁊ ex
siccatum est: ⁊ deduxit eos in abys
sis sicut in deserto. ◆◆◆◆◆

Et saluauit eos de manu odien
tium: ⁊ redemit eos de manu ini
mici. Et operuit aqua tribulan
tes eos: unus ex eis ñ remansit.
Et crediderunt in uerbis eius: ⁊
laudauerunt laudem eius. ◆◆
Cito fecerunt obliti sunt operum
eius: ⁊ non sustinuerunt ꝯsiliū eⁱ.
Et concupierunt concupiscenciam ĩ
deserto: ⁊ temptauerunt deum in
inaquoso. ◆◆◆◆◆◆◆◆◆
Et dedit eis petitionem ipsoz: ⁊ mi
sit saturitatem in animas eoz.
Et irritauerunt moysen in castris:
aaron sanctum domini. ◆◆◆
Aperta est terra ⁊ degluttiuit dathã:

152v

...ropuit sup aggaroem abyron·

Et exarsit ignis in synagoga e
oz: flamma cobussit peccatores·

Et fecerunt uitulum in oreb: et
adorauerunt sculptile·

Et mutauerunt glam suam: i si
militudinem uituli commedentis
fenum

Obliti sunt deum qui saluauit
eos: qui fecit magnalia in egypto.
mirabilia in terra cham terribilia
in mari rubro·

Et dixit ut disperderet eos: si non
moyses electus eius stetisset in con
fracoe in conspectu eius·

Et auerteret iram eius ne dispdr

153r

eos: i p nichilo habuerunt tram
desiderabilem

Non crediderunt uerbo eius: et
murmurauerunt in tabernaclis
suis: n exaudierunt uocem dni·

Et eleuauit manum suam sup
eos: ut psterneret eos in deserto·

Et ut deiceret semen eoz in nacio
nibz: i dispderet eos in regionibz·

Et iniciati sunt beelphegor: i co
mederunt sacrificia mortuorum·

Et irritauerunt eum in adinue
cionibz suis: i multiplicata est i
eis ruina

Et stetit phinees i placauit: i cef
sauit quassacio

Er reputatum est ei ad iusticiam:
in generacõe ⁊ generacõem usqʒ i
sempiternum. ❦

Et irritauerunt eum ad aquas
contradicois: ⁊ uexatus est moy
ses ppter eos qui exacerbauerunt
spiritum eius. ❦

Et distinxit in labiis suis: ñ disp
diderunt gentes q̃s dixit dñs illis.

Et commixti sunt inter gentes ⁊
didicerunt opera eoꝛ: ⁊ seruierunt
sculptilibʒ eoꝛ. ⁊ factum est illis
in scandalum. ❦

Et immolauerunt filios suos:
⁊ filias suas demoniis ❧

Et effuderunt sanguinem innoce

hem: sanguinem filioꝛ suoꝛ ⁊ fi
liaꝛ suaꝛ: quas sacrificauerũt sculp
tilibʒ chanaan. ❦

Et interfecta est terra in sangui
bʒ ⁊ contaminata est in opibʒ eoꝛ:
⁊ formicati sunt in adinuentioni
bus suis. ❦

Et iratus est dominus furore i
populo suo: ⁊ abhominatus est
hereditatem suam. ❦

Et tradidit eos in manus gentiu
um: ⁊ dominati sunt eoꝛ qui ode
runt eos. ❦

Et tribulauerunt eos inimici e
oꝛ: ⁊ humiliati sunt sub manibʒ
eoꝛum sepe liberauit eos. ❦

psi autem exacerbauerunt eum
in consilio suo: 7 humiliati sunt
in iniquitatib; suis.
Et uidit cum tribularentur: 7
audiuit oronem eorum.
Et memor fuit testamenti sui: 7
penituit eum scdm multitudinē
misericordie tue.
Et dedit eos in mias: in conspec
tu oim qui ceperant eos.
Saluos fac nos dne deus nr: 7
congrega nos de nacionib;
Et confiteamur noi sco tuo: et
gloriemur in laude tua
Benedictus dominus ds isrel:
a sclo 7 usq; in sclm 7 dicet omis

populus fiat fiat.
Confitemini domino qm
bonus: qm in sclm mia eius.
Dicant qui redempti sunt a dno:
quos redemit de manu inimici de
regionib; congregauit eos.
Solis ortu 7 occasu: ab aquilo
ne 7 mari.
Errauerunt in solitudine in in
aquoso: uiam ciuitatis habitaculi
non inuenerunt.
Esurientes 7 sicientes: anima e
orum in ipsis defecit.
Et clamauerunt ad dominum
cum tribularent: 7 de necessitatib;
eorum eripuit eos.

er dedurit eos in uiam rectam:
ut irent in ciuitatem habitaciois.
onfiteantur dno mie eius: et
mirabilia eius filijs hominum.
uia faciauit aiam inanem: 7
aiam efurientem faciauit bonis.
edentes in tenebris 7 umb mor
tis: uinctos in mendicitate 7 ferro.
uia exacerbauerunt eloquium dei:
7 consiliuim altissimi irritauerunt.
t humiliatum est in laboribz
cor eorum: 7 infirmati sunt nec fuit
qui adiuuaret
e clamauerunt ad dnm cum
tribularentur: 7 de necessitatibz
eorum liberauit eos.

t eduxit eos de tenebris 7 umb
mortis: 7 uincula eorum disrupit
onfiteantur dno mie eius: et
mirabilia eius filijs hominum.
uia contriuit portas ereas: 7 uectes
ferreos confregit
uscepit eos de uia iniquitatis
eorum: propter iniusticias enim suas
humiliati sunt
mnem escam abhominata est
aia eorum: 7 appropinquauerunt usque
ad portas mortis.
t clamauerunt ad dominum
cum tribularentur: 7 de necessitati
bz eorum liberauit eos.
isit uerbum suum 7 sanauit

eos: 7 eripuit eos de itinicoibz coꝛ.
onfiteantur domino mie eͨ.
7 mirabilia eius filijs homini.
Et sacrificent sacrificiuͥ lau
dis: 7 annuncient opera coꝛuͥ
in exultacione.
Qui descendunt mare in nauibʒ:
facientes opacoēm in aqͥs mͥtis.
Ipi uiderunt opa dͥni: 7 mira
bilia eius in pͥfundo.
Dixit 7 stetit sͬps pcelle: 7 exaltati
sunt fluctus eius.
Ascendunt usqʒ ad celos 7 descē
dunt usqʒ ad abyssos: anima coꝛ
in malis thabescebat.
Turbati sunt 7 moti sunt sicut

ebꝛius: 7 omnis sapiencia coꝛuͥ
deuoꝛata est.
Et clamauerunt ad dͥm cuͥ tͥ
bularentur: 7 de necessitatibʒ coꝛ.
eduxit eos.
Et statuit pcellam eius in auͬaͥ:
7 siluerunt fluctus eius.
Et letati sunt qͣ siluerunt: 7 de
duxit eos in poꝛtum uoluntatis
onfiteantur domino Ieoͬ.
mie eius: 7 mirabilia eius filijs
hominum.
Et exaltent euͥ in ecͥa plebis: 7
in cathedra senioꝛ laudent euͥ.
Posuit flumina in desertum: 7
exitus aquaꝛ in sitim.

terram fructiferam in salsugi
nem: a malicia inhabitancium
posuit desertum i stag[n]. [I]n sta-
gna aquaz: 4 terram sine aqua in
exitus aquarum.

Et collocauit illic esurientes: et
astituerunt ciuitatem habitacois.

Et seminauerunt agros 4 plan
tauerunt uineas: 4 fecerunt fructu
natiuitatis

Et benedixit eis 4 multiplicati sū
nimis: 4 iumenta eoz nō minorauit

Et pauci facti sunt 4 uexati sunt:
a tribulacōe maloz 4 dolore

Effusa est contencio sup princi
pes: 4 errare fecit eos in inuio et

non in uia.
Et adiuuit pauperem de inopia:
a posuit sicut oues familias.
Videbunt recti 4 letabuntur: et
omnis iniquitas opilabit os suū.
Quis sapiens 4 custodiet hec: 4 i[n]
telliget misericordias domini.
Paratum cor meum deus
paratum cor meum: can
tabo 4 psallam in gloria mea.
Exurge psalterium 4 cythara: ex
urgam diluculo.
Confitebor tibi in ppl[i]s dn[e]: 4
psallam tibi in nacionib[us].
Quia magna est sup celos mia
mia: 4 usq[ue] ad nubes ueritas mia.

107.

altare sup celos deus: 4 sup
omnem tram glona tua ut liberen
tur dilecti tui. ∎∎∎∎∎∎
aluum fac dertera tua 4 exau
di me: deus locut est in sco suo
rultabo 4 diuidam sicima:
4 quallem tabernaclou dimenar:
eus est galaad 4 meus est ma
nasses: 4 effraym susteptio capitis
uda rex meus. moab ∎ met
lebes sper mee. ∎∎∎∎∎∎
n ydumeam extendam calcia
mentum meu: michi aliemigene
lamei sci sunt. ∎∎∎∎∎∎
uis deducet me in ciuitatem
munitam: quis deducet me usq;

in ydumeam. ∎∎∎∎∎∎
onne tu deus qui replisti nos:
4 non exibis deus in uirtutib; nris.
a nobis auxilium de tribulacoe:
quia nana salus hominis. ∎∎∎
n deo faciemus uirtutem: 4 ipe
ad nichili deducet inimicos nros.
us laudem meam ne ta 108
cueris: quia os pecatons 4
os dolosi sup me apertum est. ∎
ocuti sunt aduersum me ling
dolosa: 4 sermonib; odij circude
runt me 4 expugnauerut me gras.
ro eo ut me diligerent detrahe
bant michi: ego autem orabam.
t posuerunt aduersum me ma

la p bonis: 7 odium p dilecoe mea.
onstrue sup eum pctorem: 7
dyabolus stet a dextris eius.
um iudicatur exeat condempnatꝰ
7 oro eius fiat in peccatum.
ant dies eius pauci: 7 epatum
eius accipiat alter.
iant filij eius orphani: 7 uxor
eius uidua.
utantes transferantur filij eꝰ
7 mendicent: eiciant de habitacio
nibus suis.
crutetur fenerator omnem sub
stanciam eius: 7 diripiant alieni
labores eius.
on sit illi adiutor: nec sit q̃ mi

sereatur pupillis eius.
iant nati eius in interitum: i
generacoe una deleatur nomen eſ
In memoriam redeat iniquitas
patrum suor in conspectu dni: 7 pec
catum matris eius non deleatur.
iant contra dnm semp: 7 disp̃e
eat de terra memoriam eor: p eo q̃
non est recordatus facere miam.
Et psecutus est hoiem inopem
7 mendicum: 7 conpunctum corde
mortificare.
Et dilexit maledicoem 7 uemet
ei: 7 noluit benedicoem 7 elonga
bitur ab eo.
Et induit maledicoem sicut uesti

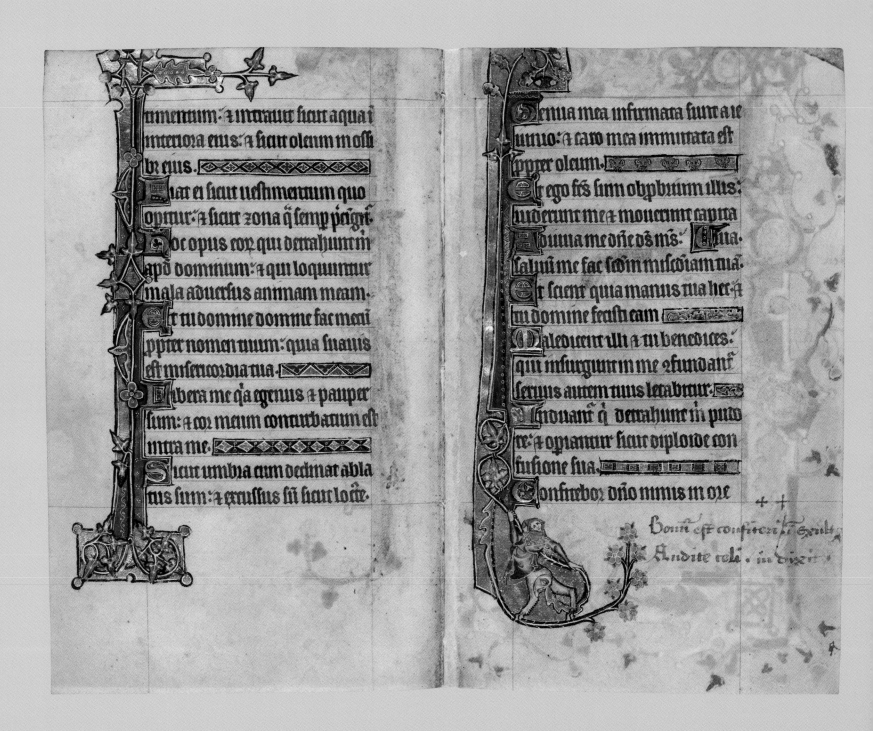

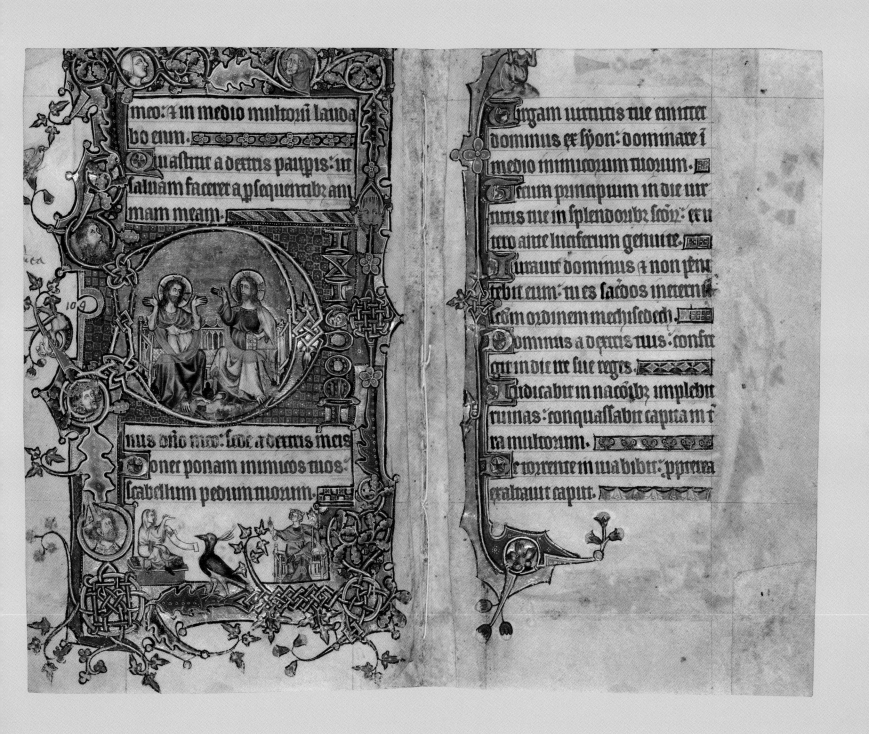

meo: ⁊ in medio multo̅ni lauda
bo eum. ⁘ Quia astitit a dextris paupis: ut
saluam faceret a p̄sequentibz ani
mam meam.

...nus d̅ro m̅o: sede a dextris meis
Donec ponam inimicos tuos.
scabellum pedum tuorum. ⁘

Uirgam uirtutis tue emittet
dominus ex syon: dominare i̅
medio inimicorum tuorum. ⁘
Tecum principium in die uir
tutis tue in splendoribz sc̅oz̅: ex u
tero ante luciferum genui te. ⁘
Iurauit dominus ⁊ non peni
tebit eum: tu es sacdos i̅ etern̅
scd̅m ordinem melchisedech. ⁘
Dominus a dextris tuis: confre
git in die ire sue reges. ⁘
Iudicabit in naco̅ibz: implebit
ruinas: conquassabit capita i̅ t̅
ra multorum. ⁘
De torrente in uia bibet: p̄pterea
exaltauit caput. ⁘

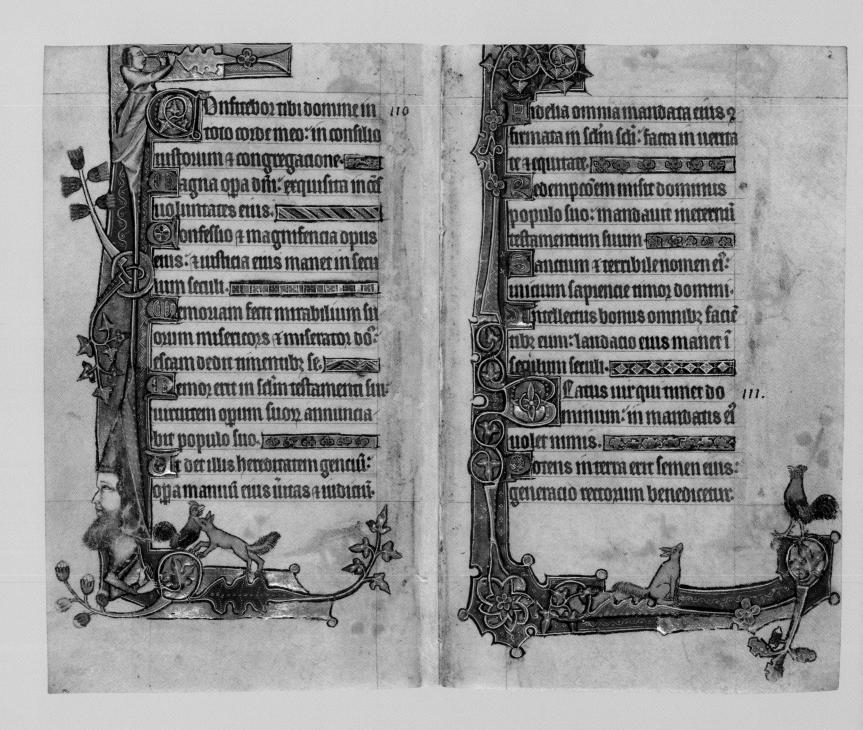

Onfitebor tibi domine in
toto corde meo: in consilio
iustorum et congregatione.
Magna opa dni: exquisita in oes
uoluntates eius.
Confessio et magnificentia opus
eius: et iustitia eius manet in secu-
lum seculi.
Memoriam fecit mirabilium su-
orum misericors et miserator do
escam dedit timentibus se.
Memor erit in seculum testamenti sui:
uirtutem opium suorum annuncia-
bit populo suo.
Et det illis hereditatem gentium:
opa manuum eius ueritas et iudiciu.

fidelia omnia mandata eius: con-
firmata in seculum seculi: facta in ueri-
tate et equitate.
Redemptionem misit dominus
populo suo: mandauit in eternum
testamentum suum.
Sanctum et terribile nomen eius:
initium sapientie timor domini.
Intellectus bonus omnibus facien-
tibus eum: laudatio eius manet in
seculum seculi.
Beatus uir qui timet do-
minum: in mandatis eius
uolet nimis.
Potens in terra erit semen eius:
generatio rectorum benedicetur.

Gloria ꞇ diuicie in domo eius: ꞇ
iusticia eꝰ manet in setin seculi.
proximum est in tenebris lumen
rectis: misericors ꞇ miserator ꞇ iꝰ.
Iocundus homo qui miseret ꞇ
commodat: disponit sermones
suos in iudicio: quia ineternum
non commouebitur.
In memoria eꞇna erit iustus: ab
auditione mala non timebit.
Paratum cor eius spare in dño:
ᵹfirmatum est cor eius non com
mouebitur: donec despiciat in
imicos suos.
Dispsit dedit pauꝑibᵤ: iusticia eꝰ
manet in setin seti: cornu eius ex

altabitur in gloria.
Peccator uidebit ꞇ irascetur dentiᵇ
bᵤ suis fremet ꞇ tabescet: deside
rium peccatorum ꝑibit.
Laudate pueri dñm: lauda
te nomen domini.
Sit nomen dñi benedictum: ex
hoc nunc ꞇ usꝗꝫ in setin.
A solis ortu usꝗꝫ ad occassii: lau
dabile nomen domini.
Excelsus suꝑ omnes gentes dñs:
ꞇ super celos gloria eius.
Quis sicut dñs deus noster qui
in altis habitat: ꞇ humilia respi
cit in celo ꞇ in terra.
Suscitans a terra inopem: ꞇ de

112.

habent + non uidebunt.
ures habent + non audient:
nares hst + non odorabunt.
Manus hst + non palpabunt:
pedes habent + non ambulabt
non clamabunt in gutture suo.
Similes illis fiant qui faciut
ea: + omnes qui confidunt in
eis.
Domus irsl' spauit in domino:
adiutor eorum + protetor eor est.
Domus aaron spauit in dno:
adiutor eor + protetor eorum est.
Qui timent dominum sperate
runt in domino: adiutor eorum
+ protetor eorum est.

Dominus memor fuit nri: + be
nedixit nobis.
Benedixit domui irsl: benedixit
domui aaron.
Benedixit omnibz qui timent
dnm: pusillis cum maioribus.
Adiciat dns sup nos: sup nos
+ sup filios uros.
Benedicti uos domino: qui fecit
celum + terram.
Celum celi domino: terram au
tem dedit filiis hominum.
Non mortui laudabunt te dne:
neqz omnes qui descendunt in in
fernum.
Sed nos qui uiuimus bndici

mus domino: ex hoc nunc 4 usqʒ
in seclm· ▨▨▨
lexi qm exaudiet domin 114·
nocem oracionis mee ▨▨
quia inclinauit aurem suam m
in diebʒ meis inuocabo ▨▨
ircumdederit me dolores mor
tis: 4 picla infern inuenerūt me·
ribulacoem 4 dolorem inueni:
4 nomen domini inuocaui ▨▨
domine libera animam meā
misericors dominus 4 iustus: et
deus noster miseretur ▨▨
ustodiens puulos dominus·
humiliatus sum 4 liberauit me·
onuere anima mea in reqem

uiam: quia dominus bńfecit t
Quia eripuit animam meam de
morte: oclos meos a lacrimis pe
des meos a lapsu ▨▨
lacebo dño: m regione uuio.
Redidi ppter qd locutus 115·
sum: ego autem humilia
tus sum nimis· ▨▨
go dixi in excessu meo: omnis
homo mendax· ▨▨
uid retribuam dño: p omsibʒ
que retribuit michi· ▨▨
alicem salutaris accipiam: 4
nomen domini inuocabo ▨▨
ota mea domino reddam corā
omni populo eius: preciosā in

espectu dni mors scoum eius.

Done quia ego seruus tuus: ego
seruus tuus: filius ancille me.

Disrupisti uincla mea tibi sacri
ficabo hostiam laudis: nomen
domini muocabo.

Uota mea domino reddam in co
spectu omnis populi eius: in atri
is domus dni in medio tui ierlm.

Laudate dnm omnes g̃s 116

Laudate eum omnes ppli

Qn afirmata est sup nos mia ei

Uentas domini manet in etnu.

Confitemini domino quo 117
niam bonus: quoniam i
seculum misericordia eius.

icat nunc isrl qm bonus: qm i
sclm misericordia eius.

Dicar nunc domus aaron: qm
in sclm misericordia eius.

Dicant nunc qui timent dnm:
qm in sclm misericordia eius.

De tribulacoe inuocaui dnm: tex
audiuit me in latitudine domini.

Dominus michi aduitor: non ti
mebo quo faciat michi homo.

Dominus michi aduitor: ego
despiciam inimicos meos.

Bonum est confidere in domino:
quam confidere in homine.

Bonum est sperare in domino:
quam sperare in principib3.

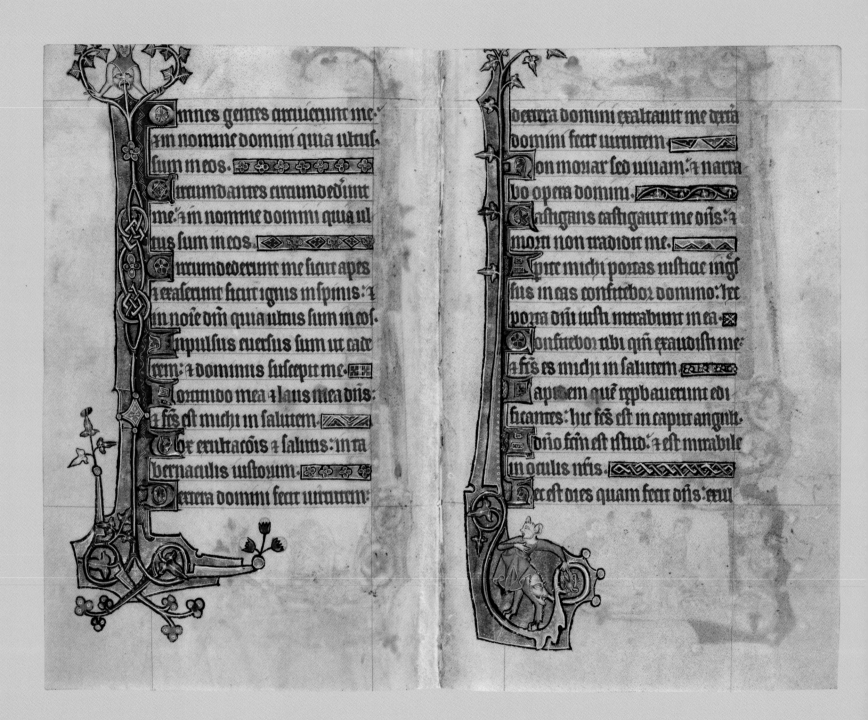

mnes gentes arcuierunt me:
in nomine domini quia ultus
sum in eos.

Circundantes circumdedirunt
me: in nomine domini quia ul
tus sum in eos.

Circumdederunt me sicut apes
et exaserunt sicut ignis in spinis: et
in noie dni quia ultus sum in eos.

Impulsus euersus sum ut cade
rem: et dominus suscepit me.

Fortitudo mea et laus mea dns:
et fts est michi in salutem.

Vox exultacois et salutis: in ta
bernaculis iustorum.

Dextera domini fecit uirtutem:

dextera domini exaltauit me dexa
domini fecit uirtutem.

Non moriar sed uiuam: et narra
bo opera domini.

Castigans castigauit me dns: et
morti non tradidit me.

Aperite michi portas iusticie ings
sus in eas confitebor domino: hec
porta dni iusti intrabunt in ea.

Confitebor tibi qm exaudisti me:
et fts es michi in salutem.

Lapidem que repbauerunt edi
ficantes: hic fts est in caput anguli.

A dno factum est istud: et est mirabile
in oculis nris.

Hec est dies quam fecit dns: exul

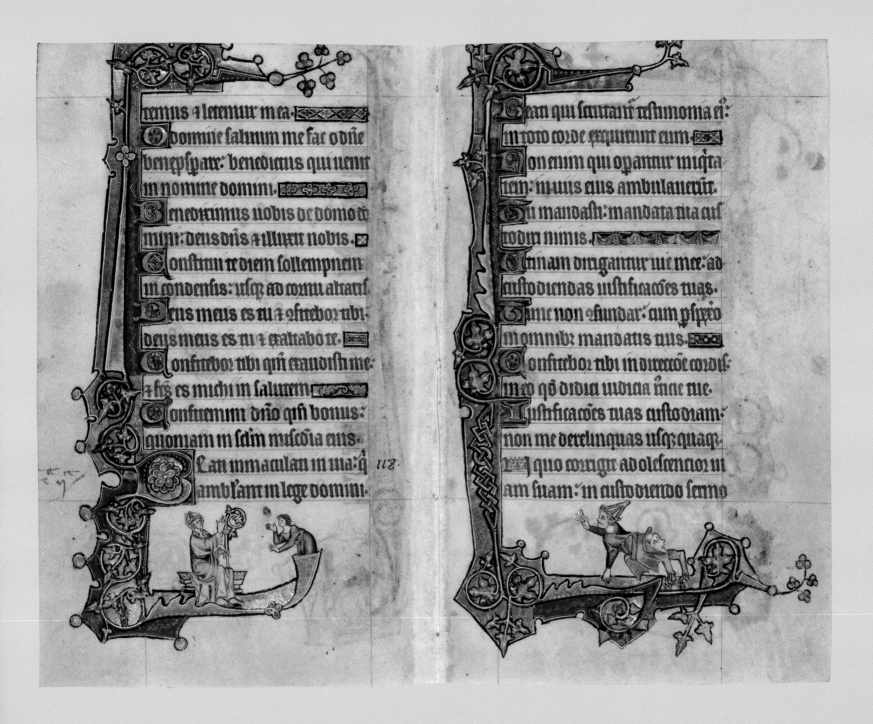

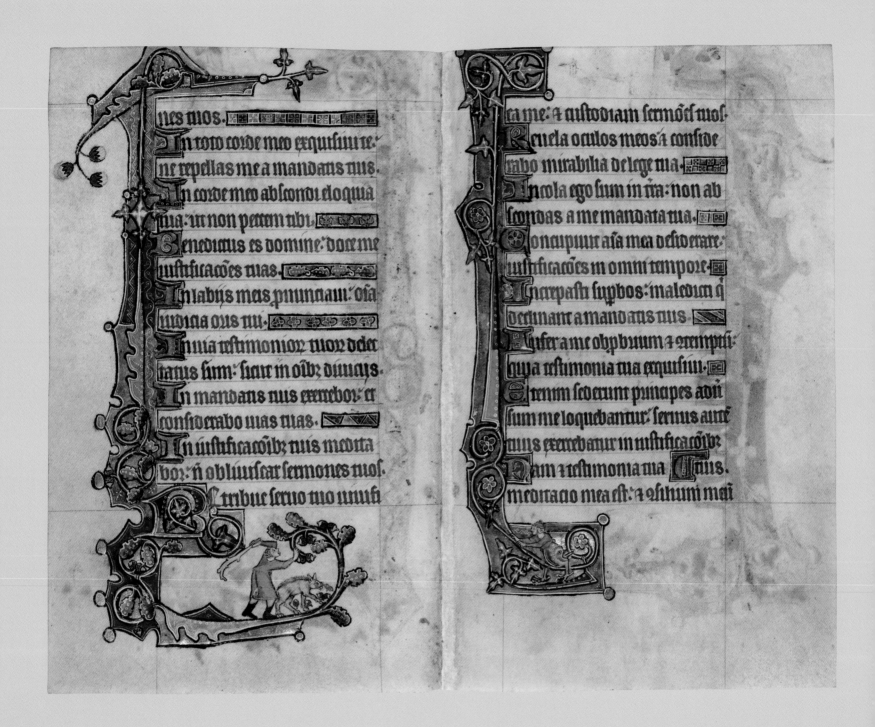

 nes mos.
In toto corde meo exquisiui te:
ne repellas me a mandatis tuis.
In corde meo abscondi eloquia
tua: ut non peccem tibi
Benedictus es domine: doce me
iustificaciones tuas.
In labiis meis pronunciaui: oia
iudicia oris tui
In uia testimonioru tuoru delec
tatus sum: sicut in oibus diuicus.
In mandatis tuis exercebor: et
considerabo uias tuas.
In iustificacoibz tuis medita
bor: ñ obliuiscar sermones tuos.
Tribue seruo tuo uiuifi

ca me: et custodiam sermones tuos.
Reuela oculos meos: et conside
rabo mirabilia de lege tua.
Incola ego sum in tra: non ab
scondas a me mandata tua.
Concupiuit aia mea desiderare
iustificaciones in omni tempore.
Increpasti superbos: maledicti q
declinant a mandatis tuis.
Aufer a me obprbrium et contemptu:
quia testimonia tua exquisiui.
Etenim sederunt principes adu
sum me loquebantur: seruus aute
tuus exercebatur in iustificacoibz.
Nam et testimonia tua Gimel.
meditacio mea est: et consilium meu

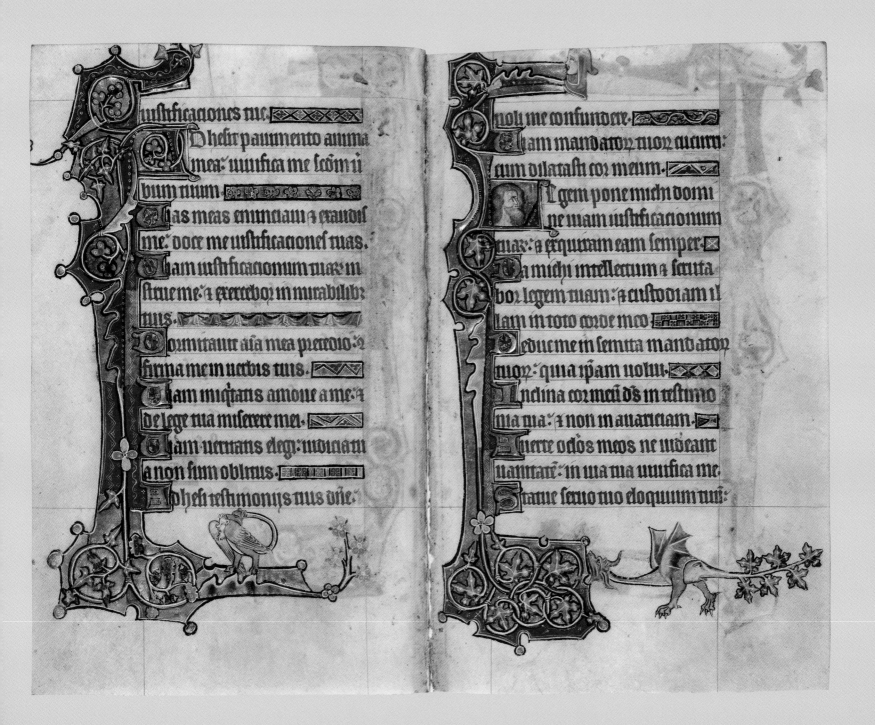

iustificaciones tue.

d hesit paumento anima
mea: uiuifica me scdm ii
bum tuum.

ias meas enunciaui t exaudisi
me: doce me iustificaciones tuas.

iam iustificacionum tuax in
strue me: t exercebor in mirabilibz
tuis.

ormitauit aia mea pretedio: t
firma me in uerbis tuis.

iam iniquitatis amoue a me: t
de lege tua miserere mei.

iam ueritatis elegi: iudicia tu
a non sum oblitus.

dhesi testimonijs tuis dne:

noli me confundere.

iam mandatox tuox cucurri:
cum dilatasti cor meum.

gem pone michi domi
ne uiam iustificacionum
tuax: t exquiram eam semper.

a michi intellectum t scruta
bor legem tuam: t custodiam il
lam in toto corde meo.

educ me in semita mandatox
tuox: quia ipsam uolui.

nclina cor meum ds in testimo
nia tua: t non in auariciam.

uerte oclos meos ne uideant
uanitatem: in uia tua uiuifica me.

tatue seruo tuo eloquium tuum:

Memor fui iudicior tuor a seclo
domine: ⁊ consolatus sum.
Defectio tenuit me p peccatorib;
derelinquentib; legem tuam.
Cantabiles michi erant iustifi-
cacões tue: in loco pegrinacõis mee.
Memor fui nocte nominis tui do
mine: ⁊ custodiui legem tuam.
Hec fca est michi: quia iustificaci-
ones tuas exquisiui.
Portio mea dñe: dixi custodi-
re legem tuam.
Deprecatus sum faciem tuam i
toto corde meo: miserere mei scdm
eloquium tuum.
Cogitaui vias meas ⁊ conuerti

pedes meos: in testimonia tua.
Paratus sum ⁊ non sum turbat;
ut custodiam mandata tua.
Funes pctor circumplexi sût me:
⁊ legem tuam non sum oblitus.
Media nocte surgebam ad cõfitê
dum tibi: sup iudicia iustificacõis.
Particeps ego sum oim ti
mencium te: ⁊ custodiencium mã
data tua.
Mia tua dñe plena est terra: iusti
ficacões tuas doce me.
Bonitatem fecisti cum seruo
tuo domine: scdm uerbum
Bonitatem ⁊ disciplinã ⁊ sciencia doce me: quia in man

cast me.

Tuus sum ego saluum me fac:
qm iustificacoes tuas exquisiui.
Me expectauerunt peccores ut per
derent me. testimonia tua intellexi.
Omnis consummacois uidi fine.
latum mandatum tuum nimis.

Quomodo dilexi legem tua
domine. tota die meditacio
mea est.

Sup inimicos meos prudente
me fecisti mandato tuo: quia meu
num michi est.

Super omnes docentes me intel
lexi: quia testimonia tua medita
cio mea est.

super senes intellexi: quia ma
data tua quesiui.

Ab omni uia mala phibui pe
des meos: ut custodiam uba tua.
A iudiciis tuis non declinaui:
quia tu legem posuisti michi.
Quam dulcia faucib; meis eloq
a tua: super mel ori meo.
A mandatis tuis intellexi: ppterea
odiui omnem uiam iniquitatis.
Lucerna pedib; meis uibu
uum: + lumen semitis me
Iuraui + statui: custodire IIS.
Iudicia iustitie tue.
Humiliatus sum usq; quaq; do
mine. uiuifica me scdm ubu tuu.

nium tuum: + doce me iustificati
ones meas.

Exitus aquarum deduxerunt oculi mei:
quia non custodierunt legem tuam.

Iustus es domine: + rectum iudici
um tuum.

Mandasti iustitiam testimonia
tua: + veritatem tuam nimis.

Tabescere me fecit zelus meus:
quia obliti sunt verba tua inimici mei.

Ignitum eloquium tuum ve
hementer: + servus tuus dilexit illud.

Adolescentulus sum ego + con
temptus: iustificationes tuas non
sum oblitus.

Iustitia tua domine iustitia in eter

num. Lex tua veritas.

Tribulacio + angustia invene
runt me: mandata tua meditacio
mea est.

Equitas testimonia tua in eter
num: + intellectum da michi + vivam.

Clamavi in toto corde exau
di me domine: iustificatio
nes tuas requiram.

Clamavi ad te salvum me fac:
ut custodiam mandata tua.

Preveni in maturitate + clama
vi: quia in verba tua supra speravi.

Prevenerunt oculi mei ad te dilu
culo: ut meditarer eloquia tua.

Vocem meam audi secundum misericordiam

luna p nocrem.

nis custodit te ab omni malo: ē
rodiat aīam tuam dominus.

nis custodiat introitum tuum
reritum tuum: ex hoc nunc ⁊ usqz
in seculum.

tatus sum in hijs que dic
ta sunt m̄: in domum dn̄i ibim'.

tantes erant pedes nr̄i: in atrijs
tuis ierl'm.

erl'm que edificatur ut ciuitas:
cui participacio eius in idipm.

luc enim ascenderunt tribz tbz
domini: testimonium isr'l ad con
fitendum nomini domini.

uia illic sederunt sedes in iudi

cio: sedet sup domum dauid.

ogate que ad pacem sūt ierl'm:
⁊ habundancia diligentibz te.

iat pax in uirtute tua: ⁊ habun
dancia in turribz tuis.

ropter frēs meos ⁊ proximos meos:
loquebar pacem de te.

ropter domum domini dei nr̄i
quesiui bona tibi.

d te leuaui oclōs meos: q
habitas in celis.

cce sicut oc̄li seruoz: in manibz
dominorum suorum.

icut oc̄li ancille in manibz dn̄e
sue: ita oc̄li nr̄i ad dn̄m deum nr̄m
donec misereatur nr̄i.

121.

122.

Miſerere nri dne miſerere nri: qa
multum repleti ſumus deſpectione
Quia multum repleta eſt anima
nra obprobrium habundantibz: et
deſpectio ſupbis

Niſi qia dominus erat in
nobis dicat nunc iſrl: niſi
quia dominus erat in nobis
Cum exurgerent hoies in nos:
forte uiuos degluttiſſent nos
Cum iraſceretur furor eor in nos:
forſitan aqua abſoruiſſet nos
Torrentem ptranſiuit anima nra:
forſitan ptranſiſſet anima nra aqm
intollerabilem
Benedictus dns: qui non dedit

nos in capcoe dentibz eorum
Anima nra ſicut paſſer: erepta
eſt de laqueo uenantium
Laqueus ctritus eſt: nos libe
rati ſumus
Qui confidunt in domino ſic
mons ſyon: non commo
uebitur ineternum qui hitat in ierlm
Montes in circuitu eius a dominus
in circuitu ppli ſui: ex hoc nunc uſq
in ſeculum
Quia non relinquet dominus ui
gam pctor ſup ſortem iuſtorum:
ut non extendant iuſti ad iniqui

tatem manus suas.
ene fac dñe: bonis ⁊ rectis cordis
eclmantes autem in obliga
cões: adducet dominus cum opi
tabz iniquitatem pax super isrł
N querendo dominus cap 125
uitatem syon: fci sumus
sicut consolati
Tunc repletum est gaudi
os nrm ⁊ lingua nra in exulta
Tunc dicent inter gentes: Co
magnificauit dñs facere cum eis.
Magnificauit dñs facere nobis
cum: fci sumus letantes.
onuerte dñe captiuitate nram:
sicut torrens in austro.

qui seminant in lacrimis: in ex
ultacone metent.
euntes ibant ⁊ flebant: mitte
tes semina sua.
Uenientes autem venient cum
exultacõe: portantes maniplos
suos.
Nisi dominus edificauerit 126
domum: in vanum laborauerit
qui edificant eam.
Nisi dominus custodierit ciuitate:
frustra uigilat qui custodit eam.
Uanum est nobis ante lucem surge
surgite postqm sederitis qui man
ducatis panem doloris.
Cum dederit dilectis suis somp

num: ecce hereditas domini filii
mercies fructus ventris.
Sicut sagitte in manu potentis:
ita filii excussorum.
Beatus vir qui implevit deside
rium suum ex ipsis: non confundet
cum loquetur inimicis suis in
porta.
Beati omnes qui timent dominum:
qui ambulant in viis eius.
Labores manuum tuarum qa ma
ducabis: beatus es et bene tibi erit.
Uxor tua sicut vitis habundans:
in lateribus domus tue.
Filii tui sicut novelle olivar: in
circuitu mense tue.

127

Ecce sic benedicetur homo: qui
timet dominum.
Benedicat tibi dominus ex syo:
ut videas bona iexlm omnibus die
bus vite tue.
Et videas filios filiorum tuorum: pa
cem super isrl.
Sepe expugnaverunt me
a iuventute mea: dicat nc
sepe expugnaverunt me ab isrl.
a iuventute mea: etenim non po
tuerunt michi.
Supra dorsum meum fabricave
runt peccatores: prolongaverunt in
iquitatem suam.
Dominus iustus concidet cervices

128

Left column (folio 187v):

peccator. effundant̃ ⁊ auertant̃ ret̃
sum oms qui oderunt syon ⁊
fiant sicut fenum tector̃: qd̃ pri
usquã euellat̃ exaruit·
De quo non impleuit manum
suam qui metet: ⁊ sinum suum q̃
manipulos colliget·
Et non dixerunt qui pt̃ibant·
benedicio dñi sup uos: benedix
imus uobis in nomine domini·
De pfundis clamaui ad te 129
domine: domine exaudi
uocem meam·
Fiant aures tue intendentes: ⁊
uocem depcacõis mee·
Si iniquitates obseruaueris do

Right column (folio 188r):

mine: domine quis sustinebit
Quia apud te ppiciacio est: ⁊ ppt̃
legem tuam sustinui te domine·
Sustinuit aĩa mea in uerbo eius:
sperauit anima mea in domino·
A custodia matutina usq̃ ad no
ctem: speret isr̃l in domino· 130
Quia apud dñm mĩa: ⁊ copiosa
apud eum redempcio·
Et ipse redimet isr̃l: ex omnib; i
niquitatib; eius·
Domine non est exaltatum
cor meum: neq̃ elati sunt
oculi mei·
Neq̃ ambulaui in magnis: neq̃
in mirabilib; super me·

non humiliter senciebam:
sed exaltani animam meam.
dicut ablactatus sup mre sua:
ita retribucio in anima mea.
peret istr in domino: ex hoc
nunc + usqz in sclm.
C memento domine dauid
+ ois mansuetudinis eius.
icut nirauit domino: notum
vonit deo iacob.
i introiero in tabernaclm dom
mee: si ascendero in lectm strati mei.
i dedero sompnum oclis meis:
+ palpebris meis dormitacionem.
t requiem temporib; meis do
nec inueniam locum domino: ta

bernaculum deo iacob.
ce audiuimus eam ineffrata:
inuenimus eam in campis silue.
igiro ibimus in tabernaclm ei
adorabimus in loco ubi steterunt
pedes eius.
urge domine in requiem tua:
tu + archa scificacois tue.
acerdotes tui induant iusticia:
t sci tui exultent.
ropter dauid seruum tuum: n
auertas faciem xpi tui.
urauit dominus dauid uerita
tem + non frustrabitur eum: de fruc
tu uentris tui ponam sup sedem tua.
i custodierint filii tui testamen

tium meum: ⁊ testimonia mea hec
que docebo eos.
Et filij eorum usqz in sclin: sede
bunt sup sedem tuam.
Quoniam elegit dominus syon:
elegit eam in habitacionem sibi.
Hec requies mea in sclin scli: hic ha
bitabo quoniam elegi eam.
Viduam eius benedicens bndi
cam: pauperes eius saturabo panibz.
Sacerdotes eius induam saluta
ri: ⁊ scti eius exultacoe exultabunt.
Illuc producam cornu dauid: pa
ui lucernam xpo meo.
Inimicos eius induam confusio
ne: sup ipm autem efflorebit scti

ficacio mea
Ecce quam bonum ⁊ qm io
cundum hitare frs in unu.
Sicut unguentum in capite: qd
descendit in barbam barbam aaro.
Quod descendit in oram uestime
ti eius: sicut ros hermon qui desce
dit in montem syon.
Qm illic mandauit dominm bene
dicoem: ⁊ uitam usqz in seculum.
Ecce nunc bndicite dnm: oms
serui domini.
Qui statis in domo domini: in
atrijs domus dei nri.
In noctibz extollite manus uras
in scta: ⁊ benedicite dominum.

132.

133.

190v

Benedicat te dominus ex syon:
qui fecit celum et terram.
Laudate nomen domini: 134
Laudate serui domini.
Qui statis in domo domini: in
atriis domus dei nostri.
Laudate dominum quia bonus dominus:
psallite nomini eius quoniam suaue.
Quoniam iacob elegit sibi dominus:
israel in possessionem sibi.
Quia ego cognoui quod magnus
est dominus: et deus noster pre omnibus diis.
Omnia quecumque uoluit dominus
fecit in celo et in terra: in mari et in
omnibus abyssis.
Educens nubes ab extremo terre:

191r

fulgura in pluuiam fecit.
Qui producit uentos de thesauris
suis: qui percussit primogenita egyp
ti ab homine usque ad pecus.
Et misit signa et prodigia in medio
tui egypte: in pharaonem et in omnes
seruos eius.
Qui percussit gentes multas: et oc
cidit reges fortes.
Seon regem amorreorum: et og re
gem basan et omnia regna chanaan.
Et dedit terram eorum hereditatem: he
reditatem israel populo suo.
Domine nomen tuum in eternum:
domine memoriale tuum in ge
neratione et generationem.

quia iudicabit dominus populum suum:
et in servis suis deprecabitur.
Simulacra gentium argentum
et aurum: opera manuum hominum.
Os habent et non loquentur: o
culos habent et non videbunt.
Aures habent et non audient: ne
que enim est spiritus in ore ipsorum.
Similes illis fiant qui faciunt
ea: et omnes qui confidunt in eis.
Domus israel benedicite domino:
domus aaron benedicite domino.
Domus levi benedicite domino:
qui timetis dominum benedicite domino.
Benedictus dominus ex syon:
qui habitat in ierusalem.

Confitemini domino quoniam
bonus: quoniam in eternum misericordia eius.
Confitemini deo deorum:
Confitemini domino dominorum:
qui facit mirabilia magna solus.
Qui fecit celos intellectu:
Qui firmavit terram super aquas.
Qui fecit luminaria magna:
Solem in potestatem diei:
Lunam et stellas in potestatem
noctis.
Qui percussit egyptum cum primo
genitis eorum:
Qui eduxit israel de medio eorum.
In manu potenti: et brachio excelso.
Qui divisit mare rubrum: in di

135.

192v

lusiones.

er edurit isrl' p medium eius.

t excussir pharaonem ↄ urrtu
tem eius: in mari rubro.

qui transduxit pplm suum p desctu.

qui persstir gentes multas.

t occidit reges fortes.

eon regem amorreox.

t og regem basan.

t dedit terra coꝛ hereditatem.

hereditatem isrl' seruo suo.

quia in humilitate nra: memoꝛ

fuit nri.

t redemit nos ab inimicis nris.

qui dat escam omni carni.

onfitemini deo celi.

193r

onfitemini dño dñoꝛ: qm in
eternum misericordia eius.

uper flumina babilonis
illuc sedimus ↄ fleuimus:
dum recordaremur syon.

n salicib; in medio eius: suspen
dimus organa nra.

quia illic interrogauerunt nos q
captiuos duxerunt nos: uerba can
ticionum.

t qui abduxerunt nos: ympnu
cantate nobis de canticis syon.

uomodo cantabimus canticu
domini: in terra aliena.

i oblitus fuero tui iherlm: obliui
oni detur dextera mea.

136

Adhereat lingua mea faucibus
meis: si non meminero tui.
Si non pposuero tui ierlm: in pn
cipio leticie mee.
Memor esto domine filior edom.
in diem ierlm.
Qui dicunt exinanite exinanite:
usq; ad fundamentum in ea.
Filia babilonis misera: beatus
qui retribuet tibi retributionem tuam
quam retribuisti nobis.
Beatus qui tenebit et allidet: par
uulos suos ad petram.
Confitebor tibi dne i toto cor
de meo: qm audisti uerba
oris mei.

In conspectu angloru psallam t:
adorabo ad templum sctm tuum
et confitebor nomini tuo.
Sup misedia tua et ueritate tua:
quoniam magnificasti sup omne
nomen sanctum tuum.
In quacuq; die inuocauero te: ex
audi me: multiplicabis in anima
mea uirtutem.
Confiteantur tibi domine oms
reges tre: quia audierunt omnia
uerba oris tui.
Et cantent in uiis domini: qm
magna est gla dni.
Qm excelsus dns et humilia respi
cit: et alta a longe cognoscit.

Si ambulauero in medio tribu
lacois uuificabis me: ⁊ sup irã
inimicoꝛ meoꝛ ectendisti manũ
tuã ⁊ saluum me fecit dectera tua.
Dommus retribuet p me: dñe
mia tua in setin opa mannũ tuaꝛ
ne despicias.

Omine pbasti me ⁊ cogno
uisti me: tu cognouisti ses
sionẽ meam ⁊ resurrectõem meam.
Intellexisti cogitacões meas de
longe: semitam meam ⁊ funicuiu
meum inuestigasti

Et omnes uias meas preuidisti:
qa non est sermo in lingua mea.

Ecce domine tu cognouisti oĩa

noussima ⁊ antiq̃ tu formasti me
⁊ posuisti sup me manum tuam.
Mirabilis fca est sciencia tua ex
me: ⁊ foꝛtata est ⁊ ñ poteꝛo ad eam.
Quo ibo a spu tuo: ⁊ quo a facie
tua fugiam.

Si ascendero in cclum tu illic es:
si descendero ad infernum ades.
Si sumpsero pennas meas diiu
culo: ⁊ habitauero in extimis maris
etenim illuc manus tua dedu
cet me: ⁊ tenebit me dectera tua.
Et dixi foꝛsitan tenebre ꝛculcabũt
me: ⁊ nox illuminacio mea in de
luciis meis.

Quia tenebre non obscurabuntuꝛ

ate: ⁊ nox sicut dies illuminabit
sicut tenebre eius ita ⁊ lumen eius.
Quia tu possedisti renes meos:
suscepisti me de utero matris mee.
Confitebor tibi quia terribiliter
magnificatus es mirabilia opa
tua: ⁊ aia mea cognoscit nimis.
Non est occultatum os meum a
te qd fecisti in occulto: ⁊ substan
cia mea in inferioribꝰ terre.
Imperfectum meum viderunt ocli
tui ⁊ in libro tuo omnes scribent
dies formabuntur ⁊ nemo in eis.
Michi autem nimis honorifica
ti sunt amici tui deus: nimis con
fortatus est principatus eorum.

Dinumerabo eos ⁊ sup arenam
multiplicabuntur: exsurrexi ⁊ ad
huc sum tecum.
Si occideris deus peccatores: uiri sa
guinum declinate a me.
Quia dicitis in cogitatoe: accipi
ant in vanitate civitates suas.
Nonne qui oderunt te domine
oderam: ⁊ sup inimicos tuos ta
bescebam.
Perfecto odio oderam illos: ini
mici facti sunt michi.
Proba me deus ⁊ scito cor meum:
interroga me ⁊ cognosce semitas me
Et vide si via iniquitatis
in me est: ⁊ deduc me in via eterna.

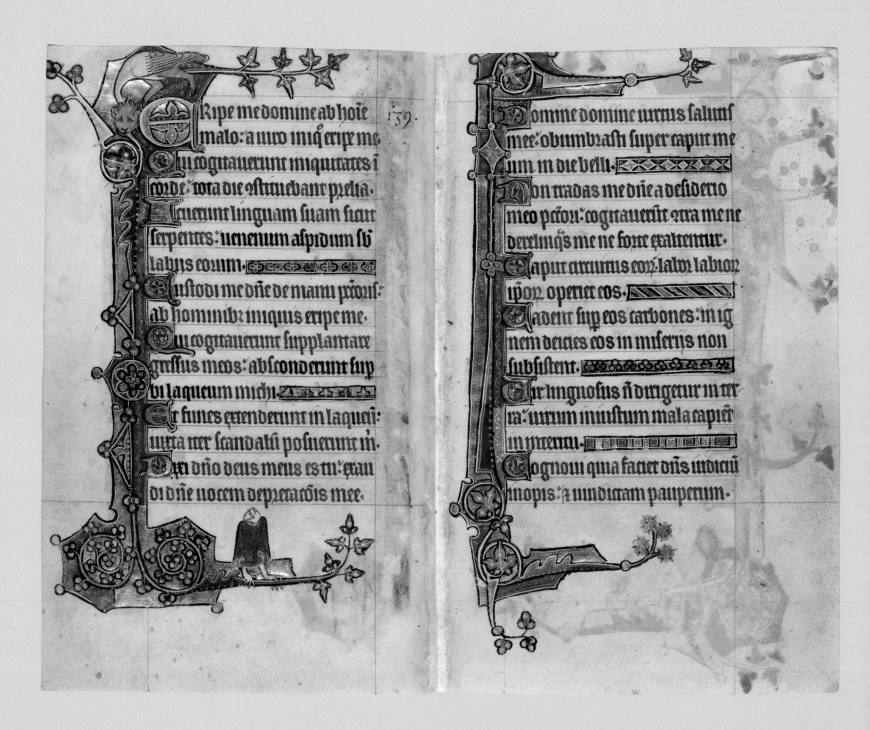

Ripe me domine ab hoïe
malo: a uiro iniq̃ eripe me.
Qui cogitauerunt iniquitates i
corde: tota die constituebant prelia.
Acuerunt linguam suam sicut
serpentes: uenenum aspidum sub
labiis eorum.
Custodi me dñe de manu pccoris:
ab hominibz iniquis eripe me.
Qui cogitauerunt supplantare
gressus meos: absconderunt sup
bi laqueum michi.
Et funes extenderunt in laquei:
iuxta uer scandalu posuerunt in.
Dixi dño deus meus es tu: exau
di dñe uocem deprecacois mee.

Domine domine uirtus salutis
mee: obumbrasti super caput me
um in die belli.
Non tradas me dñe a desiderio
meo pctori: cogitauerint cotra me ne
derelinquas me ne forte exaltentur.
Caput circuitus eorum: labor labioz
ipoz operiet eos.
Cadent sup eos carbones: in ig
nem deicies eos in miseriis non
subsistent.
Uir linguosus non dirigetur in ter
ra: uirum iniustum mala capiet
in interitu.
Cognoui quia faciet dñs iudiciu
inopis: et uindictam pauperum.

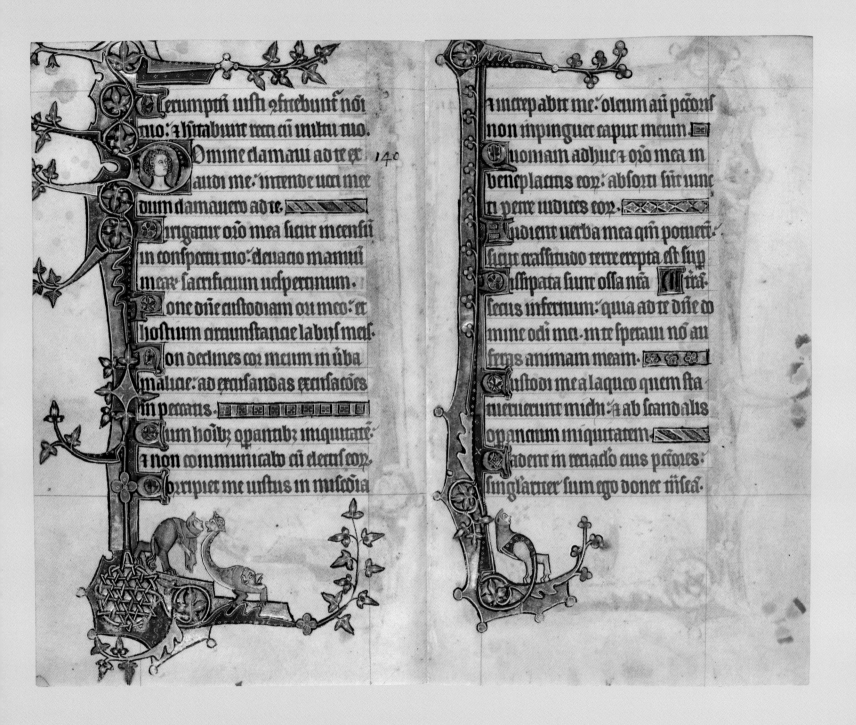

Elerumptm uisu esuedunt noi
mo: 7 hstabunt recti cu uultu tuo.

Omine clamaui ad te ex
audi me: intende uoci mee
dum clamauero ad te.

Dirigatur oro mea sicut incensu
in conspectu tuo: eleuacio manuu
mearum sacrificium uespertinum.

Pone domine custodiam ori meo: et
hostium circumstancie labiis meis.

Non declines cor meum in uerba
malicie: ad excusandas excusacoes
in peccatis.

Cum hoibus operantibus iniquitate
7 non communicabo cum electis eor.

Corripiet me iustus in misericordia

t increpabit me: oleum aut pecortis
non impinguet caput meum.

Quoniam adhuc 7 oro mea in
beneplacitis eor: absorpti sunt iuxta
petre iudices eor.

Audient uerba mea quoniam potuerunt
sicut crassitudo terre erepta est super
dissipata sunt ossa nostra. Sicut tra-
secus infernum: quia ad te domine do-
mine oculi mei: in te speraui non au-
feras animam meam.

Custodi me a laqueo quem sta-
tuerunt michi: 7 ab scandalis
operantium iniquitatem.

Cadent in retiaculo eius peccatores:
singulariter sum ego donec transeam.

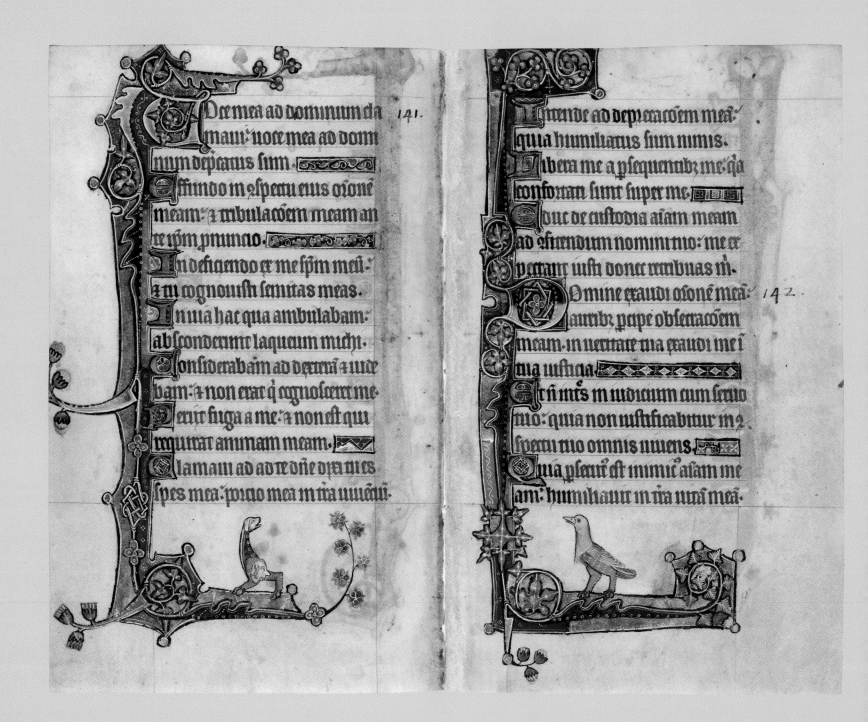

ce mea ad dominum cla
maui·uoce mea ad dom
num deprecatus sum·

effundo in conspectu eius orone
meam· τ tribulacoem meam an
te ipsum pronuncio·

In deficiendo ex me spm meu·
τ tu cognouisti semitas meas·

In uia hac qua ambulabam·
absconderunt laqueum michi·

Considerabam ad dexteram τ uide
bam· τ non erat qui cognosceret me·
periit fuga a me· τ non est qui
requirat animam meam·

Clamaui ad ad te dne dixi tu es
spes mea· porcio mea in tra uiuenciu·

Intende ad depracoem mea·
quia humiliatus sum nimis·

Libera me a psequentibz me· qa
confortati sunt super me·

Educ de custodia aiam meam
ad confitendum nomini tuo· me ex
pectant iusti donec retribuas m·

Domine exaudi orone mea·
auribz percipe obsecracoem
meam· in ueritate tua exaudi me in
tua iusticia·

Et non intres in iudicium cum seruo
tuo· quia non iustificabitur in co
spectu tuo omnis uiuens·

Quia persecutus est inimicus aiam me
am· humiliauit in tra uitam meam·

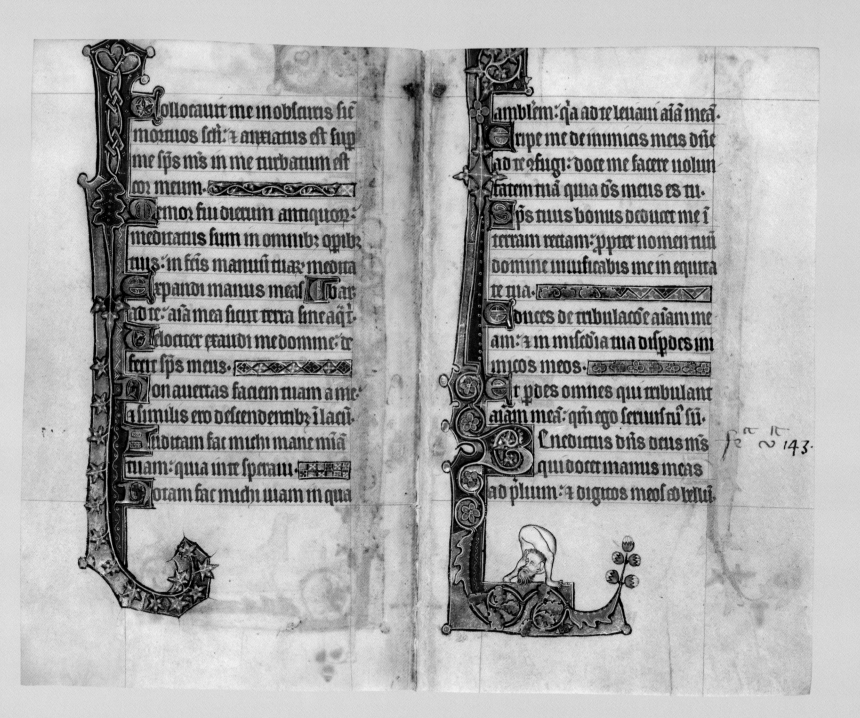

ollocauit me in obscuris sic
mortuos sci. 7 anxiatus est sup
me sps ms in me turbatum est
cor meum.

Memor fui dierum antiquor:
meditatus sum in omnibz: opibz
tuis. in fcis manuu tuar medita
Expandi manus meas Exar
dio te. aia mea sicut terra sine aq̃.

Velociter exaudi me domine. te
fecit sps meus.

Non auertas faciem tuam a me:
7 similis ero descendentibz i laci.
Auditam fac michi mane mia
tuam: quia in te speraui.

Notam fac michi uiam in qua

ambulem: qa ad te leuaui aiam meã.
Eripe me de inimicis meis dñe
ad te fugi: doce me facere uolun
tatem tuã quia ds meus es tu.

Sps tuus bonus deducet me i
terram rectam: ppter nomen tuu
domine uiuificabis me in equita
te tua.

Educes de tribulacoe aiam me
am: 7 in misedia tua dispedes in
imicos meos.

Et pdes omnes qui tribulant
aiam meã: qm ego seruus tu sũ.

Benedictus dñs deus ms
qui docet manus meas
ad plium: 7 digitos meos ad bellũ.

fc 143.

[200v]

misedia mea & refugium meū:
susceptor mꝰ & liberator meus.
protector meus & in ipo speraui:
qui subdit pplm meum sub me.
Domine quid est homo quia i̅
notuisti ei: aut filius hominis q̅a
reputas eum.
Homo uanitati similis f̅cs est:
dies eius sicut umbra preter eunt.
Domine inclina celos tuos et
descende: tange montes & fumi
gabunt.
Fulgura choruscacionem & dissi
pabis eos: emitte sa
gittas tuas & conturbabis eos.
Emitte manum tuam de alto:
eripe me & libera me de aq̅s m̅ltis.

[201r]

& de manu filioꝛ alienoꝛum:
quoꝛ os locutum est uanitate̅:
& dextera eoꝛ dextera iniquitatis.
Deus canticum nouum cantabo
tibi: in psalterio decacorꝺo psallā̅
tibi. Qui das salutem regib̅ qui rede
misti dauiꝺ seruum tuum de gla
dio maligno eripe me.
& erue me de manu filioꝛ alie
noꝛ: quoꝛ os locutum est uani
tatem: & dextera eoꝛum dextera i̅
quitatis.
Quoꝛ filii: sicut nouelle planta
coˢ in iuuentute sua.
Filie eoꝛ composite: circumor
nate ut similituꝺo templi.

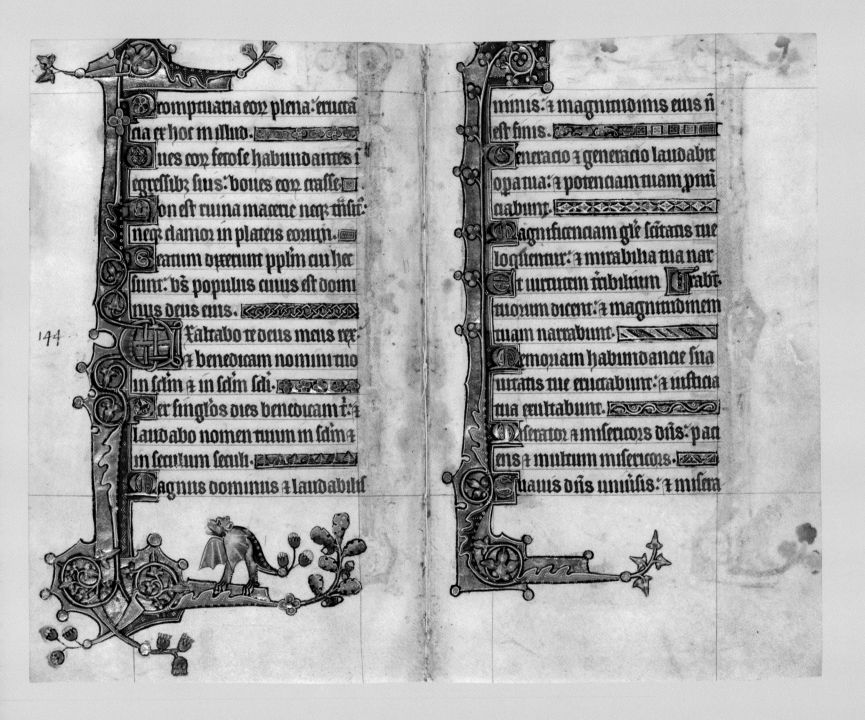

romptuaria eoz plena: eructa
cia ex hoc in illud.

ues eoz fetose habundantes i
egressib; suis: boues eoz crasse

on est ruina macerie neq; transi:
neq; clamor in plateis coruin.

eatum dixerunt pplin cui hec
sunt: bs populus cuius est domi
nus deus eius.

xaltabo te deus meus rex
t benedicam nomini tuo
in scim t in scim scli.

er singlos dies benedicam t:
laudabo nomen tuum in scim t
in seculum seculi.

agnus dominus t laudabilis

mnis: t magnitudinis eius n
est finis.

eneracio t generacio laudabit
opa tua: t potenciam tuam pnu
ciabunt.

agnificenciam gle sctatis tue
loquentur: t mirabilia tua nar
t uirtutem tribilium tabr
tuorum dicent: t magnitudinem
tuam narrabunt.

emoriam habundancie sua
uitatis tue eructabunt: t iusticia
tua exultabunt.

iserator t misericors dns: pac
iens t multum misericors.

uauis dns uniuisis: t misera

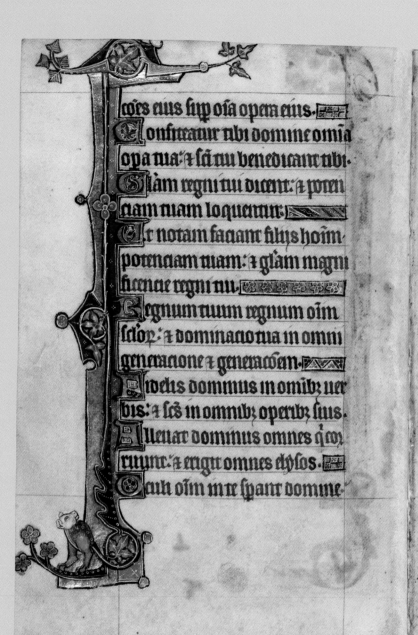

cōes eius sup ōia opera eius.
Confiteatur tibi domine omnia
opa tua: ⁊ sci tui benedicant tibi.
Glam regni tui dicent: ⁊ poten
ciam tuam loquentur.
Et notam faciant filijs hoim
potenciam tuam: ⁊ glam magni
ficencie regni tui.
Regnum tuum regnum oim
sciox: ⁊ dominacio tua in omni
generacione ⁊ generacoēm.
Fidelis dominus in omnibz uer
bis: ⁊ scs in omnibz operibz suis.
Alleuat dominus omnes q̇ cor
ruunt: ⁊ erigit omnes elysos.
Oculi oim in te sperant domine.

⁊ tu das escam illoꝝ in tempore o
portuno.
Aperis tu manum tuam: ⁊ iples
omne animal benedictoē.
Iustus dominus in omnibz uijs
suis: ⁊ scs in omnibz opibz suis.
Prope est dominus omnibz in
uocantibz eum: omnibz inuocan
tibz eum in ueritate.
Voluntatem timencium se faci
et: ⁊ depreacoēm eoꝝ exaudiet ⁊
saluos faciet eos.
Custodit dns omnes diligētes
se: ⁊ omēs pctores disperdet.
Laudacoēm dni loquetur os me
um: ⁊ benedicat omnis caro nōi

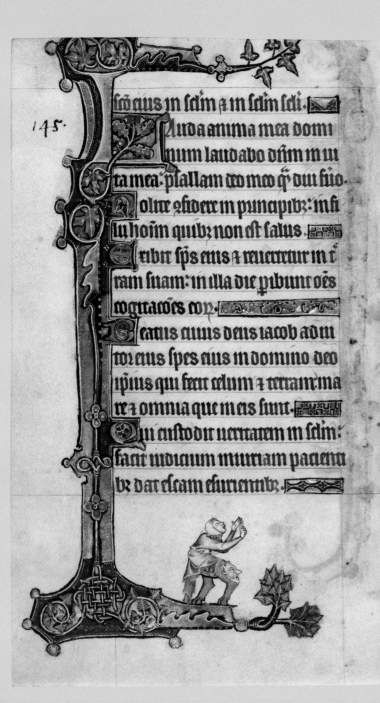

seo eius in sclm q̃ in sclm scli.
Lauda anima mea domi
num laudabo dm̃ in ui
ta mea. psallam deo meo q̃ diu fuo.
Nolite confidere in principibz: in fi
lu hoīm quibz non est salus.
Exibit sps eius q reuertetur in t
ram suam: in illa die puibunt oes
cogitacões coy.
Beatus cuius deus iacob adiu
tor eius spes eius in domino deo
ipsius qui fecit celum q terram ma
re q omnia que in eis sunt.
Qui custodit ueritatem in sclm:
facit iudicium iniuriam pacientu
bz dat escam esurientibz.

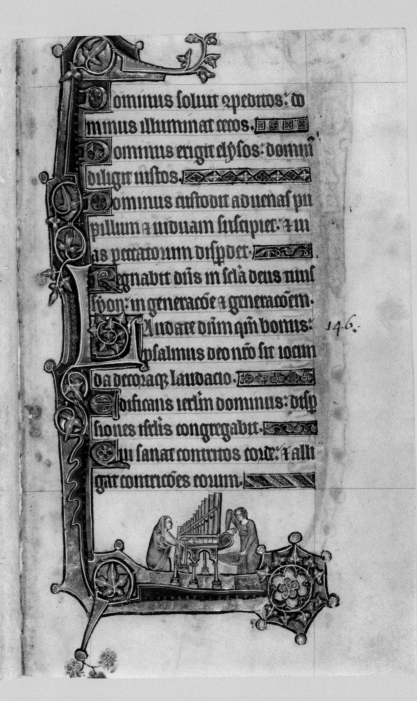

Dominus soluit compednos: do
minus illuminat cecos.
Dominus erigit elysos: domñ
diligit iustos.
Dominus custodit aduenas pu
pillum q uiduam suscipiet: q ui
as peccatorum disperdet.
Regnabit dñs in scla deus tuus
syon: in generacõe q generacõem.
Laudate dñm qm bonus:
psalmus deo ñro sit iocun
da decoraq; laudacio.
Edificans ierlm dominus: disp
siones isrlis congregabit.
Qui sanat contritos corde: q alli
gat contricões eorum.

Left page (204v):

qui numerat multitudinē stellax:
t omnibz eis nomina vocat.
Magnus dominus nr t magna
virtus eius: t sapie eī ñ est numer?
Suscipiens mansuetos dñs: hu
milians aūt pctōres usqz ad ťram.
reante domino in ofessione.
psallite deo nro in cythara.
qui opit celum nubibz: t parat
terre pluuiam.
Qui pducit in montibz fenum:
t herbam seruituti hominum.
Qui dat iumentis escam ipox: t
pullis coruox invocantibz eum.
on in fortitudine equi volun
tatem habebit: nec in tybiis viri bn

Right page (205r):

placitum erit ei.
Beneplacitum est domino super
timentes eum: t in eis qui sperant
super misericordia eius.
Lauda ierlm dñm: lauda te
hymnum syon.
Qñ ofortauit seras portax tuax:
benedixit filiis tuis in te.
Qui posuit fines tuos pacem: et
adype frumenti saciat te.
Qui emittit eloquium suum tře:
velociter currit sermo eius.
Qui dat niuem sicut lanam: ne
bulam sicut cinerem spargit.
Mittit cristallum suam sicut buc
cellas: ante faciem frigoris eius

147

quis sustinebit·

Emittet uerbum suum & liquefa
ciet ea: flauit sps eius & fluent aq.
qui annunciat uerbum suum
iacob: iusticias & iudicia sua isrł.
Non fecit taliter omni nacōi: &
iudicia sua non manifestauit eis.
Laudate dnm de celis: lau
date eum in excelsis·
Laudate eum omnes angli ei'·
laudate eum omnes uirtutes ei'·
Laudate eum sol & luna: lau
date eum oēs stelle & lumen·
Laudate eum celi celoʒ: & aque
que sup celos sunt laudent nomē
domini·

148·

qua ipse dixit & fca sunt: ipse mā
dauit & creata sunt·
statuit ea ineternum & in sclm
scli: preceptum posuit & nō pbit·
Laudate dnm de tra: dracones
& omnes abyssi·
Ignis grando nix glacies sps
pcellar: que faciunt uerbum eius·
Montes & omnes colles: ligna
fructifera & omnes cedri·
Bestie & uniuersa pecora: serpētes
& uolucres pennate·
Reges terre & omnes poph̄ pn
cipes & omnes iudices terre·
Iuuenes & uirgines senes cum
iunioribʒ laudent nomen dni·

gła exaltatũ est nomen eius solius /
Confessio eius sup celum ⁊ tra /
⁊ exaltauit cornu populi sui. /
Ympnus omnibȝ sčis eius: filijs /
israł pplo appinqñti sibi. /
Cantate dño canticum nouum: /
laus eius in ecčia sčoꝝ. /
Letetur israł in eo qui fecit eum: ⁊ /
filie syon exultent in rege suo. /
Laudent nomen eius in choro: /
in tympano ⁊ psalterio psallãt ei. /
Quia beneplacitum est domino /
in populo suo: ⁊ exaltauit man /
suetos in salutem. /
Exultabunt sči in głã: letabunt /
in cubilibȝ suis.

Exultacões dei in gutture coꝝ: /
⁊ gladii ancipites in manibȝ eoꝝ. /
Ad faciendam uindictam in na /
cõibȝ: increpacões in populis. /
Ad alligandos reges eoꝝ in cõpe /
dibȝ: ⁊ nobiles eoꝝ in manicis fer /
reis. Ut faciant in eis iudiciũ /
conscriptum: głã hec est omnibȝ /
sčis eius. /
Laudate dñm in sčis eius: lau /
date eum in firmamẽto uirtutis ei. /
Laudate eum in uirtutibȝ ei: /
laudate eum scđm multitudinẽ /
magnitudinis eius. /
Laudate eum in sono tube: lau /
date eum in psalterio ⁊ cythara.

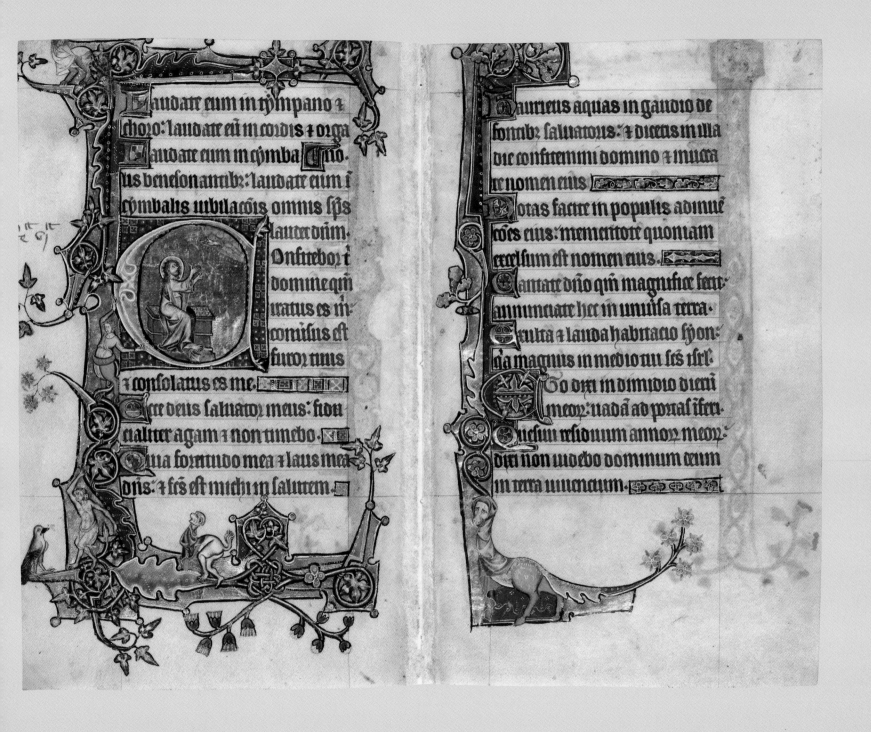

on aspiciam hoiem ultra: Iha
bitatorem quietis.
eneracio mea ablata est a con
uoluta est a me: quasi tabernacu
lum pastorum.
recisa est uelut a texente uita me
a: dum adhuc ordirer succid me
e mane usq ad uespam finis
me: sperabam usq ad mane quasi
leo sic contriuit omnia ossa mea.
e mane usq ad uespam finis
me: sicut pullus hyrundinis sic
clamabo meditabor ut columba.
tenuati sunt oculi mei: suspi
cientes in excelso
omine uim pacior responde

p me: quid dicam aut quid respo
debit mihi cum ipe fecerim.
ecogitabo tibi omnes annos
meos in amaritudine aie mee
omine si sic uiuitur et in talibe
uita sps mei: corripies me et uiui
ficabis me: ecce in pace amaritudo
mea amarissima.
u autem eruisti aiam meam
ut non pirer: pieiisti post tergum
tuum omnia peccata mea.
ia non infernus confitebitur
tibi: neq mors laudabit te: non
expectabunt qui descendunt in la
cum ueritatem tuam.
iuens iuuens ipe confitebitur

nibi: sicut + ego hodie pater filius
noram faciet ueritatem tuam.
Domine saluum me fac: + psal
mos nros cantabimus cunctis di
ebus uite nre in domo domini.
Exultauit cor meum in dno:
+ exaltatum est cor meum
in deo meo. Dilatatum est meum sup inimi
cos meos: quia letata sum in sa
lutari tuo. Non est scs ut est dominus: neq;
enim est alius extra te: + non est for
tis sicut deus noster. Nolite multiplicare loqui: subli
mia gloriantes.

credant uetera de ore nro: quia
deus scientiar dominus est + ipsi
preparantur cogitacoes. Arcus fortium superatus est: + in
firmi accincti sunt robore. Repleti prius. p panibz se locauer
+ famelici saturati sunt. Donec sterilis peperit plurimos:
+ que multos habebat filios infir
mata est. Dns mortificat + uiuificat: + de
ducit ad inferos + reducit. Dominus paupem facit + ditat:
humiliat + subleuat. Suscitans de puluere egenum:
+ de stercore erigens pauperem.

eos sicut stipulam: in spu furoris
tui congregate sunt aque·
Sicut unda fluens: congregati
sunt abyssi in medio mari·
Dixit inimicus psequar 7 com
prehendam: dividam spolia im
plebitur anima mea·
Euaginabo gladium meum: 7
interficiet eos manus mea·
Flauit sps tuus 7 opuit eos ma
re: submersi sunt quasi plumbu
in aquis uehementib3·
Quis similis tui in fortib3 dne:
quis similis tui magnificus in
sctitate terribilis atq3 laudabilis
7 faciens mirabilia·

Extendisti manum tuam 7 de
uorauit eos terra·
Dux fuisti in miscdia tua: poplo
quem redemisti·
Et portasti eum in fortitudine
tua: ad habitaclm sctm tuum·
Ascenderunt popli 7 irati sunt:
dolores optinuerunt philistijm·
Tunc turbati sunt principes e
dom: robustus moab obtinuit tre
mor obriguerunt omnes habita
tores chanaan·
Irruat sup eos formido 7 pauor:
in magnitudine brachij tui·
Fiant immobiles quasi lapis do
nec ptranseat popls tuus dne·

donec ptranseat ppls tuus iste q̃
possedisti.

Introduces eos 7 plantabis ĩ
monte hereditatis tue. firmissio
sabitaclo tuo qd opatus es domine.
sciarium tuum dñe qd firma
uerunt manus tue. dominus reg
nabit ĩeternum 7 ultra.

Ingressus est ẽ eques pharao
cum curribz 7 equitibz in mare. 7
reduxit sup eos dñs aqs maris.
filii autem irl ãbulauerunt
p siccum in medio eius.

Domine audiui. auditum
tuum 7 timui.
Domine opus tuum: in medio

annor uiuifica illud.
In medio annor notu facies:
cum iratus fuis m̃ie recordaberis.
eus ab austro ueniet. 7 scs de
monte pharan.
putt celos gl̃a eius. 7 laudis ẽ
plena est terra.
splendor eius ut lux erit: cornu
a in manibz eius.
ibi abscondita est fortitudo ei:
ante faciem eius ibit mors.
gredíatur dyabolus añ pedes
eius: stetit 7 mensus est terram.
spexit 7 dissoluit gentes: 7 con
triti sunt montes seli.
Incuruati sunt colles mundi:

ab minerib; eternitatis eius. ☒
ro iniquitate vidi tentoria
ethiopie: turbabuntur pelles terre
madian.

Nunquid in fluminib; iratus
es dñe: aut in fluminib; furor tu
us vł in mari indignacio tua. ☒

Qui ascendit sup equos tuos: et
quadrige tue saluacio.

Suscitans suscitabis arcum tuum:
iuramenta tribub; que locutus es.

Fluuios scindens terre viderunt
et doluerunt: montes gurges aqr
transiit.

Dedit abyssus vocem suam: al
titudo manus suas leuauit. ☒

Sol et luna steterunt in habitaculo
suo: in luce sagittar tuar ibunt i
splendore fulgurantis haste tue.

In fremitu conculcabis tram: in
furore obstupefacies gentes. ☒

Egressus es in salutem popli tu
in salutem cum xpõ tuo.

Percussisti caput de domo impii:
denudasti fundamentum usqz ad
collum.

Maledixisti sceptris eius capita
bellatorum eius: venientib; ut tur
bo ad dispergendum me.

Exultacio eorum sicut eius: qui de
uorat pauperem in absconditio.

Viam fecisti in mari equis tuis.

in luto aquarum multarum.
Laudaui a cuurbatus est uenter
meus: a noce timui et labia mea.
Ingrediat putredo in ossibus meis
et subter me scateat.
Ut requiescam in die tribulacois:
et ascendam ad pplin accinctum nrm.
ficus enim non florebit: et non
erit germen in uineis.
Meutietur opus oliue: et arua non
afferant cibum.
Abscidetur de ouili pecus: et non
erit armentum in presepibus.
Ego autem in dno gaudebo: et
exultabo in deo ihu meo.
Deus dns fortitudo mea: et po

net pedes meos quasi ceruorum.
Et sup excelsa mea deducet me
uictor in psalmis canentem.
Udite celi que loquar: au
diat tra uerba oris mei.
Concrescat ut pluuia docrina mea
fluat ut ros eloquium meum.
Quasi ymber sup herbam et qsi
stille sup gramina: quia nomen
domini inuocabo.
Date magnificenciam deo nro.
dei pfecta sunt opa: et omnes uie ei
iudicia.
Deus fidelis et absq; ulla iniqta
te iustus et rectus: peccauerunt ei et
non filii eius in sordibus.

Generacio praua atq3 puisa hec
cine reddis domino: popule stlte
z insipiens. ⬥⬥⬥⬥⬥⬥⬥
Nunquid non ipse est pater tu
us qui possedit te: z fecit te z crea
uit te. ⬥⬥⬥⬥⬥⬥⬥
Memento dieꝛ antiquoꝛ: cogita
generacoes singulas. ⬥⬥⬥
Interroga pꝛem tuum z annun
ciabit tibi: maiores tuos z dicent ꝶ.
Quando diuidebat altissimus
gentes: qūdo separabat filios ada.
Constituit terminos pploꝛ: iux
ta numerum filioꝛ isrł. ⬥⬥⬥
Pars aū dūi popłs eius: iacob fu
niculin hereditatis eius. ⬥⬥⬥

Inuenit eū in tra deserta: in loco
horrous z uaste solitudinis. ⬥
Circumduxit eum z docuit: z c̄
todiuit quasi pupillam oculi sui.
Sicut aquila prouocans ad uolā
dum pullos suos: z super eos uolitās.
Expandit alas suas z assūpsit e
os: atq3 portauit in humeris suis.
Dominus solus dux eius fuit: et
non erat cum eo deus alienus. ⬥
Constituit eum sup excelsam tr̄ā:
ut commederet fructus agroꝛum.
Et suggeret mel de petra: oleūq3
de saxo durissimo. ⬥⬥⬥⬥⬥
Butyrum de armento z lac de o
uibz: cum adipe agnoꝛ z arietū

filioy basan .

Et hyyeos cum medulla tritici:
t languinem uue biberet meracs
Incrassatus est dilect9 · Incrassa
t recalctrauit: incrassatus inpin
guatus dilatatus ·

ereliquid deum fcōyem suum:
t recessit a deo salutari suo ·

prouocauerunt eum in diys ali
enis: t in abhominacōib3 ad yra
cundiam concitauerunt·

Immolauerunt demonyis et
non deo: diys quos ignorabant
oui recentesq; uenerunt: quos
non coluerunt pyes eoyum·

eum qui te genuit dereliqsti: t

oblitus es domini creatoyis tui·
Uidit dns t ad yacundiam cōci
tatus est: quia puocauerunt eum fi
lii sui t filie·

Et ait abscondam faciem meam
ab eis: t considerabo nouissia eoy·
Generacio enim puersa est: t in
fideles filii·

Ipsi me puocauerunt in eo qui
non erat deus: t irritauerunt in
uanitatib3 suis·

Et ego puocabo eos in eo qui n
est ppls: t in gente stulta irritabo
illos. Ignis succensus est in
furore meo: t ardebit usq; ad in
ferni nouissima.

euorabutrp iram ctum germie
suo: 7 moncui fundanuta 2duiut
ongregabo sup eos mala. et
sagittas meas complebo in eis.
onsumentur fame 7 deuorabr
eos: aues morsu amarissimo.
entes bestiar immittam in eos:
cum furore trahencium sup tram
atq; serpenctum.
ous uastabit eos gladius: et
mus pauor.
uuenem simul ac uirginem: lac
tantem cum homine sene.
er orni ubi nam sunt: cessare fac
am ex hominib; memoriam eor.
Sed ppt iram inimicor disuli:

ne forte supburent hostes eorum.
et dicerent manus nostra excelsa:
7 non dns fecit hec omnia
ens absq; consilio est 7 sine p
dencia: utinam saperent 7 intellige
rent ac nouissima puiderent.
uomodo psequebatur unus
mille: 7 duo fugarent decem milia.
onne ideo quia deus suus uen
didit eos: 7 dns conclusit illos.
on enim est deus nr ut ds eor.
7 inimici nri sunt iudices.
e uinea sodomor uinea eor: 7
de suburbanis gomorre.
bua eor uua fellis: 7 botr ama
rissimus.

218v

...el dracouum uinum eoz: et ue
nenum aspioum insanabile.
Nonne hec condita sunt apud
me: et signata in thesauris meis.
Mea est ulcio et ego retribuam eis
in tempore: ut labatur pes eoum
iuxta est dies poonis: et adest fes
tinant tempora.
Iudicabit dominus pplin suu:
et in seruis suis miserebitur.
Uidebit qd infirmata sit manus et
clausi quoq defecerunt residui qz
sumpti sunt.
Et dicent ubi sunt dii eoz: in qbz
habebant fiduciam.
De quox uictimis comedebant

219r

adypes: et bibebant uinum libaminu.
Surgant et opitulentur nobis:
et in necessitate uos protegant.
Uidete qd ego sum solus: et non sit
alius deus preter me.
Ego occidam et ego uiuere faciam
percutiam et ego sanabo et non est q
de manu mea possit eruere.
Leuabo ad celum manum mea
et dicam uiuo ego ineternum.
Si acuero ut fulgur gladium meu
et arripuerit iudicium manus mee.
Reddam ulcoem hostib meis:
et his oderunt me retribuam.
Inebriabo sagittas meas sang
ne: et gladius ms deuorabit carnes.

219v (left column)

e cruore occisoꝛ: ꞇ de captiuita
te nudati inimicoꝛ captis
Laudate gꝫ ꝓpłin eius: qa san
guinem seruoꝛ suoꝛ ulascetur
ꝗ uindictam retribuet in hostes
coꝛ: ꞇ ꝓpicius erit re populi sui.
Te deum laudamus: te co
minum confitemur
Te eternum p̄em: omnis terra
ueneratur.
Tibi omnes angli: tibi celi ꞇ uni
uerse potestates.
Tibi cherubyn ꞇ seraphin inces
sabili uoce pclamant.
Sanctus. Sanctus. S̄s.
Dominus deus sabaoth.

220r (right column)

len sunt celi ꞇ terra: maiestatis
glorie tue.
Te glosus apłoꝛ choꝰ.
Te ꝓpħaꝛ: laudabilis numeꝰ.
Te mrm candidatus: laudat exer
Te p orbem traꝛ: sc̄a ꝯfitetur eccā
rem mmense maiestatis
Venerandum tuum uerum: et
unicum filium.
Sanctum quoqꝫ pacłitum spm.
Tu rex głe xp̄e.
Tu pris sempiternus es filius.
Tu ad liberandum suscepturus
hoiem: n horruisti uginis uteru
Tu deuicto mortis aculeo: apuis
tt credentibꝫ regna celorum.

bñdicite omnis spr dei domino.
benedicite ignis z estus dño: be
nedicite frigus z estas domino.
benedicite rores z pruina dño:
benedicite gelu z frigus domino.
benedicite glacies z nibes dño:
benedicite noctes z dies dño
benedicite lux z tenebre dño: be
nedicite fulgura z nubes domino.
benedicat terra dñm: laudet z
superaltet eum in scła
benedicite montes z colles dño:
benedicite uniuisa germinancia i
in terra dommo
nedicite fontes domino. bn
dicite maria z flumina domino.

Benedicite cete z omnia que mo
uentur in aquis domino: benedi
cite omnes uolucres celi domino.
benedicite omnes bestie z pecora
domino: benedicite filij hoim dõ.
benedicat isrł dñm: laudet z sł
exaltet eum in scła.
benedicite sacerdotes dñi dño:
benedicite serui domini domino:
bñdicite spr z aie iustor dño: ve
nedicite sci z humiles corde domino.
benedicite anania azaria misack
dño: laudate z superaltate eu i scła.
benedicamus prem z filium eu
sco spu: laudemus z superaltem
eum in scła.

enedictus es domine in firma
mento celi: et laudabilis et gloriosus
et superaltatus in secula.
Benedictus dominus deus
israel: quia visitavit et fecit
redemptionem plebis sue.
Et erexit cornu salutis nobis: in
domo david pueri sui.
Sicut locutus est per os sanctorum: qui
a seculo sunt prophetarum eius.
Salutem ex inimicis nostris: et de
manu omnium qui oderunt nos.
Ad faciendam misericordiam cum patribus
nostris: et memorari testamenti sui sancti.
Iusiurandum quod iuravit ad ab
raham patrem nostrum: daturum se nobis.

Et sine timore de manu inimi
corum nostrorum liberati: serviamus illi.
In sanctitate et iusticia coram ipso:
omnibus diebus nostris.
Et tu puer propheta altissimi voca
beris: preibis enim ante faciem do
mini parare vias eius.
Ad dandam scienciam salutis plebi eius:
in remissionem peccatorum eorum.
Per viscera misericordie dei nostri: in quibus
visitavit nos oriens ex alto.
Illuminare hys qui in tenebris
et umbra mortis sedent: ad dirigen
dos pedes nostros in viam pacis.
Magnificat: anima mea dominum.
Et exultavit spiritus meus.

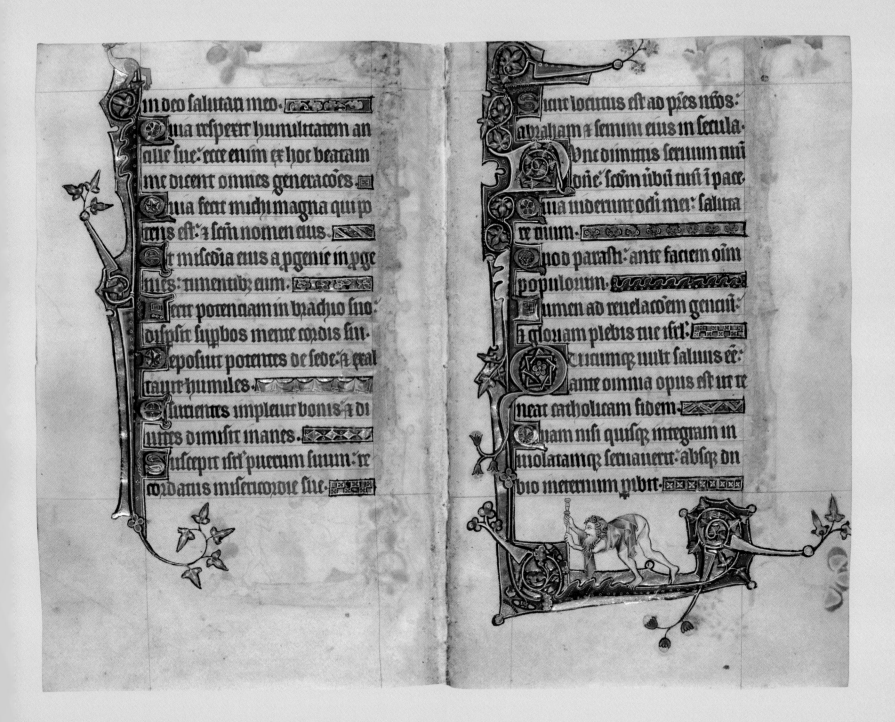

in deo salutari meo · ❦
Quia respexit humilitatem an
cille sue · ecce enim ex hoc beatam
me dicent omnes generacōes · ❦
Quia fecit michi magna qui po
tens est · 7 scm nomen eius · ❦
Et misedia eius a pgenie in pge
nies · timentibz eum · ❦
Fecit potenciam in brachio suo ·
dispsit suybos mente cordis su ·
Deposuit potentes de sede · 7 exal
tauit humiles · ❦
Esurientes impleuit bonis · 7 di
uites dimisit manes · ❦
Suscepit isrl puerum suum · re
cordatus misericordie sue · ❦

ctur locutus est ad pres nros ·
abraham 7 semini eius in secula ·
Nunc dimittis seruum tuum
domine · scm uirbil tuum i pace
Quia uiderunt ocli mei · saluta
re tuum · ❦
Quod parasti · ante faciem oim
populorum · ❦
Lumen ad reuelacōem gentiu ·
7 gloriam plebis tue isrl · ❦
Quicumqz uult saluus ee ·
ante omnia opus est ut te
neat catholicam fidem · ❦
Quam nisi quisqz integram in
uiolatamqz seruauerit · absqz du
bio in eternum peribit · ❦

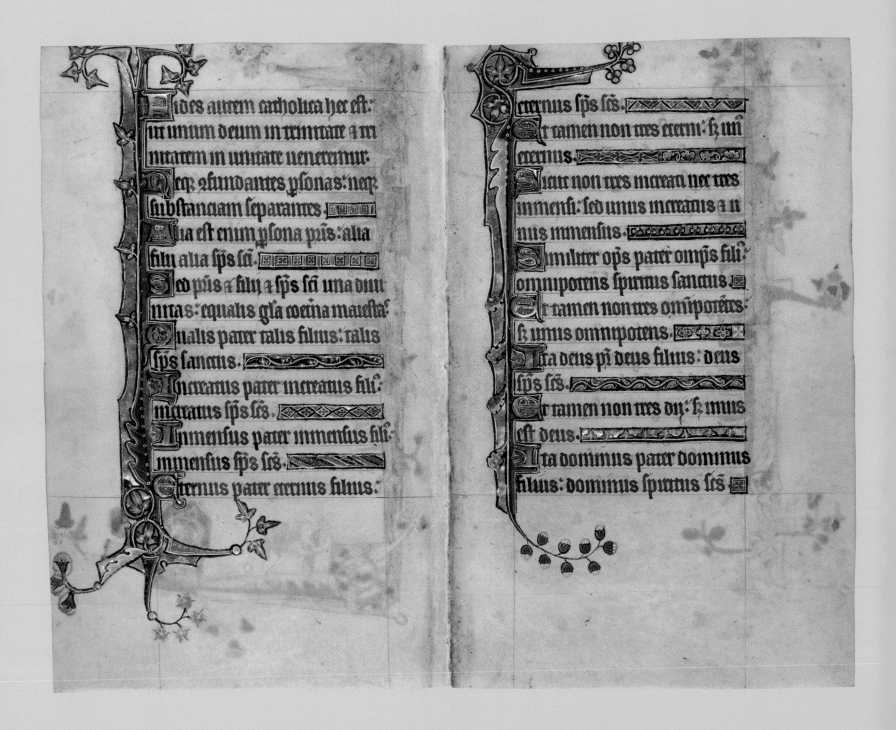

Fides autem catholica hec est:
ut unum deum in trinitate 4 tri
nitatem in unitate ueneremur.
Neq̃ 2fundentes psonas: neq̃
substanciam separantes.
Alia est enim psona pris: alia
filij alia sps sci.
Sed pris 4 filij 4 sps sci una diui
nitas: equalis gsa coeina maiestas.
Qualis pater talis filius: talis
sps sanctus.
Increatus pater increatus fili:
increatus sps scs.
Immensus pater immensus fili:
immensus sps scs.
Eternus pater eternus filius:

eternus sps scs.
Et tamen non tres eterni: sz unus
eternus.
Sicut non tres increati nec tres
immensi: sed unus increatus 4 u
nus immensus.
Similiter ops pater omps fili:
omnipotens spiritus sanctus.
Et tamen non tres omipotentes:
sz unus omnipotens.
Ita deus pr deus filius: deus
sps scs.
Et tamen non tres dij: sz unus
est deus.
Ita dominus pater dominus
filius: dominus spiritus scs.

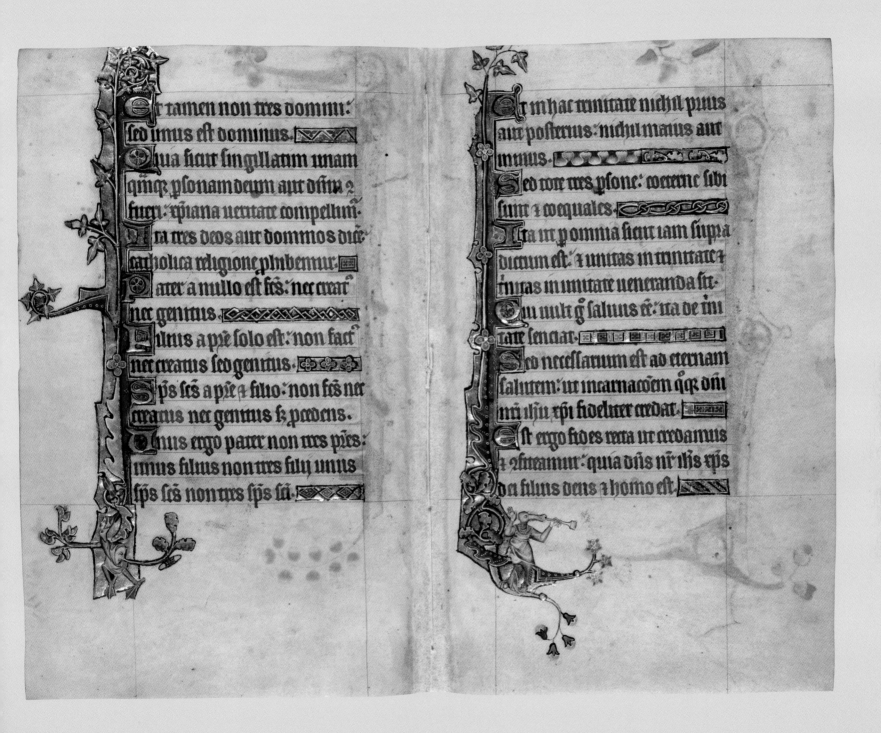

Et tamen non tres domini: sed unus est dominus. Quia sicut singillatim unam quamque personam deum ac dominum confiteri: christiana veritate compellimur: ita tres deos aut dominos dicere catholica religione prohibemur. Pater a nullo est factus: nec creatus nec genitus. Filius a patre solo est: non factus nec creatus sed genitus. Spiritus sanctus a patre et filio: non factus nec creatus nec genitus sed procedens. Unus ergo pater non tres patres: unus filius non tres filii unus spiritus sanctus non tres spiritus sancti.

Et in hac trinitate nichil prius aut posterius: nichil maius aut minus. Sed totae tres persone: coeterne sibi sunt et coequales. Ita ut per omnia sicut iam supra dictum est: et unitas in trinitate et trinitas in unitate veneranda sit. Qui vult ergo saluus esse: ita de trinitate sentiat. Sed necessarium est ad eternam salutem: ut incarnacionem quoque domini nostri iesu christi fideliter credat. Est ergo fides recta ut credamus et confiteamur: quia dominus noster iesus christus dei filius deus et homo est.

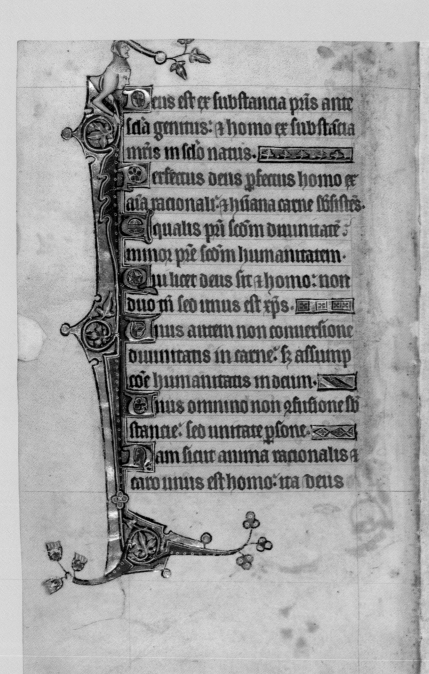

Deus est ex substancia patris ante
secla genitus: et homo ex substacia
matris in seclo natus.
Perfectus deus perfectus homo ex
anima racionali et humana carne subsistens.
Equalis patri secundum diuinitate:
minor patre secundum humanitatem.
Qui licet deus sit et homo: non
duo tamen sed unus est christus.
Unus autem non conuersione
diuinitatis in carne: set assump
cone humanitatis in deum.
Unus omnino non confusione sub
stancie: sed unitate persone.
Nam sicut anima racionalis et
caro unus est homo: ita deus

et homo unus est christus.
Qui passus est pro salute nostra: desce
dit ad inferos tercia die resurrexit a
mortuis.
Ascendit ad celos sedet ad dextera
dei patris omnipotentis: inde uenturus
iudicare uiuos et mortuos.
Ad cuius aduentum omnes homines
resurgere habent cum corporibus
suis: et reddituri sunt de factis propriis
racionem.
Et qui bona egerunt ibunt in ui
tam eternam: qui uero mala in ignem eternum
Hec est fides catholica quam nisi
nisi quisque fideliter firmiterque cre
diderit: saluus esse non poterit.

yueleyson. Xpeleyson.

Xpe audi nos

ater de celis deus miserere dñ.

ilij redemptor mundi deus

miserere nobis.

ps scē deus miserere nobis.

scā trinitas un dñ miserere nob.

scā maria ora p nobis.

scā dei genitrix. or.

scā uirgo uirginum. or.

scē michael. or.

scē gabriel. or.

scē raphael. or.

omes scā angli 7 archangli. or.

omnes scā beaton spm oromes.

scē iohes baptista. or.

omnes scā pſiarche 7 pphie. or.

scē petre. or.

scē paule. or.

scē andrea. or.

scē iacobe. or.

scē iohēs. or.

scē thoma. or.

scē iacobe. or.

scē philippe. or.

scē bartholomee. or.

scē mathee. or.

scē symon. or.

scē thadee. or.

scē mathia. or.

scē marce. or.

scē luca. or.

Left page (228v):

Scē barnaba. · · · · · · · · or.
omnes sci aplī z euuāngel· or.
omnes sci discipuli dm̄· or.
omnes sci innocentes · or.
scē stephē· or.
scē line· or.
scē clete· or.
scē clemens· or.
scē sixte· or.
scē corneli· or.
scē cypriane· or.
scē thoma· or.
scē laurenti· or.
scē vincenti· or.
scē georgi· or.
scē fabiane· or.

Right page (229r):

scē sebastiane· or.
scē dyonisi cum socꝭs tuis· or.
scē maurici cum socꝭs tuis· or.
scē eustaci cum socꝭs tuis· or.
scē ypolite cum socꝭs tuis· or.
scē albane· or.
scē aelphege· or.
scē eadmunde· or.
scē edwarde· or.
scē osewalde· or.
scē kenelme· or.
omnes sci m̄res or.
scē siluester· or.
scē gregori· or.
scē hyllari· or.
scē martine· or.

scē ambrosi. · · · · · · · · orᵃ
scē augustine. · · · · · · orᵃ
scē nicholae. · · · · · · · orᵃ
scē dunstane. · · · · · · · orᵃ
scē augustine cū socus ꝶis. orᵃ
scē eadmunde. · · · · · · orᵃ
scē eoꝶ arde. · · · · · · · orᵃ
scē cuthberte. · · · · · · orᵃ
scē botulphe. · · · · · · · orᵃ
scē ieronime. · · · · · · · orᵃ
scē benedicte. · · · · · · orᵃ
scē leonarde. · · · · · · · orᵃ
scē egidi. · · · · · · · · · · orᵃ
scē aldelme. · · · · · · · orᵃ
scē germane. · · · · · · · orᵃ
scē macute. · · · · · · · · orᵃ

scē hȳchīne. · · · · · · · orᵃ
omnes scī confessores. orᵃ
scā maria magdalena. orᵃ
scā maria egyptiaca. · · orᵃ
scā feliertas. · · · · · · · orᵃ
scā pperua. · · · · · · · · orᵃ
scā agatha. · · · · · · · · orᵃ
scā agnes. · · · · · · · · · orᵃ
scā cecilia. · · · · · · · · · orᵃ
scā lucia. · · · · · · · · · · orᵃ
scā scolastica. · · · · · · orᵃ
scā iuliana. · · · · · · · · orᵃ
scā katerina. · · · · · · · orᵃ
scā margareta. · · · · · · orᵃ
scā xp̄iana. · · · · · · · · orᵃ
scā fides. · · · · · · · · · · orᵃ

Sca spes. or.
Sca karitas. or.
Sca sapiencia. or.
Sca brigida. or.
Sca helena. or.
Sca ositha. or.
Sca etheldreda. or.
Sca editha. or.
Omnes sce uirgines. orate p n.
Omnes sci ⁊ sce. orate p nobis.
Propicius esto parce nobis dñe.
Ab omni malo libera nos dñe.
Ab insidiis dyaboli.
Subitanea ⁊ eterna morte. . lr.
A peste superbie. lr.
A carnalibz desideriis. . . . lr.

Ab omni immundicia mentis
⁊ corporis. lr.
A spu fornicacionis. . . . lr.
Ab ira ⁊ odio ⁊ omni mala uo
luntate. lr.
A cecitate cordis. lr.
Ab apetitu inanis glorie. . lr.
A fulgure ⁊ tempestate. . . lr.
Per misterium sce incarnacois
tue.
Per passionem ⁊ crucem tuã. lr.
Per glosam resurreccõem tuã. lr.
Per admirabilé ascensione nã. lr.
Per graciam sci sps paracliti. lr.
In hora mortis succurre nobis
domine.

In die iudicii. ~~XXXXX~~

Peccatores te rogamus audi nos.

Ut pacem nobis dones. ⊠ R.

Ut scam ecciam tuam catholicam

regere ⁊ defensare digneris. ⊠ R.

Ut dompnum aplicum ⁊ oes

gradus ecie in sca religione conser

uare digneris. ~~//////~~ R.

Ut regi nro ⁊ principibz nris pa

cem ⁊ ueram ccordiam atqz uicto

riam donare digneris. ⊠ R.

Ut cunctum poplm xpianum

preuoso sanguine tuo redempti

conseruare digneris. ~~XXXX~~ R.

Ut miserias paupum ⁊ captiui

rii intueri ⁊ reuelare digneris. R.

Ut remissionem oim pctor nror

nobis donare digneris. ⊠ R.

Ut aias nras ⁊ parentum nror ab

eterna dampnacoe eripias. ⊠ R.

Ut omnibz benefcorbz nostris

sempiterna bona retribuas. ⊠ R.

Ut fructus terre dare ⁊ conserua

re digneris. ~~/////~~ R.

Ut cunctis fidelibz defunctis re

quiem eternam donare digns. R.

Ut nos exaudire digneris. ⊠ R.

Fili dei te rogamus audi nos.

Agnus dei qui tollis pcta mun

di parce nobis domine. ~~XXX~~

Agnus dei qui tollis pcta mun

di exaudi nos domine. ⊠

gnus dei qui tollis pĉa mun
di miserere nobis.
Xpe audi nos. ꝓel. Xpe
audi nos. Pat nr Et ne nos.
stende nobis dne miam tuã.
t salutare tuum da nobis.
t veniat sup nos mia tua dñe.
salutare tuum secm eloqũ nũ.
erauimus dñe cu pbz nris.
iniuste egimus iniqtatẽ fecim.
sie ñ secm pĉa nra q fecim nos.
eqz secm iniqtates nras ret. n
remus p omni gradu ecclie.
aĉerdotes tui induantur iuŝ
ticiam t sĉi tui exultent.
ro frib; t fororib; nris absẽtib;.

aluos fac fernos tuos t anci[l]
las tuas deus mŝ sperantes in te.
ro cuncto populo xpiano.
aluum fac pplm tuum dñe.
benedic hereditati tue t rege eos t.
extolle illos ufqz ineternum.
ie fiat pax in uirtute tua.
t habundancia in turribz tuis.
nime famuloꝝ famularꝝqz tu
ar. requiescant in pace. amen.
ie exaudi oꝛonem meam.
t clamoꝛ meus ad te ueniat.
ns nobiscum. remus. oꝛ
Cus cui ꝓpuium est mise
reri semp t parcere suscipe
deprecacoẽm nram. t qs delictoꝛ

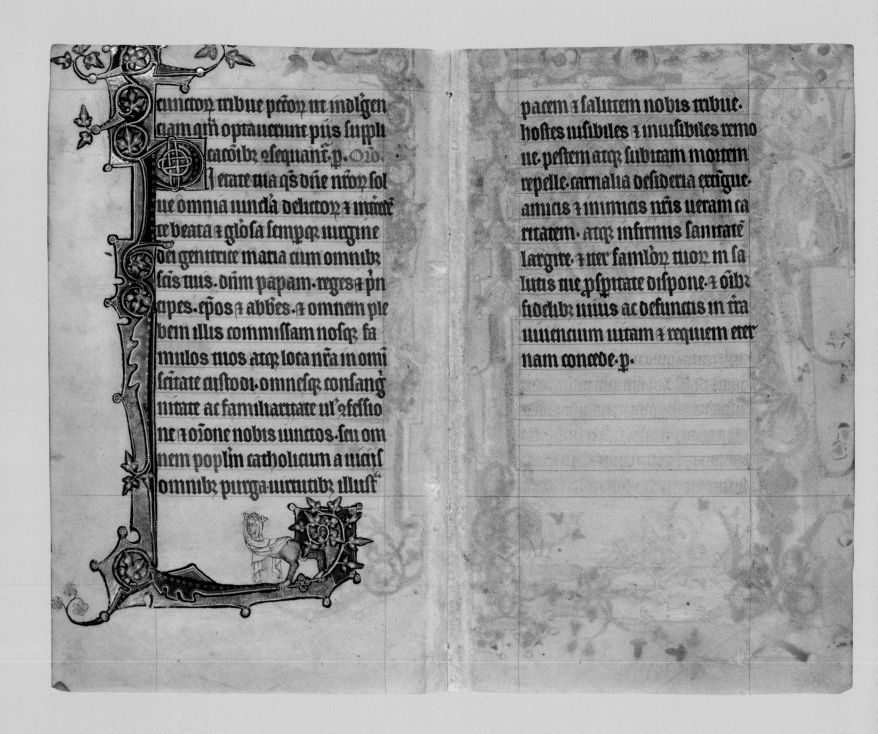

ecunctoꝝ tribue peccoꝝ ut indulgen
ciam qua̅ optauerunt piis suppli
cacoibz ꝯsequant̄. p̄. Oꝛo.

etare nia q̄s die n̄coꝝ sol
ue omnia uincla delicto̅ꝝ ⁊ miꝰe
re beata ⁊ glosa semper uirgine
dei genitrice maria cum omnibz
sc̄is tuis. dn̄m papam. reges ⁊ pn̄
cipes. ep̄os ⁊ abbes. ⁊ omnem ple
bem illis commissam nosꝗ; fa
mulos tuos atꝗ; loca n̄ra in omi
sc̄itate custodi. omnesꝗ; consang̅
uitate ac familiaritate ul̄ ꝯfessio
ne ⁊ oꝛone nobis iunctos. seu om
nem popl̄m catholicum a n̄c̄is
omnibz purga uirtutibz illust

pacem ⁊ salutem nobis tribue.
hostes uisibiles ⁊ inuisibiles remo
ue. pestem atꝗ; subitam mortem
repelle. carnalia desideria extigue
amicis ⁊ inimicis n̄ris ueram ca
ritatem. atꝗ; infirmis sanitatē
largire ⁊ uer famlo̅ꝝ tuoꝝ in sa
lutis uie psꝑitate dispone. ⁊ oibz
fidelibz uiuis ac defunctis in tra
uiuencium uitam ⁊ requiem eter
nam concede. p̄.

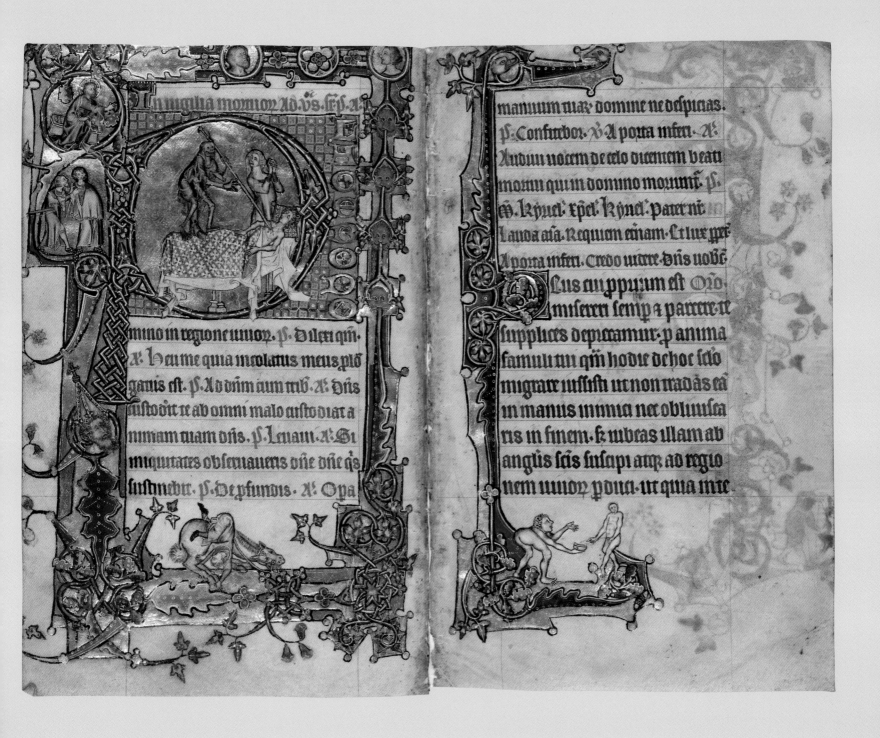

deum saluatorem meum. ꝟ. Quem
uisurus sum ego ipse a non alius et
oculi mei conspecturi sunt. Ser in. Ic. ix.
Ledet aiam meam uite mee:
dimittam aduisum me e
loquium meu. Loquar in ama
ritudine aie mee: dicam deo noli
me condempnare. Indica michi cur
me ita iudices. Nunccqd bonum
tibi uidetur si calumpnieris ꞇ op
primas me opus manuum tuar
ꞇ consilium impior adiuues. Nunc
quid oculi carnei tibi sunt aut sicut
uidet homo ꞇ tu uidebis. Nunccqd
sicut dies hominis dies tui ꞇ anni
tui sicut humana sunt tempora:

ut queras iniquitatem meam ꞇ
peccatum meum scruteris: ꞇ scias qa
nichil impium fecerim. cum sit
nemo qui de manu tua possit e
ruere. iꝫ. Qui lazar resuscitasti a mo
numento fetidum. Tu eis dne dona re
quiem ꞇ locum indulgencie. ꝟ. Qui
uenturus es iudicare uiuos ꞇ mortuos
ꞇ seculum per ignem. Tu eis. Ic. iiii.
Manus tue fecerunt me ꞇ
plasmauerunt me: totum in cir
cuitu ꞇ sic repente precipitas me
memento queso qd sicut lutum
feceris me ꞇ in puluerem reduces
me. Nonne sicut lac mulsisti me
ꞇ sicut caseum me coagulasti:

pelle ⁊ carnib; uestisti me: ossib;
⁊ neruis compegisti me. Uitam
⁊ misam tribuisti michi: ⁊ uisita
cio tua custodiuit spm meum. R.
Domine qñdo ueñis iudicare ticam
ubi me abscondam a uultu tie tue Qa
peccaui nimis in uita mea. V. Comis
sa mea pauesco ⁊ ante te erubesco dum
ueñis iudicare noli me condempnare.
Qa. In .ij. R⁊ . A. In loco pascue ibi me
collocauit. P. Dñs regit. R⁊. Delicta iu
uentutis mee ⁊ ignorancias meas ne
memineris domine. P. Ad te leuaui. R⁊
Credo uidere bona dñi in tia uiuenciu
P. Dño ill. V. In memoz. Le. ui.
Quantas habeo iniquitates

⁊ pĉa: scelera mea atq; delicta os
tende michi: Cur faciem tuam ab
scondis ⁊ arbitraris me inimicu
tuum? Contra folium qd uento
rapitur ostendis potenciam tuã ⁊
stipulam siccam psequeris. Scri
bis enim contra me amaritudiez
⁊ consumere me uis pctis adolescen
cie mee. Posuisti in neruo pedes
meos. ⁊ obseruasti omnes semi
tas meas. ⁊ uestigia pedu meoz
desiderasti. Qui quasi putredo consu
mendus sum: ⁊ quasi uestimen
tum qd commeditur a tinea. R⁊ m.
Heu michi dñe quia peccaui nimis
in uita mea. quid faciam miser ubi

fugiam nisi ad te deus meus miserere mei. Dum ueneris in nouissimo die. Anima mea turbata est ualde sed tu domine succurre ei. Dum.

R̄. V̄.

Homo natus de muliere b ui uiuens tempore. replet multis miserijs. Qui quasi flos egreditur et conteritur et fugit uelut umbra et nunq̄m in eodem statu permanet. Et dignum ducis super huiuscemodi aperire oc̄los tuos et adducere eum tecum in iudicium. Q̄s potest face mundum de imū do conceptum semine. Nonne tu q̄ solus es: Breues dies hois sunt: numerus mensium eius apud te

est. Constituisti iminos eius qui preterii non poterunt. Recede ḡ paululum ab eo ut quiescat donec optata ueniat: et sicut mercenna rii dies eius. R̄. Ne recorderis peccata mea dr̄e. Dum ueneris iudicare seclm p ignem. V̄. Dirige dr̄e dc̄ms mis in con spectu tuo uiam meam. Dum.

R̄. V̄.

Quis michi hoc tribuat ut i ferno ptegas me et abscon das me donec pranseat furor tuus et constituas michi tempus in quo re corderis mei. Putas ne mortuus lō rursum uiuat: Cunctis diebr. q̄b; nunc milito: expecto donec ueniat immutacio mea. Vocabis me: et

eis one dona requiem. Et lux. le ix.
Pare de uuilua conrexit me.
qui utinam consumptus es
sem ne oc'ls me uideret. fuissem q
si non eem de utero translatus ad
tumulum. Nunequid non pau
tas dieɔ meoɔ finietur breui. Di
mitte ɔ me oie ut plangam pau
lulum dolorem meum antequa
uadam ɔ non reuertar ad ɔram te
nebrosam ɔ optam moɔtis cali
gine. Terram miserie ɔtenebraɔ
ubi umbra moɔtis ɔ ill's orɔo sz
sempiternus hoɔror inhabitans.
ɽ. Libera me domine de moɔte eter
na in die illa tremenda qɔndo celi mo

uendi sunt de ɔa. Dum ueneris iu
dicare seɔin p ignem. ɽ. Dies illa di
es ire calamitatis ɔ miserie dies mag
na ɔ amara ualde. Qɔdo. ɽ. Quog
miserim quid dicam ul' quid faciam
dum nil boni pferam ante tui udice
Dum. ɽ. Nunc xpe te petimus misere
qs qui uenisti redimere pditos noli ɔ
dampnare redemptos. ɽ. Creatoɔ
omnium rerum deus qui me de limo
terre formasti ɔ mirabiliter sanguine
ɔppo redemisti coɔpussz meum uicet iu
putrescat de sepulcro facies in die iudi
dicij resuscitari exaudi exaudi me ut a
nimam meam in sinu abiahe psiar
che tui iubeas collocari. Dum uertis.

243v 244r

non est numerus: suscipe pia aia fa
muli tui sacerdotis preces nras
et lucis ei leticieqꝫ regionem i scoꝝ
tuoꝝ societate ꝛecde. p. Oꝛo genial
Sclina domine aurem tuã Oꝛo
ad preces nras quibꝫ mĩam tuã
supplices deprecamur ut aĩam fa
muli tui. Rꝫ. qm de hoc scõ mig
re iussisti in pacis ac lucis regio
ne estiuas. et scoꝝ tuoꝝ iubeas
ẽ ꝯsoꝛtem. p. d. n. Amen. Oꝛem
Deinde dicant oꝛones pꝛsentis fa
miliaribꝫ sub silencio ad placit. ꝗbꝫ
Animabꝫ expletis seqt Oꝛo
gꝫ domine oĩm fidelium
defunctoꝝ oꝛo pficiat supplicam

eas et a pcõis omnibꝫ exu
ne redempcõis facias ẽ p
p dm nrm ihm xpm.
scant in pace. Amen.

Confiteoꝛ tibi dñe
pater celi et terre ipꝫ
benignissime ac to
ne iesu cum scõ spu
coram scis anglis tuis et coram p
senti altari tuo. quia in pctis nat
sum. et in pcõis nutritus ꝫi pctis
post baptisma usqꝫ ad hanc hoꝛã
sum uersatus. confiteoꝛ et quia
peccaui nimis in supbia tam ui
sibili qm inuisibili. in uana gla

in excellencia tam odor
num. τ oim actuum meo
udicia · in odio · in auart
honoris qn pecunie · in
tricia · in uentris in glup
mestacoibz · τ ebrieta
octosis · in ampleri
dis osculis · in luxur
genere fornicacois τ
que τ ipse feci τ aliis facientibz c
cessi · in sacrilegiis · in puritiis · in
rapinis · in fide τ spe · τ caritate τ
accipiendo corpus τ sangnem i
digne dni nri ihu xpi · in exortaci
onibz · in adulacoibz magnis · i
ignorancia · in negligencia ma

oatoz dei · in subtrahendis ele
mosinis · in paupibz eraspanois ·
in hospitalitatibz τ paupum re
ceptoibz · in despectoibz ppinquoz ·
non uisitando infirmos · necnō
in carcere positos · non uestiendo
nudos · non recreando esurientes ·
non potando sicientes · sollemp
nitatibz scoz τ dnicis diebz ac fes
tiuis honorem debitum non im
pendendo · nec sobrie nec caste i eis
uiuendo · consenciendo michi suace
tibz · in malo · peccencium clamores
paupum non libenter nec miseri
corditer exaudiendo · τ diuina ob
sequia non recipiendo · τ etiam in

supbe intrando · sedendo · standō
t egrediendo · in turpibz colloqib
in ea insistendo · Vasa sca t scm mi
nisterium polluto corde t manibz
immundis tangendo · orōnes t di
uinum officium negghgentr t te
pide t desidiose in ecclia dei faciēdo ·
In cogitacōibz eciam pessimis · i me
dicacōibz t puersis · in suspicacōi
bz falsis · in iudicijs eciam teme
rarijs · in accensu malo · t cōsilio
iniquo · in cōcupiscencia carnali i
delectacōe ac pollucione immūda ·
in uibis supsuis t luxuriosis · in
mendacijs t falsitatibz · in iuramē
tis multimodis · t diuisis in de

racōibus · in rixis · ac discordijs
seminandis · In derisionibz i trā
gssionibz fidei xpiane · in desperaci
one dei t ppetui · in uisu auditu g
stu odoratu t tactu · t in omnibz
fere modis quibzcumqz humana
fragilitas contra deum t creatorē
suum aut cogitando aut loqndo
aut opando aut delectando aut cō
cupiscendo peccare potest in omibz
me peccasse t reum in cōspectu dei
sup omnes hoīes me ēe agnosco t
cōfiteor · cōfiteor me numqn bene
fuisse cōfessum t hoc stetit p me qa
minus dixi qn deberem · Item cō
fiteor me numqn tenuisse cōfessio

248v

nem meam qa non fci penitenciã
michi inūciam· ideo precoz ısup
plico uos omnes scī ın quoz cõ
spectu hec omnia ofessus sum ut
restes michi sitis in die magni iu
dicii contra inimicum humani
generis hec omnia me ofessum fu
isse ne gaudeat de me inimicus
meus ne glietur aduersum me di
cens me peccata mea tacuisse nec
ofessum fuisse· sz sit gaudiui de me
in celo sicut dicit dñs in euāgelio
de uno pecoze penitenciam agēte
ipo adiuuante qui uiuit et reg
nat deus p omĩa scła sclozum amen·

249r

Lniam peto cozam te
domine ihu xpe et cozã
ueneranda genitrice
tua· et cozam scā adozanda cruce
tua· et cozam omnibz scīs tuis oī
um delictoz meoz· Obsecrans te
ineffabilr benignum· ineffabili
ter pium· et ineffabiliter misericoz
dem· ut quicquid dyabolo suade
re· carne delectante· spū ofenciente
ut etiam modo contra tuoz mā
datoz rectitudinem egi· beatissie
genitricis tue marie et oĩm scłoz
tuoz mitis et intercessionibz ante
qm me de hoc mundo exire iube
as clementer indulgeas· et uiam

indignacōis tue qm male mue
do puocaui a me aueras. mentē
qz meam spu ꝯpūctois aptas.
ut tua inspiracōe ꝯpunctus trans
acta defleam mala ⁊ tuum deflen
da non committam electorqz tuor
ꝯsorcio non estimatoz mereti se ue
me largitor admitte. Qui cū pie
tus in cuius dictione
uncta sunt posita et
non est qui possit resis
tere uoluntati tue. qui dignatus
es nasci. pati mori ⁊ resurgere a mor
tuus. p misterium sce incarnacōis
tue ⁊ p tua qnqz uulnera ⁊ p oēs
scas uirtutes tuas qs operaris. mi

serere michi sicut scis necessarium
aīe mee ⁊ corpori meo. Libera me
a temptacōibz dyaboli ⁊ ab oībz
quibz me angustiarum ee agnos
cis. meqz in seruicio tuo usqz in fi
nem meum ꝯserua atqz ꝯforta. At
emendacōem ueram. spacium in
penitencie uere tribue. Remissionē
peccōr meor post obitum meum
m largire. atqz cum scis tuis ppe
tualiter sine fine gaudere. Inclina
qz sce pater mentem meam in testi
monia tua. doce me facere uolunta
tem tuam. ⁊ in hora exitus mei de
hoc seclo da michi ueram memori
am ut digne penitens ⁊ ꝯfessus

seculis accipiam viaticum corporis et sanguinis tui quem pro totius mundi salute in cruce effundere dignatus es saluator mundi. Qui cum patre et spiritu sancto viuit et regnat.

Saluator mundi salui me fac domine ihesu christe rex glorie qui solus potes saluare. Da michi posse scire et velle operari et proficere ea que tibi placita sunt et michi expediunt. Da michi in perturbacione consilium, in presencia auxilium, in tribulacione solacium, in ira modestiam, in omni tempta cione virtutem et graciam. fiat michi hoc domine deus meus. firma fides

in corde, galea salutis in capite, cibum veritatis in ore, signum sancte crucis in fronte, dilectio dei et proximi in pectore, precinctio castitatis in circuitu, honestas in accessu, sobrietas in affectu, scitas in presencia, amor et desiderium vite eterne, et perseuerancia usque in finem. saluator mundi. Et cum deo patre et spiritu sancto.

Gracias ago tibi domine ihesu christe qui me miserum peccatorem in hac nocte custodisti, prerexisti, visitasti, saluum, sanum et incolumen usque ad hanc horam peruenire fecisti. Vel ad principium huius diei et per universos be

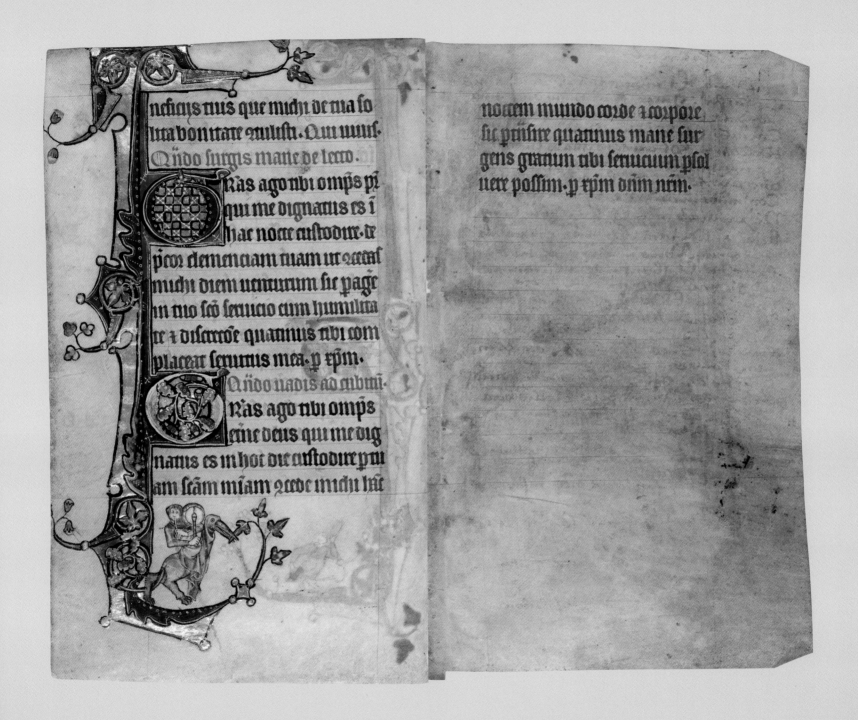

neficijs tuis que michi de tua so
lita bonitate tribuisti. Qui uuus.
Quando surgis mane de lecto.
Gras ago tibi omps pr
qui me dignatus es i
hac nocte custodire. te
precor clemenciam tuam ut concedas
michi diem uenturum sic page
in tuo sco seruicio cum humilita
te et discrecoe quatinus tibi com
placeat seruitus mea. p xpm.
Quando uadis ad ecclesi
Gras ago tibi omps
eterne deus qui me dig
natus es in hoc die custodire p tu
am scam misam concede michi lucis

noctem mundo corde et corpore
sic pristire quatinus mane sur
gens gratum tibi seruicium psol
uere possim. p xpm dnm nrm.

DESCRIPTION OF THE MACCLESFIELD PSALTER

Materials and Construction

Parchment, 252 folios, page size 170 (height) × 108 (width) mm, text area 105 × 62 mm, ruled in brown ink for 16 written lines per page (except calendar, ruled in red ink for 32 written lines per page).

32 quires: all quaternions except the first one, which was a quinion. Six leaves missing: two after fol. 1, and one each after fol. 95, fol. 117, fol. 141, fol. 252.

Binding

At the time of acquisition in 2005, early 18th-century binding of calf over pasteboards. Conserved by Robert Proctor in 2006–07: re-sewn on three sewing supports, rebound in quarter-sawn oak, and covered with a chemise of alum-tawed goatskin.

Script

Gothic Bookhand *textualis quadrata*, except for one extant catchword in *anglicana* (fol. 221v; other catchwords trimmed away).

Text

fols. 2r–7v calendar

fol. 8r–8v prayer *Suscipere dignare*

fols. 9r–207v Gallican Psalter

fols. 207v–227r canticles, hymn *Te deum*, Athanasian Creed *Quicumque vult* (see Appendix 3)

fols. 227v–235r litany with collects: *Deus cui proprium est, Omnipotens sempiterne deus, Deus qui caritatis, Deus a quo sancta desiderata, Fidelium deus omnium conditor, Pietate tua*

fols. 235v–246r Office of the Dead, with prayers for the dead after Vespers and Lauds

fols. 246r–248v Confession prayer *Confiteor tibi domine pater celi et terre*

fols. 249r–252r prayers *Veniam peto coram te domine Ihesu Christe, Deus in cuius diccione cuncta sunt posita, Salvator mundi salvum me fac, Gracias ago tibi domine Ihesu Christe qui me miserum peccatorem in hac nocte custodisti, Gracias ago tibi omnipotens pater qui me dignatus es in hac nocte custodire, Gracias ago tibi omnipotens eterne deus qui me dignatus es in hoc die custodire*

Decoration

Two full-page framed miniatures

fol. 1r, St Edmund of Bury holding an arrow

fol. 1v, St Andrew holding a book and saltire cross

One large framed miniature

fol. 8v, Christ as Judge sitting on the rainbow, displaying his wounds, and surrounded by the four Evangelists' symbols holding scrolls inscribed with their names: (*clockwise from top left*) Matthew, Mark, Luke and John

Eleven historiated initials

fol. 9r, Psalm 1, *B[eatus vir]* initial, 9 lines: Tree of Jesse extending into a full border with a hybrid playing an oval fiddle

fol. 39r, Psalm 26, *D[ominus illuminatio]* initial, 8 lines: Anointing of David; full foliage border with heralds playing long trumpets, hybrids, and busts within medallions

fol. 58r, Psalm 38, *D[ixi custodiam]* initial, 8 lines: Saul ordering the killing of the priests of Nob, a reluctant knight and Doeg departing for Nob; full foliage border with a bust within a medallion; a *bas-de-page* scene showing a mounted knight, a lady, a wildman and a dog

fol. 76r, Psalm 51, *Q[uid gloriaris]* initial, 6 lines: Doeg killing the priests of Nob; three-sided foliage border with extensions into the outer margin; a *bas-de-page* scene showing a snail and knight in combat observed by a squirrel, and a man tumbling down a tree

fol. 77r, Psalm 52, *D[ixit insipiens]* initial, 8 lines: King David and the fool with two men conversing; full foliage border with busts within medallions, a man with a hawk and a musician playing a citole; a *bas-de-page* ploughing scene

fol. 139v, Psalm 97, *C[antate domino]* initial, 8 lines: Annunciation to the Shepherds; full foliage border with hybrids, busts within medallions, an angel playing an oval fiddle; a *bas-de-page* courting scene

fol. 161v, Psalm 109, *D[ixit dominus]* initial, 8 lines: God the Father holding a book and making a blessing, with God the Son seated on his right; full foliage border with busts within medallions; a *bas-de-page* scene showing a king conversing with a clerk and a bird between them

fol. 182v, Psalm 119, *A[d dominum cum tribularer clamavi]* initial, 6 lines: King David kneeling in prayer before God, who blesses him from above; three-sided foliage border with a bust within a medallion and a hybrid; a *bas-de-page* scene showing a kneeling man, taking off his hat and conversing with a nude figure riding backwards on the facing page (fol. 183r)

fol. 207v, Canticle of Isaiah, *C[onfitebor tibi domine]* initial, 6 lines: Isaiah seated and praying to God, whose blessing hand emerges from a cloud above; three-sided foliage border with hybrids, a bird, and a caryatid-like nude figure supporting the foliage

fol. 235v, Office of the Dead, Vespers, *P[lacebo domino]* initial, 8 lines: skeleton striking a man on his deathbed with a spear, a woman in grief beside; full foliage border with busts within medallions, God blessing the dying man, and two men conversing; in the *bas-de-page* a man falling off his horse (allegory of Pride)

fol. 237v, Office of the Dead, Matins, *D[irige domine]* initial, 7 lines: a coffin surrounded by candles; three-sided foliage border; a

bas-de-page scene showing a cleric reading from an open book on a lectern and a crouching figure addressing him

Ornamental initials (throughout)

Blue, pink or orange initials, 2–3 lines, with white ornament, filled with foliage or human busts on gold backgrounds, for the calendar (KL), ordinary psalms, litany, prayers, collects, and minor text divisions in the Office of the Dead. An identical blue initial, 4 lines, at the Confession prayer *Confiteor tibi domine* (fol. 246r), now excised, may have contained the owner's arms.

Gold initials, 1 line, on blue and pink backgrounds, decorated with white foliate, geometric, zoomorphic or anthropomorphic motifs for verses in the psalms, canticles and litany.

Borders and line-fillers

One-sided foliage borders extending from the ornamental initials on every page, often sprouting foliage into the upper and lower margins, and incorporating or supporting numerous figures and scenes.

Rectangular line-fillers containing animals, human figures, foliate or geometric motifs, leopards' heads, or swags of fabric.

Provenance

(1) Unidentified coat of arms on fol. 37v, tentatively associated with four families: Warberton, Gorges, Morville and Mortimer of Attleborough.

(2) 15th-century erased inscriptions by a nun, Sister Barbara, on fols. 1r and 8v.

(3) Anthony Watson, Bishop of Chichester (1596–1605).

(4) John Smeaton.

(5) Library of the Earls of Macclesfield, Shirburn Castle, Oxfordshire; sold at Sotheby's, London, 22 June 2004, lot 587.

(6) Purchased by the Getty Museum, Los Angeles; stopped from export by the Minister of Culture on the recommendation of the Waverley Committee in August 2004.

(7) Purchased by the Fitzwilliam Museum in February 2005.

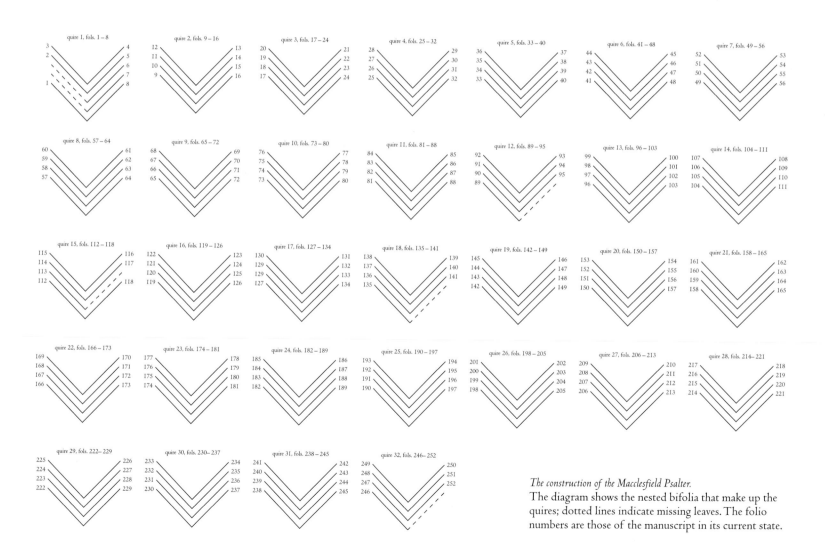

The construction of the Macclesfield Psalter.
The diagram shows the nested bifolia that make up the quires; dotted lines indicate missing leaves. The folio numbers are those of the manuscript in its current state.

COMPARATIVE TABLE OF CALENDARS

Abbreviations: d.f. = duplex festum i.d. = invitatorium duplex l. = lessons l.m. = letania maior m. = memoria tantum
m.d. = maius duplex festum n.s. = non Sarum / non est Sarum Oct. = Octave Trans. = Translation

lxx = Septuagesima, the 70th day before Easter
xl = Quadragesima, the 40th day before Easter, the beginning of Lent

Note: The entries under the Douai Psalter are based on an examination of the only surviving calendar leaf (January–February), on the comparative study in S. C. Cockerell, *The Gorleston Psalter*, London, 1907, and on the reconstruction in C. S. Hull, 'The Douai Psalter and Related East Anglian Manuscripts', Ph.D. thesis, Yale University, 1994, 48–58 and Appx D.

Month		Macclesfield Psalter	Douai Psalter	Stowe Breviary	Gorleston Psalter
January		Prima dies mensis et septima truncat ut ensis	+	+	+
	1	Circumcision 9 l. d.f.	+ d.f.	+ d.f.	+ d.f.
	2	Oct. Stephen 3 l.	+ 3 l.	+ 3 l.	+ 3 l.
	3	Oct. John 3 l.	+ 3 l.	+ 3 l.	+ 3 l.
	4	Oct. Holy Innocents 3 l.	+ 3 l.	+ 3 l.	+ 3 l.
	5	Oct. Thomas of Canterbury	+ 3 l.	+ m., Edward Confessor	+ m.
	6	Epiphany 9 l. m.d.	+ m.d	+ m.d.	+ m.d.
	7				
	8				
	9				
	10				
	11				
	12				
	13	Oct. Epiphany, Hilary 9 l.	+ 9 l.	+ 9 l.	+ 9 l.
	14	Felix 3 l.	+ 3 l.	+ 3 l.	+ 3 l.
	15	Maurus 3 l.	+ 3 l.	+ 3 l.	+ 3 l.
	16	Marcellus 3 l.	+ 3 l.	+ 3 l.	+ 3 l.
	17	Sulpicius	+ 3 l.	+ 3 l.	+ 3 l.
	18	Prisca 3 l.	+ 3 l., Prima lxx	+ 3 l., Prima lxx	+ 3 l., Prima lxx
	19	Wulfstan 9 l.	+ 9 l.	+ 9 l.	+ 9 l.
	20	Fabian and Sebastian 9 l.	+ 9 l.	+ 9 l.	+ 9 l.
	21	Agnes 9 l.	+ 9 l.	+ 9 l.	+ 9 l.
	22	Vincent 9 l.	+ 9 l.	+ 9 l.	+ 9 l.
	23				
	24				
	25	Conversion of Paul 9 l.	+ 9 l.	+ 9 l., Preiectus m.	+ 9 l., Preiectus m.
	26				
	27	Julian 3 l.	+ i.d. 3 l.	+ i.d. 3 l.	+ i.d. 3 l.
	28	Agnes 3 l.	+ i.d. 3 l.	+ i.d. 3 l.	+ i.d. 3 l.
	29				
	30	Batilda 3 l.	+ 3 l.	+ 3 l.	+ 3 l.
	31				
February		Quarta subit mortem prosternit tercia fortem	+	+	+
	1	Bridget 3 l.	+ 3 l.	+ 3 l.	+ 3 l.
	2	Purification 9 l. m.d.	+ m.d.	+ m.d.	+ m.d.
	3	Blasius 3 l.	+ i.d. 3 l.	+ i.d. 3 l.	+ i.d. 3 l.
	4				
	5	Agatha 9 l.	+ 9 l.	+ 9 l.	+ 9 l.
	6	Vedast and Amand 3 l.	+ 3 l.	+ 3 l.	+ 3 l.
	7				
	8				
	9				
	10	Scolastica 3 l.	+ 3 l.	+ 3 l.	+ 3 l.
	11				
	12				
	13				
	14	Valentine 3 l.	+ 3 l.	+ 3 l.	+ 3 l.
	15				
	16	Juliana 3 l.	+ i.d. 3 l.	+ i.d. 3 l.	+ i.d. 3 l.
	17				
	18				
	19				
	20				
	21	–	Ultima lxx	Ultima lxx	Ultima lxx
	22	Cathedra Sancti Petri 9 l.	+ 9 l.	+ 9 l.	+ 9 l.
	23				
	24	Matthias. Locus bisexti. Quando bisextus fuerit festum fiat Quarta die a Cathedra S. Petri	+ Locus bisexti. Quum bisextus fuerit festum S. Matthie fiat Quarta die a Cathedra S. Petri	+ Locus bisexti. Quum bisextus fuerit festum S. Matthie fiat Quarta die a Cathedra S. Petri	+ Locus bisexti. Quum bisextus fuerit festum S. Matthie fiat Quarta die a Cathedra S. Petri
	25				
	26				
	27				
	28				
March		Primus mandantem consumit Quarta bibentem	+	+	+
	1				
	2				
	3	–	–	Wynwaloe n.s.	–
	4				
	5				
	6				
	7	Perpetua and Felicitas 3 l.	+ 3 l.	+ 3 l.	+ 3 l.
	8	–	Dedication of St Andrew, Gorleston m.d.	Felix of Dunwich n.s.	Dedication of St Andrew, Gorleston m.d.

Day		Col 1	Col 2	Col 3
9				
10				
11				
12	Gregory 9 l.	+ 9 l.	+ 9 l.	+ 9 l.
13				
14	–	Ultima xl	Ultima xl	Ultima xl
15				
16				
17				
18	Edward 9 l.	+ 9 l.	+ 9 l.	+ 9 l.
19				
20	Cuthbert 9 l.	+ 9 l.	+ 9 l.	+ 9 l.
21	Benedict 9 l.	+ 9 l.	+ 9 l.	+ 9 l.
22				
23				
24				
25	Annunciation d.f.	+ d.f.	+ d.f.	+ d.f.
26				
27	Resurrection	+	+	+
28				
29				
30				
31				
April	Denus et undenus est mortis vulnere plenus	+	+	+
1				
2	Mary of Egypt n.s.	+ n.s.	–	+ n.s.
3	Richard of Chichester 9 l.	+ 9 l.	+ 9 l.	–
4	Ambrose 9 l.	+ 9 l., si ante passionem evenerit	+ 9 l., si ante passionem evenerit	+ 9 l., si ante passionem evenerit
5				
6				
7				
8				
9				
10				
11				
12				
13				
14	Tyburcius and Valerian 3 l.	+ 3 l.	+ 3 l.	+ 3 l.
15	Claves rogacionum	+	+	+
16				
17				
18				
19	Aelphege 3 l.	+ 3 l.	+ 3 l.	+ 3 l.
20				
21				
22				
23	George 3 l.	+ 3 l. Chorus regitur	+ 3 l. Chorus regitur	+ 3 l. Chorus regitur
24				
25	Mark	+ l.m.	+ l.m.	+ l.m.
26				
27				
28	Vitalis 3 l.	+ i.d. 3 l.	+ i.d. 3 l.	+ i.d. 3 l.
29	Claves pentecostes	+	+	+
30	Erkenwald	+ n.s.	–	+ n.s.

Day		Col 1	Col 2	Col 3
May	Tercius occidit et septimus ora relidit	+	+	+
1	Philip and James	+	+	+
2				
3	Finding of the True Cross	+ d.f., m. de martyribus	+ d.f., m. de martyribus	+ d.f., m. de martyribus
4				
5				
6	John before the Latin Gate 3 l.	+ 3 l., cum regimine chori	+ 3 l., cum regimine chori	+ 3 l., cum regimine chori
7				
8				
9				
10	Gordian and Epimachus. Pentecost	+ 3 l.	+ 3 l.	+ 3 l.
11				
12	Nereus, Achilleus and Pancracius 3 l.	+ 3 l.	+ 3 l.	+ 3 l.
13				
14				
15				
16				
17				
18				
19	Dunstan	+	+, Potenciana Chorus regitur	+, Potenciana Chorus regitur
20				
21				
22				
23				
24				
25	Aldhelm 9 l.	+ 9 l.	+ 9 l., Urban	+ 9 l., Urban
26	Augustine of Canterbury 9 l.	+ 9 l.	+ 9 l.	+ 9 l.
27				
28	Germanus of Paris 3 l.	+ 3 l.	+ 3 l.	+ 3 l.
29				
30				
31	Petronilla 3 l.	+ 3 l. cum Nocturno	+ 3 l. cum Nocturno	+ 3 l. cum Nocturno
June	Denus pallescit quindenus federa nescit	+	+	+
1	Nicomedes 3 l.	+ 3 l.	+ 3 l.	+ 3 l.
2	Marcellinus and Peter 3 l.	+ i.d. 3 l.	+ i.d. 3 l.	+ i.d. 3 l.
3	Ultimus dies ascensionis	+	+	+
4				
5	Boniface 3 l.	+ i.d. 3 l.	+ i.d. 3 l.	+ i.d. 3 l.
6				
7				
8	Medard and Gildard 3 l.	+ 3 l.	+ 3 l.	+ 3 l.
9	Primus and Felician 3 l.	+ i.d. 3 l.	+ i.d. 3 l.	+ i.d. 3 l.
10				
11	Barnabas 9 l.	+ 9 l.	+ 9 l.	+ 9 l.
12	Basilides, Quirinus, Nabor and Nazarius	+ i.d. 3 l.	+ i.d. 3 l.	+ i.d. 3 l.
13	Ultimum pentecostes	+	+	+
14	Basil 3 l.	+ 3 l.	+ 3 l.	+ 3 l.
15	Vitus and Modestus 3 l.	+ i.d. 3 l.	+ i.d. 3 l.	+ i.d. 3 l.
16	Trans. Richard of Chichester 9 l., Messa de martyribus	Trans. Richard of Chichester 9 l.	Trans. Richard of Chichester 9 l.	Cyricus and Julitta 3 l.
17	Botulph 9 l.	+ 9 l.	+ 9 l. n.s.	+ 9 l.
18	Mark and Marcellian 3 l.	+ i.d. 3 l.	+ i.d. 3 l.	+ i.d. 3 l.
19	Gervase and Protase 3 l.	+ i.d. 3 l.	+ i.d. 3 l.	+ i.d. 3 l.

July (continued)

Day	Feast			
20	Trans. Edward Confessor 9 l.	+ 9 l.	+ 9 l.	+ 9 l.
21				
22	Alban 9 l.	+ 9 l.	+ 9 l.	+ 9 l.
23	Etheldreda	+ 3 l.	+ 3 l.	+ 3 l.
24	Nativity of John the Baptist d.f.	+ d.f.	+ d.f.	+ d.f.
25				
26	John and Paul 3 l.	+ i.d. 3 l.	+ i.d. 3 l.	+ i.d. 3 l.
27				
28	Leo	+ 3 l.	+ 3 l.	+ 3 l.
29	Peter and Paul d.f. 9 l.	+ 9 l.	+ d.f.	+ d.f.
30	Commemoration of Paul 9 l.	+ 9 l.	+ 9 l.	+ 9 l.
July	Terdecimus mactat julii decimus labefactat	+	+	+
1	Oct. St John the Baptist 3 l.	+ 3 l.	+ 3 l.	+ 3 l.
2	Sts Processus and Martinian	+	+, St Swithun	+, St Swithun
3				
4	Trans. St Martin 9 l.	+ 9 l.	+ 9 l.	+ 9 l.
5				
6	Oct. Sts Peter and Paul 9 l.	+ 9 l.	+ 9 l.	+ 9 l.
7	Trans. St Thomas of Canterbury	+ 3 l.	+ 9 l.	+ 9 l.
8				
9				
10	Seven Brothers 3 l.	+ i.d. 3 l.	+ i.d. 3 l.	+ i.d. 3 l.
11	Trans. Benedict 9 l.	+ 9 l., si infra passionem	+ 9 l., si infra passionem	+ 9 l., si infra passionem
12				
13				
14	Dies caniculares incipiunt	+	+	+
15	Trans. Swithun 9 l.	+ and companions 9 l.	+ and companions 9 l.	+ and companions 9 l.
16				
17	Kenelm 3 l.	+ i.d. 3 l.	+ i.d. 3 l.	+ i.d. 3 l.
18	Arnulf 3 l.	+ 3 l.	+ 3 l.	+ 3 l.
19				
20	Margaret 9 l.	+ 9 l.	+ 9 l.	+ 9 l.
21	Praxedes 3 l.	+ 3 l.	+ 3 l.	+ 3 l.
22	Mary Magdalene 9 l.	+ 9 l., Wandrille	+ 9 l., Wandrille	+ 9 l., Wandrille
23	Apollinarius 3 l.	+ 3 l.	+ 3 l.	+ 3 l.
24	Christina 3 l.	+ 3 l.	+ 3 l.	+ 3 l.
25	James 9 l.	+ 9 l.	+ 9 l., Christopher and Cucufate m.	+ 9 l., Christopher and Cucufate m. St Anne n.s.
26	—	—		—
27	Seven Sleepers of Ephesus 3 l.	+ i.d. 3 l.	+ i.d. 3 l.	+ i.d. 3 l.
28	Samson of Dol 3 l.	+ i.d. 3 l.	+, Pantaleon i.d. 3 l.	+, Pantaleon i.d. 3 l.
29	Felix, Simplicius, Faustinus and Beatrice 3 l.	+ i.d. 3 l.	+ i.d. 3 l.	+ i.d. 3 l.
30	Abdon and Sennen 3 l.	+ i.d. 3 l.	+ i.d. 3 l.	+ i.d. 3 l.
31	Germanus of Man 3 l.	+ 3 l.	+ 3 l.	+ 3 l.
August	Prima necat fortem perditque secunda cohortem	+	+	+
1	Peter in chains	+, Maccabees m.	+, Maccabees m.	+, Maccabees m.
2	Stephen 3 l.	+ i.d. 3 l.	+ i.d. 3 l.	+ i.d. 3 l.
3	Finding of Stephen 9 l.	+ 9 l.	+ 9 l.	+ 9 l.
4				

August (continued) – September

Day	Feast			
5	Oswald	+ 9 l., Dominic	+ 9 l., Dominic n.s.	+ 9 l., Dominic
6	Sixtus, Felicissimus and Agapitus 3 l.	+ i.d. 3 l.	+ i.d. 3 l.	+ i.d. 3 l.
7	Donatus 3 l.	+ 3 l.	+ 3 l.	+ 3 l.
8	Cyriacus and companions 3 l.	+ i.d. 3 l.	+ i.d. 3 l.	+ i.d. 3 l.
9	Romanus 3 l.	+ 3 l. cum Nocturno	+ 3 l. cum Nocturno	+ 3 l. cum Nocturno
10	Laurence 9 l.	+ 9 l.	+ 9 l.	+ 9 l.
11	Tyburtius 3 l.	+ i.d. 3 l.	+ i.d. 3 l.	+ i.d. 3 l.
12				
13	Hippolitus and companions 3 l.	+ i.d. 3 l.	+ i.d. 3 l.	+ i.d. 3 l.
14	Eusebius	+	+	+
15	Assumption of the Virgin m.d.	+ m.d.	+ m.d.	+ m.d.
16				
17	Oct. Laurence	+ m.	+ m.	+ m.
18	Agapitus	+ m.	+ m.	+ m.
19	Magnus	+ m.	+ m.	+ m.
20				
21				
22	Oct. Assumption 9 l.	+ 9 l.	+ 9 l., Timothy and Simphorian	+ 9 l., Timothy and Simphorian
23	Timothy and Apollinaris	+	+	+
24	Bartholomew 9 l.	+	+	+, Audoenus
25				
26				
27	Rufus 3 l.	+ i.d. 3 l.	+ i.d. 3 l.	+ i.d. 3 l.
28	Augustine of Hippo	+	+	+, Hermes
29	Beheading of John the Baptist	+ i.d.	+ i.d., Sabina m.	+ i.d., Sabina
30	Felix and Adauctus 3 l.	+ 3 l.	+ 3 l.	+ 3 l.
31	Cuthburga 3 l.	+ 3 l.	+ 3 l.	—
September	Tercia septembris et denus fert mala membris	+	+	+
1	Egidius 9 l.	+ 9 l.	+, Priscus 9 l.	+, Priscus 9 l.
2				
3				
4	Trans. Cuthbert 9 l.	+ 9 l. nisi fuerit in xl. i.d.	+ 9 l. nisi fuerit in xl. i.d.	+ 9 l. nisi fuerit in xl. i.d.
5	Bertin 3 l.	+ 3 l. cum Nocturno	+ 3 l. cum Nocturno	+ 3 l. cum Nocturno
6				
7				
8	Nativity of the Virgin m.d.	+ d.f.	+ d.f.	+ d.f.
9	Gorgonius	+ m.	+ m.	+ m.
10				
11	Protus and Hyacinth	+ m.	+ m.	+ m.
12				
13				
14	Exaltation of the Holy Cross 9 l.	+ 9 l.	+ 9 l.	+ 9 l., Cornelius and Cyprian
15	Oct. Nativity of the Virgin 9 l., Messa de martyribus	+ 9 l.	Sarum feast of Relics	+ 9 l.
16	Edith 9 l.	+ 9 l.	+, Eufemia 9 l.	+, Eufemia 9 l.
17	Lambert 3 l.	+ 3 l.	+ 3 l.	+ 3 l.
18				
19				
20				
21	Matthew	+	+, Laudus	+, Laudus
22	Maurus and companions 3 l.	+ 3 l.	+ 3 l.	+ 3 l.

Date	Feast			
23	Tecla 3 l.	+ 3 l. cum Nocturno	+ 3 l. cum Nocturno	+ 3 l. cum Nocturno
24				
25	Firminus	+ 3 l.	+ 3 l.	+ 3 l.
26	Cyprian 3 l.	+ i.d. 3 l.	+, Justina i.d. 3 l.	+, Justina i.d. 3 l.
27	Cosmas and Damian 3 l.	+ i.d. 3 l.	+ i.d. 3 l.	+ i.d. 3 l.
28				
29	Michael 9 l. d.f.	+ d.f.	+ d.f.	+ d.f.
30	Jerome 9 l.	+ 9 l.	+ 9 l.	+ 9 l.
October	Tercius et denus est sicut mors alienus	+	+	+
1	Germanus, Remigius and Vedastus 9 l.	+ 9 l.	+ 9 l.	+ 9 l.
2	Thomas of Hereford 9 l.	+ 3 l.	+ 3 l.	Leger 3 l.
3				
4	Francis 9 l.	+ 9 l.	+ 9 l. n.s.	+ 9 l.
5				
6	Faith 3 l.	+ 3 l.	+ 3 l.	+ 3 l.
7	Mark, Marcellian and Apuleius 3 l.	+ i.d. 3 l.	+ i.d. 3 l.	+ i.d. 3 l.
8				
9	Denys, Rusticus and Eleutherius 9 l.	+ 9 l.	+ 9 l.	+ 9 l.
10	Gereon and companions 3 l.	+ i.d. 3 l.	+ i.d. 3 l.	+ i.d. 3 l.
11	Nicasius and companions 3 l.	+ i.d. 3 l.	+ i.d. 3 l.	+ i.d. 3 l.
12				
13	Trans. Edward Confessor 9 l.	+ 9 l.	+ 9 l.	+ 9 l.
14	Callistus 3 l.	+ i.d. 3 l.	+ i.d. 3 l.	+ i.d. 3 l.
15	Wulfram 9 l.	+ 9 l.	+ 9 l.	+ 9 l.
16	Dedicatio sancti Michaelis in monte tumba	+ 9 l.	+ 9 l.	+ 9 l.
17				
18	Luke 9 l.	+ 9 l.	+ 9 l.	+ 9 l., Justus of Beauvais
19				
20				
21	11,000 virgins 3 l.	+ i.d. 3 l.	+ i.d. 3 l.	+ i.d. 3 l.
22				
23	Romanus 3 l.	+ 3 l. cum Nocturno	+ 3 l. cum Nocturno	+ 3 l. cum Nocturno
24				
25	Crispin and Crispinian 3 l.	+ i.d. 3 l.	+ i.d. 3 l.	+ i.d. 3 l.
26				
27				
28	Simon and Jude 9 l.	+ 9 l.	+ 9 l.	+ 9 l.
29				
30				
31	Quentin 3 l.	+ 3 l. cum Nocturno	+ 3 l. cum Nocturno	+ 3 l. cum Nocturno
November	Scorpius est quintus et tercius est nece cinctus	+	+	+
1	All Saints m.d.	+ m.d.	+ m.d.	+ m.d.
2	All souls	+	+, Eustace and companions	+, Eustace and companions
3				
4				
5				
6	Leonard 9 l.	+ 9 l.	+ 9 l.	+ 9 l.
7				
8	Four Crowned Martyrs 3 l.	+ i.d. 3 l.	+ i.d. 3 l.	+ i.d. 3 l.
9	Theodore 3 l.	+ 3 l.	+ 3 l.	+ 3 l.

Date	Feast			
10				
11	Martin 9 l.	+ 9 l.	+ 9 l., Menas	+ 9 l., Menas
12				
13	Brice 3 l.	+ i.d. 3 l.	+ i.d. 3 l.	+ i.d. 3 l.
14				
15	Malo 9 l.	+ 9 l.	+ 9 l.	+, Martin 9 l.
16	Edmund Rich 9 l.	+ 9 l.	+ 9 l.	+ 9 l.
17	Anianus 3 l.	+ i.d. 3 l.	+ i.d. 3 l.	+ i.d. 3 l.
18	Oct. Martin 3 l.	+ i.d. 3 l.	+ i.d. 3 l.	+ i.d. 3 l.
19				
20	Edmund of Bury 9 l.	+ 9 l.	+ 9 l.	+ 9 l.
21				
22	Cecilia 9 l.	+ 9 l.	+ 9 l.	+ 9 l.
23	Clement 9 l.	+ 9 l.	+ 9 l., Felicitas	+ 9 l., Felicitas
24	Chrysogonus 3 l.	+ 3 l.	+ 3 l.	+ 3 l.
25	Catherine 9 l.	+ 9 l.	+ 9 l.	+ 9 l.
26	Linus 3 l.	+ 3 l.	+ 3 l.	+ 3 l.
27				
28				
29	Saturninus 3 l.	+ 3 l. cum Nocturno	+ 3 l. cum Nocturno	+ 3 l. cum Nocturno
30	Andrew 9 l. d.f.	+ d.f.	+ d.f.	+ d.f.
December	Septimus ex[s]anguis virosus denus et anguis	+	+	+
1				
2				
3	—	—	Birin 9 l.	—
4				
5				
6	Nicholas 9 l.	+ 9 l.	+ 9 l.	+ 9 l.
7	Oct. Andrew 3 l.	+ i.d. 3 l.	+ i.d. 3 l.	+ i.d. 3 l.
8	Conception of the Virgin 9 l.	+ 9 l.	+	+
9				
10				
11				
12				
13	Lucy 9 l.	+ 9 l.	+ 9 l.	+ 9 l.
14				
15				
16				
17				
18				
19				
20				
21	Thomas 9 l.	+ 9 l.	+ 9 l.	+ 9 l.
22				
23				
24				
25	Nativity m.d.	+ m.d.	+ m.d.	+ m.d.
26	Stephen d.f. 9 l.	+ d.f.	+ d.f.	+ d.f.
27	John d.f. 9 l.	+ d.f.	+ d.f.	+ d.f.
28	Holy Innocents d.f. 9 l.	+ d.f.	+ d.f.	+ d.f.
29	Thomas of Canterbury d.f. 9 l.	+ d.f.	+ d.f.	+ d.f.
30				
31	Silvester 9 l.	+ 9 l.	+ 9 l.	+ 9 l.

THE PSALMS AND CANTICLES

The Numbering of the Psalms

Two versions of the Latin psalter were in use in the 14th century: the Gallican Psalter, the version used in the Macclesfield Psalter, and the Hebrew Psalter, from which the translations used in the Authorized Version of the Bible and the Church of England liturgy were made (see §3 of the commentary, 'The Texts'). The numbering of the psalms, which is slightly different in the two versions, is set out in the table below.

Gallican Psalter	*Hebrew Psalter*
Latin Vulgate Bible	*Authorized Version of the Bible*
Douai–Rheims Bible	*Book of Common Prayer*
Psalms 1–8	Psalms 1–8
Psalm 9	Psalms 9–10
Psalm 10	Psalm 11
Psalm 11, etc.	Psalm 12, etc.
Psalm 112	Psalm 113
Psalm 113	Psalms 114–115
Psalms 114–115	Psalm 116
Psalm 116	Psalm 117
Psalm 117, etc.	Psalm 118, etc.
Psalm 145	Psalm 146
Psalms 146–147	Psalm 147
Psalm 148	Psalm 148
Psalm 149	Psalm 149
Psalm 150	Psalm 150

The Canticles and Creed in the Macclesfield Psalter

The canticles that are included in the Macclesfield Psalter are listed below, together with their biblical sources. The series ends with the Athanasian Creed. The final element in each citation indicates the office at which the text was recited.

fol. 207v, Canticle of Isaiah (Isaiah 12: 1–6), *Confitebor tibi domine*
 Monday at Lauds

fol. 208r, Canticle of Hezekiah (Isaiah 38: 10–12), *Ego dixi in dimidio*
 Tuesday at Lauds

fol. 209v, Canticle of Hannah (I Samuel 2: 1–10), *Exultavit cor meum*
 Wednesday at Lauds

fol. 210v, Canticle of Moses (I) (Exodus 15: 1–19), *Cantemus domino*
 Thursday at Lauds

fol. 212v, Canticle of Habakkuk (Habakkuk 3: 2–19), *Domine audivi*
 Friday at Lauds

fol. 215r, Canticle of Moses (II) (Deuteronomy 32: 1–44), *Audite celi*
 Saturday at Lauds

fol. 219v, *Te deum laudamus*
 Sunday and feast days at Matins

fol. 221r, Canticle of Three Hebrew Youths in the Fiery Furnace (Daniel 3: 57–88), *Benedicite omnia opera*
 Sunday at Lauds

fol. 222v, Canticle of Zacharias (Luke 1: 68–79), *Benedictus dominus deus Israel*
 daily at Lauds

fol. 223r, Canticle of the Virgin (Luke 1: 46–55), *Magnificat anima mea dominum*
 daily at Vespers

fol. 224r, Canticle of Simeon (Luke 2: 29–32), *Nunc dimittis*
 daily at Compline

fol. 224r, Athanasian Creed, *Quicumque vult*
 Sunday at Prime

THE PIGMENTS OF THE MACCLESFIELD PSALTER

by Spike Bucklow

Identification of pigments

The technical examination of the pigments in the Macclesfield Psalter took place while the manuscript was fully disbound for conservation and its leaves were sewn temporarily into individual quires. Exclusively non-destructive methods of examination were used and the same passages were analysed by a combination of techniques, in an effort to obtain unambiguous results. One folio was examined in an environmental scanning electron microscope at the Cavendish Laboratories, Cambridge, by Debbie Stokes. Many others were studied during a three-day campaign by the MOLAB team of chemists from the University of Perugia, under the auspices of the EU-ARTECH project of the Sixth Framework Programme of the European Community. The team included Bruno Brunetti, Laura Cartechini, Aldo Romani and Francesca Rosi. All examination was guided by Spike Bucklow from the Hamilton Kerr Institute of the Fitzwilliam Museum. The MOLAB team used portable X-ray fluorescence, UV/visible fluorescence, near- and mid-FTIR spectroscopy and microfluorescence. The identifications were based on analysis of areas of 10 sq mm or more, so comparisons were made between written and painted areas and adjacent areas of bare parchment, which was found to contain salt residues from the treating of the skins and from handling.

This summary of the materials identified in the psalter is presented according to the approximate order of their use by the scribe and the illuminator.

The black ink was identified as an iron gall ink. This was usually prepared by boiling crushed oak galls with a piece of rusty iron or a mineral known as vitriol. The psalter's ink was made from vitriol with an unusually high zinc content. Most recipes describing the preparation of black ink recommend gum arabic, the resin of the acacia tree. This was probably the binder used for the psalter. The rubrics, or text written in red ink, contain vermilion, a synthetic mercury sulphide. Vermilion does not form a very strong bond with the binder and small amounts of it can be rubbed off the letters, transferring to other surfaces. In bound manuscripts, traces of pigment can migrate to the opposite folio, a phenomenon known as 'off-setting'. However, microscopic amounts of vermilion were found on some folios that neither contained, nor faced folios containing, rubrication. The transfer of vermilion might be the result of folios being shuffled in loose stacks at various stages of the production.

All work on the text was completed before the illuminations were executed. Then the artist made preparatory drawings with an organic black pigment, probably vine black, a fine charcoal usually made from beech or willow. The next task for the illuminator was to lay the gold. In the Macclesfield Psalter, the predominant type is gold leaf. It was laid onto a thin cushion consisting mainly of chalk, probably in the same medium as the ink that preceded it and the paints that were to follow. Most, though not all, of the gold leaf is burnished. Another type of gold found in the manuscript – for example, on the fur of St John the Baptist's clothing on folio 133r – is mosaic gold, or synthetic tin sulphide. This was used mixed with a relatively thick layer of medium.

After the gold leaf was burnished, the artist could begin to apply the pigments. Passages of the same colour were probably applied across a number of images, the artist building them up slowly, rather than completing one image at a time. The exact sequence varied, but it is clear that backgrounds and figures were worked on simultaneously. The final touch was usually the delineation of decorative features, flesh and drapery with either vine black or lead white.

The element lead was detected everywhere and lead white (synthetic lead carbonate) is the predominant white pigment, used for most flesh and for the lion on folio 43v, for example. In the flesh of a few very small marginal figures, as on folio 11r, lead white was used moderately, and the white might be due also to the preparatory chalk layer that underlies much of the gilding and painting.

The only blue pigment to be identified was azurite, a natural blue copper carbonate. There was no evidence of the other blues available in East Anglia during the Middle Ages – ultramarine (extracted from lapis lazuli) or the plant products indigo and woad. The pale blue-greys were created with mixtures of vine black and lead white. The green pigment was not fully identified; it contains copper, but it is not malachite. It may be chrysocolla (a copper silicate mineral) or a synthetic pigment made from verdigris, the green rust of copper. The illuminator made many variations, mixing it with chalk and lead white and also possibly with organic greens such as sap green (extracted from ripe buckthorn berries), as is suggested by the fading of some passages, such as the pea-pods on folio 42r. Where the green is particularly saturated, as in the grass on folio 1v, an additional yellow colourant, probably saffron, was detected.

The main red pigment identified in the illuminations was minium (lead oxide). This was modified, as the green was, with the addition of a number of other pigments. For example, a yellow, probably saffron, was used to make the orange of the marginal hybrid's jacket on folio 11v. Two different transparent reds were used to make passages of darker red. They are lakes (that is, dyes absorbed onto white pigments) – probably kermes and madder (discussed in the commentary below). They were either bound with alum and chalk or used alone as glazes – for example, in the drapery. The red lakes were also used, mixed with carbon black to make violet, as on the hybrid's hat on folio 20v.

Commentary

The materials used in the Macclesfield Psalter were prepared and employed with a high level of skill. This is evident in the excellent condition of most paint passages, the faded green pea-pods being a notable exception.

The pigments are broadly representative of those found in other East Anglian 14th-century painted works of art. Surprises in the list of materials are omissions rather than inclusions. For example, vermilion was not used in the illuminations, although it was used in the text. Further, the artists did not use shell gold, also known as liquid gold or gold ink, because it was prepared by mixing powdered gold with animal or fish glue. This is surprising, since plenty of waste gold leaf would have been created in the process of gilding the psalter.

The omissions were almost certainly a matter of choice, and the artists were not restricted by the lack of a few pigments. In the absence of vermilion, a good range of reds was made with opaque lead pigments and transparent organic pigments. The illuminator's alternative to shell gold was mosaic gold, one of several synthetic pigments used in the psalter (the others are iron gall ink, vermilion, lead white, alum and probably copper green). We might have expected to find ultramarine in such a rich manuscript, but it is not present, and the rich blues were all created with the cheaper pigment azurite.

Yet the relative cost of alternative pigments is unlikely to have been a decisive factor in choosing materials – there is no shortage of expensive gold leaf in the manuscript, and the cost of the illuminators' labour would have been far greater than the cost of their materials. Nonetheless, artists' materials were increasingly important economic items in 14th-century East Anglia and their widespread significance is closely related to the ability of East Anglian patrons to commission works such as the psalter.

The wealth of Norwich, for example, can be gauged from the fact that when the Macclesfield Psalter was made the city had sixteen active goldsmiths. Much of this wealth was generated by the cloth trade, and records for the period 1320–39 show that the city also had thirty-five active dyers.[1] Painters and illuminators (of which the records show five) could use the same raw materials as dyers. Indeed, analysis of the red squares in the background of St Edmund (fol. 1r) identified the colour as a dye that had been extracted from wool.[2]

The main dyes used in the East Anglian cloth trade were woad, cochineal, kermes and madder. Woad has a long history of use in Europe and there are a number of historic recipes for extracting the colour.[3] While this blue was not identified in the psalter, it may have been a component in some passages of dull grey-blue. Cochineal and kermes were both red colours produced from insects, the former from an insect that lived on grasses in north-eastern Europe, the latter from insects that lived on oak trees around the Mediterranean. At the time the psalter was being painted, these dried insects were traded in vast quantities as 'grains' in Flanders, an important East Anglian trading partner.[4] Madder, which was extracted from the roots of a plant, was cheaper than the insect reds. Its importance to the Norwich economy is evident from the name of a district that still survives – Maddermarket.

Another dyestuff used in the Psalter was saffron, one ounce of which is obtained from the stigmas of over 4,000 crocuses. Its colour was compared to gold and in manuscripts it was sometimes painted over thin sheets of tin to imitate gold.[5] Tin covered with yellow saffron was not found in the psalter, but tin alchemically joined with yellow sulphur[6] is present in the mosaic gold of the fur on St John the Baptist's clothing on folio 133r. Saffron was used over white to give a transparent yellow and was mixed with reds and greens.

The saffron in the psalter was probably imported, possibly from Persia, where it had been grown as a commercial crop since the 10th century.[7] However, some was grown in Europe and the pigment is mentioned in an artists' manual written in northern France. It says that French saffron 'does not have the exact colour, smell or taste of the perfect sort', but that good quality saffron could be found in Spain, Italy and especially Sicily.[8]

Saffron was eventually grown in England and, like madder, became celebrated in an East Anglian place name. The town of Saffron Walden owes its name to the yellow dye. The cultivation and processing of saffron was of great importance and was described in detail by William Harrison.[9] At the time the Macclesfield Psalter was painted, Saffron Walden was still called Chepyng Walden (it changed its name in the 16th century), but local artists may very lately have tried the new, precious pigment. According to a legend reported by Richard Hakluyt, the dye was brought to Saffron Walden by a pilgrim returning from the Holy Land who, risking death, hid a crocus bulb in his hollowed-out staff.[10] Other accounts say it was smuggled during the reign of Edward III (1327–77). It is apt that saffron's introduction to England is credited to a pilgrim. This reminds us that, around 1330, the East Anglian artists who illuminated this Book of Psalms chose to do so with, among other things, a material that had been celebrated in the Song of Songs.[11]

1 E. Rutledge, 'Economic Life', in *Medieval Norwich*, ed. C. Rawcliffe and R. Wilson, Hambledon and London, 2004, 157–88.

2 The pigment's origin in cloth was indicated by the detection (by EDX in an ESEM) of phosphorus, an element found in proteins such as wool.

3 *Mappae clavicula*, 9th century, recipes 166–168, ed. C. S. Smith and J. G. Hawthorne, *Transactions of the American Philosophical Society*, 64/4 (1974), 51–52.

4 J. H. Munro, 'The Medieval Scarlet and the Economics of Sartorial Splendor', in *Cloth and Clothing in Medieval Europe*, ed. N. B. Harte and K. G. Ponting, London, 1983, 13–71.

5 Theophilus, *On Divers Arts*, c. 1120, book I, recipe no. 30, ed. J. G. Hawthorne and C. S. Smith, New York: Dover, 1979, 37.

6 S. Bucklow, *The Marriage of Fire and Water*, Cambridge, 2008.

7 M. Grieve, *A Modern Herbal*, ed. C. F. Leyel, Harmondsworth, 1977, 699.

8 Peter of St Audemar, *On Making Colours*, c. 1300, recipe 165, in *Original Treatises on the Arts of Painting*, ed. M. P. Merrifield, New York: Dover, 1967, vol. 1, 130–32.

9 W. Harrison, *The Description of England* (1587), ed. G. Edelen, New York: Dover, 1994, 348–56.

10 R. Hakluyt, *The Principal Navigations, Voyages, Traffiques and Discoveries of the English Nation* (1582), Glasgow, 1904, vol. 5, 240–41.

11 *Song of Songs*, 4: 14.

The Conservation of the Macclesfield Psalter

by Robert Proctor

Condition on Arrival

The Macclesfield Psalter came to the Fitzwilliam Museum in very poor condition. Its simple 18th-century binding (calf over pasteboards) was split along the spine in several places [1], separating the text block into two halves and leaving gatherings attached only by adhesive or by single threads. Several of the sections, particularly towards the end of the text, had lost the spine folds through previous repair and rebinding. The resulting single leaves had been over-sewn into gatherings with green thread [2, 3]. Earlier attempts to remove animal glue from the spine had badly damaged all the remaining spine folds and left them too fragile to accept re-sewing. In places animal glue had penetrated between the gatherings making leaves adhere together or causing the skinning of the vellum where they had been forced apart [4].

No evidence remained of an earlier or possibly original binding. However, where sewing holes were

I

evident in the spine folds, they suggested that the 18th-century binding was not the first rebinding [5]: there had been at least one other re-sewing before it.

Unfortunately the major damage to the psalter is of a kind that can never be repaired. The 'cropping' or trimming of the leaves had removed parts of the illuminated borders [6]. The reason may have been as mundane as the cutting down of the manuscript to the height of a particular shelf.

Repair and Rebinding

The condition on arrival at the museum rendered the manuscript unsuitable for handling. Since the binding was beyond repair and of little intrinsic value or historic interest, it was decided to disbind, re-sew and rebind the manuscript. This made it possible for the museum to display over sixty pages during the 'Cambridge Illuminations' exhibition (July–December 2005). Conservation also allowed for the complete digitization of the manuscript, making it widely available, even if in a surrogate form.

After careful disbinding, all of the spine folds were repaired or re-created, using layered, long-fibre Japanese tissue, adhered with wheat-starch paste.

Unbleached linen thread was used to sew the gatherings to three sewing supports of alum-tawed skin, reinforced with linen braid. Primary end bands were sewn over cores made up in the same way [7]. Spine lining of aero-linen was loosely attached at this point to reinforce the joints, with slots cut to accommodate the raised sewing supports.

Boards of locally sourced quarter-sawn oak were cut to size and prepared for a binding in a style broadly contemporary with the manuscript. Although the quarter-sawing of wood is the most wasteful, and therefore most expensive, way of preparing timber, it produces the strongest material, with less propensity to split along the grain. The holes and channels that accommodate the laced-in sewing supports are staggered for the same reason [8].

The sewing supports are laid along channels cut into the outside of the board, fed through holes along an inside channel and then through a second hole where they are secured [9]. Traditionally this would have been done with a soft wood peg, but in this case they are held with wedges of alum-tawed skin soaked in wheat-starch paste, pulled through until tight, allowed to dry, and cut off. The end-band cores are attached in a similar manner.

The aero-linen spine liner, left loose over the text-block spine, is adhered to the inside of the boards. A recess is cut to accommodate a strap of double-layered alum-tawed skin with a linen braid core that secures the closure of the book. It is secured in the board channel by a pasted tawed-skin wedge. The boards are covered with alum-tawed goatskin. Compatible with 14th-century binding practices, it was favoured for its strength and resistance to wear. To reduce the use of adhesive, the covers are simply folded over at the head, tail and fore-edges, and are sewn at the four corners, thus forming a protective jacket or chemise. A sewn line of coloured braid at the head and tail of the spine attaches the jacket to the end-band sewing [10]. Clasps of cut and filed sheet brass, decorated with leather insets, attached to the boards by brass pins, complete the work [11].

5

8

2

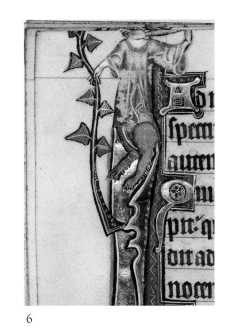

6

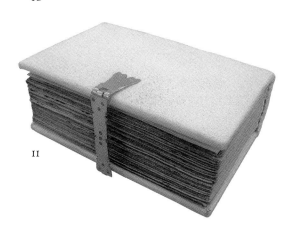

9

3

10

4

7

11

NOTES

Introduction

1 De Hamel 2004.
2 Lucy Sandler's comment during the fundraising campaign for the Macclesfield Psalter, 2004.

I A Web of Interpretations

1 Vale 1982.
2 Boyle 1985.
3 London, British Library, Royal MSS 6.E.VI–6.E.VII; Sandler 1996.
4 London, British Library, Arundel MS 83.II; Sandler 1983; Sandler 2002b.
5 Young 1933, vol. 1, 82–83; Deitering 1984; Enders 1992, 54–68.
6 Camille 1992, 92–93.
7 Le Goff and Schmitt 1981.
8 Bakhtin 1984.
9 Heers 1983; Stallybrass and White 1986.
10 Camille 2006.
11 Nykrog 1974; Gaunt 2006.
12 Hughes and Abraham 1960, 1–13, 82–106; Page 1997.
13 Owst 1933; Schmitt 1990, 278–84.
14 Bynum 2001, 57–58.
15 Carruthers and Ziolkowski 2002, 205–14; Carruthers forthcoming.
16 Vale 1982, 38–40, 72–75.
17 Vale 1982, 51.
18 Stanton 2001, 212–13.
19 Sinclair 1979; Camille 1992, 114.
20 O'Carroll 1980; Boyle 1982.
21 D'Avray 1985; De la Marche 1992.
22 London, British Library, Add. MS 47682; Hassall 1954; Sandler 1986b, vol. 2, no. 97; Kauffmann 1994; Brown 2007.
23 Binski 2004, 226–30.
24 Rosenwein 2001, 229–34.
25 Larrington 2001.
26 Binski 2004, 209–10.
27 Garrison 2001.
28 Schmitt 1990; Schmitt 1991.
29 Carruthers 1998; Bynum 2001, 69–73.
30 Pächt 1943.
31 Lunghi 1996, 106–29.
32 Bellosi 1999.
33 Carli 1996; Lunghi 1996, 154–82.
34 Davis and Gordon 1988, 99–116, plates 69–78.
35 Cannon 1980; Cannon 1982; Cannon 1994.
36 Marks 1998, 177–271.
37 French and O'Connor 1987; Marks 1993, 154–58; Brown 1999, 48–54.
38 Binski and Park 1986.
39 Binski 1995.
40 Binski and Park 1986.
41 Smalley 1960, 75–108.
42 Smalley 1960, 66–74; Courtenay 1987, 133–47.
43 Altamura 1954.
44 Smalley 1960.
45 Smalley 1960, 133–202.
46 Zutshi, Ombres and Morgan 1988; Zutshi and Ombres 1990; Zutshi 2002.
47 Formerly owned by Viscount Astor, Ginge Manor, Oxfordshire, and now in a private collection; Sandler 1986b, vol. 2, no. 111; Dennison 1986a.
48 Courtenay 1987.

49 Courtenay 1987, 106–11.
50 Cockerell 1907.
51 Sandler 1986b, vol. 1, 27–30; Michael 1988; Michael 1990; Michael 2007.
52 London, British Library, Add. MS 49622; Cockerell 1907; Sandler 1986b, vol. 2, no. 50; McIlwain 1999; McIlwain Nishimura and Nishimura 2008.
53 London, British Library, Stowe MS 12; Lasko and Morgan 1973, no. 26; Sandler 1986b, vol. 2, no. 79; Michael 1990.
54 Oxford, Bodleian Library, MS Douce 366; Cockerell and James 1926; Sandler 1986b, vol. 2, no. 43; Law-Turner 1998.
55 McIlwain 1999, 26–28.
56 El Escorial, MS Q.II.6; Sandler 1979; Sandler 1986b, vol. 2, no. 80; Michael 1990.
57 Herdringen, Fürstenbergische Bibliothek, MS 6; Sandler 1986b, vol. 2, no. 81; Michael 1990.
58 Oxford, All Souls College, MS 6; Sandler 1986b, vol. 2, no. 82; Michael 1990.
59 London, British Library, Add. MS 47680; Sandler 1986b, vol. 2, no. 85; Michael 1986; Michael 1990.
60 New York, Morgan Library and Museum, MS M.107; Sandler 1986b, vol. 2, no. 78; Michael 1988; Michael 1990.
61 Michael 1990.
62 Greatrex 1997, 546–47.
63 London, British Library, Yates Thompson MS 14; Lasko and Morgan 1973, no. 28; Sandler 1986b, vol. 2, no. 106.
64 Douai, Bibliothèque Municipale, MS 171; Cockerell 1907; Sandler 1986b, vol. 2, no. 105; Hull 1994; Hull 2001.
65 Hull 2001.
66 Cockerell 1907.
67 Hull 1994.
68 Cambridge, Trinity College, MS R.7.3; Dennison 1986a, 50 n. 36; Hull 1994; Panayotova 2005, 52–53.
69 London, British Library, Royal MS 8.G.XI; Michael 2007.
70 Clark 2004, 99–101.
71 De Hamel 2004.
72 Reproduced in Cockerell 1907, plate XVII.
73 Michael 2007, 116.
74 Tanner 1984; Finch 2004; Harper-Bill and Rawcliffe 2004; Rutledge 2004.
75 Hull 1994.
76 Dennison 1986a; Michael 1988; Dennison 1990a; Michael 2007; Rogers 2007; Dennison forthcoming. I thank Lynda Dennison for sharing a draft of her paper with me.
77 Ker 1978; Carley 1986; Humphreys 1990, 196; Smale 2001, Appendix I, xix–xxvii.
78 Michael 1988; Michael 2007.
79 Dennison 1986a.
80 London, British Library, Arundel MS 83.I; Michael 1981; Sandler 1986b, vol. 2, no. 51; Michael 1988; Michael 2007.
81 Michael 2007.
82 London, British Library, Royal MS 2.B.VII; Sandler 1986b, vol. 2, no. 56.
83 Michael 1981; Michael 1988; Dennison 1990a.
84 Dennison 1986b; Dennison 1990a.

85 Longleat House, Wiltshire, Library of the Marquess of Bath, MS 11, fol. 126r; Sandler 1986b, vol. 2, no. 73; Dennison 1986b; Dennison 1990a.
86 Norwich Castle Museum, MS 158-926/4d; Dennison 1986b.
87 Dennison forthcoming.
88 Oxford, Bodleian Library, MS Douce 131; Alexander 1983; Sandler 1986b, vol. 2, no. 106; Dennison 1986a; Michael 1994; Dennison forthcoming.
89 Cambridge University Archives, Luard 33a*; Dennison 1986a; Binski in Binski and Panayotova 2005, 366, and no. 179.
90 London, British Library, Add. MS 42130; Sandler 1986b, vol. 2, no. 107; Camille 1998; Brown 2006.
91 New Haven, Beinecke Library, MS 417; Sandler 1986b, vol. 2, no. 108.
92 Brescia, Biblioteca Queriniana, MS A.V.17; Sandler 1986b, vol. 2, no. 109; Dennison 1986a.
93 See note 47.
94 Cambridge, St John's College, MS D.30 (103**); Lasko and Morgan 1973, no. 30; Sandler 1986b, vol. 2, no. 112; Dennison 1986a; Binski in Binski and Panayotova 2005, no. 77.
95 New York, Metropolitan Museum of Art, The Cloisters Collection, Acc. No. 54.1.2; Morand 1962; Boehm, Quandt and Wixom 2000.
96 Paris, Bibliothèque Nationale de France, MS lat. 17155; Sandler 1986b, vol. 2, no. 70.
97 Paris, Bibliothèque Nationale de France, MS lat. 11935; Avril 1978, 13–20; Avril 1998.
98 Sandler 1970.
99 Avril 1978, 20–23.

2 The Making of the Macclesfield Psalter

1 Derolez 2003.
2 London, British Library, Royal MS 2.B.VII; Cambridge, Corpus Christi College, MS 53; Oxford, Bodleian Library, MS Douce 366; London, British Library, Add. MS 42130; Brown 2006, 88–91.
3 Norwich, Castle Museum, MS 158.926.4f; Sandler 1986b, vol. 2, no. 47.
4 Derolez 2003, 74–75.
5 De Hamel 2004; Panayotova 2005, 12; Panayotova in Binski and Panayotova 2005, no. 78.

3 The Texts

1 Morgan 2001.
2 London, Society of Antiquaries, MS 59, fol. 32v; Morgan 1982–88, vol. 1, no. 47.
3 Brussels, Bibliothèque Royale, MS 9961–62, fol. 13v; Sandler 1974, fig. 24; Sandler 1986b, vol. 2, no. 40.
4 London, BL, Harley MS 3950, fol. 2v; Hull 1994, 31–32.
5 Douai, Bibliothèque Municipale, MS 171, fol. Ir–v; Hull 1994, 31, Appx A. London, BL, Add. MS 49622, fol. 7v; McIlwain 1999, 228.
6 Leroquais 1940–41, vol. 1, v–cxxxvi.
7 Sandler 1985a.
8 Dublin, Royal Irish Academy, s.n.; De Hamel 1994, 22, plate 12.
9 Weiss 1998, 146–47.
10 Maguire 1997.
11 Burnett 1992.
12 Hughes 1982, 50–80, 226–31; Taft 1993, 134–40.
13 Kahsnitz 1979, 134–35; Hughes 1982, 50–80, 226–31.

14 De Hamel 2001, 12–31.
15 *Biblia sacra iuxta Vulgatam versionem*, revised by R. Weber, Stuttgart, 1983.
16 *The Holy Bible Translated from the Latin Vulgate*, originally published by the Douay Bible House, New York, 1941; repr. New Hampshire, 2002
17 Hughes 1982, 24; Pfaff 1992, 103–04.
18 Cross and Livingstone 2005, 1592–93.
19 Hughes 1982, 37–38.
20 Kelly 1964; Hughes 1982, 38–39.
21 Ottosen 1993.
22 Boyle 1982.
23 Rubin 1991, 98–108, 334–45.

4 The Owners of the Macclesfield Psalter

1 Boyle 1994.
2 Vatican City, Biblioteca Apostolica Vaticana, MS Rossianum 3; Boyle 1994.
3 Binski 1996, 29–47.
4 Michael 1997.
5 Herald's Roll, Dering Roll, Charles's Roll and St George's Roll; Mitchell 1983, EB 646, A 122, F 360, E 245; Brault 1997, vol. 1, 132 (HE 647), 154 (A 122), 283 (F 360), 222 (E 245); Michael 2007, 119 n. 35.
6 Segar's Roll, Collin's Roll, Caerlaverock Poem, Smallpece's Roll, Lord Marshall's Roll, First Dunstable Roll, Parliamentary Roll, Sir William Le Neve's Second Roll, Ashmolean Roll, Cooke's Ordinary; Mitchell 1983, G 135, Q 318, K 96, SP 123, LM 186 (William Gorges is entered under LM 168 with argent, on a chief gules two mullets or debruised by a riband sable), L 70, N 76, WNS 29, AS 88, CKO 421; Brault 1997, vol. 1, 316 (G 135), 382 (Q 318), 442 (K 96), 478 (SP 123).
7 Cokayne, 1910–59, vol. 6, 9–15.
8 Correspondence, 25 September 2007.
9 Correspondence, 9 August 2007; Woodcock and Robinson 1988, plate 24.
10 Stringer 1985; *ODNB* 2004, vol. 39, 444–46.
11 Cockayne, 1910–59, VI, 9.
12 *ODNB* 2004, vol. 57, 395–99.
13 *ODNB* 2004, vol. 57, 399–403.
14 McIlwain 1999, 109–35; McIlwain Nishimura and Nishimura 2008.
15 De Hamel 2004.
16 Jones 2002, 51–55.
17 Carruthers 1990, 245–47; Carruthers forthcoming.
18 Fitzwilliam Museum, MS 298; Davenport 1984, 564–1049; Morgan in Binski and Panayotova 2005, no.52.
19 Three of the Gorleston examples are reproduced in Cockerell 1907, plate IX.
20 *Patent Rolls* 1903, 16, 51–2.
21 *Patent Rolls* 1898, 411; *ODNB* 2004, vol. 57, 399–403.
22 *ODNB* 2004, vol. 19, 757–58, 768–69.
23 *Patent Rolls* 1903, 480.
24 Paris, Bibliothèque Nationale, MS latin 31141-2; Sandler 1986b, vol. 2, no. 90, illus. 228–29; Avril and Stirnemann 1987, no. 182, plate J, figures LXXIII–LXXIV.
25 Sandler 1986b, vol. 2, no. 90.
26 McIlwain Nishimura and Nishimura 2008.
27 King forthcoming. I thank David King for letting me see a draft of his future publication.
28 Corder 1998, 381.
29 Bothwell 2004, 151–53.
30 Given-Wilson 1991.
31 Tierney 1834, 672–74; VCH *Sussex* 1973, 93–4.
32 I thank Claire Daunton for discussing her research on

the Mileham glass and its patronage with me.
33 King 2006. David King's forthcoming volume on Norfolk glass is eagerly awaited.
34 Correspondence, 1 June 2007; National Library of Wales, Chirk Castle Collection, D 9, account of the Receiver of Chirk, 1341–42, membrane 3, lines 4ff; Nichols 1780, 132.
35 *ODNB* 2004, vol. 38, 773–75.
36 *ODNB* 2004, vol. 38, 767.
37 Cambridge, St John's College, MS D.30 (103**); Sandler 1986b, vol. 2, no. 112; Dennison 1986a; Binski in Binski and Panayotova 2005, no. 77.
38 Binski and Park 1986.
39 Sandler 1985b; Sandler 1986b, vol. 1, 34–36; Dennison 1988; Dennison 1990b; Sandler 2002a; Sandler 2002c; Sandler 2003; Sandler 2004.
40 De Hamel 2004.
41 McDonnell 2005.

5 The Decoration

1 Dennison forthcoming.
2 Tracy 1997; Michael 2007.
3 Norton, Park and Binski 1987; Massing 2003.
4 Massing 2003, 50; see Appendix II in this volume.
5 Norton, Park and Binski 1987, 57–81.
6 Norton, Park and Binski 1987, 87–92; Smale 2001, 93–102; for Edmund Gonville, see *ODNB* 2004, vol. 22, 730–31; for Henry of Lancaster, see *ODNB* 2004, vol. 26, 572–76.
7 Massing 2003, 50, 113–21, 225.
8 King forthcoming.
9 Tudor-Craig 1988.
10 Gardner 1994, 12.
11 Smale 2001, 29–53; Finch 2004, 61–62; Harper-Bill and Rawcliffe 2004, 102–08.
12 Massing 2003, 14.
13 Rogers forthcoming; I am grateful to Nicholas Rogers for sharing with me a draft of his forthcoming article.

6 Moving Pictures

1 Light 1994.
2 Rouse and Rouse 2000.
3 Branner 1977, 15–21.
4 Morgan 1982–88, vol. 1, 61, 72–76.
5 Dickinson 1950; Boyle 1985.
6 Panayotova 1997.
7 Cockerell 1907, plate. XVII.
8 Tristram 1955, 75–77, 262–63, plates 22–24.
9 De Hamel 2004.
10 Sandler 1980; Sandler 2007.
11 Carruthers forthcoming.
12 Sandler 1996.
13 Orme 1984; Hunt 1991; Reynolds 1996.
14 Jones 1998, 100–01.
15 Jones 2002, 287–89.
16 Camille 2006.
17 Wentersdorf 1984; Camille 1992; Ziolkowski 1998; Jones 2002; McDonald 2006.
18 Randall 1966; Sandler 1997; Carruthers 1998; Bynum 2001; Mellinkoff 2004.
19 Camille 2006.
20 Randall 1962; Pinon 1980; Camille 1992, 31–36; Jones 2002, 160–61.
21 *ODNB* 2004, vol. 19, 757.
22 I thank Dr John Pinnegar for this information.
23 Montagu 2006.
24 Helm 1981, 19–26.
25 Helm 1981, 11–19, 27–33.
26 Vale 1982, 70–71; Jones 2002, 112.
27 Camille 1992, 130–43.
28 Cambridge, Trinity College, MS B.11.22; Meuwese

2006; Panayotova and Morgan 2008, entry on MS B.11.22.
29 Sandler 1986b, vol. 1, 20–22; Dennison 2005.
30 I am grateful to Claire Daunton for sharing her current research on stained glass in Norfolk. While most of the glass at Ringland is known only from antiquarian sources, the 14th-century centaur playing a viol, still *in situ*, reappears in different guises and in the Macclesfield Psalter (fols. 92r, 121v).
31 Jones 1989; Jones 2002.
32 Remnant 1969; Grössinger 1997.
33 Brown 1999, 43.
34 Camille 1993.
35 Mellinkoff 1973.
36 Jones 2002, 57–8.
37 Varty 1999.
38 Jason 1952.
39 London, British Library, Yates Thompson MS 13; Sandler 1986b, vol. 2, no. 98; Brownrigg 1989.
40 London, British Library, Royal MS 10.E.IV; Sandler 1986b, vol. 2, no. 101; Bovey 2000; Bovey forthcoming.
41 Rushing 1995; Rushing 1998.
42 Ramsay, Sparks and Tatton-Brown 1992; Bovey forthcoming.
43 Randall 1966, figures 402, 407, 408.
44 Sandler 1985a.
45 CFMA 84, 94.
46 CFMA 84, 157.
47 Nykrog 1974, 66.
48 Smith 2003, 169–70.
49 Jones 2002, 259–60.
50 Carruthers 1998; Bynum 2001.
51 Kuczynski 1995.
52 Phillips 1986.
53 Maddicott 1986.
54 Smith 1993; Stanton 2001.
55 Sandler 2002a; Sandler 2002c.
56 Schmidt 1978.
57 Camille 1998; Brown 2006.
58 Rubin 1987; Cullum 1993.
59 Binski 1996, 123–63.
60 Wille 2002.
61 Wille 2002, 44–48.
62 Dykmans 1973; Sandler 1986a.
63 Smalley 1960, 136–41.
64 Denzinger 1957, 197–98; Sandler 1986a.
65 Sandler 1986a.
66 Bober and Rubinstein 1986.
67 Bede refers to Grantacæstir, the old Roman name of Cambridge, which would become Granta Brycge by 875. The medieval name of Grantchester, the village outside Cambridge, was Grantasæta; Bryan 1999, 12; Taylor 1999, 43.
68 Camille 1992, 88–89.
69 Montaiglon and Raynaud 1872–90, vol. 5, 243–62.
70 Randall 1966, 16, figures 554–57.
71 London, British Library, Royal MS 2.D.iv; Smalley 1960, 167–68.
72 Reynolds 1965a, vol. 1, 312–23.
73 Reynolds 1965b; Fohlen 2000.
74 Rouse and Rouse 1979; Munk Olsen 2000.
75 Reynolds 1965b; Fohlen 2000.
76 Ker 1978.
77 Smalley 1960, 153.
78 Reynolds 1996, 150–54.
79 Clark 2004.

Alexander 1983: J. J. G. Alexander, 'Painting and Manuscript Illumination at the English Court in the Later Middle Ages', in *English Court Culture in the Later Middle Ages*, ed. V. J. Scattergood and J. W. Sherborne, London, 1983, 141–62

Altamura 1954: Ricardo de Bury, *Philobiblon*, ed. A. Altamura, Naples, 1954

Avril 1978: F. Avril, *Manuscript Painting at the Court of France: The Fourteenth Century (1310–1380)*, New York, 1978

Avril 1998: F. Avril, 'Bible de Robert de Billyng', in *L'Art au temps des rois maudits: Philippe le Bel et ses fils, 1285–1328*, Paris, 1998, no. 195 [exhibition catalogue]

Avril and Stirnemann 1987: F. Avril and P. D. Stirnemann, *Manuscrits enluminés d'origine insulaire, VIIe–XXe siècle*, Paris, 1987

Bakhtin 1984: M. Bakhtin, *Rabelais and his World*, trans. H. Iswolsky, Bloomington, 1984

Bellosi 1999: L. Bellosi, *Duccio, the Maestà*, London, 1999

Binski 1995: P. Binski, *Westminster Abbey and the Plantagenets: Kingship and the Representation of Power, 1200–1400*, New Haven and London, 1995

Binski 1996: P. Binski, *Medieval Death: Ritual and Representation*, London, 1996

Binski 2004: P. Binski, *Becket's Crown: Art and Imagination in Gothic England, 1170–1300*, New Haven and London, 2004

Binski and Panayotova 2005: *The Cambridge Illuminations: Ten Centuries of Manuscript Production in the Medieval West*, ed. P. Binski and S. Panayotova, London and Turnhout, 2005 [exhibition catalogue]

Binski and Park 1986: P. Binski and D. Park, 'A Ducciesque Episode at Ely: The Mural Decoration of Prior Crauden's Chapel', in *England in the Fourteenth Century: Proceedings of the 1985 Harlaxton Symposium*, ed. W. M. Ormrod, Woodbridge, 1986, 28–41

Bober and Rubinstein 1986: P. P. Bober and R. O. Rubinstein, *Renaissance Artists and Antique Sculpture*, London, 1986, repr. 1991

Boehm, Quandt and Wixom 2000: B. D. Boehm, A. Quandt and W. D. Wixom, *The Hours of Jeanne d'Evreux*, Lucerne, 2000 [commentary volume for facsimile published by Faksimile Verlag Luzern]

Bothwell 2004: J. S. Bothwell, *Edward III and the English Peerage: Royal Patronage, Social Mobility and Political Control in Fourteenth-Century England*, Woodbridge, 2004

Bovey 2000: A. Bovey, 'Didactic Distractions Framing the Law: The Smithfield Decretals (BL Royal MS 10.E.IV)', Ph.D. thesis, Courtauld Institute of Art, London, 2000

Bovey 2002: A. Bovey, 'A Pictorial Ex Libris in the Smithfield Decretals', in *English Manuscript Studies, 1100–1700*, vol. 10, ed. A. S. G. Edwards, London, 2002, 60–82

Bovey forthcoming: A. Bovey, *The Smithfield Decretals*, London, forthcoming

Boyle 1982: L. E. Boyle, 'Summae confessorum', in *Les Genres littéraires dans les sources théologiques et philosophiques médiévales*, Louvain, 1982, 227–37

Boyle 1985: L. E. Boyle, 'The Fourth Lateran Council and Manuals of Popular Theology', in *The Popular Literature of Medieval England*, ed. T. J. Heffernan, Knoxville, 1985, 30–43

Boyle 1994: L. E. Boyle, '"The Ways of Prayer of St Dominic": Notes on MS Rossi 3 in the Vatican Library', *Archivum Fratrum Praedicatorum*, 64 (1994), 5–17

Branner 1977: R. Branner, *Manuscript Illumination in Paris during the Reign of Saint Louis*, Berkeley and Los Angeles, 1977

Brault 1997: G. J. Brault, *Rolls of Arms, Edward I (1272–1307)*, 2 vols, Aspilogia 3, Woodbridge, 1997

Brown 1999: S. Brown, *Stained Glass at York Minster*, London, 1999

Brown 2006: M. P. Brown, *The Luttrell Psalter*, London, 2006 [commentary volume for facsimile published by The Folio Society]

Brown 2007: M. P. Brown, *The Holkham Bible Picture Book*, London, 2007 [commentary volume for facsimile published by The Folio Society]

Brownrigg 1989: L. Brownrigg, 'The Taymouth Hours and the Romance of *Beves of Hampton*', in *English Manuscript Studies, 1100–1700*, vol. 1, ed. P. Beal and J. Griffiths, Oxford, 1989, 222–41

Bryan 1999: P. Bryan, *Cambridge: The Shaping of the City*, n.p. [Cambridge], 1999

Burnett 1992: C. Burnett, 'The Prognostications of the Eadwine Psalter', in *The Eadwine Psalter: Text, Image, and Monastic Culture in Twelfth-Century Canterbury*, ed. M. Gibson, T. A. Heslop and R. W. Pfaff, London, 1992, 165–67

Bynum 2001: C. W. Bynum, *Metamorphosis and Identity*, New York, 2001

Camille 1992: M. Camille, *Image on the Edge: The Margins of Medieval Art*, London, 1992

Camille 1993: M. Camille, 'At the Edge of the Law: An Illustrated Register of Writs in the Pierpont Morgan Library', in *England in the Fourteenth Century: Proceedings of the 1991 Harlaxton Symposium*, ed. N. Rogers, Stamford, 1993, 1–14

Camille 1998: M. Camille, *Mirror in Parchment: The Luttrell Psalter and the Making of Medieval England*, London, 1998

Camille 2006: M. Camille, 'Dr Witkowski's Anus: French Doctors, German Homosexuals and the Obscene in Medieval Church Art', in *Medieval Obscenities*, ed. N. McDonald, Woodbridge, 2006, 17–38

Cannon 1980: J. Cannon, 'Dominican Patronage of the Arts in Central Italy: The Provincia Romana,

c. 1220–c. 1320', Ph.D. thesis, University of London, 1980

Cannon 1982: J. Cannon, 'Simone Martini, the Dominicans and the Early Sienese Polyptych', *Journal of the Warburg and Courtauld Institutes*, 45 (1982), 69–93

Cannon 1994: J. Cannon, 'The Creation, Meaning, and Audience of the Early Sienese Polyptych: Evidence from the Friars', in *Italian Altarpieces, 1250–1550: Function and Design*, ed. E. Borsook and F. S. Gioffredi, Oxford, 1994, 41–79

Carley 1986: J. P. Carley, 'John Leland and the Contents of English Pre-Dissolution Libraries: The Cambridge Friars', *Transactions of the Cambridge Bibliographical Society*, 9/1 (1986), 90–99

Carli 1996: E. Carli, *Simone Martini, La Maestà*, Milan, 1996

Carruthers 1990: M. Carruthers, *The Book of Memory: A Study of Memory in Medieval Culture*, Cambridge, 1990

Carruthers 1998: M. Carruthers, *The Craft of Thought: Meditation, Rhetoric, and the Making of Images, 400–1200*, Cambridge, 1998

Carruthers forthcoming: M. Carruthers, 'Thinking in Images', in *Sign and Symbol: Essays in Memory of Janet Backhouse, Proceedings of the 2006 Harlaxton Symposium*, ed. J. Cherry, Donington, forthcoming

Carruthers and Ziolkowski 2002: *The Medieval Craft of Memory: An Anthology of Texts and Pictures*, ed. M. Carruthers and J. M. Ziolkowski, Philadelphia, 2002

CFMA 84: Classiques Français du Moyen Âge, vol. 84, Paris, 1957

Clark 2004: J. G. Clark, *A Monastic Renaissance at St Albans: Thomas Walsingham and his Circle, c. 1350–1440*, Oxford, 2004

Cockerell 1907: S. C. Cockerell, *The Gorleston Psalter*, London, 1907

Cockerell and James 1926: S. C. Cockerell and M. R. James, *Two East Anglian Psalters at the Bodleian Library*, Roxburghe Club, Oxford, 1926

Cokayne 1910–59: G. E. Cokayne, *The Complete Peerage of England, Scotland, Ireland, Great Britain, and the United Kingdom, Extant, Extinct, or Dormant*, rev. edn, ed. V. Gibbs et al., London, 1910–59

Corder 1998: J. Corder, *A Dictionary of Suffolk Crests: Heraldic Crests of Suffolk Families*, Woodbridge, 1998

Courtenay 1987: W. J. Courtenay, *Schools and Scholars in Fourteenth-Century England*, Princeton, 1987

Cross and Livingstone 2005: *The Oxford Dictionary of the Christian Church*, ed. F. L. Cross, 3rd edn, rev. E. A. Livingstone, Oxford, 2005

Cullum 1993: P. H. Cullum, 'Poverty and Charity in Early Fourteenth-Century England', in *England in the Fourteenth Century: Proceedings of the 1991 Harlaxton Symposium*, ed. N. Rogers, Stamford, 1993, 140–51

Davenport 1984: S. K. Davenport, 'Manuscript Illumination for Renaud de Bar, Bishop of Metz

(1301–1316)', Ph.D. thesis, University of London, 1984

Davis and Gordon 1988: M. Davis, *The Early Italian Schools before 1400*, rev. D. Gordon, London, 1988

D'Avray 1985: D. L. D'Avray, *The Preaching of the Friars: Sermons Diffused from Paris before 1300*, Oxford, 1985

De Hamel 1994: C. de Hamel, *A History of Illuminated Manuscripts*, London, 1994

De Hamel 2001: C. de Hamel, *The Book: A History of the Bible*, London and New York, 2001

De Hamel 2004: C. de Hamel, 'The Macclesfield Psalter', in *The Library of the Earls of Macclesfield Removed from Shirburn Castle*, London, n.d. [2004], lot 587 [sale catalogue, Sotheby's, 22 June 2004]

Deitering 1984: C. Deitering, *The Liturgy as Dance and the Liturgical Dancer*, New York, 1984

De la Marche 1992: A. L. de la Marche, *Le Rire du prédicateur: récits facétieux du Moyen Age*, rev. edn, ed. J. Berlioz, Turnhout, 1992

Dennison 1986a: L. Dennison, 'The Fitzwarin Psalter and its Allies: A Reappraisal', in *England in the Fourteenth Century: Proceedings of the 1985 Harlaxton Symposium*, ed. W. M. Ormrod, Woodbridge, 1986, 42–66

Dennison 1986b: L. Dennison, 'An Illuminator of the Queen Mary Psalter Group: The Ancient 6 Master', *Antiquaries Journal*, 66 (1986), 287–314

Dennison 1988: L. Dennison, 'The Stylistic Sources, Dating and Development of the Bohun Workshop, *ca.* 1340–1400', Ph.D. thesis, University of London, 1988

Dennison 1990a: L. Dennison, '"Liber horn", "Liber custumarum" and Other Manuscripts of the Queen Mary Psalter Workshop', in *Medieval Art, Architecture and Archaeology in London*, London, 1990, 118–34

Dennison 1990b: L. Dennison, 'Oxford, Exeter College MS 47: The Importance of Stylistic and Codicological Analysis in its Dating and Localization', in *Medieval Book Production: Assessing the Evidence*, ed. L. L. Brownrigg, Los Altos Hills, 1990, 41–60

Dennison 2005: L. Dennison, 'Transformation, Interaction and Integration: The Career and Collaboration of a Fourteenth-Century Flemish Illuminator', in *Manuscripts in Transition: Recycling Manuscripts, Texts and Images*, ed. B. Dekeyzer and J. Van der Stock, Leuven, 2005, 173–91

Dennison forthcoming: L. Dennison, 'The Technical Mastery of the Macclesfield Psalter: a Stylistic Appraisal of the Illuminators and their Suggested Origin', *Transactions of the Cambridge Bibliographical Society*, 13/2, forthcoming

Denzinger 1957: H. Denzinger, *Enchiridion symbolorum*, trans. R. J. Deferrari, St Louis and London, 1957, 197–98

Derolez 2003: A. Derolez, *The Palaeography of Gothic Manuscript Books: From the Twelfth to the Early Sixteenth Century*, Cambridge Studies in Palaeography and Codicology, 9, Cambridge, 2003

Dickinson 1950: J. C. Dickinson, *The Origins of the Austin Canons and their Introduction into England*, London, 1950

Dykmans 1973: M. Dykmans, *Les Sermons de Jean XXII sur la vision béatifique*, Miscellanea Historiae Pontificae, 34, Rome, 1973

Enders 1992: J. Enders, *Rhetoric and the Origins of Medieval Drama*, Ithaca, 1992

Finch 2004: J. Finch, 'The Churches', in *Medieval Norwich*, ed. C. Rawcliffe and R. Wilson, London, 2004, 49–72

Fohlen 2000: J. Fohlen, 'La Tradition manuscrite des Epistulae ad Lucilium (IXe–XVIe s.)', *Giornale Italiano di Filologia*, 52 (2000), 111–62

French and O'Connor 1987: T. French and D. O'Connor, *York Minster: A Catalogue of Medieval Stained Glass, fascicule 1: The West Windows of the Nave*, Corpus Vitrearum Medii Aevi: Great Britain, 3, Oxford, 1987

Gardner 1994: J. Gardner, 'Altars, Altarpieces, and Art History: Legislation and Usage', in *Italian Altarpieces, 1250–1550: Function and Design*, ed. E. Borsook and F. S. Gioffredi, Oxford, 1994, 5–40

Garrison 2001: M. Garrison, 'The Study of Emotions in Early Medieval History: Some Starting Points', *Early Medieval Europe*, 10 (2001), 243–50

Gaunt 2006: S. Gaunt, 'Obscene Hermeneutics in Troubadour Lyric', in *Medieval Obscenities*, ed. N. McDonald, Woodbridge, 2006, 85–104

Given-Wilson 1991: C. Given-Wilson, 'Wealth and Credit, Public and Private: the Earls of Arundel, 1306–1397', *English Historical Review*, 106 (1991), 1–26

Greatrex 1997: J. Greatrex, *Biographical Register of the English Cathedral Priories of the Province of Canterbury, c. 1066 to 1540*, Oxford, 1997

Grössinger 1997: C. Grössinger, *The World Upside Down: English Misericords*, London, 1997

Harper-Bill and Rawcliffe 2004: C. Harper-Bill and C. Rawcliffe, 'The Religious Houses', in *Medieval Norwich*, ed. C. Rawcliffe and R. Wilson, London, 2004, 73–119

Hassall 1954: O. W. Hassall, *The Holkham Bible Picture Book*, London, 1954

Heers 1983: J. Heers, *Fêtes des fous et carnivals*, Paris, 1983

Helm 1981: A. Helm, *The English Mummers' Play*, Woodbridge, 1981

Hughes 1982: Dom A. Hughes, *Medieval Manuscripts for Mass and Office: A Guide to their Organization and Terminology*, Toronto, 1982

Hughes and Abraham 1960: *Ars Nova and the Renaissance, 1300–1540*, ed. Dom A. Hughes and G. Abraham, Oxford, 1960, repr. 1998

Hull 1994: C. S. Hull, 'The Douai Psalter and Related East Anglian Manuscripts', Ph.D. thesis, Yale University, 1994

Hull 2001: C. S. Hull, 'Abbot John, Vicar Thomas and M. R. James: The Early History of the Douai Psalter', in *The Legacy of M. R. James*, ed. L. Dennison, Donington, 2001, 118–27

Humphreys 1990: K. W. Humphreys, *The Friars' Libraries*, Corpus of British Medieval Library Catalogues, 1, London, 1990

Hunt 1991: T. Hunt, *Teaching and Learning Latin in Thirteenth-Century England*, Cambridge, 1991

Jason 1952: H. W. Jason, *Apes and Ape Lore in the Middle Ages and the Renaissance*, London, 1952

Jones 1989: M. Jones, 'Folklore Motifs in Late Medieval Art, I: Proverbial Follies and Impossibilities', *Folklore*, 100 (1989), 201–16

Jones 1998: P. M. Jones, *Medieval Medicine in Illuminated Manuscripts*, London, 1998

Jones 2002: M. Jones, *The Secret Middle Ages*, Stroud, 2002

Kahsnitz 1979: R. Kahsnitz, *Der Werdener Psalter in Berlin*, Düsseldorf, 1979

Kauffmann 1994: C. M. Kauffmann, 'Art and Popular Culture: New Themes in the Holkham Bible Picture Book', in *Studies in Medieval Art and Architecture Presented to Peter Lasko*, ed. D. Buckton and T. A. Heslop, Stroud, 1994, 46–69

Kelly 1964: J. N. D. Kelly, *The Athanasian Creed*, New York, 1964

Ker 1978: N. R. Ker, 'Cardinal Cervini's Manuscripts from the Cambridge Friars', in *Xenia medii aevi historiam illustrantia oblata Thomae Kaeppeli OP*, ed. R. Creytens and P. Künzle, 2 vols, Rome, 1978, 1, 51–71; repr. in N. R. Ker, *Books, Collectors and Libraries: Studies in the Medieval Heritage*, ed. A. Watson, London, 1984, 437–58

King 2006: D. King, *The Medieval Stained Glass of St Peter Mancroft, Norwich*, Corpus Vitrearum Medii Aevi: Great Britain, 5, Oxford, 2006

King forthcoming: D. King, 'John de Warenne, Edmund Gonville and the Thetford Dominican Altar Paintings', in *Contexts of Medieval Art: Images, Objects and Ideas*, ed. J. Luxford and M. A. Michael, London and Turnhout, forthcoming

Kuczynski 1995: M. P. Kuczynski, *Prophetic Song: The Psalms as Moral Discourse in Late Medieval England*, Philadelphia, 1995

Larrington 2001: C. Larrington, 'The Psychology of Emotion and the Study of the Medieval Period', *Early Medieval Europe*, 10 (2001), 251–56

Lasko and Morgan 1973: *Medieval Art in East Anglia, 1300–1520*, ed. P. Lasko and N. J. Morgan, Norwich, 1973 [exhibition catalogue]

Law-Turner 1998: F. Law-Turner, 'Artists, Patrons and the Sequence of Production in the Ormesby Psalter (Oxford MS Douce 366)', Ph.D. thesis, University of London, 1998

Le Goff and Schmitt 1981: *Le Charivari*, ed. J. Le Goff and J.-C. Schmitt, The Hague and New York, 1981

Leroquais 1940–41: V. Leroquais, *Les Psautiers manuscrits latins des bibliothèques publiques de France*, 3 vols, Macon, 1940–41

Light 1994: L. Light, 'French Bibles, *c.* 1200–1230: A New Look at the Origin of the Paris Bible', *The Early Medieval Bible: Its Production, Decoration and Use*, ed. R. Gameson, Cambridge, 1994, 155–76

Lunghi 1996: E. Lunghi, *The Basilica of St Francis at Assisi: The Frescoes by Giotto, his Precursors and Followers*, London, 1996

McDonald 2006: *Medieval Obscenities*, ed. N. McDonald, Woodbridge, 2006

McDonnell 2005: H. McDonnell, 'The Strange, Strange World of Admiral Lord Mark Kerr: Nelson's Surrealist Captain at the Time of Trafalgar', *British Art Journal*, 6/2 (2005), 28–30

McIlwain 1999: M. McIlwain, 'The Gorleston Psalter: A Study of the Marginal in the Visual Culture of Fourteenth-Century England', Ph.D. thesis, Institute of Fine Arts, New York, 1999

McIlwain Nishimura and Nishimura 2008 : M. McIlwain Nishimura and D. Nishimura, 'Rabbits, Warrens, and Warenne: The Patronage of the Gorleston Psalter', in *Tributes to Lucy Freeman Sandler: Studies in Manuscript Illumination*, ed. K. A. Smith and H. Krinsky, London and Turnhout, 2008

Maddicott 1986: J. R. Maddicott, 'Poems of Social Protest in Early Fourteenth-Century England', in *England in the Fourteenth Century: Proceedings of the 1985 Harlaxton Symposium*, ed. W. M. Ormrod, Woodbridge, 1986, 130–44

Maguire 1997: H. Maguire, 'Images of the Court', in *The Glory of Byzantium: Art and Culture of the Middle Byzantine Era, A.D. 843–1216*, ed. H. C. Evans and W. D. Wixom, New York, 1997, 183–91 [exhibition catalogue]

Marks 1993: R. Marks, *Stained Glass in England during the Middle Ages*, London, 1993

Marks 1998: R. Marks, *The Medieval Stained Glass of Northamptonshire*, Corpus Vitrearum Medii Aevi: Great Britain, 4, Oxford, 1998

Massing 2003: *The Thornham Parva Retable: Technique, Conservation and Context of an English Medieval Painting*, ed. A. Massing, Cambridge, 2003

Mellinkoff 1973: R. Mellinkoff, 'Riding Backwards: Theme of Humiliation and Symbol of Evil', *Viator*, 4 (1973), 153–76

Mellinkoff 2004: R. Mellinkoff, *Averting Demons: The Protecting Power of Medieval Visual Motifs and Themes*, 2 vols, Los Angeles, 2004

Meuwese 2006: M. Meuwese, 'The Secret History of the Fox and the Hare in Trinity B.11.22', in *Medieval Manuscripts in Transition: Tradition and Creative Recycling*, ed. W. G. H. M. Claasens and W. Verbeke, Leuven, 2006, 179–95

Michael 1981: M. A. Michael, 'The Harnhulle Psalter-Hours: An Early Fourteenth-Century English Psalter at Downside Abbey', *Journal of the British Archaeological Association*, 134 (1981), 81–99

Michael 1986: M. A. Michael, 'The Artists of the Walter of Milemete Treatise', Ph.D. thesis, University of London, 1986

Michael 1988: M. A. Michael, 'Oxford, Cambridge and London: Towards a Theory for "Grouping" Gothic Manuscripts', *Burlington Magazine*, 130 (1988), 107–15

Michael 1990: M. A. Michael, 'Destruction, Reconstruction and Invention: The Hungerford Hours and English Manuscript Illumination of the Early Fourteenth Century', *English Manuscript Studies, 1100–1700*, vol. 2, ed. P. Beal and J. Griffiths, Oxford, 1990, 33–108

Michael 1994: M. A. Michael, '"The Little Land of England is Preferred before the Great Kingdom of France": The Quartering of the Royal Arms by Edward III', in *Studies in Medieval Art and Architecture Presented to Peter Lasko*, ed. D. Buckton and T. A. Heslop, Stroud, 1994, 113–26

Michael 1997: M. A. Michael, 'The "Privilege of Proximity": Towards a Re-definition of the Function of Armorials', *Journal of Medieval History*, 23 (1997), 55–74

Michael 2007: M. A. Michael, 'Seeing-in: The Macclesfield Psalter', in *The Cambridge Illuminations: The Conference Papers*, ed. S. Panayotova, London and Turnhout, 2007, 115–28

Mitchell 1983: R. W. Mitchell, *English Medieval Rolls of Arms*, 1: *1244–1334*, Tweeddale, 1983

Montagu 2006: J. Montagu, 'Musical Instruments in the Macclesfield Psalter', *Early Music*, 34 (2006), 189–204

Montaiglon and Raynaud 1872–90: *Recueil général et complet des fabliaux des XIIIe et XIVe siècles*, ed. A. de Montaiglon and G. Raynaud, 5 vols, Paris, 1872–90

Morand 1962: K. Morand, *Jean Pucelle*, Oxford, 1962

Morgan 1982–88: N. J. Morgan, *Early Gothic Manuscripts, 1190–1285*, 2 vols, A Survey of Manuscripts Illuminated in the British Isles, 4, London and Oxford, 1982–88

Morgan 2001: N. J. Morgan, 'The Introduction of the Sarum Calendar into the Dioceses of England in the Thirteenth Century', in *Thirteenth Century England*, 8, ed. M. Prestwich, R. Britnell and R. Frame, Woodbridge, 2001, 180–206

Munk Olsen 2000: B. Munk Olsen, 'Les florilèges et les abrégés de Sénèque au Moyen Âge', *Giornale Italiano di Filologia*, 52 (2000), 163–83

Nichols 1780: J. Nichols, *A Collection of All the Wills of Kings and Queens of England*, London, 1780

Norton, Park and Binski 1987: C. Norton, D. Park and P. Binski, *Dominican Painting in East Anglia: The Thornham Parva Retable and the Musée de Cluny Frontal*, Woodbridge, 1987

Nykrog 1974: P. Nykrog, 'Courtliness and the Townspeople: The Fabliaux as a Courtly Burlesque', in *The Humor of the Fabliaux: A Collection of Critical Essays*, ed. T. D. Cooke and B. L. Honeycutt, Columbia, MO, 1974, 59–73

O'Carroll 1980: M. O'Carroll, 'The Educational Organisation of the Dominicans in England and Wales, 1221–1348: A Multidisciplinary Approach', *Archivum Fratrum Praedicatorum*, 1 (1980), 23–62

ODNB 2004: *Oxford Dictionary of National Biography*, ed. H. C. G. Matthew and B. Harrison, 60 vols, Oxford, 2004

Orme 1984: N. Orme, *From Childhood to Chivalry: The Education of the English Kings and Aristocracy, 1066–1530*, London and New York, 1984

Ottosen 1993: K. Ottosen, *The Responsories and Versicles of the Latin Office of the Dead*, Aarhus, 1993

Owst 1933: G. R. Owst, *Literature and Pulpit in Medieval England*, Oxford, 1933

Pächt 1943: O. Pächt, 'A Giottesque Episode in English Medieval Art', *Journal of the Warburg and Courtauld Institutes*, 6 (1943), 51–70

Page 1997: C. Page, 'An English Motet of the 14th Century in Performance: Two Contemporary Images', *Early Music*, 25 (1997), 7–32

Panayotova 1997: S. Panayotova, 'Typological Interpretation and Illustration in English Psalters, c. 1150–1250', Ph.D. thesis, Oxford, 1997

Panayotova 2005: S. Panayotova, *The Macclesfield Psalter*, Cambridge, 2005

Panayotova and Morgan 2008: *A Catalogue of Western Book Illumination in the Fitzwilliam Museum and the Cambridge Colleges, 6th to 16th Centuries: Part I*, ed. S. Panayotova and N. Morgan, London and Turnhout, 2008 (forthcoming)

Patent Rolls 1898: *Calendar of Patent Rolls, Edward III (1338–1340)*, London, 1898

Patent Rolls 1903: *Calendar of Patent Rolls, Edward III (1345–1348)*, London, 1903

Pfaff 1992: R.W. Pfaff, 'The Tituli, Collects, Canticles, and Creeds', in *The Eadwine Psalter: Text, Image, and Monastic Culture in Twelfth-Century Canterbury*, ed. M. Gibson, T. A. Heslop, and R. W. Pfaff, London, 1992, 88–107

Phillips 1986: J. R. S. Phillips, 'Edward II and the Prophets', in *England in the Fourteenth Century: Proceedings of the 1985 Harlaxton Symposium*, ed. W. M. Ormrod, Woodbridge, 1986, 189–201

Pinon 1980: R. Pinon, 'From Illumination to Folksong: The Armed Snail, a Motif of Topsy-Turvy Land', in *Folklore Studies in the Twentieth Century: Proceedings of the Centenary Conference of the Folklore Society*, ed. V. J. Newall, Woodbridge, 1980, 76–113

Ramsay, Sparks and Tatton-Brown 1992: *St Dunstan: His Life, Times, and Cult*, ed. N. Ramsay, M. Sparks and T. Tatton-Brown, Bury St Edmunds, 1992

Randall 1962: L. M. C. Randall, 'The Snail in Gothic Marginal Warfare', *Speculum*, 37 (1962), 358–67

Randall 1966: L. M. C. Randall, *Images in the Margins of Gothic Manuscripts*, Berkeley, 1966

Remnant 1969: G. L. Remnant, *A Catalogue of Misericords in Great Britain*, Oxford, 1969

Reynolds 1965a: L. D. Reynolds, *L. Annaeus Seneca, Epistulae morales ad Lucilium*, 2 vols, Oxford, 1965

Reynolds 1965b: L. D. Reynolds, *The Medieval Tradition of Seneca's Letters*, London, 1965

Reynolds 1996: S. Reynolds, *Medieval Reading: Grammar, Rhetoric and the Classical Text*, Cambridge, 1996, repr. 2004

Rogers 2007: N. Rogers, 'From Alan the Illuminator to John Scott the Younger: Evidence for Illumination in Cambridge', in *The Cambridge Illuminations: The Conference Papers*, ed. S. Panayotova, London and Turnhout, 2007, 287–99

Rogers forthcoming: N. Rogers, 'The Provenance of the Thornham Parva Retable', in *Proceedings of the 2007*

Harlaxton Symposium, ed. N. Rogers, Donington, forthcoming

Rosenwein 2001: B. Rosenwein, 'Writing Without Fear about Early Medieval Emotions', in *Early Medieval Europe*, 10 (2001), 229–34

Rouse and Rouse 1979: R. H. Rouse and M. A. Rouse, *Preachers, Florilegia and Sermons: Studies on the 'Manipulus florum' of Thomas of Ireland*, Toronto, 1979

Rouse and Rouse 2000: R. H Rouse and M. A. Rouse, *Manuscripts and their Makers: Commercial Book Production in Medieval Paris, 1200–1500*, 2 vols, London and Turnhout, 2000

Rubin 1987: M. Rubin, *Charity and Community in Medieval Cambridge*, Cambridge, 1987

Rubin 1991: M. Rubin, *Corpus Christi: The Eucharist in Late Medieval Culture*, Cambridge, 1991

Rushing 1995: J. Rushing, *Images of Adventure: Ywain in the Visual Arts*, Philadelphia, 1995

Rushing 1998: J. Rushing, 'Adventure in the Service of Love: Yvain on a Fourteenth-Century Ivory Panel', *Zeitschrift für Kunstgeschichte*, 61 (1998), 55–64

Rutledge 2004: E. Rutledge, 'Economic Life', in *Medieval Norwich*, ed. C. Rawcliffe and R. Wilson, Hambledon and London, 2004, 157–88

Sandler 1970: L. F. Sandler, 'A Follower of Jean Pucelle in England', *Art Bulletin*, 52 (1970), 363–72

Sandler 1974: L.F. Sandler, *The Peterborough Psalter in Brussels and Other Fenland Manuscripts*, London, 1974

Sandler 1979: L. F. Sandler, 'An Early Fourteenth-Century English Psalter in the Escorial', *Journal of the Warburg and Courtauld Institutes*, 41 (1979), 65–80

Sandler 1980: L. F. Sandler, 'Reflections on the Construction of Hybrids in English Gothic Marginal Illustrations', in *Art, the Ape of Nature: Studies in Honor of H. W. Janson*, ed. M. Barasch and L. F. Sandler, New York, 1980, 51–66

Sandler 1983: L. F. Sandler, *The Psalter of Robert de Lisle in the British Library*, London, 1983, paperback edn 1999

Sandler 1985a: L. F. Sandler, 'A Bawdy Betrothal in the Ormesby Psalter', in *Tribute to Lotte Brand Philip*, ed. W. W. Clark et al., New York, 1985, 154–59

Sandler 1985b: L.F. Sandler, 'A Note on the Illuminators of the Bohun Manuscripts', *Speculum*, 60 (1985), 364–72

Sandler 1986a: L. F. Sandler, 'Face to Face with God: A Pictorial Image of the Beatific Vision', in *England in the Fourteenth Century: Proceedings of the 1985 Harlaxton Symposium*, ed. W. M. Ormrod, Woodbridge, 1986, 224–35

Sandler 1986b: L. F. Sandler, *Gothic Manuscripts, 1285–1385*, 2 vols, A Survey of Manuscripts Illuminated in the British Isles, 5, London and Oxford, 1986

Sandler 1996: L. F. Sandler, *Omne bonum: A Fourteenth-Century Encyclopaedia of Universal Knowledge, British Library MSS Royal 6 E VI– 6 E VII*, 2 vols, London, 1996

Sandler 1997: L. F. Sandler, 'The Study of Marginal Imagery: Past, Present, and Future', *Studies in Iconography*, 20 (1997), 1–49

Sandler 2002a: L. F. Sandler, 'The Illustrations of the Psalms in Fourteenth-Century English Manuscripts: The Case of the Bohun Family Psalters', in *Reading Texts and Images: Essays on Medieval and Renaissance Art and Patronage in Honour of Margaret M. Manion*, ed. B. J. Muir, Exeter, 2002, 123–52

Sandler 2002b: L. F. Sandler, 'John of Metz, The Tower of Wisdom', in *The Medieval Craft of Memory: An Anthology of Texts and Pictures*, ed. M. Carruthers and J. M. Ziolkowski, Philadelphia, 2002, 215–25

Sandler 2002c: L. F. Sandler, 'Political Imagery in the Bohun Manuscripts', *English Manuscript Studies, 1100–1700*, vol. 10, ed. A. S. G. Edwards, 2002, 114–53

Sandler 2003: L. F. Sandler, 'Lancastrian Heraldry in the Bohun Manuscripts', in *The Lancastrian Court: Proceedings of the 2001 Harlaxton Symposium*, ed. J. Stratford, Donington, 2003, 221–32

Sandler 2004: L. F. Sandler, *The Lichtenthal Psalter and the Manuscript Patronage of the Bohun Family*, London and Turnhout, 2004

Sandler 2007: L. F. Sandler, 'In and Around the Text: The Question of Marginality in the Macclesfield Psalter', in *The Cambridge Illuminations: The Conference Papers*, ed. S. Panayotova, London and Turnhout, 2007, 105–14

Schmidt 1978: P. G. Schmidt, *Visio Thurkilli*, Leipzig, 1978

Schmitt 1990: J.-C. Schmitt, *La Raison des gestes dans l'Occident médiévale*, Paris, 1990

Schmitt 1991: J.-C. Schmitt, 'The Rationale of Gestures in the West: Third to Thirteenth Centuries', in *A Cultural History of Gesture from Antiquity to the Present Day*, ed. J. Bremmer and H. Roodenburg, Oxford, 1991, 59–83

Sinclair 1979: K. V. Sinclair, 'Comic *Audigier* in England', *Romania*, 100 (1979), 257–59

Smale 2001: E. Smale, 'Dominican Art and Architecture in the Cambridge Visitation circa 1220 – circa 1540', Ph.D. thesis, University of Cambridge, 2001

Smalley 1960: B. Smalley, *English Friars and Antiquity in the Early Fourteenth Century*, Oxford, 1960

Smalley 1983: B. Smalley, *The Study of the Bible in the Middle Ages*, 3rd edn, Oxford, 1983

Smith 1993: K. A. Smith, 'History, Typology and Homily: The Joseph Cycle in the Queen Mary Psalter', *Gesta*, 32 (1993), 147–59

Smith 2003: K. A. Smith, *Art, Identity and Devotion in Fourteenth-Century England: Three Women and their Books of Hours*, London and Toronto, 2003

Stallybrass and White 1986: P. Stallybrass and A. White, *The Politics and Poetics of Transgression*, Ithaca, 1986

Stanton 2001: A. R. Stanton, *The Queen Mary Psalter: A Study of Affect and Audience*, Philadelphia, 2001

Stringer 1985: K. J. Stringer, 'The Early Lords of Lauderdale, Dryburgh Abbey and St Andrew's Priory at Northampton', in *Essays on the Nobility of Medieval Scotland*, ed. K. J. Stringer, Edinburgh, 1985, 44–71

Taft 1993: R. Taft, *The Liturgy of the Hours in East and West*, Collegeville, PA, 1986, repr. 1993

Tanner 1984: N. P. Tanner, *The Church in Late Medieval Norwich, 1370–1532*, Toronto, 1984

Taylor 1999: A. Taylor, *Cambridge: The Hidden History*, Stroud, 1999, repr. 2001

Tierney 1834: M. A. Tierney, *History and Antiquities of the Castle and Town of Arundel*, London, 1834

Tracy 1997: C. Tracy, 'An English Painted Screen at Kingston Lacy', *Apollo*, 146 (1997), 20–28

Tristram 1955: E. W. Tristram, *English Wall Painting of the Fourteenth Century*, London, 1955

Tudor-Craig 1988: P. Tudor-Craig, Review of C. Norton, D. Park and P. Binski, *Dominican Painting in East Anglia: The Thornham Parva Retable and the Musée de Cluny Frontal*, Woodbridge, 1987, *Antiquaries Journal*, 68 (1988), 367–68

Vale 1982: J. Vale, *Edward III and Chivalry: Chivalric Society and its Context, 1270–1350*, Woodbridge, 1982

Varty 1999: K. Varty, *Reynard, Renart, Reinaert and Other Foxes in Medieval England: The Iconographic Evidence*, Amsterdam, 1999

VCH *Sussex* 1973: *Victoria History of the County of Sussex*, vol. 2, London, 1973

Weiss 1998: D. H. Weiss, *Art and Crusade in the Age of Saint Louis*, Cambridge, 1998

Wentersdorf 1984: K. P. Wentersdorf, 'The Symbolic Significance of the "Figurae scatologicae" in Gothic Manuscripts', in *Word, Picture and Spectacle*, ed. C. Davidson, Kalamazoo, MI, 1984, 1–20

Wille 2002: F. Wille, *Die Todesallegorie im Camposanto in Pisa: Genese und Rezeption eines berühmten Bildes*, Munich, 2002

Woodcock and Robinson 1988: T. Woodcock and J. M. Robinson, *The Oxford Guide to Heraldry*, Oxford, 1988

Young 1933: K. Young, *The Drama of the Medieval Church*, 2 vols, Oxford, 1933

Ziolkowski 1998: *Obscenity: Social Control and Artistic Creation*, ed. J. M. Ziolkowski, Leiden, 1998

Zutshi 2002: P. N. R. Zutshi, 'The Mendicant Orders and the University of Cambridge in the Fourteenth and Fifteenth Centuries', in *The Church and Learning in Later Medieval Society: Essays in Honour of R. B. Dobson: Proceedings of the 1999 Harlaxton Symposium*, ed. C. M. Barron and J. Stratford, Donington, 2002, 210–27

Zutshi and Ombres 1990: P. N. R. Zutshi and R. Ombres, 'The Dominicans in Cambridge, 1238–1538', *Archivum Fratrum Praedicatorum*, 60 (1990), 313–73

Zutshi, Ombres and Morgan 1988: P. N. R. Zutshi, R. Ombres and N. Morgan, *The Dominicans in Cambridge, 1238–1538*, Cambridge, 1988 [exhibition catalogue]

INDEX